China's Vanishing Worlds Countryside, Traditions, and Cultural Spaces

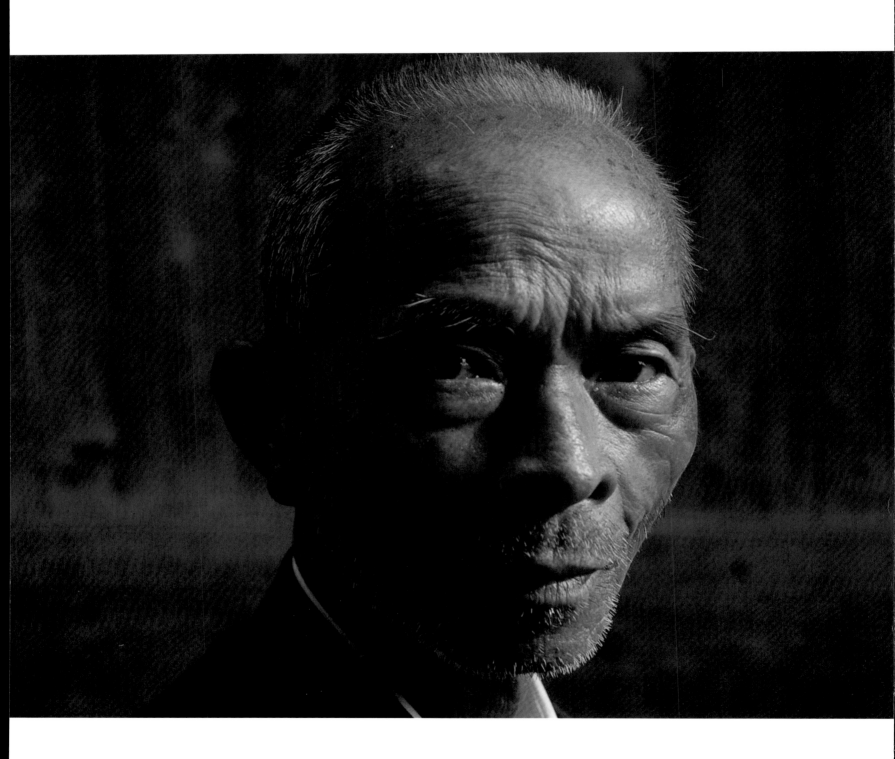

Matthias Messmer & Hsin-Mei Chuang

China's Vanishing Worlds

Countryside, Traditions, and Cultural Spaces

The MIT Press
Cambridge, Massachusetts

MIT Press books may be purchased at special quantity discounts for business or sales promotional use. For information, please email special_sales@mitpress.mit.edu or write to Special Sales Department, The MIT Press, 55 Hayward Street, Cambridge, MA 02142.

Printed and bound in Spain.

Library of Congress Cataloging-in-Publication Data

Messmer, Matthias, 1967–
China's vanishing worlds : countryside, traditions, and cultural spaces / Matthias Messmer and Hsin-Mei Chuang.
 p. cm.
Includes bibliographical references.
ISBN 978-0-262-01986-6 (hardcover : alk. paper)
1. China—Rural conditions. 2. China—Rural conditions—Pictorial works. 3. Rural population—China. 4. Rural population—China—Pictorial works. 5. Villages—China. 6. Villages—China—Pictorial works. I. Chuang, Hsin-Mei, 1979– II. Title.
HN733.5.M474 2013
306.0951—dc23
 2013007932

10 9 8 7 6 5 4 3 2 1

Contents

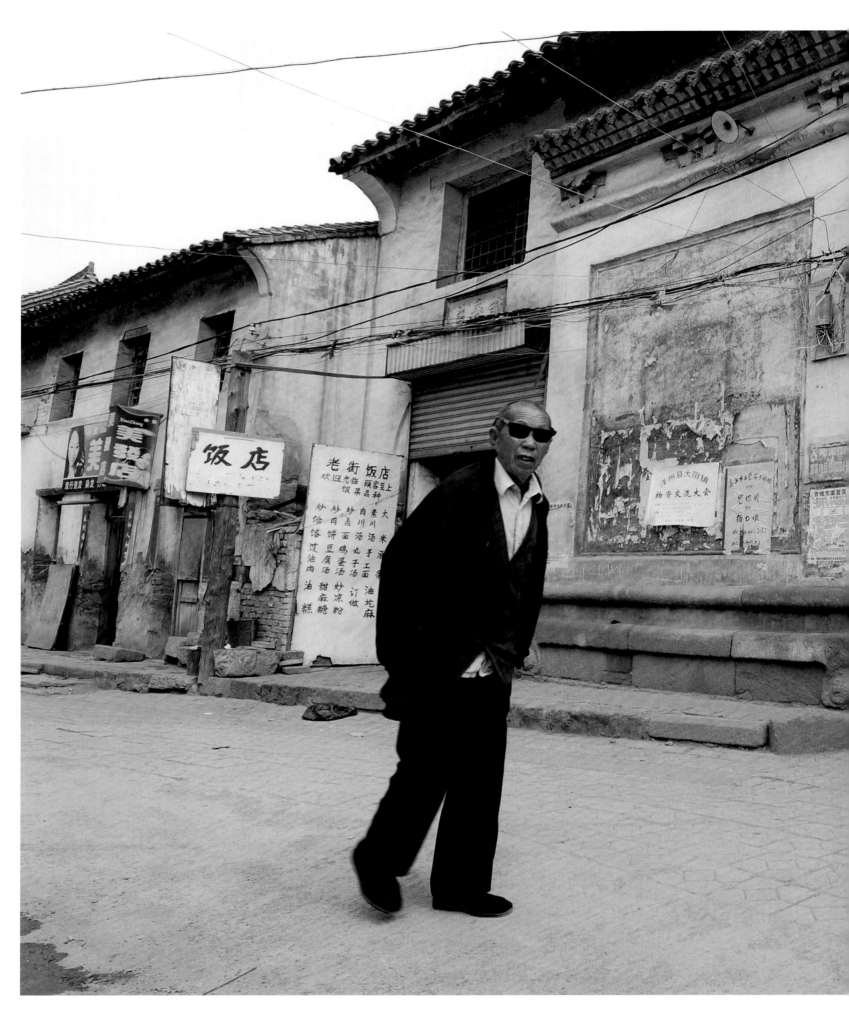

Dayang Old Town, Shanxi Province

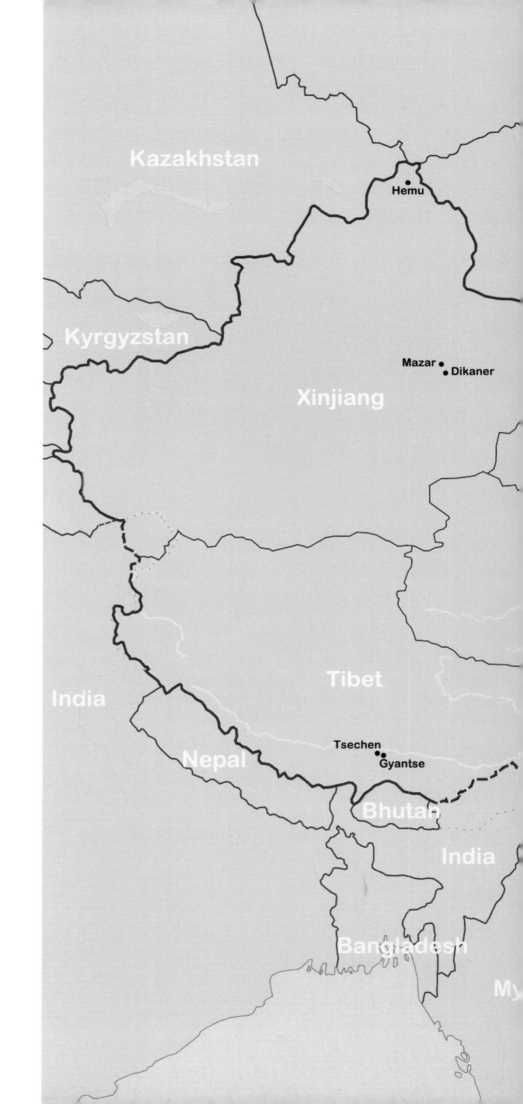

Map of places included in the *Villages in Focus*

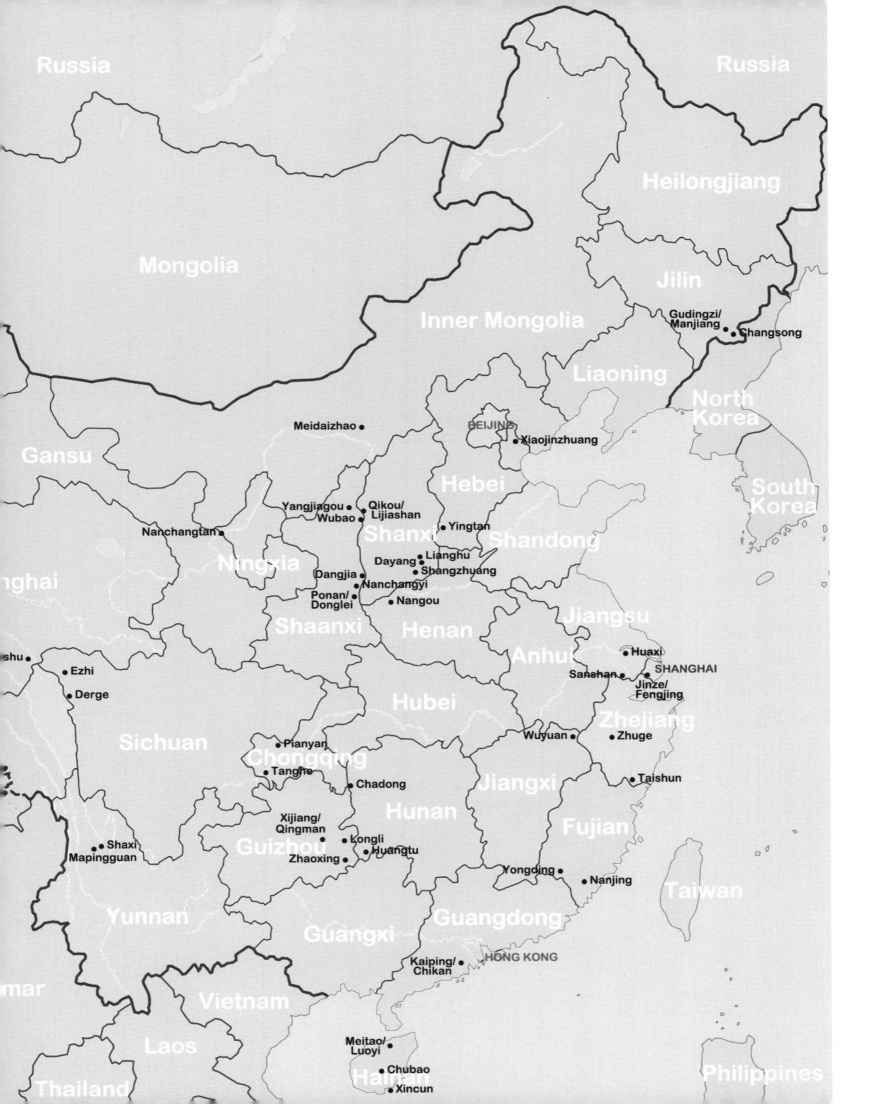

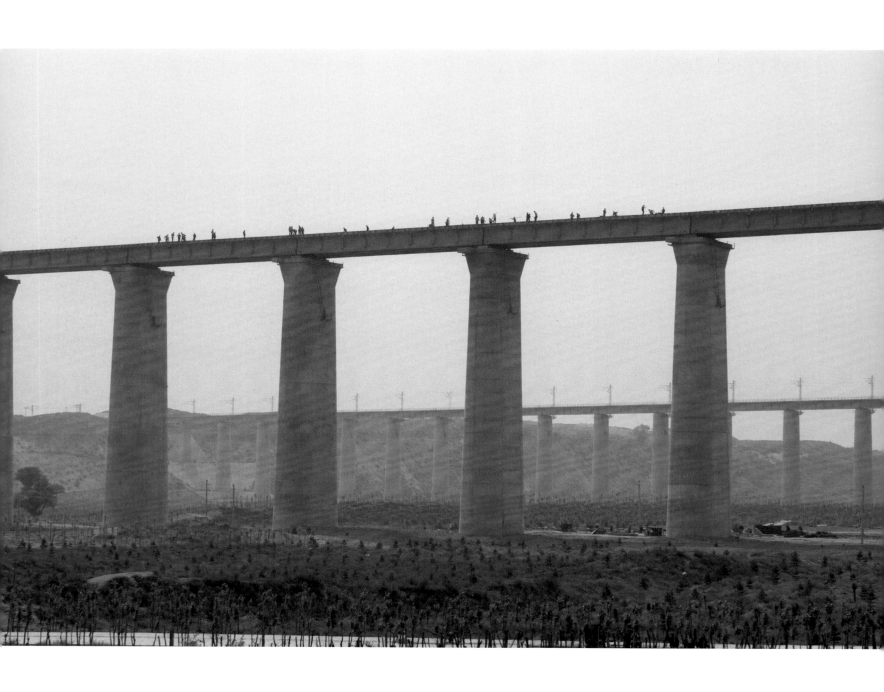

Infrastructure projects,
Yijinhuoluo Banner, Inner Mongolia Autonomous Region

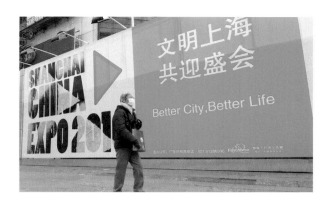

Introduction

This is a book about the 'other China,' the often-neglected rural China – and the Chinese peasant.

It may seem trite, but modernization has exacted a very high price: China's cultural landscapes are steadily vanishing, and at a tempo that cries out for documentation. *China's Vanishing Worlds – Countryside, Traditions and Cultural Spaces* is about the largest share of Chinese territory and the lifestyles of the majority of its inhabitants. China's land area is more than twice as large as all the European Union countries combined, and its population is almost three times as large. Can we offer a comprehensive picture of this great, diverse country? For what has been most characteristic of the Middle Kingdom, if not its diversity?

Notwithstanding the difficulties posed by this project, we hope to present an integrated picture of the inevitable loss of cultural landscapes, fully aware that the spread of great urban clusters is permanently changing the countryside: "Better City – Better Life" was the popular slogan at the 2010 Shanghai World Exhibition. In the next twenty years, an estimated 280-million Chinese villagers will become city dwellers, attracted by urban jobs and opportunities. With all the daily reports of the construction boom and rapid economic expansion in the big cities, nobody seems to be interested in the vast rural areas of a country striving to become modern, urban, cosmopolitan and prosperous. We have therefore chosen to present a book on the often overlooked, neglected and forgotten corners of China, a country and a civilization whose economic and social foundations had, until the 1980s, always been primarily agrarian.

This book is also about lifestyles – but not about the glamorous lifestyles of Shanghai, Beijing or Hong Kong. In these metropolises, Louis Vuitton boutiques, Rolex showrooms and Cartier flagship stores have spread like wildfire, as if to show the world that China has indeed become modern

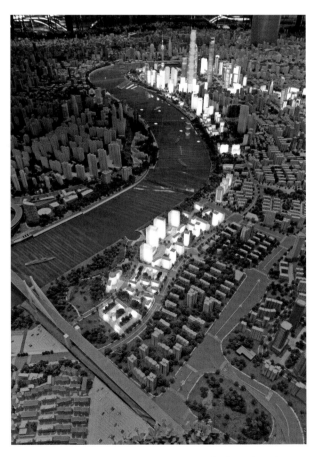

A scale model of urban Shanghai in the Shanghai Urban Planning Exhibition Centre shows the city in 2020 with endless skyscrapers.

and international. Sometime in the future, China will thus no longer be a developing country, but instead a member in good standing of the 'developed world.' 'Lifestyle,' in the urban sense and as a common term in the contemporary vocabulary, has come to mean a chic, posh way of life, e.g., a New York, Paris or Shanghai lifestyle – a symbol of sophisticated luxury in a globalized world. Our presentation of rural lifestyles in this book reveals a different side of China.

It may seem paradoxical, but *China's Vanishing Worlds* is also about a special type of luxury: The privilege of seeing beauty that others cannot see or have not yet noticed, of discovering the cultural riches of rural China without neglecting its poverty. We show, however, that 'back-

This illustration shows China's urbanization process from 1949 to 2009. The degree of urbanization has accelerated greatly after the Opening-up. It nearly doubled, increasing from 26 percent to 46 percent, between 1989 to 2009, whereas it had taken three decades to grow from seven percent to 18 percent before 1979.

中国城市化六十年演进: 1949-2009
60 Years of China's Urbanization: 1949-2009

ward' sometimes means more than simply the opposite of so-called progress. As far as we know, this is the first book to give readers a comprehensive view of the 'other China' – through a complementary arrangement of photographs and text. As our title indicates, we deal with the steady loss of Chinese cultural spaces. By 'cultural spaces,' we mean living and lived-in spaces, land shaped by cultural groups, not the physical remnants of the past, such as ancient cities or prehistoric sites.

Our perspective is not naïve: The transformation of landscapes is a natural and inevitable aspect of modernization that is occurring in Western countries as well. We do not idealize or glorify life in rural China. Instead, we try to offer descriptions that are as objective as possible, while also presenting our subjective experiences of a world that has not yet been adequately portrayed in the West. Life in rural China is burdened by hardship, need and misery – but it is also often blessed by simplicity, tranquility and authenticity. We offer readers insights into a land that has been neglected for decades and describe how greatly it has changed. Our approach is not judgmental, but instead offers keys for unlocking the realities, mysteries and miracles of rural China.

Our book does not focus on familiar tourist destinations. Nor does it try to compete with coffee-table books with their striking and often moving pictures of the world-famous Terracotta Army near Xi'an, the Great Wall of China near Beijing, the majestic snowy mountain peaks of Tibet, the lush green hills of the panda bear preserve in Sichuan Province or the splendid sand dunes of Dunhuang in Gansu Province.

China's Vanishing Worlds shows places chosen from among the many ancient towns and villages now threatened by the encroachment and pressures of rapid modernization. China's territory is vast, as is the diversity of its topographies, regions and lifestyles. A personal note regarding how we selected the areas covered: We chose them carefully not only to meet the book's formal needs – i.e., to show the broad diversity of China's rural landscapes – but also in accord with our desire to present places with unique cultural and often aesthetic accents. We wanted to show an unknown spot in the vast territory of China, a forgotten hamlet with a centuries-old history in a minority region, preferably far from the beaten track, or a once-extolled *model village* [mofan cun].

This book is not an academic study: It hopes to appeal to the eye, heart and feelings. Just as these places have intrigued us with their history, people, architecture or culture, we hope that they will stimulate our readers' curiosity and awaken their interest in the fascinating diversity of rural China. On the one hand, our book documents rural China, and on the other it calls for reflection on the process of modernization. Many of the regions we visited have been cultural spaces for centuries, crisscrossed or inhabited by peasant farmers, merchants, writers, artists, adventurers and travelers. Some places, because of their accessibility by waterways or roads, once flourished as major centers on trade routes, while others – perhaps isolated in remote mountainous areas – were re-

In 1980, an art student named Luo Zhongli painted the portrait *Father*, which touched the hearts of millions of Chinese and later became a milestone in modern Chinese art history. It was the first large portrait of an ordinary old man after decades of socialist-realism painting. Luo, born in 1948 in Chongqing, is one of the country's leading painters, an artist who during his youth had made portraits of Mao and other Party leaders for propaganda posters. This huge portrait of a wrinkled old farmer, which frankly portrays the burdens and hardships of his life, depicts the Chinese farmer *par excellence* at that time. But even today, faces and lives that resemble those of the man in the painting can still be found in many rural areas.

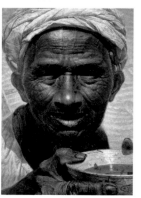

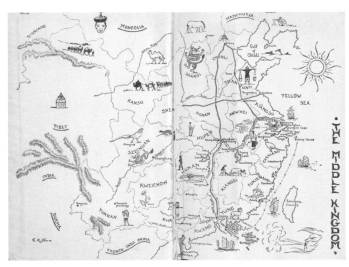

Since the time of Marco Polo's famous visit to China, the country's cultural spaces have excited and fascinated Western travelers perhaps even more than they have the Chinese themselves. Whether it was doing research on ancient trade routes, studying remote minority areas or simply enjoying Chinese aesthetics, explorers, scholars, missionaries or adventurers all found their own captivating topics.

nowned for their resistance to invaders. Some regions we visited reminded us of the old cultural spaces in Eastern Europe, such as the Carpathian Mountains, Transylvania or Moravia. In many cases, these once-important regions have lost their vitality and importance, their houses long deserted or dilapidated, and only ruins suggest their former glory.

Gradually, some rural places are being discovered by the tourism industry and – overwhelmed by thoughtless swarms of tourists seeking cheap thrills – are destined to lose their distinctive spirit and character. Local governments are keen to make a profit, which they can do more easily by building golf courses or amusement parks than by uncovering cultural traces that in many cases are only an embarrassing nuisance for the government. Just as the regime 'leads' the Chinese people, it prefers to 'manage' the culture and history of the whole country. It does this more subtly than during the period of socialist realism, but in a manner that still leaves no doubt as to who is the master and whose plans are to be realized.

Despite our generally nostalgic feelings for disappearing cultural landscapes, we do realize that 'the loss of history' is partly inevitable in the process of modernization. It would therefore be wrong to interpret this book as a simple protest against all aspects of change. Sometimes only architecture bears witness to the past: That of imperial dynasties (mostly the Qing Dynasty, 1644–1911, very rarely that of the Ming Dynasty, 1368–1644), of Republican China (1911–1949) and of the People's Republic of China (PRC). The *Cultural Revolution* [wenhua dageming] from 1966 to 1976

Constantly on the Road

The experience of traveling in China has changed along with the disappearance of cultural spaces. An appendix to *An Official Guide to Eastern Asia*, published by the Imperial Japanese Government Railway in 1915, specifies three languages besides Chinese that were used in different parts of China: Russian and Japanese in parts of former Manchuria, and English in the European and American concessions. A description in this pamphlet of contemporary means of transportation offers a more vivid picture:

> *Steam-launch Services. Quite extensive steam-launch services are maintained on lakes, canals and rivers, using small steamboats either for passenger service or as tugboats for towing houseboats… National Highways. China is traversed by highways in all directions. These, to judge from the remains of roofed stone bridges or spacious rest stations by the roadsides, must have been splendid in days past, but today they are sadly in disrepair…*

Other Means of Transportation: Chiao-che (horse-drawn carriage), Lo-to-chiao (riding box borne by two mules), Chang-che (mule-drawn carriage), Hsiao-che (wheelbarrow), Chiao-tzu (sedan chair), rickshaw (also known as tung-yang-che), riding animals, European carriages, and automobiles. Chiao-che… are sturdily built and more suitable for carrying heavy merchandise than passengers… cover 37 m. a day if drawn by one horse… constitute the universal means of travel in the interior of N. and N.W. China, except where railways are open…. Lo-to-chiao… more expensive than Chiao-tzu, but make for more comfortable riding. Chiao-tzu are chairs carried on the shoulders of coolies (sedan chairs). They are a great convenience in places where rickshaws are not available due to narrow streets or in going uphill…

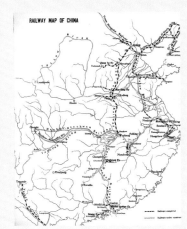

A railway map of China around 1910

The Washington Times

China's 'cancer villages' heavily polluted

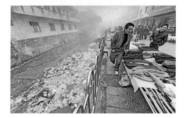

Life in rural China has never been short of tragedies. Certainly during the era of Mao Zedong, farmers also had to cope with misery and calamities. With industrialization, material conditions have improved, but at a high cost. In the past decade, activists and the media have begun to expose shocking facts about an exploited countryside and its inhabitants, sometimes victimized on a vast scale.

was especially devastating for the Chinese people, and its scars can still be found and felt almost everywhere in rural China. In fact, this *Ten-year Catastrophe* [shinian haojie] caused irreversible damage, above all for ordinary people, but also for the cultural legacy of a country that was once home to one of the great ancient civilizations.

In this sense, *China's Vanishing Worlds* is also a mapping out within a political context. Even though our original aim was to write an apolitical book, it soon became clear that this goal was impossible. Despite the Chinese countryside's obvious beauty and the nostalgia it so often evokes, modernization policies have had disastrous consequences for rural areas. We do not dwell on the 'cancer villages' whose high rates of health problems bear witness to the destructive consequences of the economic boom, or on topics such as rising suicide rates in rural China. Suicide rates have particularly risen among rural women, due to family pressure, low educational levels and restricted social communication, further exacerbated by the rampant use of agricultural pesticides. Nor do we document the tragedies of farmers losing their homes and land in the government's massive relocation programs. Nevertheless, this book cannot completely ignore the fact that Chinese landscapes are also often political landscapes. This is not just a material fact; it has also left traces in the minds of peasants. The psychic scars they bear are sometimes more devastating than the historical upheavals themselves.

Modernization slowly and relentlessly encroaches upon ancient cultural landscapes. It is like spreading a new carpet on an old wooden floor, even though the floor is worn and needs restoration. Industrialization, unfortunately, shows no respect for tradition or aesthetics. The government's master plan for the coming decades is to connect 'what has to be connected' in order for China to become a world power. Yet somehow, it often seems as though mega-projects are tearing apart more than they are binding together. Organically integrated regions and cultural networks that existed for centuries are being subdivided into smaller units lacking socio-historical links. China already has more than 160 cities with over one-million inhabitants apiece. High-speed railways make it possible to travel between Shanghai and Wuhan, or Beijing and Harbin, in roughly four hours, and the vast web of railway connections is expanding year after year. The government plans to open seventy new airports in the next decade, which means the country will have almost 250 civilian airports by the end of 2020. 'High-speed' means rapid development, and *Development is the Ultimate Principle* [fazhan cai shi ying daoli], as Deng Xiaoping once emphasized. In the course of implementing this principle, the old, underdeveloped 'China of Yesterday' will disappear, be destroyed and forgotten, replaced in the end by a shining 'new China.'

Today, there is a good chance that by offering material incentives, one can gain official approval for any project that aspires to increase China's economic growth. Any plan to preserve old traditions and forgotten cultural spaces has little chance of receiving a sympathetic hearing. These traditions and spaces will remain forever limited to nostalgic memories of the past. *China's Vanishing Worlds* offers both a glimpse of the Chinese past and a view of the present state of rural areas in upheaval. We have tried to capture moments of life that may soon be lost forever and leave it to the reader to imagine the future of rural China. Visiting and photographically documenting the Chinese countryside is a source of consolation for us, a way to reconcile ourselves to

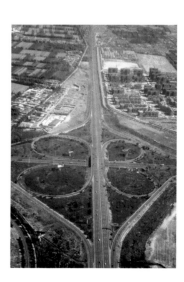

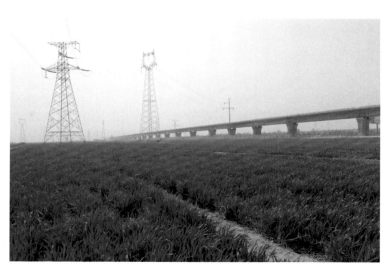

Construction of high-speed railway tracks and super highways cutting across rural landscapes: Illustrated (Right) is a part of the Beijing-Shanghai High-Speed Railway.

Already in 1949, Mao Zedong decided to shift the Communist Party's strategy from the countryside to the cities. Therefore, state policy began to focus on industrialization projects rather than on agriculture. From the 1980s on, modernization and urbanization have become the keywords for development.

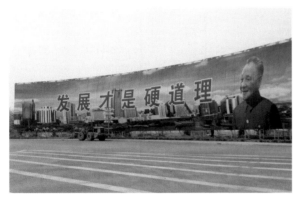

In 1992, Deng Xiaoping made his famous tour of southern China and commented: "Our country must develop. We will be bullied if we don't develop. Development is the ultimate principle." In response, China's Economic Reforms and Opening-up policy was further intensified. The Shenzhen Special Economic Zone, a once-quiet fishing village bordering Hong Kong, and Shanghai became China's economic hubs.

loss and bid farewell to the past. We have tried to preserve moments of cultural memory before they simply vanish. In our documentary travels, we try to rediscover spaces and traces that once made Chinese civilization so rich and colorful. Like cultural anthropologists, we wish to record still existing, but gradually vanishing cultural landscapes. 'Space' is not abstract for us: With increasing progress and modernization, space can be used up and exhausted, just like any other resource. 'Places' constructed in 'spaces' can, however, live on in the minds of later generations.

As many analysts have concluded, peasants in contemporary China may be enjoying the most abundant material lifestyle they have ever known. Yet their social status and perceptions of their quality of life are on a downward trajectory. We do not try to resolve this paradox in the various chapters of our book, but rather guide readers through the periods and generations of the Chinese countryside. Readers could profitably take a moment to reflect on literary works set in rural China, such as Pearl Buck's *The Good Earth,* Eileen Chang's *The Rice-Sprout Song* or even Mo Yan's *Red Sorghum*. Although they are set in a China that existed more than half a century ago, some parts of life have surprisingly resisted the waves of time, more often than expected. What is it in *The Rice-Sprout Song*, first published in 1955, that troubles the government enough to continue banning it to this day? Our photographs can help readers visualize and imagine the vanishing worlds presented in these works, in order to reflect on the geography of time. They will then be able to take a variety of different imaginary walks through the cultural and literary landscapes of rural China. If readers succeed in developing positive connotations to replace the negative stereotypes ('vulgar' or 'lacking culture') that many naïve outsiders associate with 'rural,' and in particular with the character *tu* [土], meaning 'earth,' we will regard this as no small accomplishment.

A 1952 map of aviation routes shows that only the chief cities, mostly those of political significance, were connected. In the last two decades, dozens of new airports have been opened, not only in the interior, but also in remote and high-altitude areas. They cater to the growing number of travelers, as well as serving military purposes. Once-hidden jewels found by explorers and adventurers far from civilization are literally vanishing, and, with them, local cultures and traditional lifestyles are also gradually disappearing. (Photo: Kanasi Airport is one of sixteen airports in Xinjiang, and it is only open in the summer for tourists visiting the area).

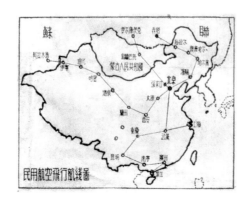
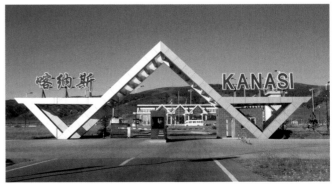

New Cities = Ghost Cities?

Chinese modernization has been driven first and foremost by the rapid urbanization process. The country's strategy of 'development first' has unleashed an unprecedented rush to exploit natural resources, be they gas, oil or coal. New cities have been built up in areas where once only farmers or nomads lived.

 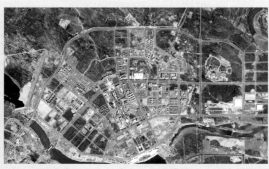 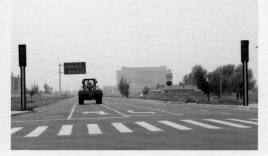

Ordos [E'erduosi] City in Inner Mongolia Autonomous Region, for instance, belongs to one of the richest regions in the country due to its petrochemical resources and coal mining, but is at the same time dubbed "China's most famous ghost city." A city with empty residential high-rises and broad streets has risen on the horizon of this once-uninhabited desert. Promotion slogans such as *Strive to Create a Civilized City. Building a Beautiful E'erduosi* promise investors a blossoming future. The city is known for its lavish government projects, but besides a rather unexpectedly large number of BMWs, Mercedes and Porsches, the place cannot boast of any cultural institutions.

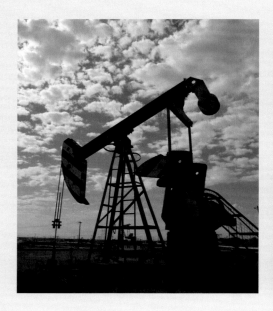 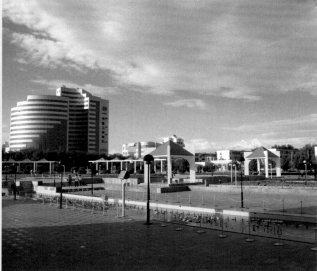

The region where present-day Karamayi [Kelamayi] City in Xinjiang Uyghur Autonomous Region is located was among the first areas to flourish, thanks to its oil fields. After 1955, the small town was upgraded to a county-level city and then further to a prefecture-level city. The oil resources are expected to be exhausted in four decades. The city will probably become deserted at that time.

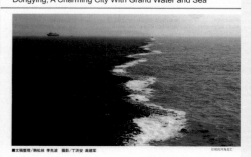

Dongying City in Shandong Province was only established in the early 1980s as a base for China's second-largest oil field, *Victory Field [Shengli Youtian]*, and to develop the Yellow River Delta. Today, the government attracts visitors by describing it as a "charming ecological city with grand water and sea" vistas and foreign merchandise retailers.

One last note concerning definitions: Rural China is a cultural kaleidoscope, a bewildering variety of villages and lifestyles in transition. It is not always easy to distinguish clearly between urban and rural, even though China has a dichotomous classification system based on a set of administrative criteria: *Cities* [chengshi] and *officially designated towns* [jianzhi zhen] make up the urban sector, whereas *villages* [nongcun], *undesignated towns* [fei jianzhi zhen] and *market towns* [jizhen] make up the rural sector. However, these abstract distinctions often overlap, not least because the decision to designate a settlement an urban place is often a political one linked to fiscal policy. A *jizhen*, the highest-order rural settlement, is essentially a larger village with a dominant agricultural economy combined with a substantial and growing commercial sector.

Our book sometimes strays into urban areas because rural communities are never isolated, self-contained units, but instead interact with and are influenced by neighboring urban centers. For most rural Chinese, small towns or *county seats* [xiancheng] are the most familiar experience of an urban place. While our definitions of rural China may occasionally differ from the official ones, we have specifically based them on the living conditions of the majority of rural residents.

One last word on reading this book: Whereas the photographs, which form its core, offer a subjective selection of our personal experiences, we have composed the text to complement the pictures in an objective and more comprehensive way. Our visual images are atmospheric in nature, but we want our texts to stimulate thought. If readers try to assimilate these two sides of the book, they will be better able to grasp at least some of the realities of rural China today. We have arranged our material so that readers can either read the book from beginning to end to get an overview of life in rural China or start with any topic that attracts their interest. A special section *Villages in Focus* stands at the end of every chapter. These villages exemplify the particular topics of each chapter in a vivid and personal way.

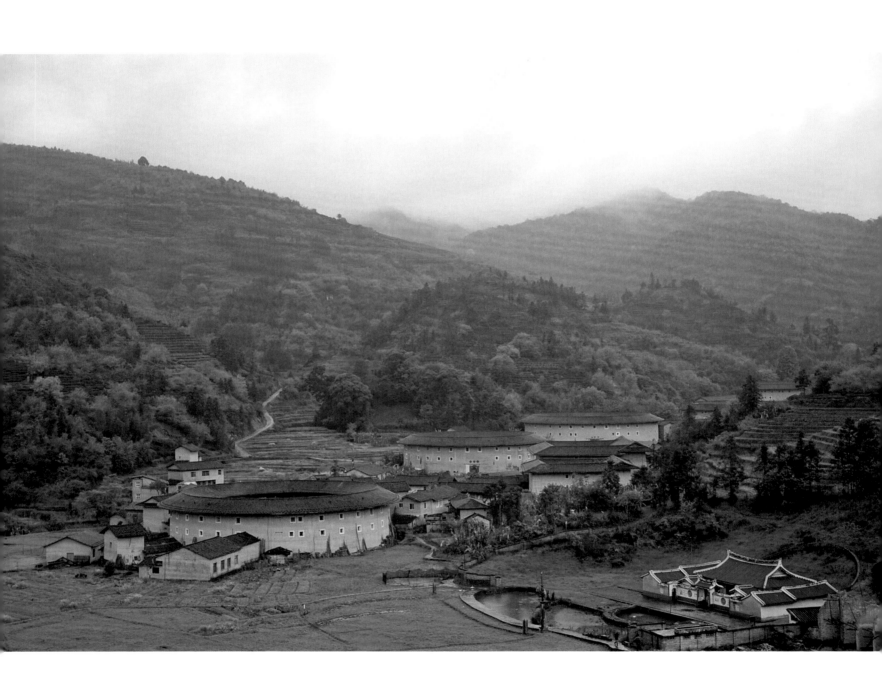

Hakka earth houses,
Nanjing County, Fujian Province

Over the centuries, countless Western travelers have been enchanted by Chinese landscapes with their *fengshui* aesthetics. These illustrations drawn in the nineteenth century provide some of their precious impressions.

Settlements of *Fengshui*

*That Chinese villages differ from region
to region is a truism, a reality that can easily be observed from the air
or when crossing the country by rail or highway.*

China's natural and cultural landscapes form a complex mosaic of histories, varied topographies and natural surroundings, and so do its villages – dwellings clustered along rivers, crossroads settlements on trade routes, military strongholds in remote mountain areas, coastal hamlets and the rude shelters of migrant herdsmen.

We can often get clues about a village's history from its name. The most common generic character suffixes used to form specific toponyms for rural settlements are *cun* and *zhuang*. Besides these two characters, there are other characters that are used only regionally or for specific reasons. Thus, for example, *bao, ying* and *tun* suggest that troops were at some time stationed at a defensive post in a given location. *Zhai* points to mountain or minority settlements. *Xu* and *ji* both signify a marketplace; *wan, ba* and *tang* suggest a settlement located near a body of water; *pu* was the ancient name for a postal station; *ping* suggests a flat open setting in a hilly region; *gou* denotes a location near a trench or in a valley; *zhao* refers to Mongolian settlements that grew up around a temple.

Similarly, one can easily imagine the historical background of a village from the prefix of its name, which, for instance, can allude to the family name of the dominant clan in a village, common occupations in ancient times, major religious shrines, local legends or special geographical features. Though there may be various theories about the origins of a village's name, the different colorful stories associated with a particular prefix are often so fascinating that it seems pointless to argue about which of them is really true.

At first glance, Chinese villages may seem to lack the conspicuous arrangements and spatial layouts that are commonplace in the West (such as broad plazas, town halls or imposing religious sanctuaries), but they actually have quite characteristic spatial requirements arising from different ways of cultivating the land. Access to water has always been the most important factor in choosing a village site. Furthermore, despite the immensity of Chinese landscapes, almost every house in the entire country faces south to catch more sunlight and reduce exposure to the wind. This orientation also creates an impression of compactness and unity. In Han Chinese villages and towns, for instance, most of the larger buildings were designed for residential use. Shops and the houses of prominent families are usually located in the center of a town, whereas the ancestral hall may be integrated into a house, and temples or pagodas are often located on the outskirts of villages.

Minority settlements display a variety of planning principles. We can take those in southwestern China as an example. They generally feature a plaza where village residents hold communal activities and festivals, with the main public buildings, such as drum towers, located nearby. Villagers' houses cluster alongside a hill, while those of respected elders and families occupy

the heights and offer a view of the surrounding countryside. Even though disorder occasionally seems more the rule than the exception, Chinese village settlements have their own order, based on *fengshui* or geomancy.

"The place he had come to was level and spacious. There were houses and cottages arranged in a planned order. There were fine fields and beautiful pools. There were mulberry trees, bamboo groves, and many other kinds of trees as well. There were elevated pathways around the fields. And he heard the sounds of chickens and dogs. Going to and fro in all this, and busied with working and planting, were people, both men and women. Their dress was unlike that of people outside, but all of them, whether old people with white hair or children with their hair tied in a knot, were happy and content with themselves." These are the words of the famous poet Tao Yuanming (365-427), known as the 'Poet of the Fields' because he so vividly described the idyllic pastoral life of farming and the simple pleasures of rural life. He is also renowned for *The Tale of the Peach Blossom Spring* [Tao Hua Yuan Ji], which became synonymous with the conventional Chinese term for 'utopia.' In many parts of the country, a visit to rural China still evokes the pleasant mood of traditional villages where peasants live and work together in peace and harmony.

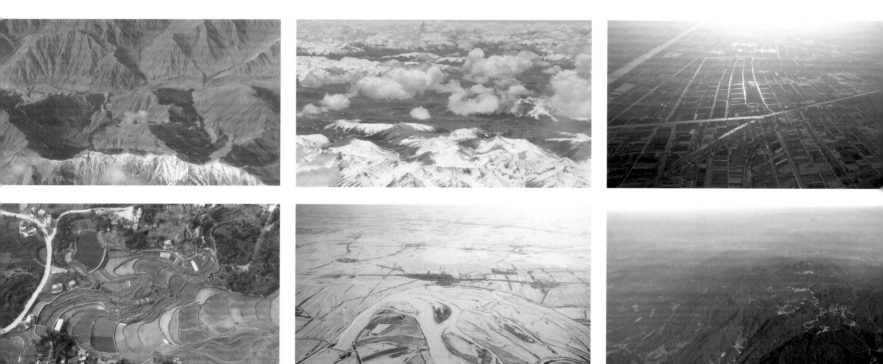

Fengshui is an ancient system of aesthetics that is believed to apply the laws of Heaven and Earth to help people improve their lives by counteracting negative forces and receiving positive energy. It is concerned with a cosmic pattern and the symbolism of directions, seasons, winds and constellations. The Chinese traditionally believed that some locations were more favorable than others, and therefore also more auspicious. Accordingly, many Chinese villages offer picturesque patterns against a background of hills and overlook meandering rivers or placid lakes. Not only did Christian missionaries describe *fengshui* as a collection of nonsensical superstitious beliefs, the Chinese Communists also deemed it a 'social evil': During the Cultural Revolution, *Red Guards* [hongweibing] beat and tortured many *fengshui* practitioners. Today, the official policy may seem more tolerant, but the government still brings legal proceedings against the proponents of 'superstitious feudalistic beliefs.' Often it targets people who believe that progress should not be limited to economic development, but should also respect the ancient philosophical and esoteric knowledge that once made China one of the great ancient civilizations.

Temples [simiao], *ancestral halls* [zongci or citang] and sometimes *theater stages* [xitai] are possibly the most prominent buildings originally found in Chinese villages. A shrine dedicat-

ed to the local God of the Earth, the *Tudigong*, a Taoist deity, often stands in the shade of a large tree, be it a banyan in the south or a poplar in the north. In times of drought or famine, villagers would turn to this god for aid: He was responsible for managing village affairs. Some villages in regions where Western missionaries were active in the nineteenth century still possess a church, or at least a cross mounted somewhere on a stone or mud-walled house. It is surely unnecessary to point out that there are regional differences in the particular religious architecture of different areas, and some areas include mosques or other places of worship.

Chinese villages not only mark the boundaries of residential spaces, but also to some extent the boundaries of production and consumption. Consequently, some villages boast of a street with a few *mom-and-pop stores* [xiaomaibu] that typically sell beverages, snacks and children's toys for everyday consumption. Eateries are rare in villages and almost nonexistent in northern China, but snack bars, like noodle- or dim-sum shops, are common in the larger settlements of southern China. Larger open spaces, such as near a pond, along a canal or around a well, are places where children play or villagers gather to chat, play cards or simply enjoy an after-dinner smoke. In some villages, spaces are set aside for threshing, winnowing and drying crops. In others, spaces such as the flat roofs of dwellings, roads, and temple courtyards are 'borrowed' for

The unique Karst landscape of southwestern China has often been depicted in Chinese paintings. The idyllic scenery in a peaceful yet striking natural environment reflects the principles of *fengshui*. In the gardens of many wealthy Chinese, similarly shaped stones were arranged close to ponds to imitate such landscapes.

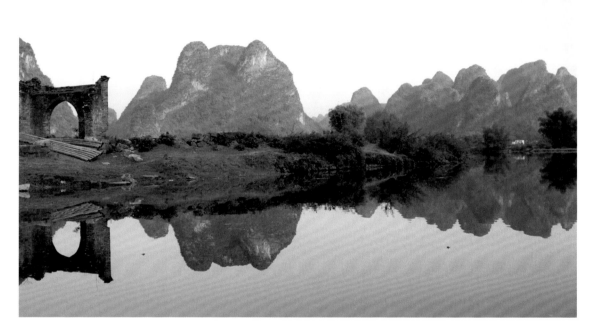

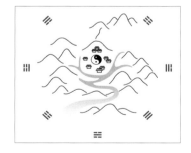

Fengshui practitioners were usually called on to examine building sites before work began on a house, village or even a cemetery. A mountain in the background and water in the foreground are essential elements of a good site. The theory of *bagua*, the Eight Trigrams featured in Taoist cosmology, is interpreted in terms of the different natural elements of the landscape. Thereby the inherent forces of *yin* and *yang* should be in perfect harmony.

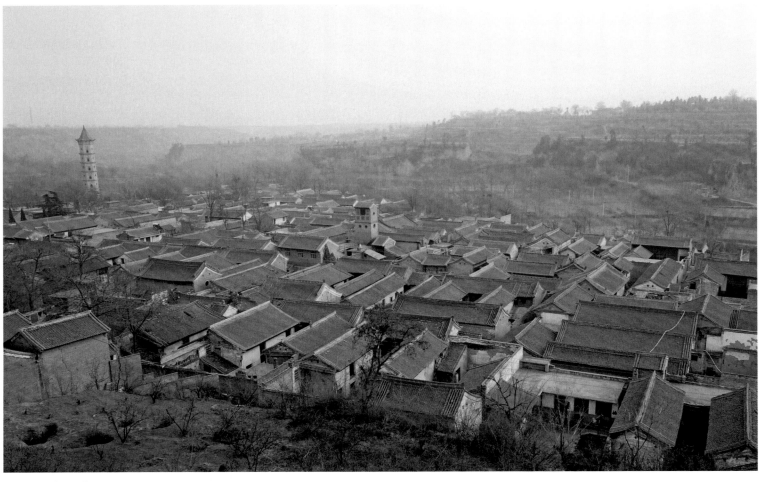

Dangjia Village, Shaanxi Province

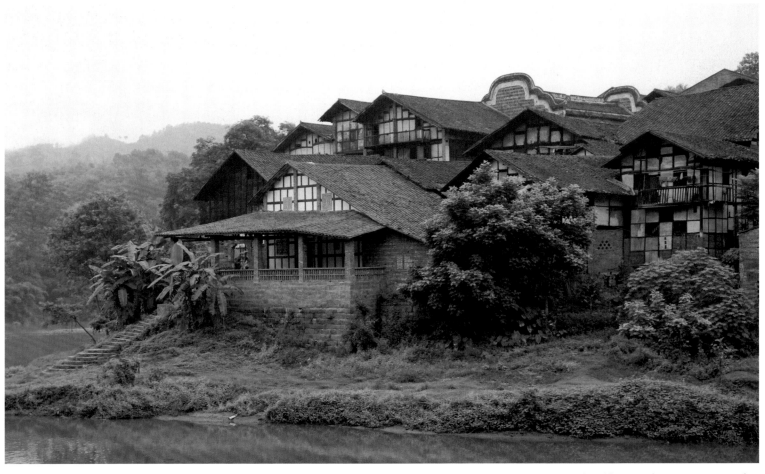

Tanghe Old Town, Chongqing Municipality

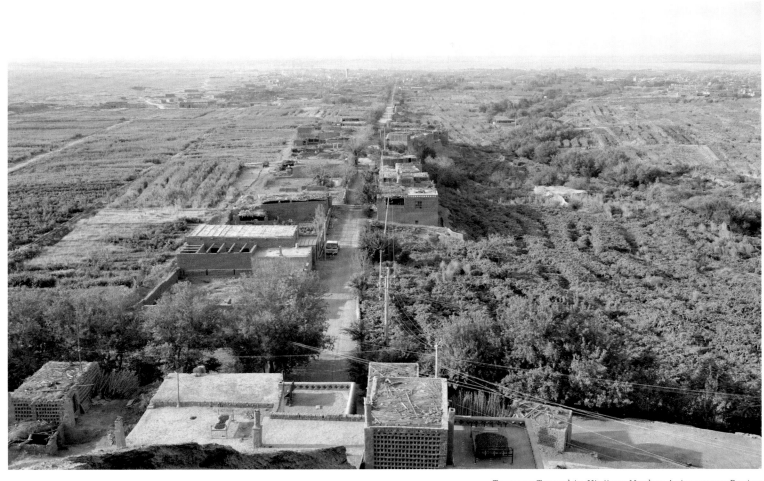

Tuyugou Township, Xinjiang Uyghur Autonomous Region

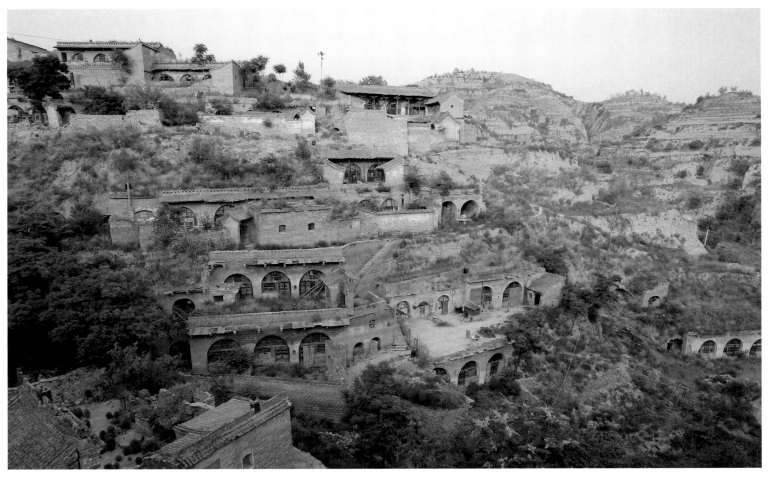

Lijiashan Village, Shanxi Province

such purposes. As in most Chinese farming communities, villagers divide their time between the fields and their homes. The saying *Go out to work by sunrise, and return to rest by sunset* [richu er zuo, riluo er xi] aptly describes the rhythm of village life.

Besides their form, location and size, Chinese villages differ chiefly in their economic functions. Most depend on agricultural activities, and the majority are the grain-based farming villages found everywhere in China, although industry has become a priority in the coastal provinces. Herding villages are widely dispersed in the semi-arid and arid regions of China, while fishing villages are naturally concentrated near the seaside, rivers and lakes. Some villages specialize in forest products, while others cultivate bamboo, tea, various fruits, chili peppers or mulberry trees. In some remote areas inhabited mostly by ethnic minorities, gathering medicinal herbs or hunting and trapping for meat and fur are still important economic activities.

Until the twentieth century, Chinese village landscapes had remained relatively unchanged for centuries. It was only after 1949 that government policies, often finding expression in political movements and showing no respect for tradition, guided the restructuring of many Chinese villages and towns. Scholars have suggested a division into five periods, during which the overall trend has been the continuous, irreversible urbanization of many villages, the construction of roads, new houses, administrative offices and the like.

During the land-reform period (1949–1958), the government focused on redistributing land, confiscating it from landlords and assigning it to poor peasants. For the first time after

Village on Water

The settlements of the Danjiaren on the southernmost coast of Hainan Province are a unique example of a living space on the sea. The name Danjiaren was given to this minority in ancient times because of the eggshell shape of its boats. There are no historical records of their origin, but scholars suggest that the Danjiaren were Han Chinese exiled by the government in the Qin Dynasty (221-207 BCE) for reasons no longer known. In subsequent dynasties, they were allowed neither to resettle on land nor to study in schools or marry outside their community. Lack of contacts with people on the mainland fueled prejudices and discrimination that continued at least until the late twentieth century.

Current estimates are that there are now fewer than 100,000 of these 'gypsies on the sea.' In the Danjiaren settlement near Xincun Harbor, for instance, there are no schools or other public institutions on the sea, but only a marine police station to maintain public order. Since the Opening-up, their economic conditions have improved, so that buying a house in the nearby seaport has become increasingly common.

Although living on a boat is more consistent with their traditional lifestyle, many of them, especially during the typhoon season, leave their boats and reside on shore. Furthermore, with the commercialization of seaports for the purposes of industrialized marine production and tourism, the 'price of the sea' is rising. The hectic pace of development, as in Sanya Bay, has caused increased pollution, threatening their already limited living and working spaces.

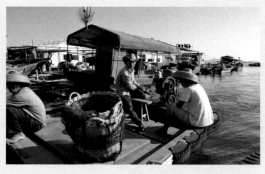

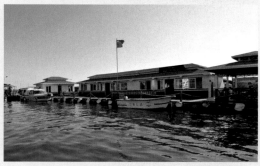

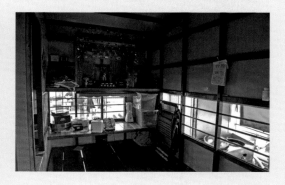

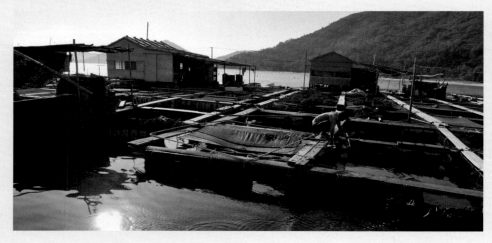

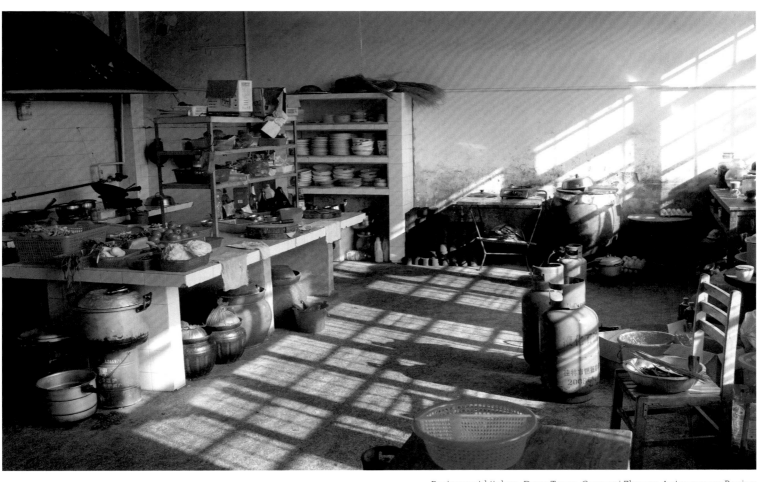

Restaurant kitchen, Daxu Town, Guangxi Zhuang Autonomous Region

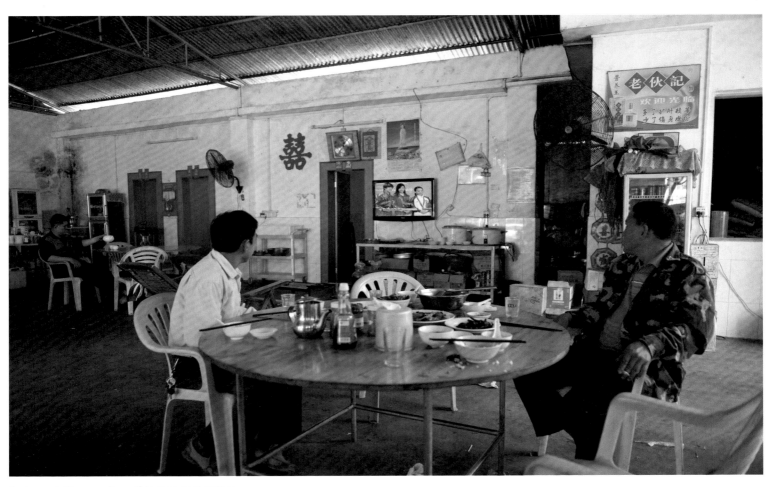

Restaurant, Shenyun Township, Hainan Province

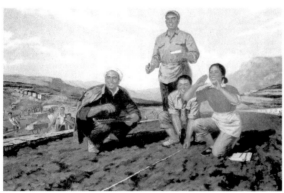

Dazhai in Shanxi Province was for more than a decade the most famous *model village* on the political map of China (Top). Other localities in rural areas followed its example of filling in marshes and leveling hills to create new farmland. A 1970s propaganda poster shows enthusiastic peasants measuring the newly won acreage.

many decades of war and chaos, farmers could cultivate their own land. People recall the early 1950s as a golden era with sufficient food and equality for all. Beyond this, however, the government did little more than provide villagers with shelter. There were practically no improvements in living standards, and sometimes 'improvements' consisted of no more than the introduction of thermos bottles or enamel washbasins in villages. During this period, the *Patriotic Sanitation Movement* [aiguo weisheng yundong] tried to improve the quality of life through public-health measures, first by eliminating the *four pests* [sihai], i.e., rats, flies, mosquitoes and sparrows, and later by promoting public health. The government policy at that time was to convince villagers of the need to clearly separate the spaces allocated to humans and domestic animals, a measure that is still being promoted in many rural areas today. The government also tried to improve sanitary standards for toilet facilities, which continue to be inferior or sometimes have scarcely changed for centuries.

Between 1958 and 1964, *People's Communes* [renmin gongshe] were established, marking the start of the disastrous *Great Leap Forward* [dayuejin]. By the end of 1958, the Communists had organized almost 27,000 People's Communes, which enrolled more than 98 percent of all the rural households in the country. They tore down many temples, shrines and ancestral halls and 'recycled' their foundation stones and bricks to erect buildings for People's Communes, the new rural landmarks. With the *enthusiasm of the masses* [qunzhong jixing], the Communist Party advocated *militarized organization, combative action and a collectivized lifestyle* [zuzhi junshihua, xingdong zhandouhua, shenghuo jitihua]. It also consolidated dispersed hamlets and villages into single administrative units to increase the efficiency of agricultural production. Socialist plans called for new settlements to serve functional needs in the most efficient way possible. As history has shown, the Communists implemented these *rapid plans* [kuaisu guihua] for development precipitately, and their ill-conceived measures soon caused devastating famines. The rise of the People's Communes saw the decline of tradition and the neglect of the ancient heritage of villagers living in close harmony with nature and the cosmos.

In 1964, the movement *In Agriculture, Learn from Dazhai* [nongye xue Dazhai] set the stage for a new political movement that encouraged peasants all over the country to follow the example of Dazhai, a village in Shanxi Province. Its peasants turned uncultivable hills into fertile terrace fields by relying on hard work. Dazhai soon became the best-known *model village*, setting an example for others to follow. This appeal coincided almost exactly with the start of the Cultural Revolution. It dealt another blow to the tradition of preserving cultural landscapes by aiming to

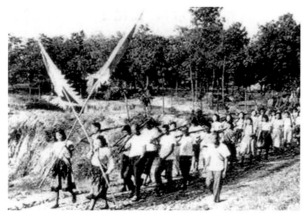

People's Communes were the highest administrative level in rural areas and a symbol of a collectivized lifestyle. In the 1980s, these socio-political entities, planned to achieve the overall modernization of rural areas, were abolished and replaced by *townships* [xiang].

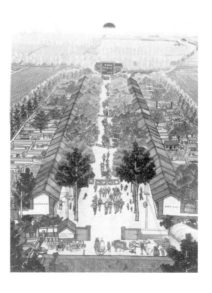

During the Cultural Revolution, houses or even whole villages were built largely according to uniform-looking socialist plans. Yet their realization mostly failed to fulfill the ideal. This artwork was painted in 1974 by farmers of Hu County in Shaanxi Province. In the 1950s, the county's local government began to train peasant painters to draw propaganda works on village walls and billboards in line with the Great Leap Forward campaign. This politically motivated action unexpectedly set a new local tradition of famers' painting that flourishes to this day.

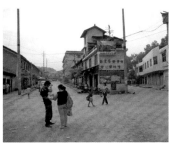

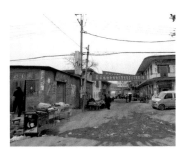

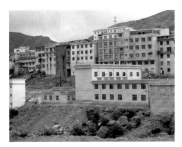

destroy the 'vestiges of the past, of feudalism and capitalism.' Some 18-million *urban youth* [zhi-shi qingnian] were assigned to either mountainous or rural areas, in accord with Mao's policy *Up to the Mountains, Down to the Countryside* [shangshan xiaxiang], where they were to learn from local farmers. These young people came to be known as 'the lost generation,' because under this policy their education was abruptly cut short.

At the close of the 1970s, the government introduced its *Economic Reforms and Opening-up* [gaige kaifang] policy in an effort to correct the most conspicuous errors of past policies. These reforms included introducing the *household-responsibility system* [jiating lianchan cheng-bao zerenzhi] and promoting a *commodity economy* [shangpin jingji] to change China's economic structure from a grain-based and state-run economy to a mixed and market-based one. Throughout the countryside, many workshops and factories were set up in or near villages, and industrialization projects drew many farm laborers away from the fields, helping to relieve the problem of rural unemployment. Incomes grew, and in the early 1980s a housing boom spread throughout most of China's countryside – unfortunately not one supportive of aesthetic values: Largely identical structures and a confusing patchwork of incompatible styles gave an impression of either bland monotony or architectural chaos.

It was not until the late 1980s that the government realized it had to cool the 'building fever' of the preceding years. However, the loss of arable land continued to be a serious problem, as it still is today. In 2005, the government launched a policy of *Building a New Socialist Country-*

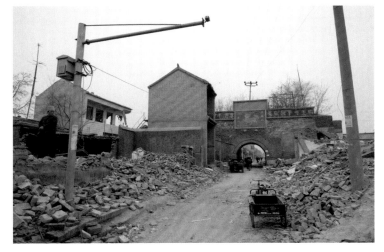

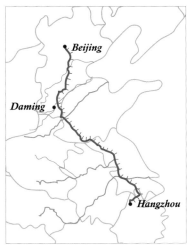

The county seat of Daming in Hebei Province, once a flourishing town along the Grand Canal, has been undergoing renovation in an old-town reconstruction project. Not much remains from its once-affluent past. Many towns along this imperial waterway, completed at the end of the sixth century, rose to fame as trading centers and declined with the advent of modern transportation in the early twentieth century.

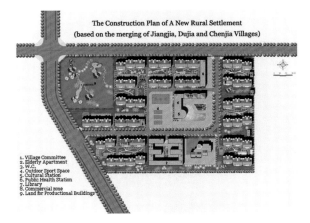

This village master plan of a new settlement in Shandong Province, based on the concept of *Building a New Socialist Countryside*, features modern houses and many facilities such as a clinic, a library, a commercial street, a cultural bureau and a sport field. In many ways it embodies the logic of an ideal and modernized People's Commune.

The once-rural areas around Badaling, during imperial times a military outpost near the Great Wall, today lie within the 'one-hour traffic radius' of Beijing and are conceived as forming a new ecological city. This is just one example of the nationwide trend of rapid urbanization.

Hemu Village, Xinjiang Uyghur Autonomous Region

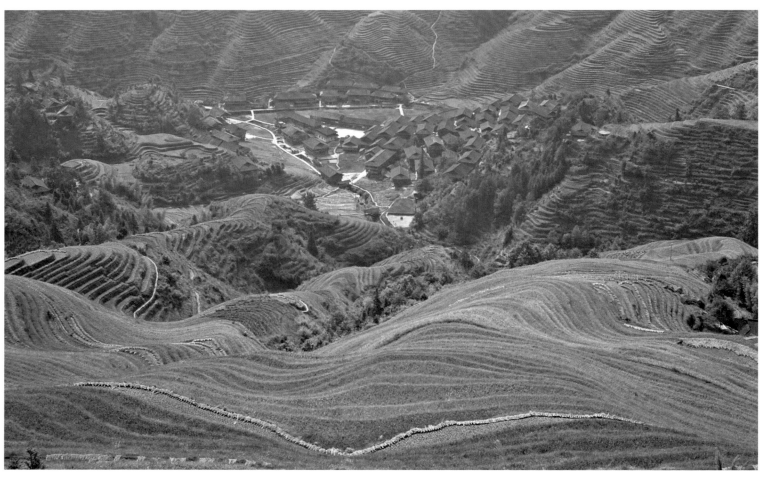

Miao Settlement in Longji Rice Terraces, Guangxi Zhuang Autonomous Region

In the mountainous areas and grasslands where Tibetan nomads live, the government has been advocating settlement policies since the 1960s. With projects of *nomadic settlements* [mumin dingju], the government is trying to entice Tibetan nomads with free housing and other benefits. But as has often been objected, the government also sometimes employs semi-coercive strategies. For instance, the goal of advanced development and a *long peaceful reign* [changzhi jiu'an] has been set for the newly designated Lari Village of Sichuan Province, which is 3,850 meters above sea level. A modern Tibetan settlement was built in 2010, equipped with solar energy and other public services, such as running water, street lamps, bulletin boards for publicizing new technology, village activity offices and clinics. More and more elderly members and the children of nomadic families live in such new settlements, while adults in their working years still earn their daily bread engaging in traditional nomadic activities. The government's ultimate goal is to replace the traditional Tibetan nomadic lifestyle with modern forms of animal husbandry. The UNDP warns, however, of the possible negative consequences of rash implementation, such as the loss of a sustainable pastoral economy and the traditions of Tibetan nomadic culture.

side [jianshe shehuizhuyi xin nongcun]. This and *urbanization* [chengzhenhua] have since then become the new key slogans for the development of rural areas. Planning rural housing and promoting quality construction in appropriate vernacular styles remain complex challenges. The situation in the countryside is aggravated by the increasing pollution of the air and groundwater by factories, as well as by heavy-handed, poorly planned development projects intended to encourage mass tourism. With few exceptions, history and traditions are being sacrificed to economic expansion.

In one way or another, the contradictions between traditional patterns and current needs will continue to keep planners, architects and villagers, all with different standpoints, in a permanent tug of war. Many villages now create an impression of chaos or banality, because planners have locally implemented guidelines that Beijing set for the whole country. Unfortunately, this centralized system has often ignored and obliterated local, regional and historical differences. While traditional Chinese villages are not likely to disappear any time in the near future, they are steadily losing their formal and aesthetic uniqueness. The sustainable principles of *fengshui* that were employed for thousands of years in building rural settlements were superseded in a very short time, first by Communist doctrines and now by state urbanization plans.

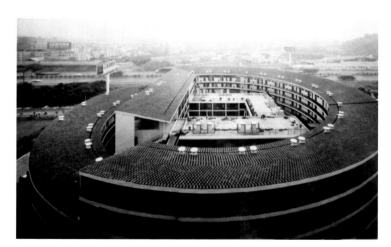

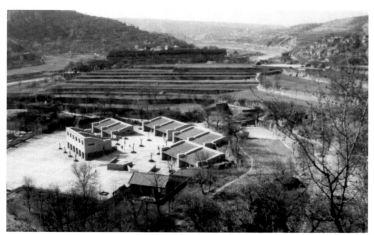

In recent years, some architects and designers have realized that the dramatic development and urbanization process currently taking place in China is being achieved at the cost of excessive resource consumption, leaving in its wake a broad swath of environmental damage. Sustainable development has thus become a slogan in the new discussion. It means not only the use of new eco-friendly technology, but also innovations based on traditional rural architecture. In this regard, a rethinking is taking place in some academic circles on the issues of social responsibility and low-budget construction by, for example, adapting the principles of rural *earth buildings* to modern cities (Top left: Nanhai, Guangdong Province); by designing eco-urban buildings in accord with traditional aesthetics (Top: Lijiang Yulong New Town, Yunnan Province); or by experimenting with traditional local architectural technology in poor areas, such as the Loess Plateau region (Left: Maosi Ecological Primary School, Gansu Province).

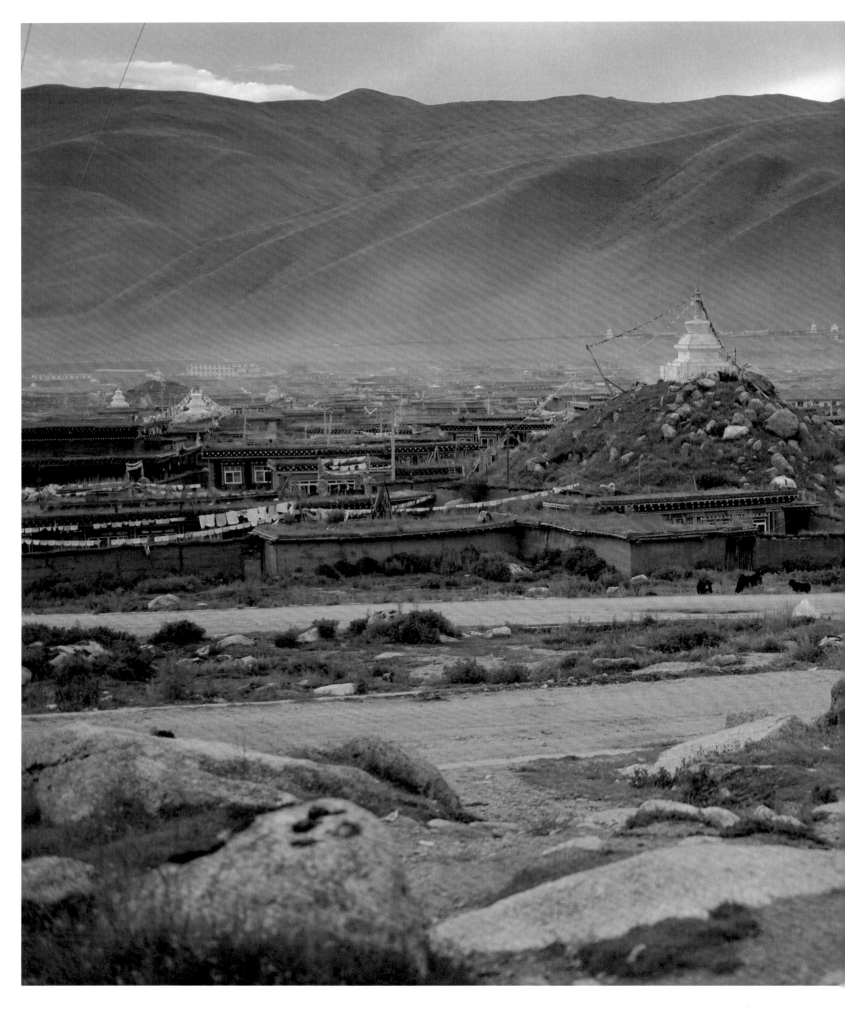

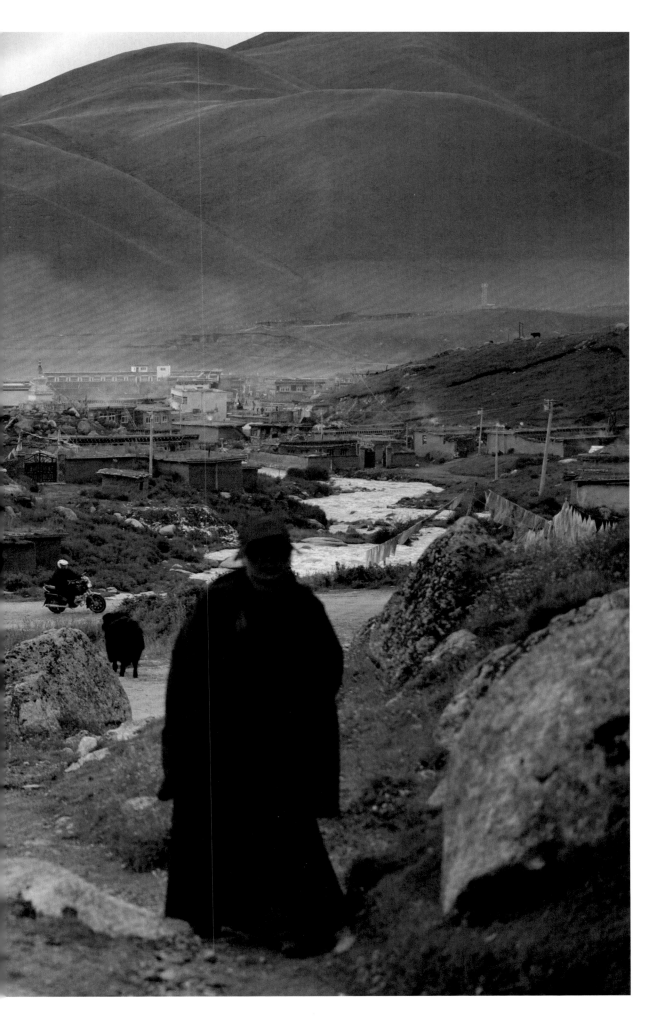

Zhuqing Township,
Sichuan Province

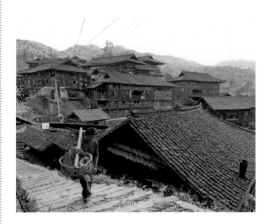

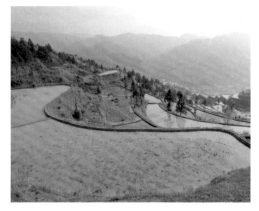

Xijiang Miao Minority Settlement in eastern Guizhou Province has a setting that is characteristic and typical of Miao villages. This huge rural settlement consists of several villages and is nicknamed *Qianhu miaozhai*, meaning thousands of Miao families. Like the majority of Miao villages, the houses are built against a backdrop of hills, with a river winding around below the settlement. Although discovered by the tourism industry a few years ago, a large part remains untouched. The main street of Xijiang, at the entrance of the settlement, has been over-renovated and paved, but the authentic lifestyles of the Miao are still preserved in the upper sections. Almost every house follows the traditional three-story ground plan: The ground floor provides stables for domestic animals; the second floor with a verandah is for residents, and the third floor is for food storage. The area surrounding the settlement is covered with rice terraces and fields of grain and vegetables. The graves of family members and ancestors are located on the hilltop.

Today, traditional Miao festivals are held regularly, and the spiritual heads take the lead in these activities. The pictured elderly man is, for instance, the *labor leader* [huolu tou] who, at a ceremony held in the spring, declares the start of sowing and the appropriate crops for the year. Between 1950 and 1979, his position was replaced by a government-appointed labor supervisor. Though this traditional practice has been revived, it is unclear if his son, who is a migrant worker living away from the village, will later return to take over this position.

During imperial times, the Miao were often a source of political and military problems for the emperors. They were never assimilated and rebelled on several occasions. Since the early eighteenth century, the imperial government sent more troops, garrisons and officials to forcibly assimilate the Miao in the Xijiang area. In the course

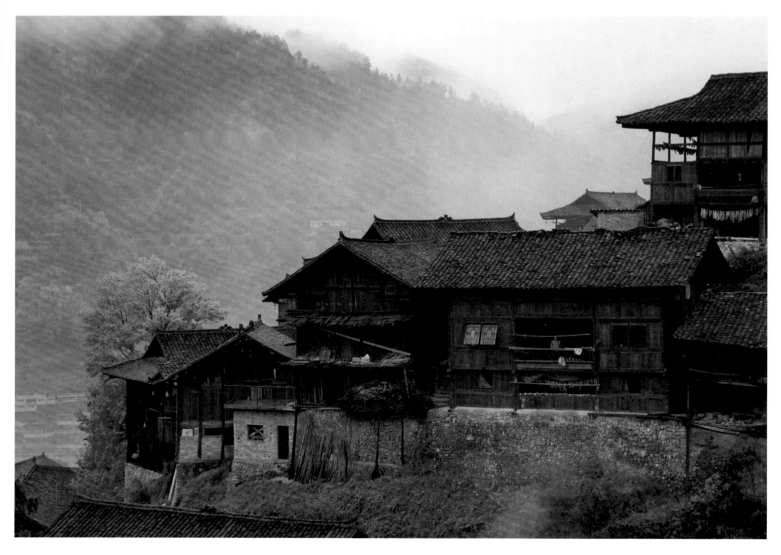

of revolts and wars, thousands of Miao were killed, and later on many migrated to the Western colonies of Indochina and Burma, where they are known as Hmong. Until recently, the Han Chinese believed the Miao knew the secrets of black magic and thus disliked or even feared them. After the founding of the PRC, the Miao became an official ethnic minority and were granted a limited degree of autonomy. Because many Miao did not speak or write Mandarin, the Han Chinese regarded them as mountain dwellers and barbarians. Indeed, even the name Miao, originally used by the Han Chinese for various tribes in the south, has derogatory connotations. The Miao formerly raised opium as a cash crop until the Communists banned this practice.

Many other Miao villages are scattered across the lush, hilly eastern parts of Guizhou Province. They are distinctly smaller compared to Xijiang and therefore more charming and idyllic. Some villages bear beautiful names such as *Qingman*, which literally means 'green and graceful.' Corncobs are hung on strings outside the house to dry after the harvest. Either the kernels are cut off the cobs and ground for human consumption, or the whole cob is used as pig-feed.

A square at the center of the village is the most important place to hold festive activities like dancing and singing. The most unusual game involves climbing up a ladder of knives to worship the ancestors or the gods. This custom originated in a legend about a young man who fetched dew from the moon to heal his father's eye ailment. Perhaps thanks to the brave young man in the legend, on many hills in this area, tea bushes today are constantly drenched and nourished by fog and dew.

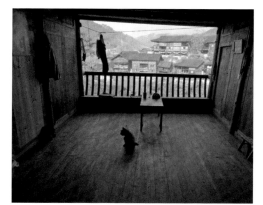

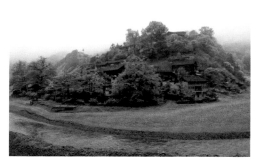

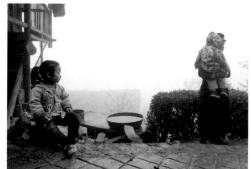

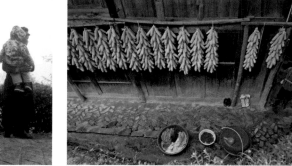

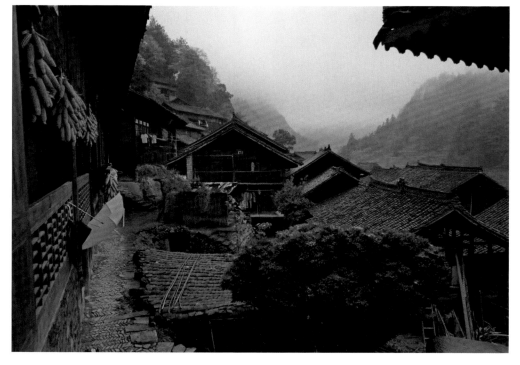

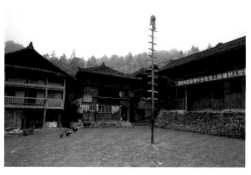

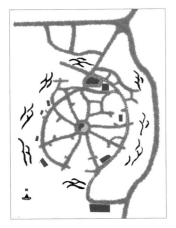

Zhuge Village in Zhejiang Province is sometimes called the *Eight Trigrams Village* [bagua cun] due to its distinctive town plan. A map illustrates how ponds, twisted paths that wind up and down, and the surrounding hills are integrated into the pattern to form the shape of the Eight Trigrams, a powerful symbol of Taoist cosmology and *fengshui*. In the center of the layout is a *taiji* made up of a semi-circular pond fit into a square to symbolize the unity of yin and yang (the female and male principles in dualistic Chinese cosmology).

The residents of Zhuge Village are said to be descendants of the famous military strategist and astronomer Zhuge Liang, who lived during the Three Kingdoms period (220-280 AD). When the Zhuge clan established the village in the Ming Dynasty (1368-1644), they aimed to achieve the greatest possible harmony between man and nature. Fortunetellers with their typical desks decorated with face- or palm-reading sketches are still eager to offer their services and tell visitors how their village's *fengshui* has saved its residents from many disasters. One obvious blessing of the complex street plan is that burglars unfamiliar with the village layout cannot easily find their way around.

Architecture in Zhuge Village still recalls the grandeur of its past, with its temples, memorial halls and dignified monuments.

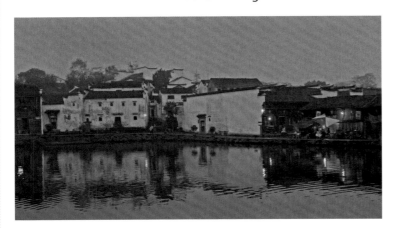

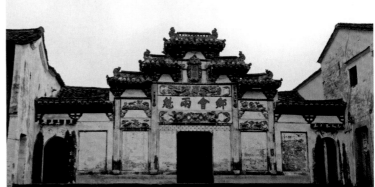

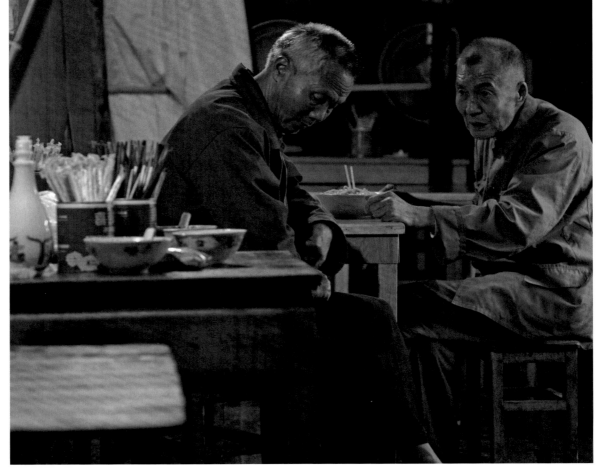

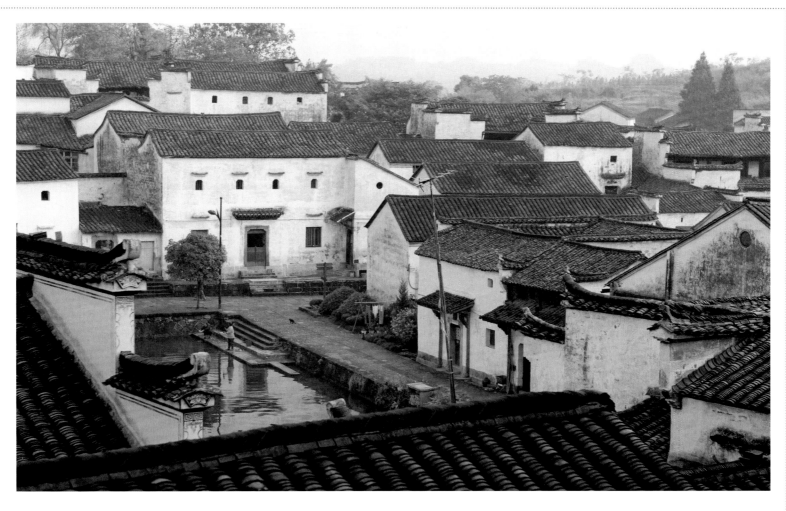

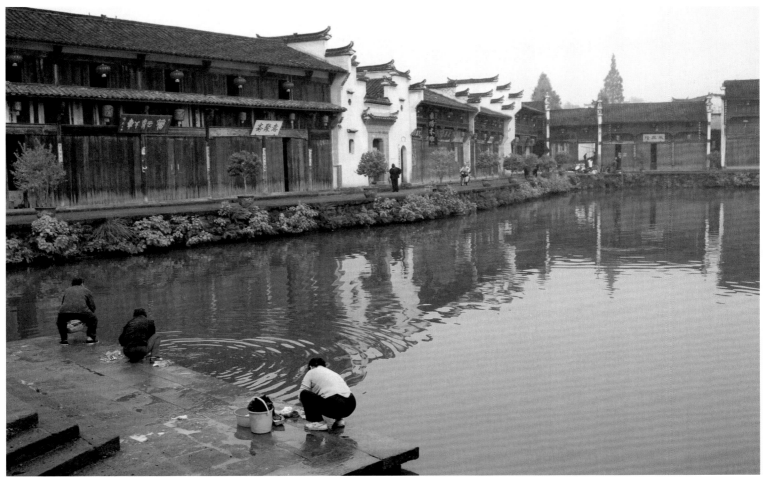

Community life in Zhuge Village takes place entirely around the largest pond. The most popular businesses are no doubt the eateries that serve noodle soups and steamed buns. For many male residents, meeting friends and enjoying breakfast here is a daily ritual. Afterwards, many of them simply move over to the tea house next door to play card games. The grandchildren of eatery owners often do their homework in this hustling and bustling atmosphere.

To satisfy the basic needs of daily life, a barbershop, vegetable stands, pharmacies offering Chinese medicines and grocery stores form a ring around the pond. Some sellers from nearby towns come here regularly to peddle basic household appliances such as hairdryers and desk lamps. A major difference between residential buildings and these eateries and shops is that the latter have a wooden structure, with storefronts fully open during business hours, whereas the former are made of bricks.

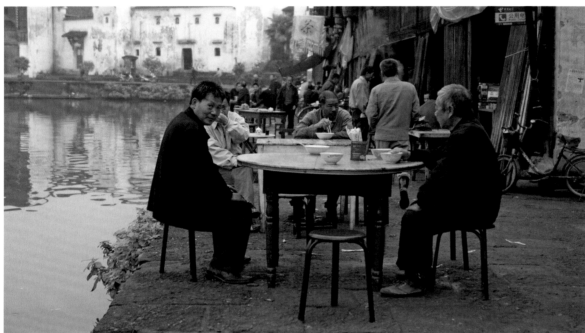

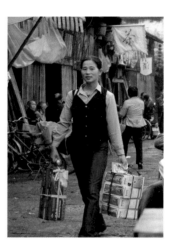

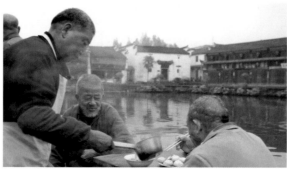

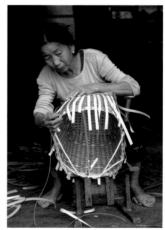

The Dagong Hall is a memorial dedicated to Zhuge Liang. On the wall, the Chinese characters *zhong* and *wu* stand for loyalty and militancy.

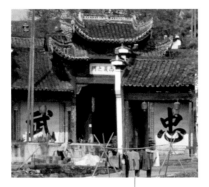

It is more the rule than the exception that laundry and food are washed in the same pond and then hung together in the sun.

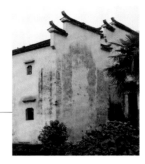

Gable walls [shanqiang] are a common feature of courtyard houses. Their main function is to separate adjoining buildings in case of fire.

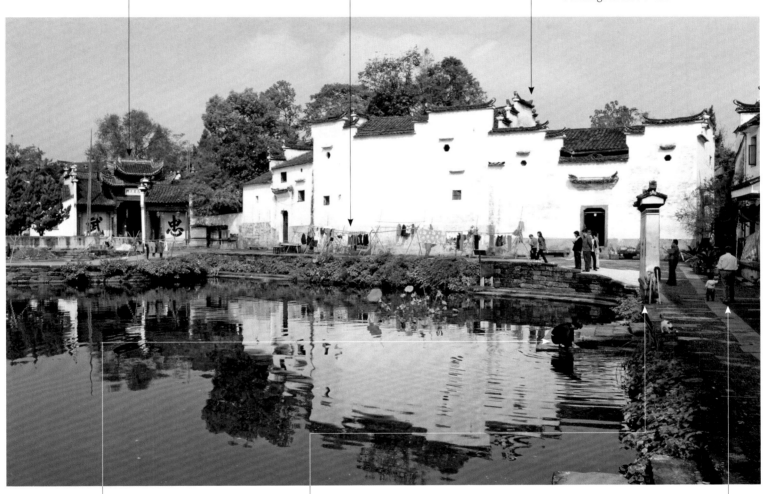

There are currently 18 ponds and 18 wells in Zhuge Village. All the ponds still play an important role in the daily life of the villagers. The half-round Zhong Pond lies in the center of the *bagua* layout.

A screen wall with a *bagua* symbol on one side and the character *fu*, meaning 'good luck,' on the other side is placed by the pond.

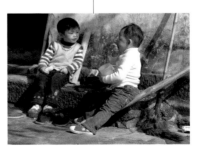

Elderly residents and children enjoy village life, while most young people have left for work in cities.

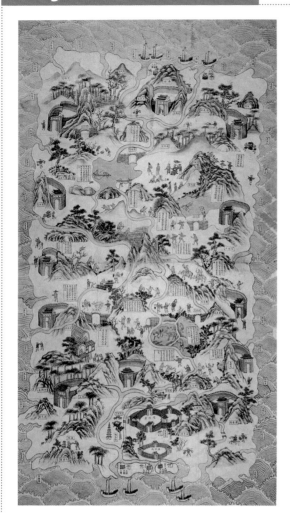

The remote *Chubao Village*, located in the central highlands of tropical Hainan Province, is home to the largest indigenous ethnic group on the island, the Li Minority. The Li are believed to have migrated to the island from southern China 3,000 years ago and thus become the earliest settlers here. They were then driven from the coastal areas into the mountains by Han Chinese in the fifteenth century. An illustrated map of the island from 1875 shows the characteristic thatched houses and scenes from daily life. In the 1920s and 30s, many Communists exiled from the mainland took refuge in the island's mountains. In the violent resistance against the Japanese Occupation, the Li suffered greatly, and many villages were burned to the ground. The island was taken over by the Communists in 1950.

The boat-shaped thatched houses are the traditional dwellings of the Li and are considered examples of the crudest vernacular housing style in southern China. Moreover, today these houses only survive in very remote locations like Chubao Village on top of Mt. Wuzhi. In the last few decades, many Li have built larger thatched houses, supported by wooden walls, and others have even left their traditional dwellings and moved into brick houses.

Today, the Li are considered one of the poorest minorities in China and suffer the stigma of derogatory stereotyping, accused of being lazy, dirty, violence-prone and drunken. In the late 1990s, 90 percent of the Li still earned their living in the agricultural sector, and the illiteracy rate for young Li was over 50 percent. The situation has improved, but the difference in prosperity between the Li and the better-educated Han Chinese remains. In addition, the strict governmental control over natural resources has angered Li communities that have been living on forest products for centuries.

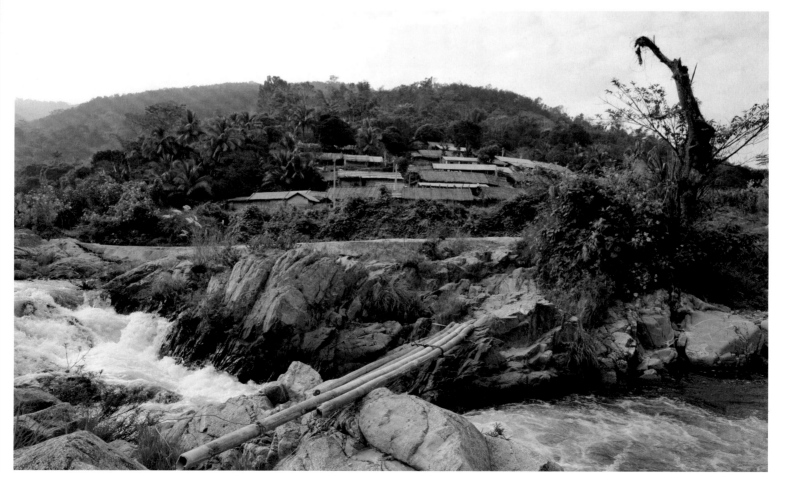

Not only are traditional Li settlements slowly disappearing, but the customs of this distinctive minority are also on the brink of vanishing forever. There was once a long tradition of tattooing Li women on the face and body. The application of tattoos was governed by a strict set of rules, and the tattoos were believed to have the power to bear souls into the afterlife. This custom can be traced back to an ancient legend, but the practical reason was to frighten away enemies and prevent Li women from being kidnapped. After the founding of the PRC, policies intended to stamp out superstitious beliefs soon caused the original lifestyles and many practices of the Li's animistic religion to die out. The production of sweet glutinous rice liquor in private houses is one of the few old traditions that are still popular today.

With the government's focus on economic growth and its corresponding disregard for social sustainability, the traditional Li socio-cultural system has been further diminished. During the last decade, the government's strategic policy has been to develop Hainan Province as the country's major beach-holiday destination. In 2010, a plan was developed to divide Hainan into four principal regions. The scheme relies on two key industries – tourism and modern services – and is intended to create a 'harmonious Hainan' based on urban and rural modernization.

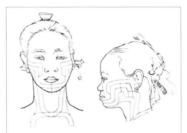

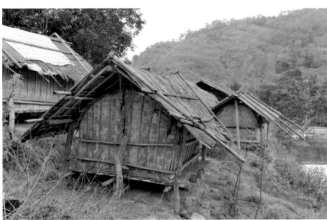

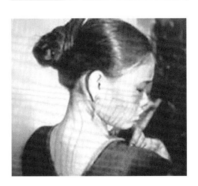

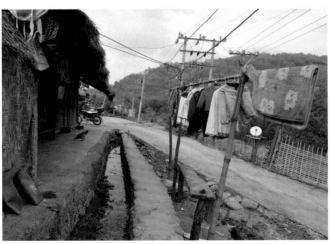

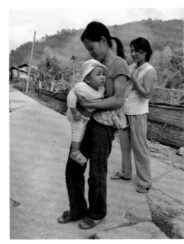

39

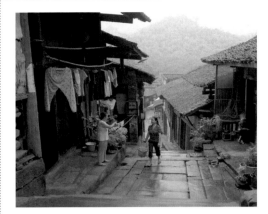

Tanghe Old Town is a typical ancient rural riverside community in Chongqing Municipality whose ancient charms still survive. Along the Yangtze River and several other rivers in this region, many towns and villages sprang up on the hilly, foggy banks due to the busy water transportation and the trading activities during imperial times. The construction of the Three Gorges Dam that began in 1994 inundated many rural communities. More than 200,000 residents of Wanzhou, for example, were relocated, and numerous old buildings and historic dwellings were demolished to make way for the dam.

Although new buildings are continually being added on the edges of old towns in this thriving area, a few settlements still boast of the area's traditional half-timbered stilt-style *hanging houses* [diaojiaolou]. In addition, *Hui-style* [Huipai] architecture, famous for its exquisite design, was introduced to Tanghe from the lower reaches of the Yangtze. A few fine examples await visitors in this old town as silent witnesses to its past affluence. Hui merchants dominated commerce for many centuries, and traces

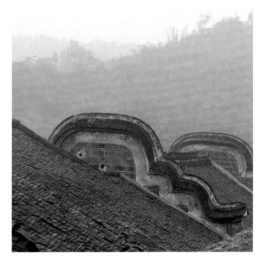

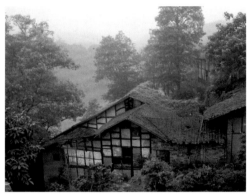

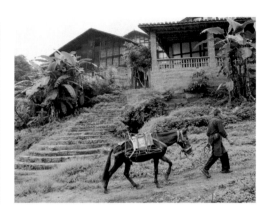

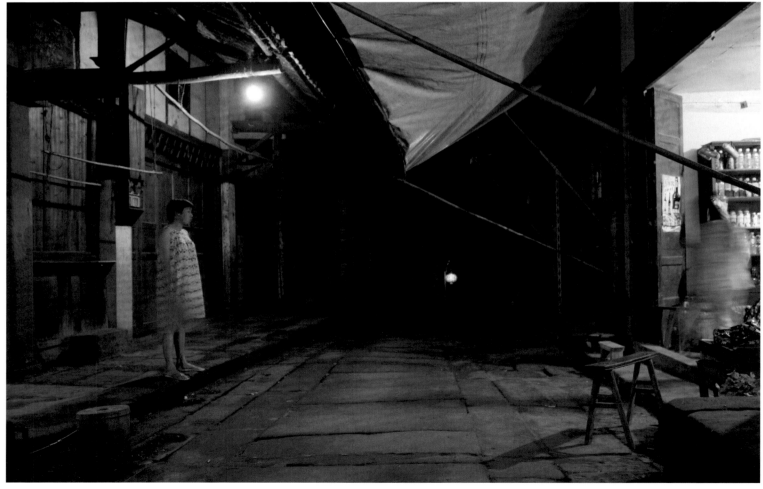

of their influence remain all over the country. The horseback-shaped side walls, which function as firewalls, are a common feature in Hui-style architecture.

In spite of its distance from the booming coastal cities, Chongqing has emerged as one of China's most rapidly changing metropolitan areas. The territory of this directly governed municipality is about the size of Austria. However, the so-called world's largest city actually consists of a great number of rural communities. The hot, muggy Chongqing summer has earned the area a reputation as one of China's three greatest furnaces. Lichen clings to every inch of the stone-paved alleys, a hint of mildewed smell pervades every house, and both men and women, standing or sitting, all wait expectantly for the next feeble breeze from outside. After sunset, the alleys of Tanghe Old Town are plunged into darkness, dominated by the chirping of cicadas. Only one or two grocery stores lit with fluorescent lamps stay open. Among the half-timbered houses, a building with Western details like a verandah with a row of arched pillars and stucco-covered walls seems out of place.

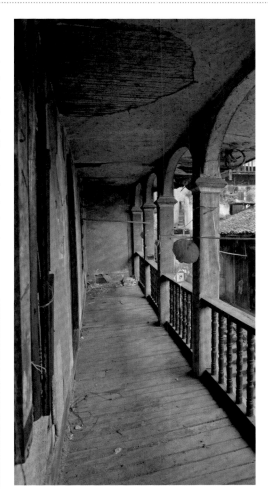

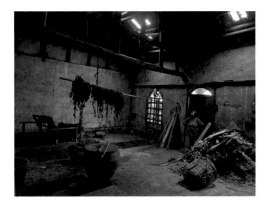

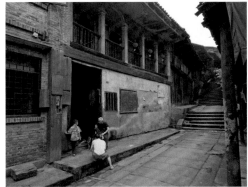

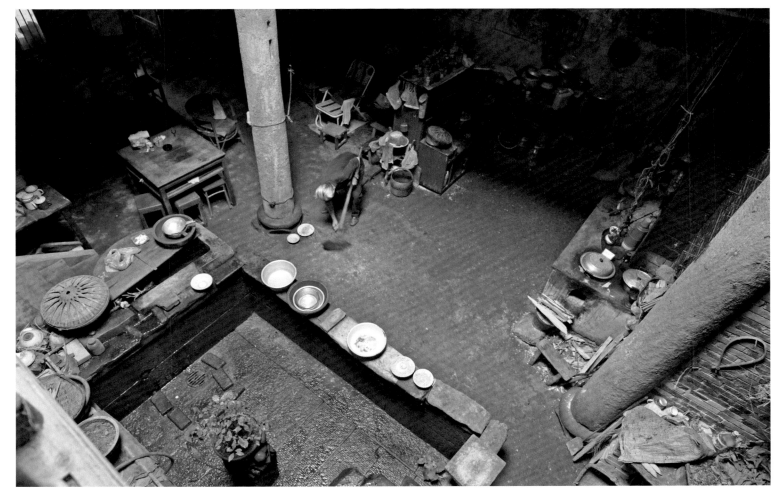

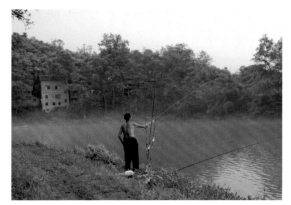

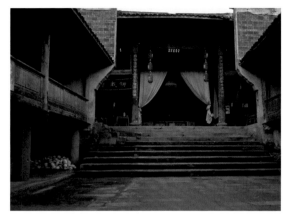

In Tanghe, the main Temple, *Wangye Miao*, is dedicated to the Qin governor, Li Bing, who built the famous Dujiangyan Irrigation System during the Warring States Period (406-221 BCE). Because this great hydraulic engineering project effectively ended the recurring floods in Sichuan Province, Li Bing came to be revered as a popular deity in this area after he passed away. This temple was built in an ideal location, convenient for traders arriving in Tanghe via both the river and the roads. Its two entrances, one on the main street of Tanghe and the other on the riverfront near a wharf, welcomed hundreds of thousands of travelers coming to pay their respects and pray for a safe journey before venturing forth again.

The theater stage inside the temple reaches a peak of animation every summer on Li Bing's birthday, when there is a great celebration, along with a performance and a feast. The porcelain bowls stored near the steps are prepared for the feast. Paper money is produced in local workshops beforehand. When winter reaches its peak in the twelfth month of the lunar calendar, two rectangular stone blocks in front of the temple serve to support an eleven-meter-long wooden beam with 74 lanterns.

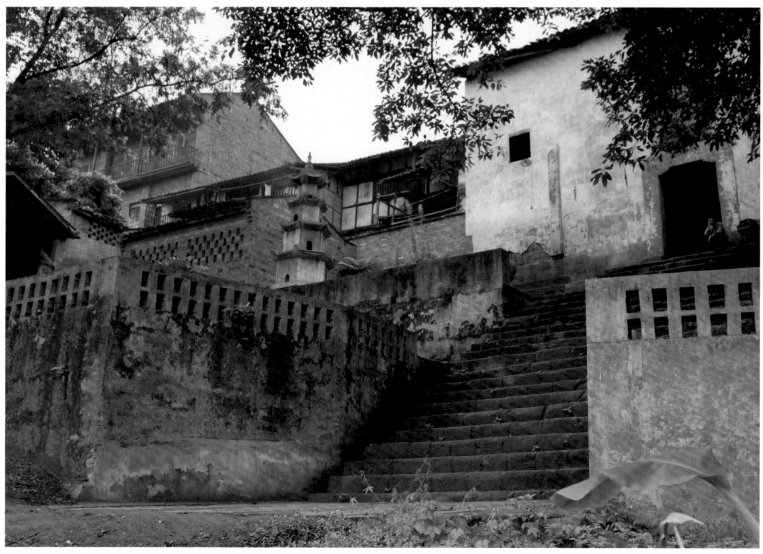

Pianyan Old Town is another settlement in Chongqing Municipality that arose on the busy water-transportation route during the Qing Dynasty (1644–1911). Narrow riverside alleys with houses on one side are a distinctive feature of old towns in this region. This design shows how local people adapted the settlement plan to the natural environment while maximizing the available land for housing. On the busier main street, the changes and influences of urbanization are becoming visible. Most old houses were adorned with tasteless modern decorations during their last renovation. Currently, the government of Chongqing is trying to speed up its urbanization process. Residents are encouraged to give up their land, i.e., the usufruct, in exchange for an urbanite identity. This strategy is visible not only in propaganda slogans and posters, but also in the construction of factories and standardized residential housing in the vicinity of Pianyan Old Town. Residents are promised a better future in exchange for cooperating in the urbanization process, while their current lifestyle during this transition period is a mixture of tradition and modern, albeit modest, consumerism.

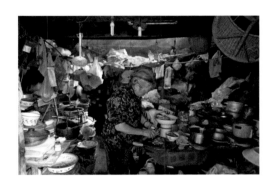
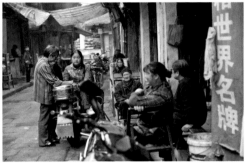
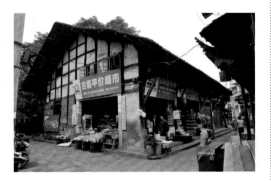

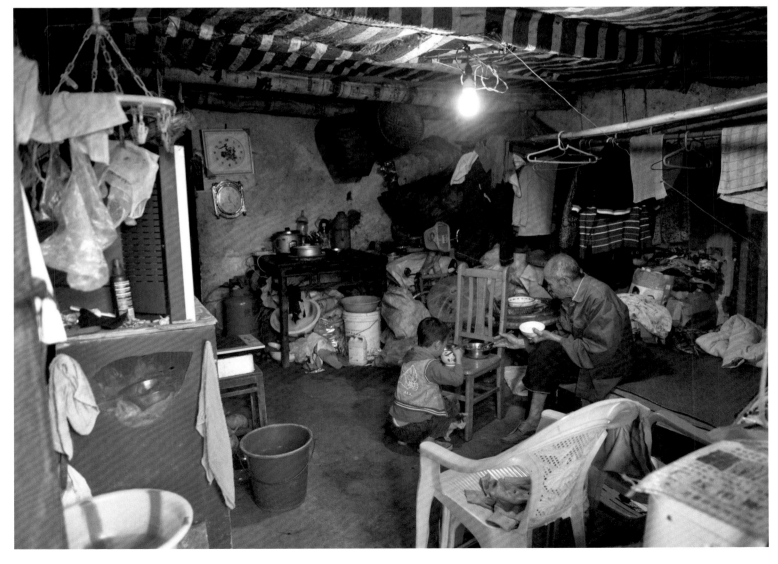

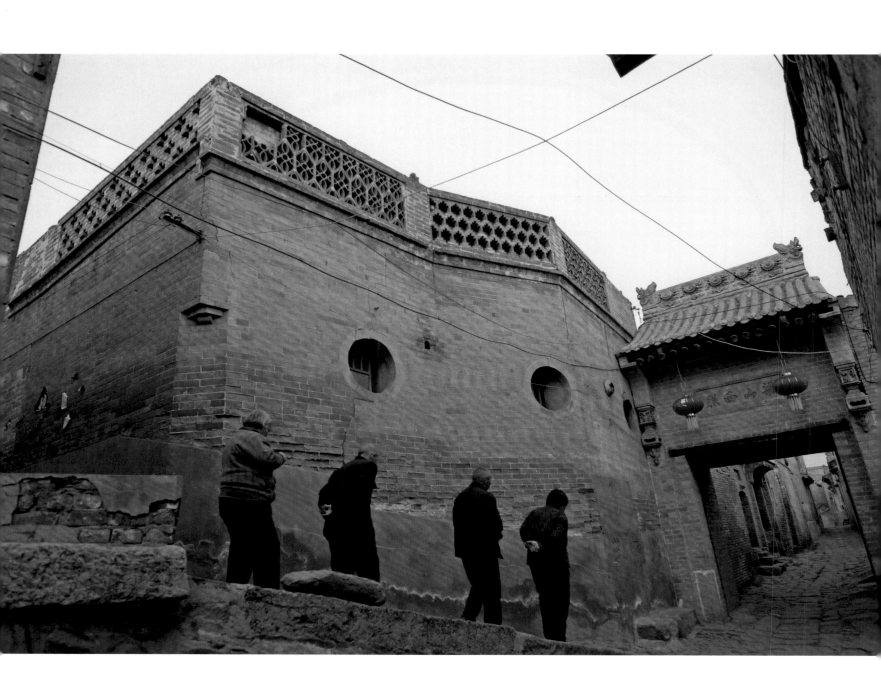

Dangjia Village,
Shaanxi Province

Prior to 1949, Moganshan in Zhejiang Province was a popular summer resort for the Westerners residing in Shanghai. Their architectural footprints are scattered across the hills in old villas, churches and other structures that once served Europeans and Americans as places of refuge from the summer heat. They are now within easy reach of cities with millions of inhabitants.

The Italian missionary Leone Nani (1880–1935) came to China in 1903 and stayed for eleven years. He traveled far to the southwest of Shaanxi Province, where many poor peasants lived. Highly regarded by the local population, he taught in several dioceses, including the church in Guluba (Pictured). Its main building featured a Western façade with a beautiful Chinese roof and wooden window carvings. This building served as a college during the Sino-Japanese War. It was torn down and served as building material for socialist-style houses during the Cultural Revolution. Nani's residence and the nunnery attached to the church survived the Cultural Revolution but were seriously damaged by the 2008 Sichuan earthquake.

Arts of Architecture and Labyrinths of Space

In creating the world's fastest growing national economy, China has changed the lifestyle of millions of its citizens.

However, this change chiefly benefits the residents of urban areas, which China is using to demonstrate to the outside world that it is a modern society and a globalized member of the world community. Urban China has become a paradise for city planners and architects alike who want to realize their dreams and achieve the aims formulated by officials who are themselves often motivated more by personal vanity than by the aspiration to create a pleasant living space for city dwellers.

The skylines of Chinese cities have often been disfigured beyond recognition since the Opening-up. Even worse, the urban landscapes of Chinese settlements have been 'regimented' almost everywhere in the country. Outside overcrowded urban areas, Chinese cultural landscapes still more or less reflect the atmosphere, and sometimes the grandeur, of an ancient world civilization, or what people in the West would describe as the authentic China. In saying this, we do not mean to downplay the poverty, want and hardship of millions of farmers. We simply think that rural China has so far preserved Chinese characteristics and tastes better than have the globalized cities with their commercial malls (even if they are sometimes decked out in pseudo-Tang architecture), amusement parks, foreign luxury merchandise and international five-star hotels.

To be sure, rural China has also changed under the Opening-up policy, but more gradually. In spite of changes due to the strategy of urbanizing rural China by upgrading administrative units and merging villages into urban areas, the process of globalization in the countryside has so far had a smaller impact on its architectural landscapes. In the past, Westerners left traces

Shangri-La, an imaginary utopia, was introduced by James Hilton in his popular 1933 novel *Lost Horizon*. The name has become synonymous with an earthly paradise, a mysterious and peaceful land in a remote mountain valley of the Himalayas. In 2001, hopeful Chinese officials renamed the former Zhongdian County of Yunnan Province Shangri-La. An airport and tourist facilities were constructed to attract thousands of visitors every year in search of so-called traditional Tibetan lifestyles.

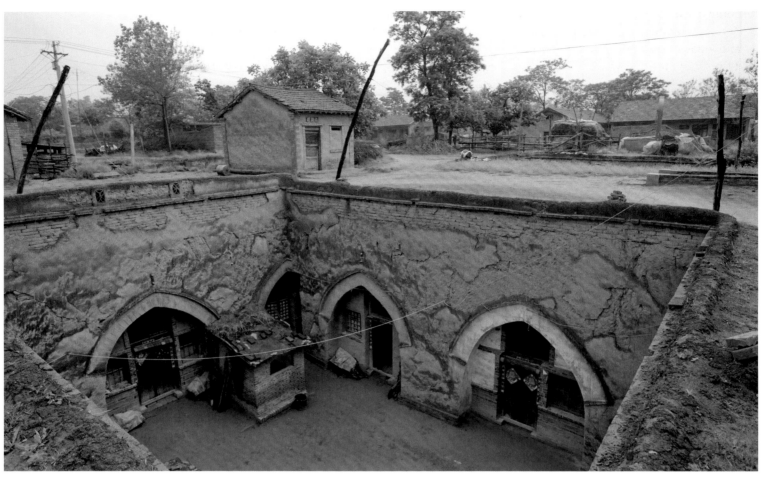

Underground courtyard house, Miaoshang Village, Henan Province

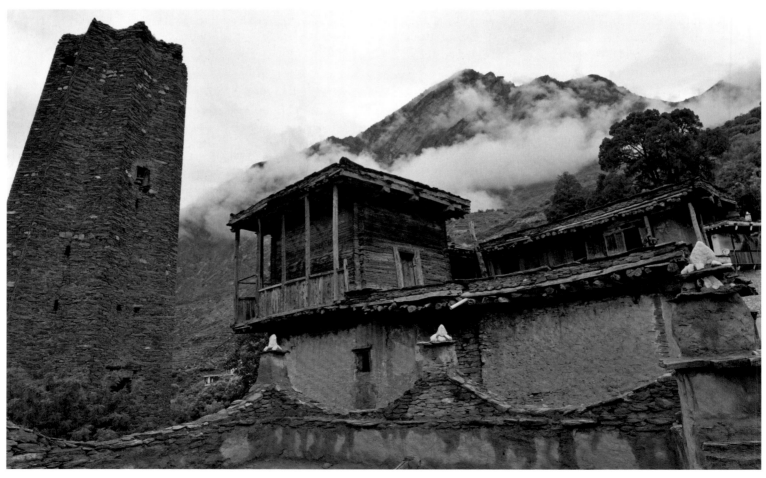

Tibetan fortress, Moluo Village, Sichuan Province

not only in the foreign concessions of coastal cities or in riparian towns, but also in rural China. Evidence of Western missionary activity is still visible in rural churches and chapels or the houses and villas of former mountain retreats. While many Chinese urban areas, including second- and third-tier cities, nowadays boast of their international flair, the local tourism industry also hopes to attract visitors and lure them into the nearby 'untouched' countryside. Luxury resorts have sprung up in formerly unspoiled areas, such as 'Shangri-La' in Yunnan Province, the brainchild of shrewd officials and businessmen inspired by James Hilton's famous novel *Lost Horizon*. Golf courses are being laid out in hilly areas, and huge villa complexes have been planned in once largely untouched areas, such as in Ordos [E'erduosi] in Inner Mongolia, often emulating European styles or sometimes even adopting the traditional courtyard house design.

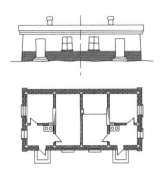

The organization of private space, i.e., residential architecture, has also sparked an architectural boom, a competition among many who are ambitious to modernize 'undeveloped' rural China. Unfortunately, as in urban areas, many architects, investors and building contractors who work with space in rural China simply want to realize their own visions or, even worse, just make a profit. They seldom take account of local customs and lifestyles. The consequences of this top-down planning mania are uniform housing designs and the introduction of modern lifestyles that might or might not have something to do with local realities, topographies and traditions.

Yet there still are villages where traditional dwellings predominate, mostly in remote or poverty-stricken areas. These villages bear witness to the slow pace of life in one of the world's great ancient civilizations. A study of their architecture and town planning reveals a complex history and social networks dating back to bygone eras. A house or a cluster of houses, as one of the most prominent elements in any cultural landscape, is more than the mere combination of building materials, especially for those who could afford more than just a roof over their head. To sum up: The art of architecture works with a complex network of ideas and traditions, of time and space. In its perfection, Chinese architecture is a terrestrial mirror of the cosmos.

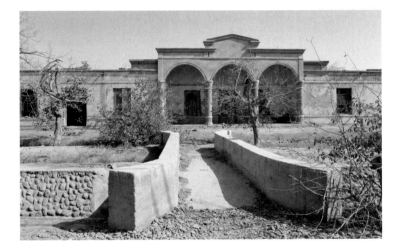

As stated above, the diverse Chinese topography, along with the complexity of Chinese history, has shaped different cultural landscapes and thereby given rise to a variety of different housing types. The typical Chinese house does not exist – nor does a single Chinese style. Still, if we want to generalize about the characteristics of residential architecture, we could well begin by noting that traditionally most Chinese houses were constructed using local building materials. Most houses in northern China were earth, sand or stone structures, while houses in the south were of wood, thatch or even bamboo. Another common characteristic is that over the past century the form and layout have displayed continuity with no radical changes. Finally, in the past – at least during peaceful times – Chinese villages were relatively open to the outside world. In times of upheaval or in response to banditry, rebellions or wars, however, village fortifications like watch towers and solid walls became indispensable.

Before the Cultural Revolution, Mao Zedong advocated an *architectural-design revolution* [sheji geming yundong]. While both traditional Chinese architecture and Western-style buildings were rejected soon after 1949, Soviet-influenced socialist architecture was also discarded when Mao split with Moscow in 1961. From then on, the government promulgated its own revolutionary designs, based on Mao's ideal of *more, quicker, better, and more efficient* [duo kuai hao sheng]. The sketch at the top shows an adobe house of the sort promoted during this period. Many socialist-style buildings formerly used as public offices have been abandoned in the last few years.

Rudofsky's *Architecture without Architects*, published in the 1960s, examines many non-pedigreed architectural styles around the world. It also includes a few pictures of *underground courtyard houses* [tianjingyuan or dikengyuan] near Luoyang in Henan Province that are likely to catch the reader's eye. The builders literally dug these houses into the Loessland, a region of soil blown in from the Gobi desert. Loess is a yellowish-brown silt or clay covering an area of more than 600,000 sq. km. According to recent statistics, roughly 40-million peo-

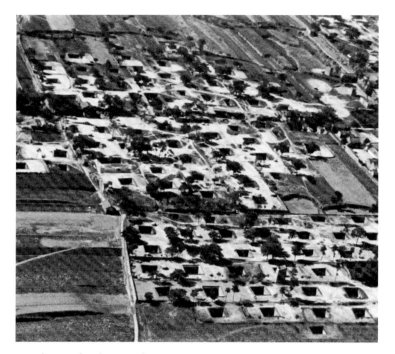

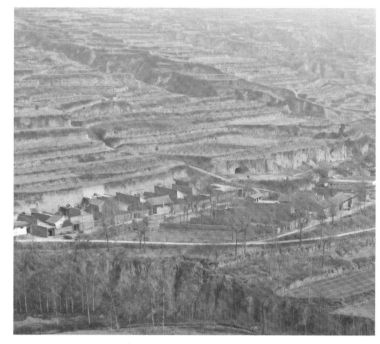

Aerial view of underground court-yard houses from pre-1949 in Henan Province.

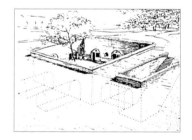

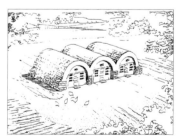

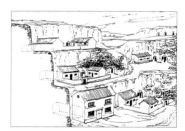

Different types of earth dwellings in the loess landscape of northern China.

ple live in *earth-sheltered cave dwellings* [yaodong] in the loess regions of Gansu, Shaanxi, Shanxi and Henan Provinces.

In ancient times, the *Loess Plateau* [Huangtu Gaoyuan], one of the earliest inhabited areas of China, was very fertile and easy to farm, but centuries of deforestation and over-grazing, as well as the expanding population, have resulted in what the German geologist Baron Ferdinand von Richthofen, in letters written in the 1870s, described as follows: "Everything is yellow. The hills, the roads, the fields, the water of the rivers and brooks are yellow, the houses are made of yellow earth, the vegetation is covered with yellow dust... even the atmosphere is seldom free from a yellow haze." It is surprising that under such conditions these dwellings are relatively clean and free of vermin, warm in winter and cool in summer.

Another argument for literally digging houses into the ground is cost reduction: These earth-sheltered dwellings cost only a quarter as much as houses built above ground. A disadvantage, however, is that China's Loessland is located in an earthquake-prone region, and in 1556 the most devastating quake in recorded history wreaked havoc in the region, with a loss of life estimated at 830,000 people. Again in 1920, a catastrophic earthquake with its epicenter in Ningxia obliterated many villages, burying thousands of people in the ruins of their loess houses.

If we wanted to name another remarkable example of non-conforming architectural expression in rural China, we would definitely mention the so-called *tulou*, the earth buildings constructed by the Hakka people, chiefly in the provinces of Fujian and Guangdong. These mag-

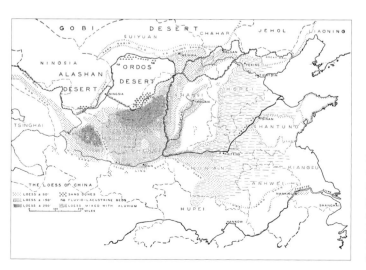

In the 1920s, the American scholar George Cressey (1896–1963) traveled extensively in China's interior to survey its geology and geography. This map shows the areas covered with wind-blown silt within the Loess Plateau, which spread across parts of five provinces, and the Yellow Plain in Shandong.

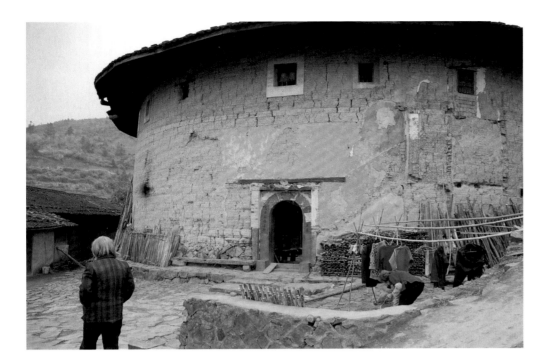

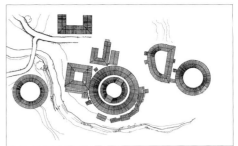

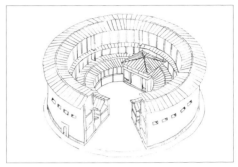

nificent clay buildings, circular or rectangular in form, are two- to six-story dwellings with a defensive character. Many centuries ago, after the Hakkas were forced by droughts and wars to migrate south from the *Central Plain* [Zhongyuan], they built monumental buildings in mountainous areas as strongholds for their families. Most of these fortress-like buildings reflect the Chinese dwelling tradition of 'closed outside, open inside,' with only one main entrance. Unlike other housing types found across the country, a *tulou* reflects a kind of balanced hierarchy: All the rooms are about the same size, with the same style of doors and windows, and similar decorations. From the beginning, a *tulou* was regarded as a model for community housing. One of the largest contains some 400 rooms for 800 residents in three concentric ring-shaped buildings with an overall diameter of more than seventy meters. It therefore comes as no surprise that when these huge structures were first 'discovered' by American satellite photos in the 1960s, they were mistaken for missile silos.

An important concept in the Chinese art of architecture is the enclosure of space in the process of home building. Whereas Western architectural practice usually concentrates above all on lifestyle and living requirements, Chinese traditional thinking on residential construction considers space from the start. Dwellings enclose open spaces within an overall layout designed for an extended family. In practice, this means that enclosed open spaces play a prominent role in most buildings throughout China, be they as open *courtyards* [yuan] or so-called *sky wells* [tianjing], which are small patios. The late Nelson Ikon Wu, a respected scholar of Asian art and archi-

The typical three-rooms-in-a-row vernacular house style varies in depth and ventilation design due to climatic differences from north to south. Whereas the simple style in the north features *brick beds* [kang] connected to stoves for warmth, the more complex style in the south includes additional interior rooms and windows.

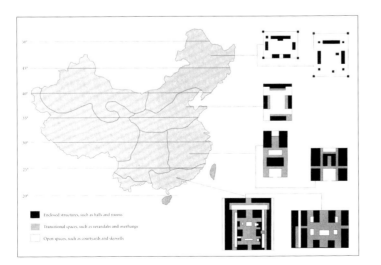

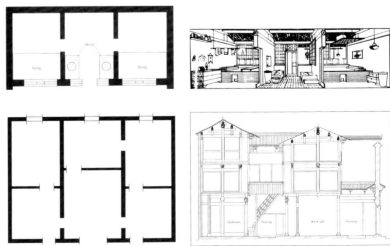

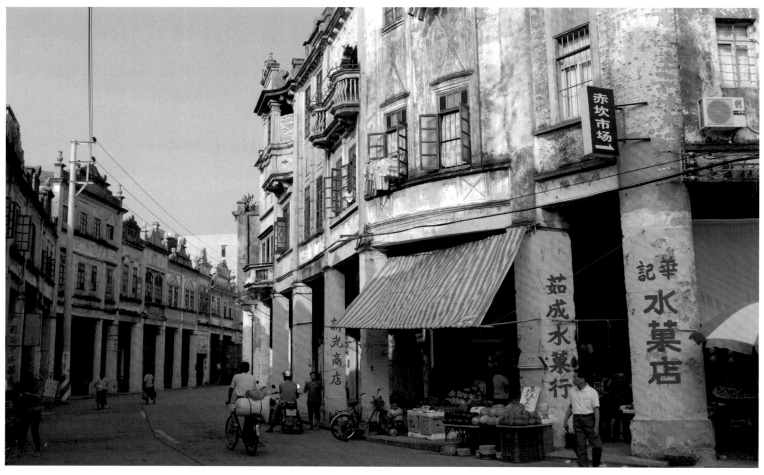

Chikan Old Town, Guangdong Province

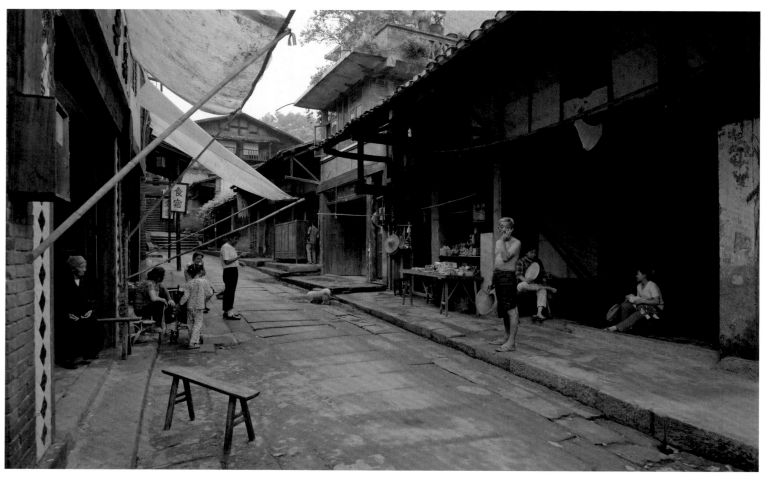

Tanghe Old Town, Chongqing Municipality

tecture, emphasized that space is of real significance and relevance for Chinese art and architecture. "The student of Chinese architecture will miss the point if he does not focus his attention on space and the intangible relationships among the elements of this complex, but, rather, fixes his eyes on the solids of the building alone."

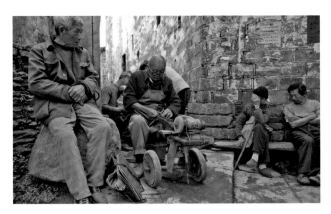

In general, the 'management' of space varies greatly from north to south. These differences are due mainly to the extensive regional variations in the country's natural environments. In northern China, where there are extreme differences between summer and winter temperatures, dry desert winds and only sporadic rainfall, people tend to use open space more generously. Put differently, the architecture of a northern Chinese house-courtyard complex is meant to both capture as much sunlight as possible by including a larger courtyard and keep out cold winter winds by eliminating windows and doors at the back and next to sidewalks. By contrast, the seasonal torrential rains and summer heat typical of southern China give people an incentive to minimize the exposed spaces of houses by providing only a limited view of the sky through a sky well, a tiny version of a courtyard. To illustrate the courtyard vs. sky well contrast, think of a Rubik's cube. Seen from above, a typical southern Chinese dwelling complex with a sky well looks like a white square at the center of the cube, surrounded by uniformly colored squares. In contrast, in the open courtyard of a northern Chinese dwelling complex, the white squares extend from the center to the edges.

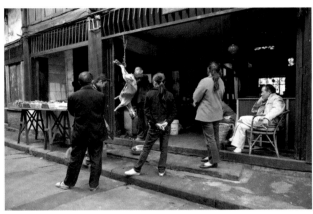

If we nevertheless try to find a single characterization of the labyrinths of space in Chinese architecture, we are frustrated by the manifold micro-regional differences. The two above-described basic plans vary from region to region. In some areas, a hybrid of the two designs can often be found, and transitional spaces such as verandahs, roofed corridors, rooms with open-faced lattice door panels or even balconies are common, especially in the south, although far less so than in Europe.

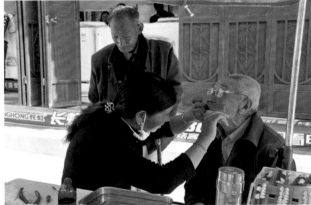

Much of daily life in rural China takes place outdoors, be it in village alleys and lanes or in the courtyards of houses. Privacy has never been a priority for most Chinese, whether they live in urban or rural areas. The Chinese do not avoid hustle and bustle, which are considered to provide a sense of security and community, especially in remote areas. Craftsmen usually keep their workplaces open to passers-by, whether they own a barbershop, a store offering paper goods for funerals or a blacksmith's workshop. They make their life spaces accessible to neighbors and strangers alike. Wandering through China's vanishing worlds, we often feel as though we have strayed into a great theatrical performance, be it in a marketplace, a temple festival or a wedding celebration. Whereas over the years outdoor museums, open-air theaters and temporary stages in villages, castles or on lake shores have been set up at great expense in parts of Europe, many places in rural China still boast of natural stages that attract lovers of art, culture and history.

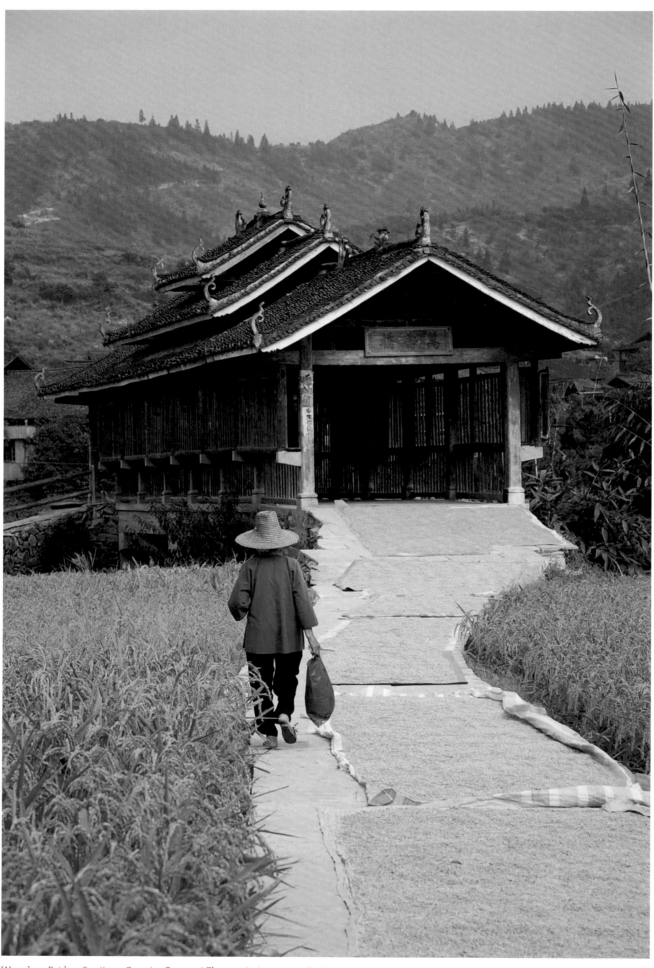

Wanshou Bridge, Sanjiang County, Guangxi Zhuang Autonomous Region

Architecture over Rivers

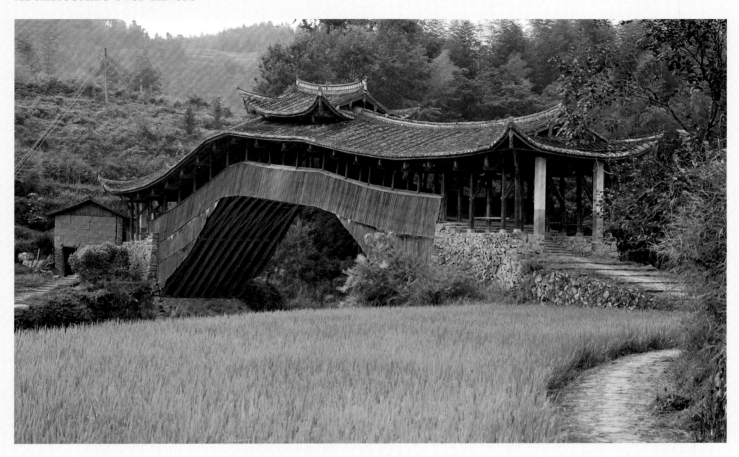

The designs of bridges in China often involve more than simply meeting the need to cross bodies of water. Taishun County in Zhejiang Province is dotted by *covered bridges* [langqiao] that display an array of different structures with beautiful additions. These bridges have played an important role on postal roads and trade routes. Beneath the arches of the traditional roofs, decorative woodcuts and paintings were common. The photo of a detail shows that a corner of the wooden framework supporting the roof was carved to resemble a bat, a symbol of good fortune. Sometimes, a small shrine was integrated into the bridge itself. Travelers who might have walked for hours or even days without encountering another person in the wild landscape surely took pleasure in the aesthetics and found consolation in the deities' blessings.

Extra features were added to bridges for reasons going beyond simple decoration. Besides heavy rainfall, typhoons and floods are common in this region. A lightweight bridge could easily be swept away by a strong summer thunderstorm. Therefore, the extra weight affixed to a bridge by additions can actually stabilize the whole structure.

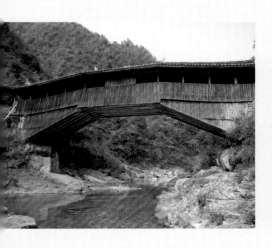

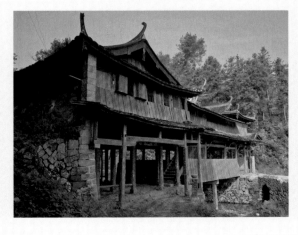

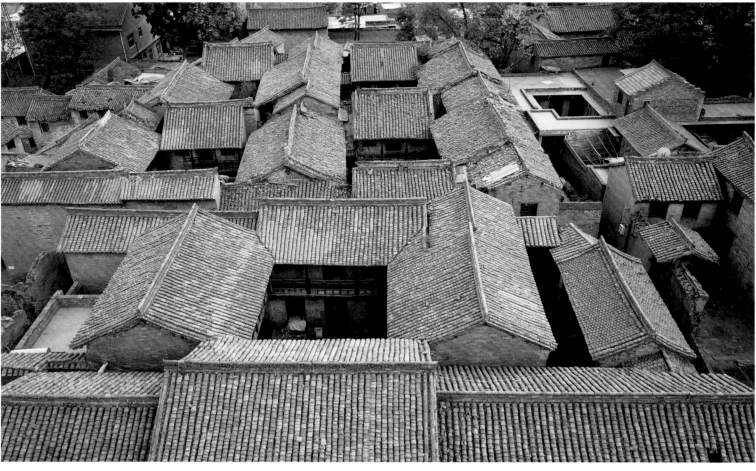

Guoyu Village, Shanxi Province

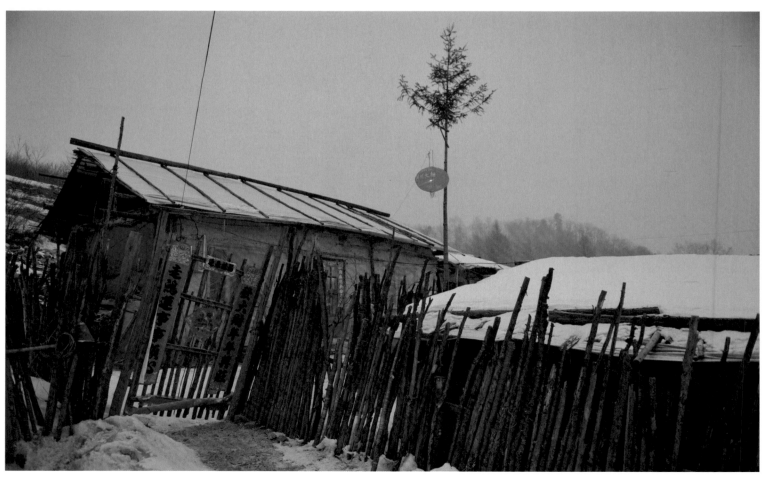

Gudingzi Village, Jilin Province

Hemu Village, Xinjiang Uyghur Autonomous Region

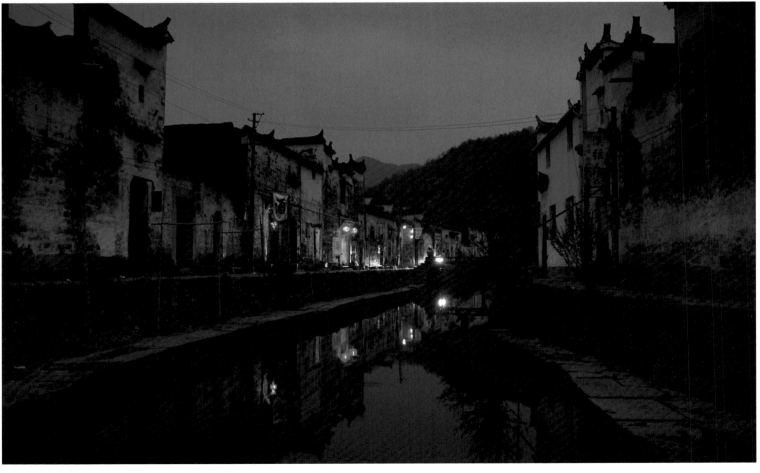

Wuyuan County, Jiangxi Province

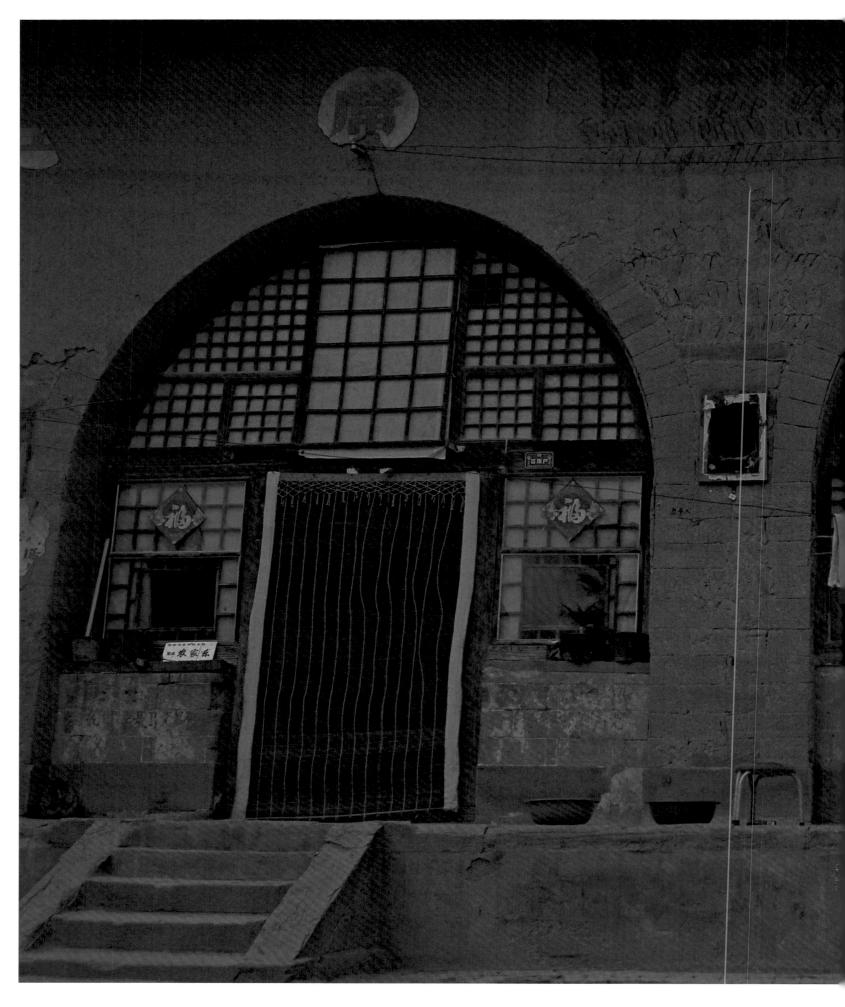

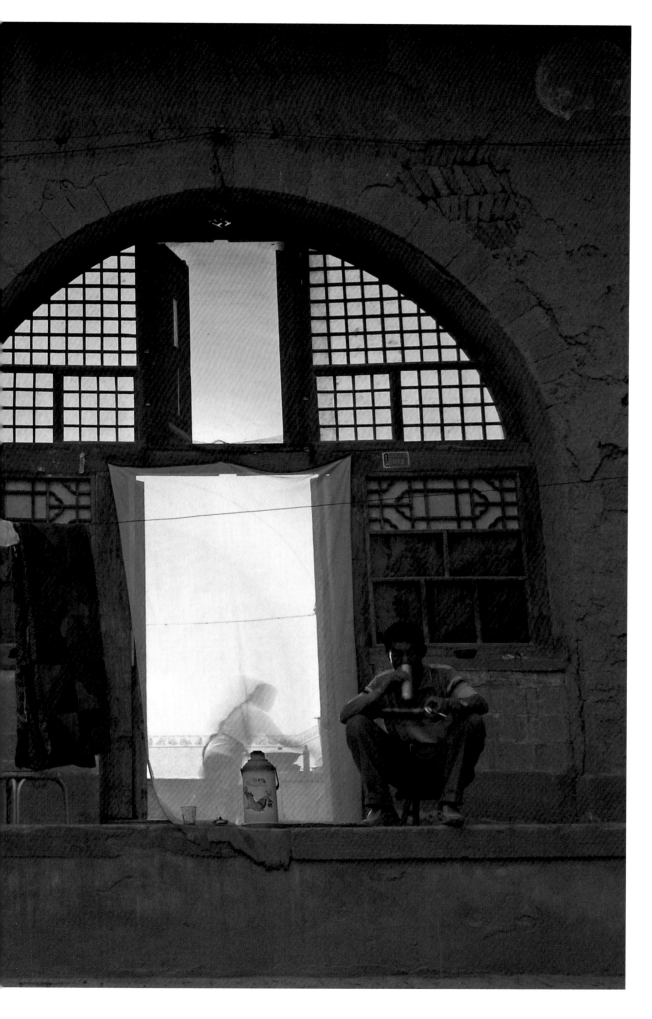

Yangjiagou Village,
Shaanxi Province

The round earth buildings of the Hakka are scattered around *Yongding County* and *Nanjing County* in southern Fujian Province. Building such houses, which can accommodate hundreds of families, required a certain level of prosperity. The Hakka make up a large share of the population in Fujian and Guangdong Provinces. Although they speak their own dialect and have their own customs, the Hakka are not considered an ethnic minority, but are rather believed to be Han Chinese who came here from the Central Plain to escape social and political upheavals.

After the Hakka moved into this area in the ninth century, they slowly accumulated wealth through trading in tea, lumber and mushrooms. Their business activities even reached Japan and South Asian countries, which was forbidden by the imperial court. As the Hakka became wealthier, they began to worry about the safety of their clansmen in the remote bandit-infested hills. The Hakka have always had strong clan ties, which led them to build huge fortress-like earth houses. Windows in the external walls are found only on the upper floors. The round courtyard in the middle of the earth houses is particularly suitable for wind circulation, one reason why these huge clay buildings have survived numerous typhoons. Although earth houses may be architecturally less sophisticated than other ancient dwelling styles, they adequately fulfilled their functions to defend against attackers and support the clan's communal lifestyle.

The space is logically organized: Rooms on the ground floor are used as kitchens and barns, on the first floor are storage rooms, and clan members occupy the upper levels. The courtyard is a public space where people wash, hang out their laundry and perform religious rituals. In the larger earth houses, there is often an ancestral hall in the courtyard, while in smaller houses the ancestral hall may simply be located in one of the interior rooms.

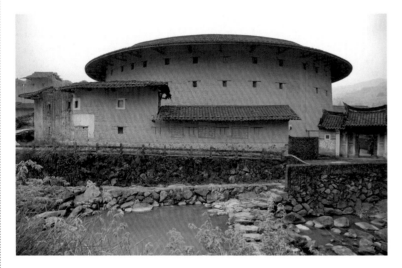

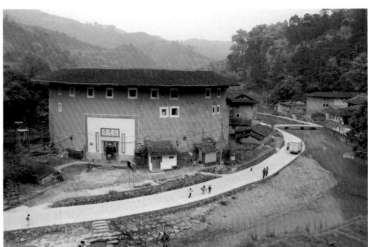

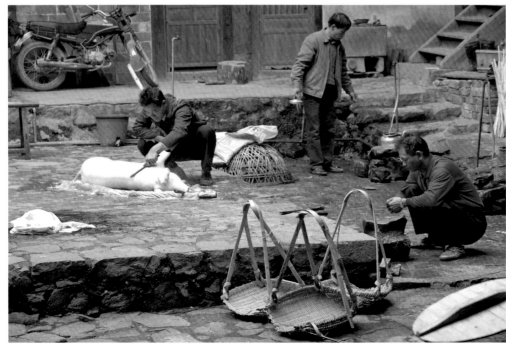

Excerpts from the *Quotations of Chairman Mao* [Mao Zhuxi Yulu], written in red on the exterior wall of an earth house, bear witness to China's modern history.

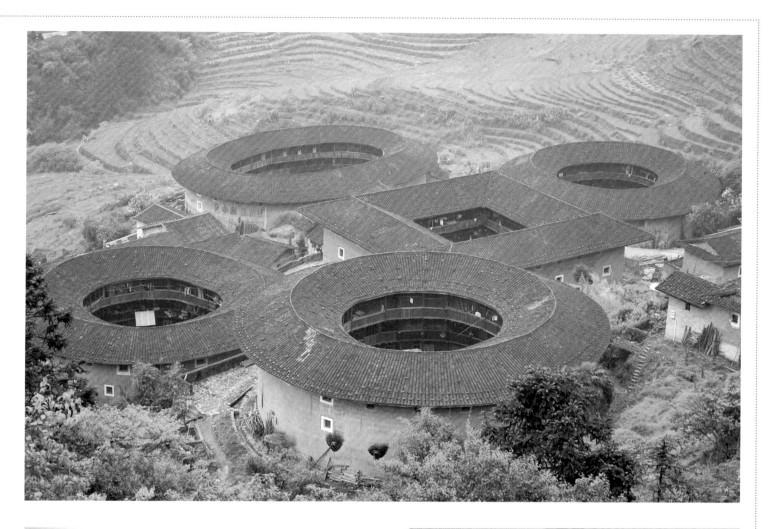

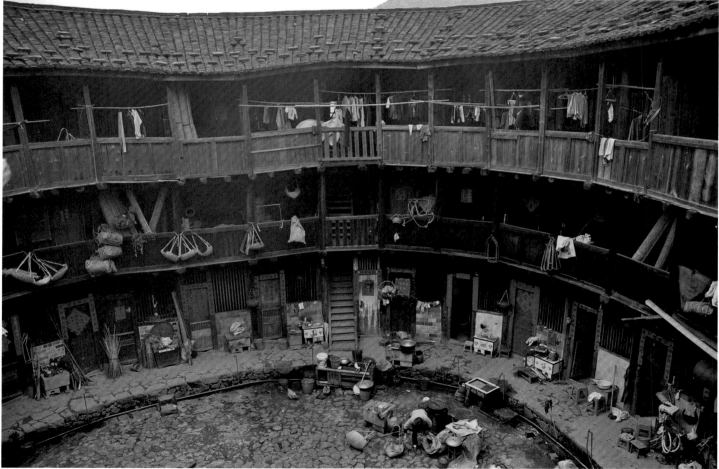

Tianluokeng Village, Fujian Province

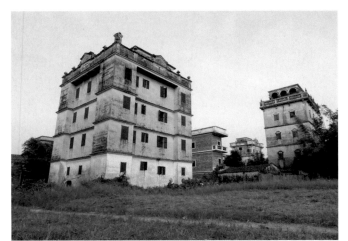

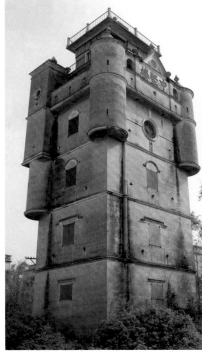

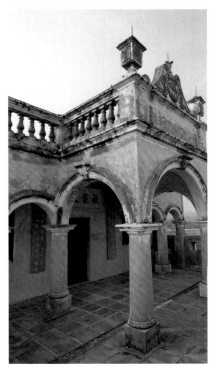

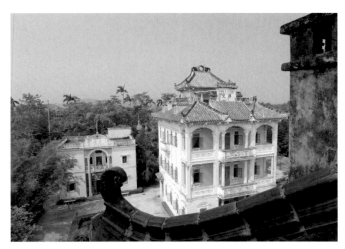

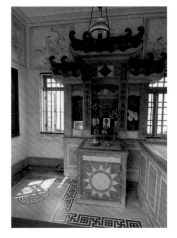

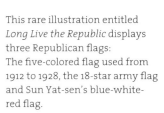

The area around *Kaiping*, strewn with numerous villages, is one of the so-called *hometowns of overseas Chinese* [qiaoxiang] in Guangdong Province. In this area, the low-lying land, with its dense network of rivers, was plagued by frequent floods. Furthermore, Kaiping was situated at the conjunction of four counties, where bandits were once more powerful than the local governments. Thus, people began to construct fortified *watchtowers* [diaolou] in the early seventeenth century.

However, it was only at the beginning of the Republican era (1911-1949) that the building of *diaolou* reached its peak. An unstable political situation, social turmoil and poverty forced many men to look for better work opportunities elsewhere. Due to its convenient location in the southwestern part of the Pearl River Delta, going abroad became a popular choice. Besides emigration to Southeast Asian countries, America, with its gold-rush fever, was then a strong magnet. In the New World, these migrant Chinese workers most commonly found work in railway construction, restaurants and laundries. As soon as these overseas Chinese saved enough money, many returned to their hometowns – bringing with them tastes influenced by exposure to Western culture. Their first priority was to build a safe, comfortable home for their families. *Diaolou* were naturally ideal for this purpose.

The cream-colored *diaolou* with the green Chinese-style tiled roofs and Western-style arched balconies are the only ones that have been renovated and opened to the public as a museum. The interiors have been partly restored to their original appearance. Imported Western bathroom facilities, painted ceramic floor tiles and an ancestral altar painted with the national flag of the Republic of China – a blue sky, a white sun and a completely red earth – on the top floor recall a long-forgotten history.

This rare illustration entitled *Long Live the Republic* displays three Republican flags: The five-colored flag used from 1912 to 1928, the 18-star army flag and Sun Yat-sen's blue-white-red flag.

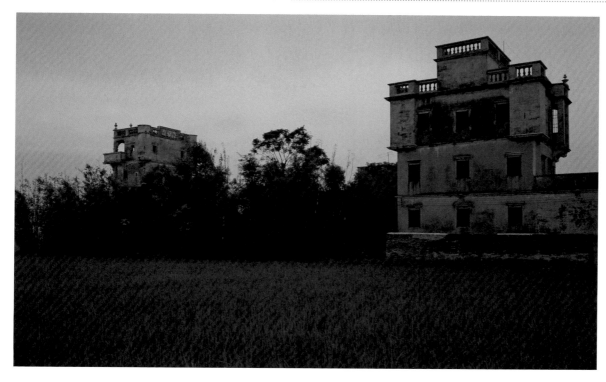

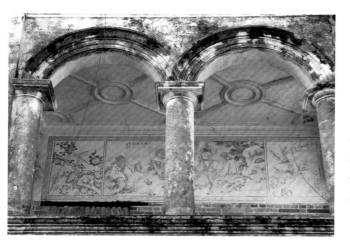

Typically, *diaolou* were built of solid stone blocks. All the narrow windows and the door were designed with iron blinds, and small peepholes for sharpshooters were placed in the upper part of the buildings. It was common for brothers to build their houses next to each other, and thus small clusters of *diaolou* scatter the fields.

Unlike traditional Chinese architecture, where a courtyard or a garden played an essential role, *diaolou* were not oriented horizontally, but rather vertically to provide a good view. Details like Romanesque pillars, Baroque stucco and glass mosaics are integrated into the traditional watchtower architecture as a reflection of the owners' wealth and impressions gathered in the West.

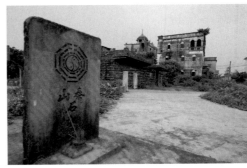

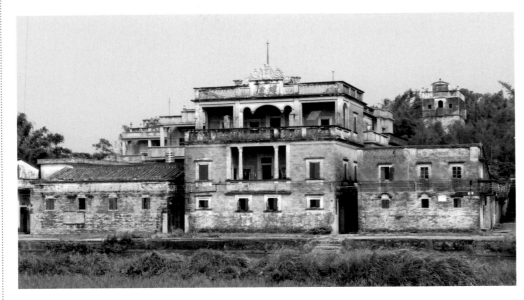

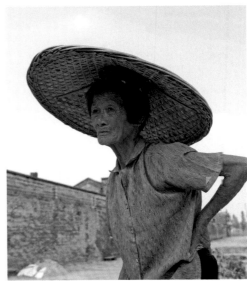

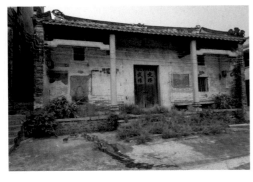

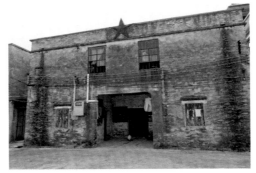

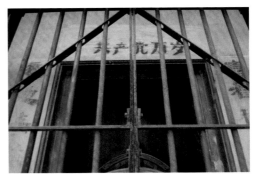

Depending on their function, *diaolou* can be categorized into three types: *Genglou* are smaller watchtowers located on the edges of villages; *zhonglou* are built together by a few families and used only when they need to take refuge from bandits; and the most common type is the *julou*, which are fortified residential houses.

Thanks to their solid construction, these buildings resisted destruction by the Red Guards during the Cultural Revolution. However, their rich decorations in Western and traditional Chinese styles were considered a *tail of capitalism* [zibenzhuyi weiba] and symbols of the *evil old society* [wan'e de jiu shehui]. Because *overseas Chinese* [huaqiao] were often denounced as either traitors or capitalists, many of them remained abroad after 1949. Their *diaolou* were confiscated and only returned to them after the 1980s in accordance with the Communists' United Front strategy. Today, most of these *diaolou* are no longer inhabited, and the windows and doors are barred shut and locked. Most the original owners' descendants live abroad and have never seen these buildings.

A map shows that in 1957, Kaiping was one of the cities and counties in Guangdong Province where more than ten percent of the population were *huaqiao* and their dependents. The twentieth century's upheavals and tragedies have left their mark on these remnants of a region once rich with cultural spaces.

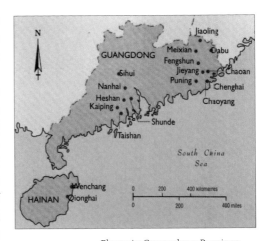

Places in Guangdong Province where *huaqiao* and their dependants exceeded ten percent of the total population in 1957.

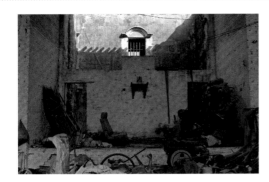

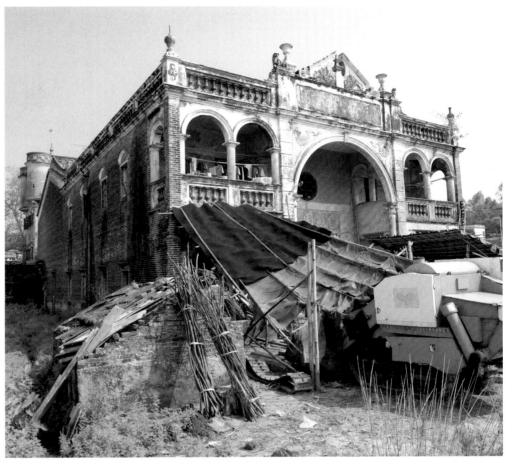

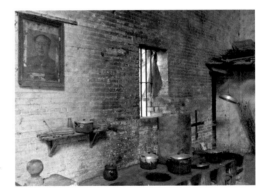

This beautiful but run-down building standing in front of a *diaolou* was once an ancestral hall. The façade of this architecture is also a mixture of Chinese and Western styles, whereas its interior space reflects a classic design. The open courtyard, which is normally lacking in *diaolou*, served as an important space for clan ceremonies like weddings, funerals and memorial rites. Sadly, this building has not recovered from the ravages of the Cultural Revolution. It has been rented out to a farm family from the Central Plain as living and storage space. It is obvious that this fine old building is unsuitable for residential purposes. There are basically no room divisions. The loft-like ground floor is now used for cooking, sleeping and storage, and the upper floor as a chicken coop.

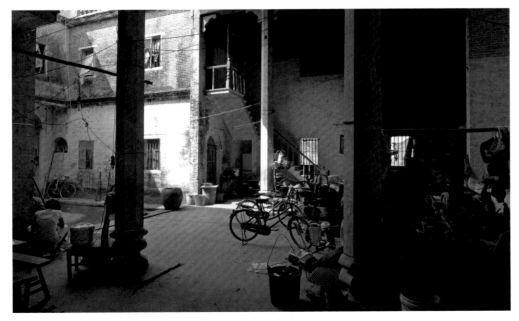

Chikan Town used to be the county seat of Kaiping. During imperial times, water transportation by junks flourished, and numerous harbors were constructed. Chikan developed into a bustling medium-sized traditional Chinese trading town with regularly scheduled transportation to Macao and many other places in Guangdong Province. In the 1920s, the government began to construct roads in this area, and the waterways slowly quieted down. It was also only at this time that many overseas Chinese sent money home to build new houses and invest in local businesses. Many buildings with Western architectural features on the riverside and main streets were refurbished for commercial use. Chikan took on an extremely exotic appearance. Due to the heat and frequent rain, Mediterranean-style *arcades* [qilou] were a predominant element in the architectural design.

The sub-tropical climate here makes outdoor space an important part of daily activities. Food stalls, fish markets and hairdressing salons are common on the streets. The culture of *drinking morning tea* [chi zaocha], accompanied by various dishes of dim-sum, small bite-sized portions of food, is essential to daily life in Chikan Town.

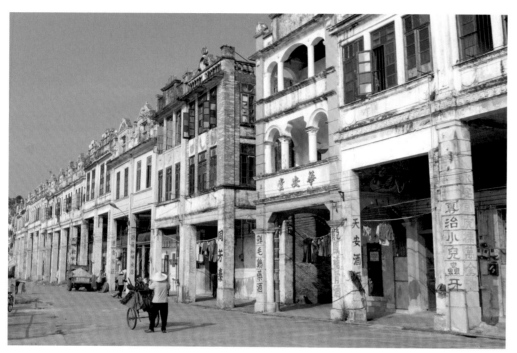

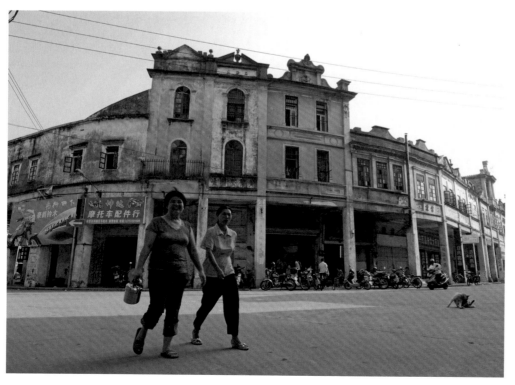

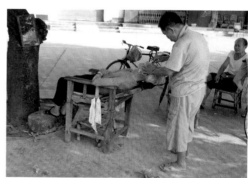

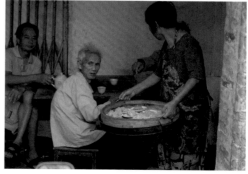

Kite-flying is nowadays a rarely-seen traditional activity in rural areas. Narrow winding stone-paved alleys meandering between the high walls of more than a hundred courtyard houses form a labyrinthine public space in *Dangjia Village* in Shaanxi Province. The square of an elementary school with a pagoda at the corner creates an open space where vendors sell toys, stationery and refreshments. The pagoda was dedicated to Confucius and is the tallest building. In the past, Confucianism and its teachings were highly regarded in this once-wealthy village.

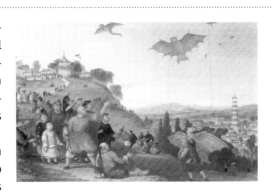

Dangjia Village, literally 'Village of the Dang Family,' was founded by this clan in the fourteenth century. This farming-based clan village was later linked by marriage to the Jia family. In the early Qing Dynasty (1644-1911), the residents began to do business in the once-prosperous Central Plain, the cradle of Chinese civilization. Thus, courtyard houses were introduced here to replace the earth-cave dwellings. Today, the Dang and Jia clans still make up 90 percent of the villagers. Dangjia Village is considered one of the best-preserved of the northern-style villages. The exquisite brick carvings on the *alley gates* [menlou], special stone stoves for *burning used writing paper* [xizilu] and a protruding watchtower with a round and a hexagonal window on its front are a few marvelous examples of its unique architecture.

The variety of delicate architectural details in Dangjia Village makes it an open-air museum. The outer parts of these courtyard houses were usually built with greater attention to detail than the inner parts in order to display the family's wealth and status.

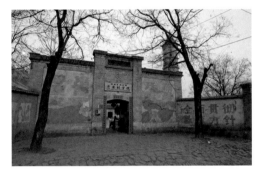

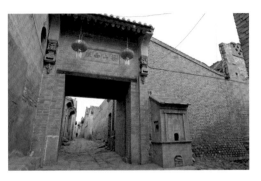

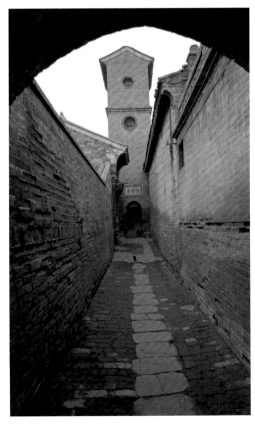

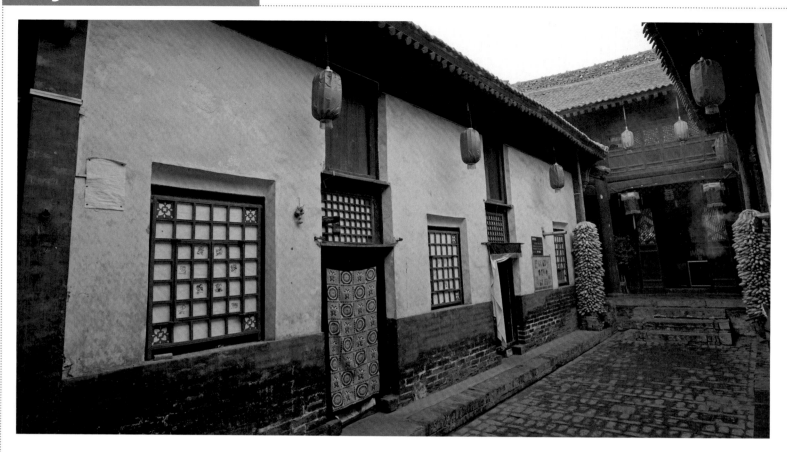

The carved *bearing stones on both sides of a house door* [menzhenshi] function to stabilize the wooden gates, and their style accords with the family's social status and class. Only in the residences of high officials and in temples was it permissible to carve these *stones into a drum shape* [baogushi] decorated with a lion or a dragon, whereas they were smaller and rectangular for wealthy families that did not hold any government position. Another indicator of a family's status was how people hitched their horses. Beautifully designed iron hooks or rings on exterior walls were the most common fixtures for tethering horses. In front of officials' residences, a short stone pillar with auspicious carvings, such as an old man riding on a lion, symbolized longevity and power. This pillar was used to tether horses and was usually paired with a smaller carved stone that people stood on when climbing into the saddle of a horse.

In many houses, local people tactfully used a bench as a doorsill between the two *menzhenshi* during the day, as a signal for strangers not to enter. Visitors are denied a peek through the gate into the courtyard by a beautifully decorated stone *screen wall*. Dangjia villagers tend to integrate a small shrine for the *God of the Earth* into the screen wall. *Wadang* tiles, another smaller decorative and functional architectural detail, were commonly located along the edge of a roof to protect the eaves from wind and rain damage. Flowers, animals and mythological creatures are popular motifs on such tiles.

Although the structure of the houses in Dangjia Village resembles the typical courtyard houses in Beijing, their courtyards form a smaller rectangle because the residents were less prosperous.

Stone, wood and brick carvings in Dangjia Village are another architectural treasure handed down for centuries. The

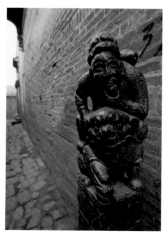
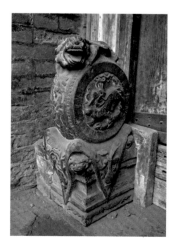

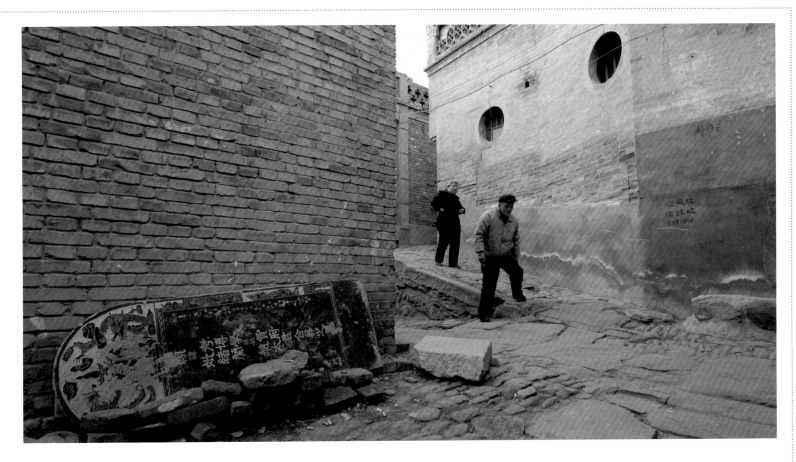

stone carving shown in the picture illustrates a deer with a *lingzhi* mushroom in its mouth and, above it, two monkeys clamber up a pine tree to gather pine nuts, while a pair of *birds of happiness* [xique] watches them. In the middle of the carving, a lightly carved triangle suggests a distant mountain. The deer and the pine tree are metaphors of longevity, and in Classical Chinese the word for 'monkey' is pronounced exactly like the word for an 'official,' *hou*.

Woodcuttings are mostly placed on the doors of important rooms in houses. This one pictured above very likely depicts a story about Confucius: When Confucius traveled through a remote mountain area, he saw a woman weeping sorrowfully. He went to find out what had happened. The woman said that a tiger had killed her father-in-law, then her husband, and now her son. He was puzzled as to why they had not moved away. She replied, "There is no harsh and greedy government here." Confucius commented sadly, "Tyranny and exorbitant levies are fiercer than a tiger." Unfortunately, in the 1960s many of these antique treasures were destroyed and replaced by Mao portraits.

Gravesites are always selected on the basis of *fengshui* and are believed by the Chinese to have the power to influence a family's destiny across many generations. A cemetery is placed close to a village, usually in a location higher than the village itself. Expensive gravestones were commonly used to honor the deceased. Cemeteries became a favorite target for the Red Guards during the Cultural Revolution. One reason was their 'outdated' aesthetics, and another was that they symbolize the tradition of ancestor worship. Several gravestones from imperial times are now scattered randomly in the alleys of Dangjia Village.

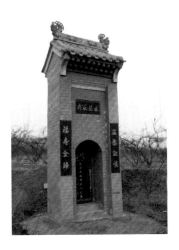

Some 50 kilometers south of Dangjia Village lies *Nanchangyi Village*. Although these two villages are both situated in the loess region near the Yellow River, their location and destiny differ significantly. Nanchangyi Village is spectacularly situated upon a cliff, which makes it accessibly only from the west. On the edge of the hill stands a dilapidated temple dedicated to the *God of Medicine* [Yaowang]. At the very corner of the temple precinct, a pagoda was located to compensate for the geographic *fengshui* of this location.

The decoration and couplets engraved on the temple gate are still partially legible. The horizontally placed characters *shu ke hui tian* proclaim that the healing powers of the God of Medicine can even 'bring the dead back to life.' Since roof ridges were most vulnerable to rainwater damage, an extra strip of decorative tiles, the so-called *wuji*, was added for protection. Much attention was given to the artistic presentation of the *wuji*: A mini-gate was placed in the middle, and various animals and flowers were carved on the side. Unlike the ruins of this temple, the other houses in this hamlet do not recall the grandeur of the past. Some months after these photos were taken, there were reports that this settlement was being partly restored as a film location.

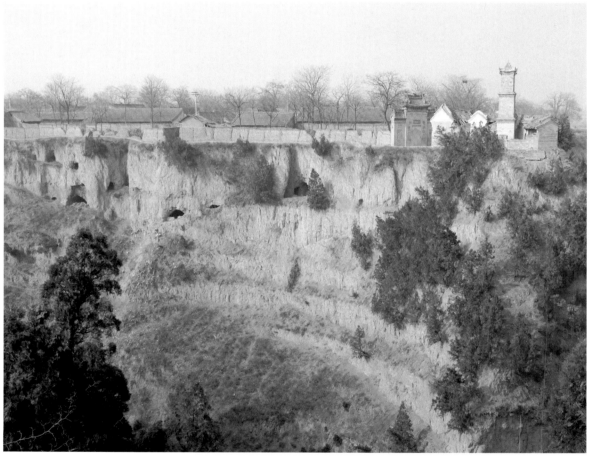

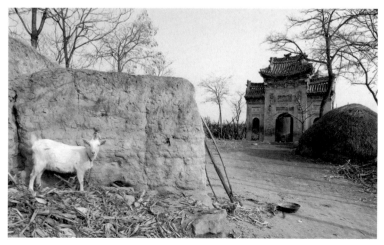

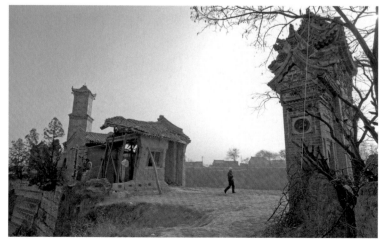

Zhaoxing Dong Minority Village in the southeastern part of Guizhou Province combines several traditional Dong settlements boasting of much characteristic Dong architecture, such as drum towers, theater stages and *wind-and-rain bridges* [feng yu qiao].

Drum towers are symbolic public buildings in Dong villages. Although the wooden pagoda-shaped towers are usually the tallest buildings in these places, their height is only a status symbol and does not have any practical function. The ground floor of a drum tower is the only functional floor and serves as a space where Dong elders gather to discuss village affairs and everybody socializes. The style of drum towers is highly eclectic, with a variety of different architectural details, but the towers always narrow upward and the number of eaves is always odd, as the Dong regard odd numbers to be auspicious. Besides utilizing drum towers as spaces for singing and dancing, the Dong also like to hold theater performances. Thanks to the popular oral-performance culture, the history of the Dong has been passed down from generation to generation without a written record. The so-called wind-and-rain bridges are covered bridges with a unique pavilion design. The cornices are a distinctive feature.

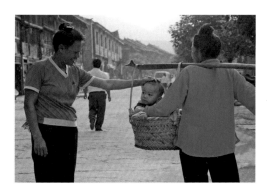
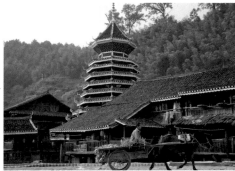
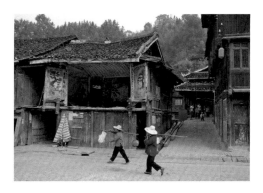

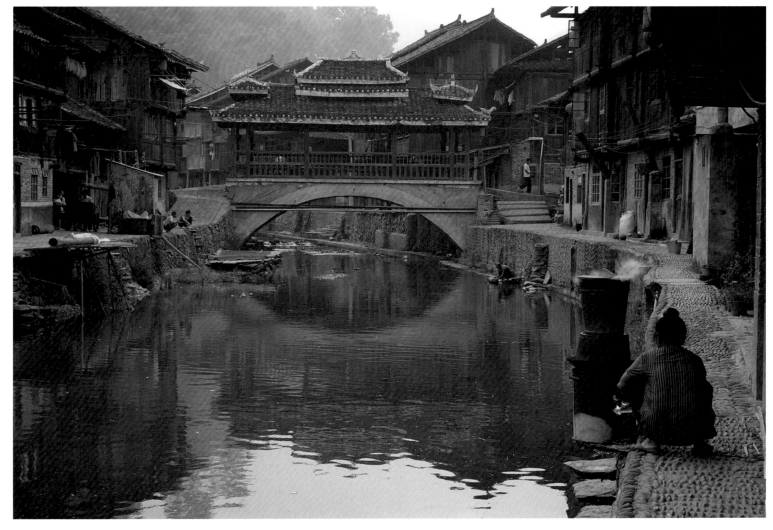

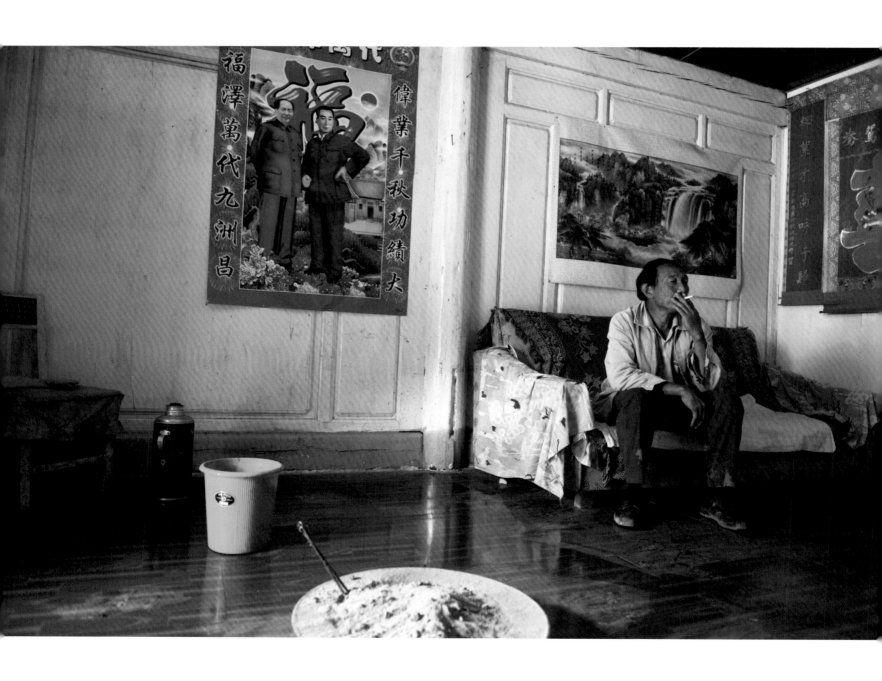

Mapingguan Village,
Yunnan Province

These three illustrations depict different scenes of folk life in the countryside during the late Qing Dynasty (1644–1911). Interesting to observe are the details of interior decorations and the house furnishings, including a fan, a lantern and a feather duster on the pillar in the shop. Furthermore, in the homes of wealthy families it was common to find landscape paintings, calligraphy, religious statues and an ancestral altar surrounded by different styles of chairs. In less prosperous families, a chair-shaped oil lamp, a *straw rain cape* [suoyi] and a *coir-woven bed* [zongchuang] supported by two benches could be found, as depicted in the illustration of the fisherman's home.

Rural Aesthetics and Modern Kitsch

A visitor to any randomly selected Chinese village is likely to find it dirty, rundown or impoverished.

In other words, he misses signs of aesthetics and culture. Architecture *per se* has of course survived down through the centuries in China. Yet nowhere in the vast expanses of rural China can we expect to find an ancient house with its original interior design and furnishings intact. Possible exceptions include a few restored historic houses such as the boyhood home of Mao Zedong in Hunan Province or the Wang Family Manor in Shanxi Province, if we can count them as exceptions. Compared with exterior ornaments, interior decorations and furniture have been far more fragile and vulnerable to damage in the course of Chinese history.

To understand why rural residents in previous times achieved a higher aesthetics in interior decoration, we have to take into account that the wealth gap between urban and rural areas was not nearly as extreme as it is today. At one time, wealthy families – landlords, merchants and officials – resided in rural areas, where they maintained a tradition of giving priority to both agriculture and study. It was common for these families to set up *home schools* [sishu] for their offspring and children with family ties, or even for the children of neighboring families. The notion of *cultivating both the land and the mind as the family discipline* [geng du chuan jia] arose under the influence of Confucianism. When survival was no problem for a rural family, members were encouraged to pursue both intellectual and aesthetic endeavors. In return, these educated elites brought cultural enrichment to rural communities. Unlike the reclusive *literati art* [wenren yishu], which was spiritually motivated and manifested itself, for example, in *landscape painting* [shanshuihua], educated rural elites expressed their aesthetic values in architectural ornaments, interior decorations and everyday utilitarian handicrafts. In decorations, both interior and exterior, one can easily discover symbols that express the pursuit of a peaceful life and the desire for harmony between man and nature.

Unlike lifestyles that have changed significantly in the last century, the landscape of rural China still reminds visitors of the traditional landscape painting (Image right by Wang Hui, 1632–1717), which embodies harmony between man and nature. Although rapid urbanization is transforming the face of China's countryside, the vastness of its territory helps to slow the disappearance of cultural spaces.

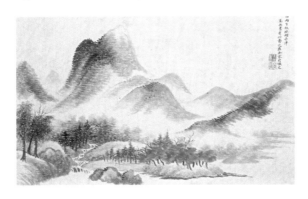

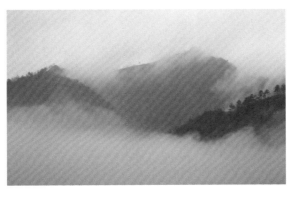

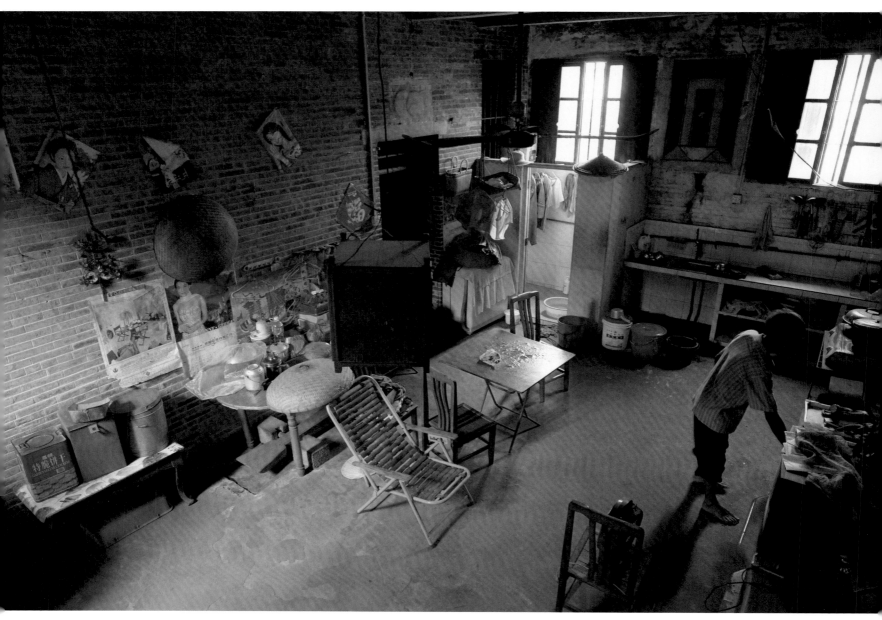

Baihe Town, Guangdong Province

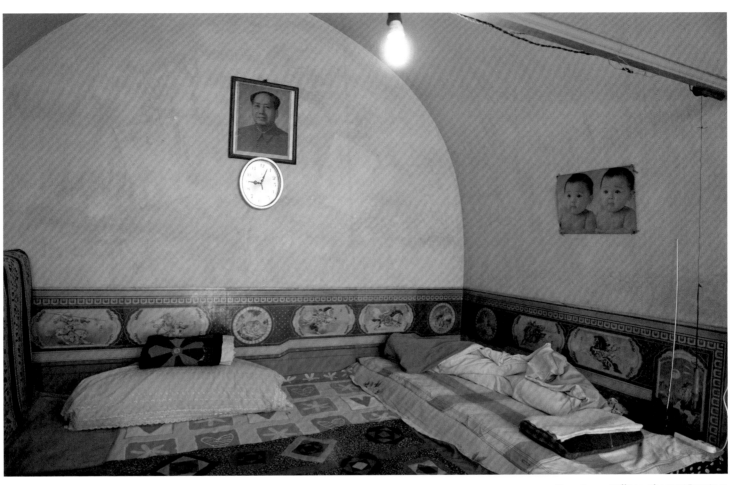

Yangjiagou Village, Shaanxi Province

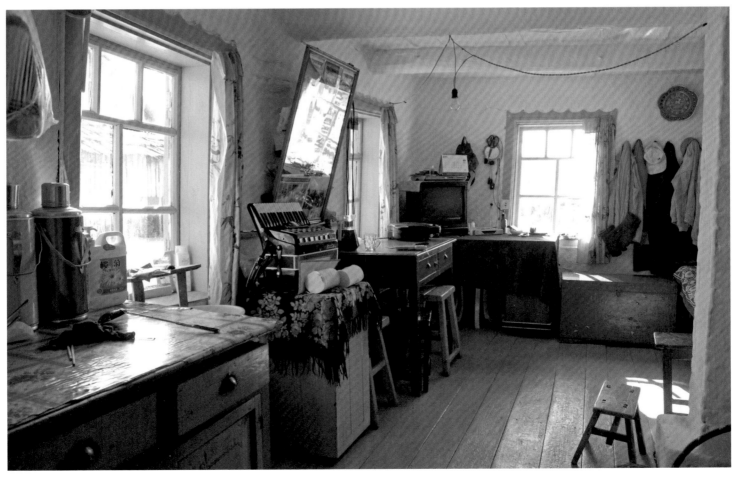

Enhe Village, Inner Mongolia Autonomous Region

Despite the suppression of geomancy after 1949, *fengshui* practices have survived and are widely followed, especially in rural areas. Mirrors and scissors above a doorway are believed to combat evil forces, i.e., negative energy from the surroundings. Paintings and carvings of auspicious animals are frequently integrated into decorations. For example, fish symbolize wealth, and a lioness playing with her cubs stands for harmonious family relationships.

In addition to aesthetic ideals, the design of residential ornaments reflected Chinese mysticism and beliefs, such as the principles of *fengshui*. The Han Chinese and various ethnic minorities created residential ornaments according to the principle that 'Ornaments follow folk beliefs.' In minority regions with strong religious roots, such as Tibet and Xinjiang, interior design often mirrors these spiritual traditions. Still, in most parts of China's inland, we find a remarkable uniformity in the adoption of common symbolic motifs, like the crane for longevity, butterflies for love and bats for good luck. Some artisans included these meaningful and purposeful ornaments when building houses, and families sometimes added such decorations after moving in.

In traditional Chinese belief, ornaments can serve a dual function: Symbols are used not only to assure good fortune and protect homes, but also to counter the negative influences of imperfect *fengshui* or any evil spells hidden in and around houses. Carpenters and masons were not just renowned for their craftsmanship, they were also thought to possess magic spells with which to afflict a household. If they felt unfairly treated, they might cast evil spells on houses, which was not hard for them to do. To neutralize possible evil spells and *fengshui* curses on their home, families attached amulets to pillars or walls – esoteric, cryptic writing on yellow paper is still a frequently encountered example – and took various other measures. In some cases at least, the apparently superstitious arts work with a sort of utilitarian logic, and their practical value is often not hard to infer. A *screen wall* [yingbi] with auspicious painted decorations, for example, is commonly located before the entrance of a courtyard house not only to protect the residents against evil powers, but also to ensure a certain degree of privacy.

No one would deny that the Chinese upheld high aesthetic standards in the past, but times have changed. Beginning with several *land reforms* [tudi gaige] in the 1950s, the government redistributed land to reduce the economic inequality between rich landlords and peasants. But farmers soon lost the right to own land and were permitted only to use a certain plot of land for planting. The government plan to eliminate inequality did succeed, but only in the sense that all farmers became equally poor, and – as could be expected – the rural elites who once contributed so much to local aesthetics and culture disappeared. During the Cultural Revolution, the practitioners of traditional aesthetics and *fengshui* were fanatically persecuted or even killed as agents of the *Four Olds* [sijiu]. Their artworks escaped destruction only if they were well hidden or concealed under a layer of clay. Today, some fine surviving works are preserved in private collections, some can be appreciated in museums, and still others wait patiently in their accustomed places to delight the curious visitor. Exquisite antique artworks, furniture and handicrafts still enhance the appearance of some ancient houses, where they offer a powerful and poignant contrast to the rest of an otherwise utilitarian interior.

This page from the *Treatise of Lu Ban* [Lu Ban Jing], based on the thoughts of the famous carpenter and philosopher Lu Ban (507–440 BCE), shows twelve spells a carpenter could cast on a house while building it. As a measure to ensure that carpenters would be treated decently and paid fairly by their employers, the majority of the spells in this book were believed to bring misfortune upon a house. For instance, as shown in the top left of the illustration, if a cow's bone is hidden in a room, the residents will be condemned to a hard, difficult life and be buried without a coffin.

Many rich and meaningful decorations that once adorned houses were lost, destroyed or neglected in the last century. Clockwise from left: Broken pieces of stone fixtures; wall carving of an *Qilin*, a mythical beast, shown riding on *ancient copper coins* [tongqian]; a wood carving with decapitated figures on the door; a caramel candy box imported from the Russian Empire via ancient trade routes; and a stone carving of groups of happy boys cavorting in a garden.

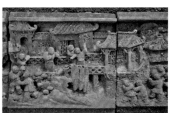

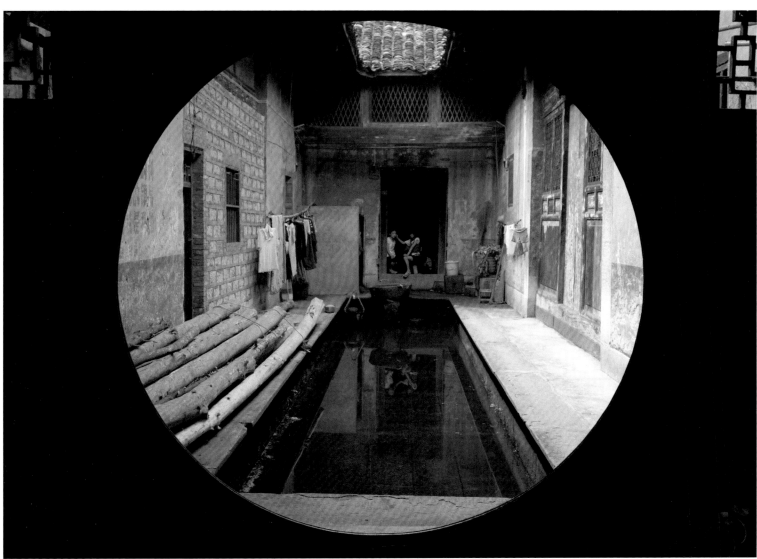

Up until today, most of the countryside has been unable to restore its former cultural wealth. When we wander through the streets and alleys of ancient villages and towns still redolent of bygone charms, we cannot but notice how traditional architecture and old household objects are denied a chance to evolve over time. Nowadays rural households often dispose of tasteless plastic furnishings but lack basic infrastructure such as sewer connections and modern toilets. Many *female migrant workers* [dagongmei] who have returned from cities to villages to get married complain that the most inconvenient living condition is a lack of hygienic facilities in homes, together with the long distance to the public bathhouse.

It is easy to understand why traditional aesthetic values have been relegated to the past. The political movements promoted by the government since the 1950s marked a drastic break with traditional lifestyles, not just with artifacts, but also, and probably even more crucially, with the ability to appreciate and redesign traditional household articles to serve new functions. Today, time-honored Chinese aesthetics are enjoying a revival among certain urban elites, but traditional craftsmen are gradually dying out in rural areas. Younger ones, most of whom are already in their sixties and learned their skills prior to the Cultural Revolution, are finding

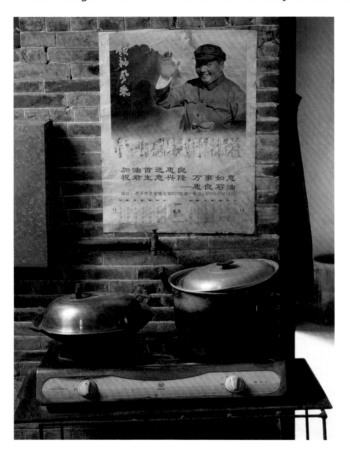

it hard to regain their former proficiency, given inadequate resources and underpayment. Many village temples, for instance, survived the Cultural Revolution, but hardly any original Buddhist or Taoist icons escaped destruction. The lack of funds and skilled craftsmen has inevitably resulted in unattractive, poorly made replacement statues. In some extreme cases, fastened to a wall in place of a carved figure is merely a piece of paper bearing a deity's name.

Ironically, those who participated actively in the Cultural Revolution as Red Guards 'learned' various different attitudes toward traditional aesthetics, depending on what the government was promoting at any given time. Villagers usually agree with a visitor's praise for the traditional aesthetic values that inform their homes and surroundings, but they would often really prefer to move into a new dwelling. Occasionally, some villagers respond to praise with raised eyebrows and laugh at an outsider's naïve appreciation. It is of course obvious that the fixtures and appliances in newly built brick or concrete houses are more modern, but the advantages come at the cost of a monotonous, uninspired appearance. Furthermore, modern facilities do not necessarily guarantee better public hygiene, because the improvements they offer are often offset by high population density and a lack of public education. County seats usually tend to offer low-quality new housing in a more cramped and stultifying environment, and this housing is often less attractive than traditional village houses. For villagers, though, such urban areas provide better opportunities for earning a living and consequently stand for a better quality of life.

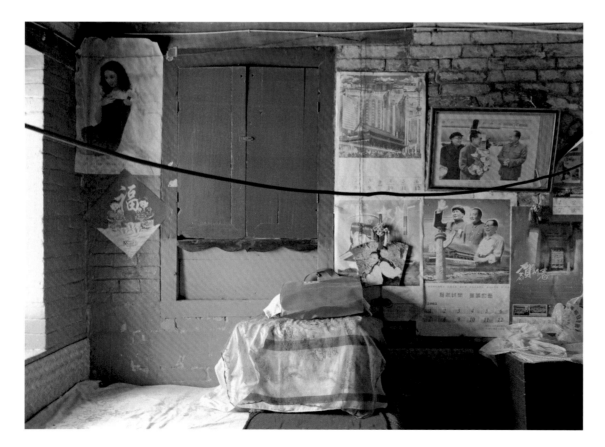

The decline of traditional aesthetics: While Chinese art and culture were appreciated for centuries, the collapse of the 'old world' changed the interior of almost every Chinese rural home overnight. The widespread intrusion of politics into households, followed by the rise of popular culture and materialism, took only a few decades to alter people's ideas about beauty.

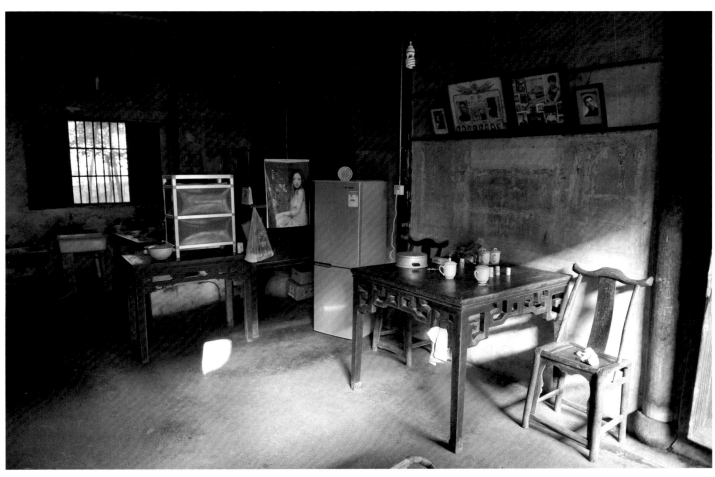

Sizhai Village, Zhejiang Province

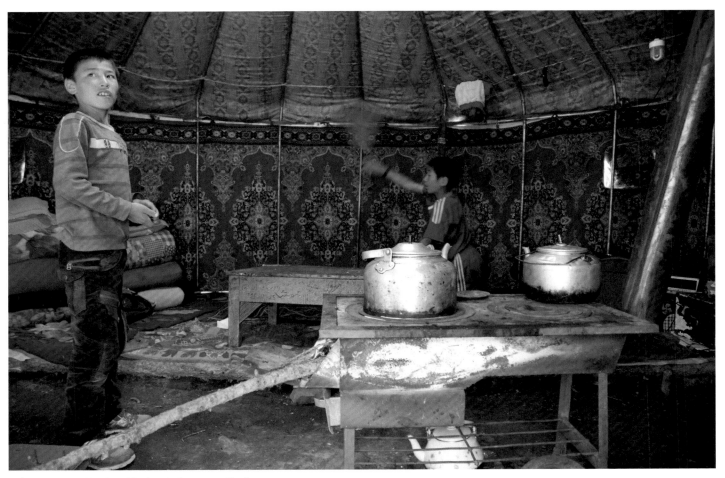

Bu'erjin County, Xinjiang Uyghur Autonomous Region

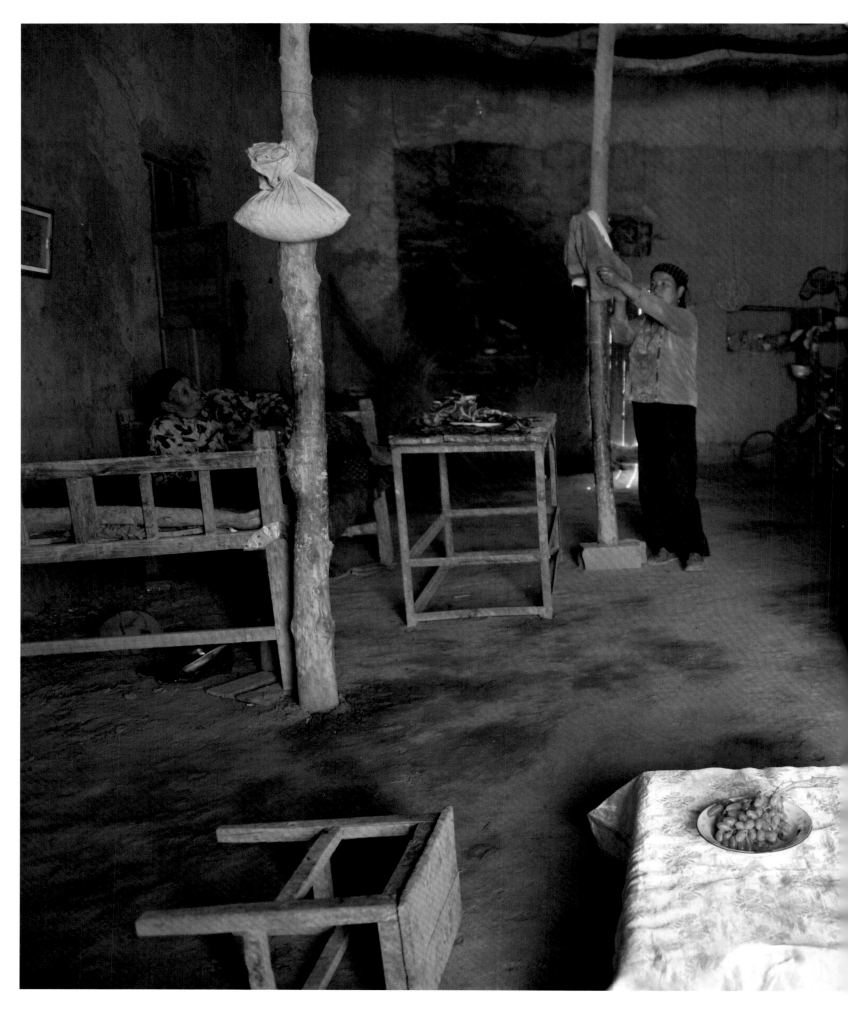

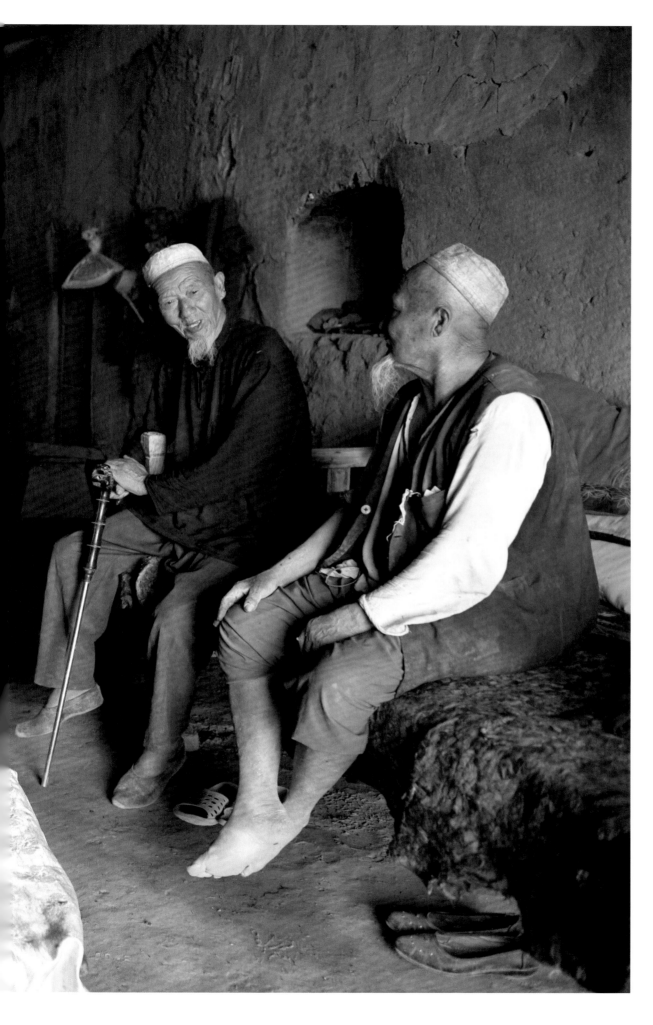

Dikaner Village, Xinjiang Uyghur
Autonomous Region

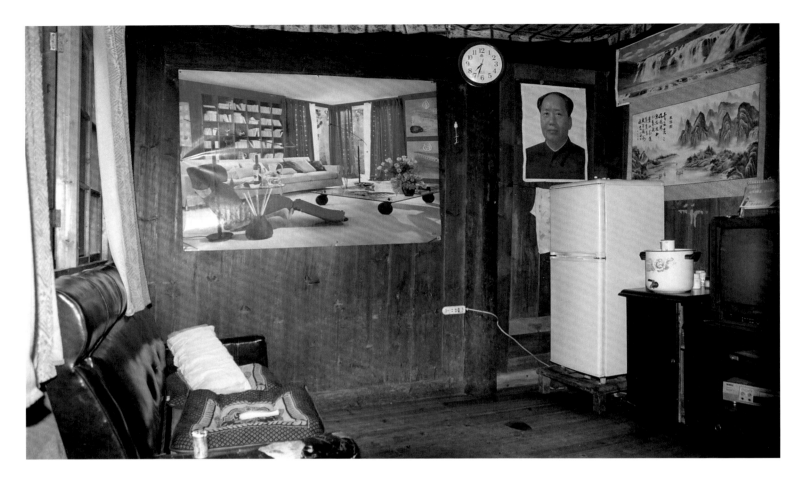

Since the early 1980s, the Chinese have not slackened in their drive to achieve a higher standard of living. The economy has overshadowed all other aspects of life. Ironically, given the founding ideology of the PRC, materialism and consumerism have become the very heart of contemporary Chinese culture. Modernization entails not just technological progress, but also a devaluation of traditional ways of life. The consequences are glaringly obvious when we stroll through China's economically thriving but aesthetically unattractive urban areas, especially in smaller cities. In these places, historic structures give way to nondescript modern high-rise buildings. Not only is a monotonous, uniform cityscape replicated in city after city, a lifestyle has also become dominant whose mantra is 'New is beautiful, bigger is better.' Today the typical rural home interior is much the same everywhere: The residents usually display family photos, posters of admired political leaders or pop stars alongside children's school award certificates in the living room, where the only furniture consists of a *square table* [baxian zhuo], a few chairs, a cabinet and a TV set. The arrangement is purely functional – quite the opposite of the great aesthetic sensitivity the residents' ancestors prided themselves on.

In most ancient villages, hardly any new ideas have arisen for renovating traditional interiors and furnishings. The reason is definitely not a lack of solutions, but rather the media-popularized attraction of modern lifestyles. Since mainstream values have seduced rural residents into believing that living in old houses is a sign of backwardness, it seems only natural that these rural residents should wholeheartedly embrace the promise of radical modernization. Often the walls of ancient houses are adorned with colorful posters displaying glossy images of a contemporary Western-style apartment. For many who live in the countryside, this seems to be the only vision of a better quality of life.

Rural Fashionistas

Urban fashion trends promoted in the media quickly find their way into the vast countryside, especially since the beginning of the twenty-first century. Even in remote areas, TV sets have become widespread. Fashion-conscious youngsters in rural areas are eager to adopt the latest trends and are no less motivated to try out bold new styles than their urban peers. In the last decade, modern hairdressing parlors adorned with posters of delicately trimmed and waved hairdos have sprung up in county seats and small towns and have become the most chic rural institution, even in minority regions.

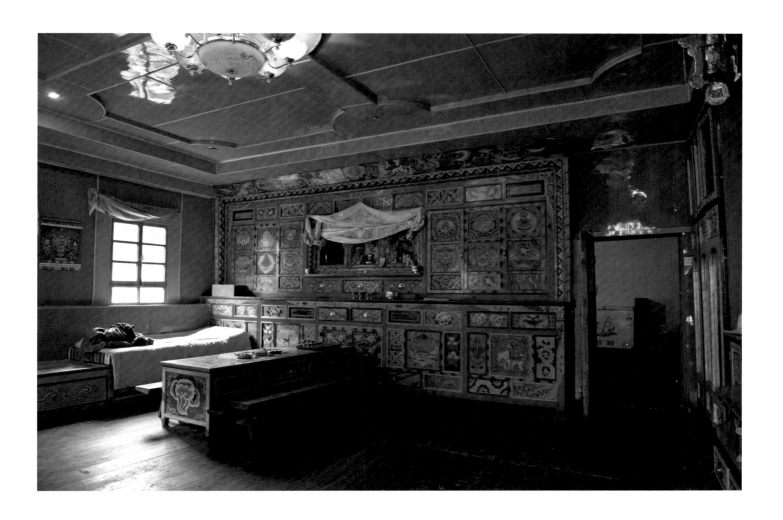

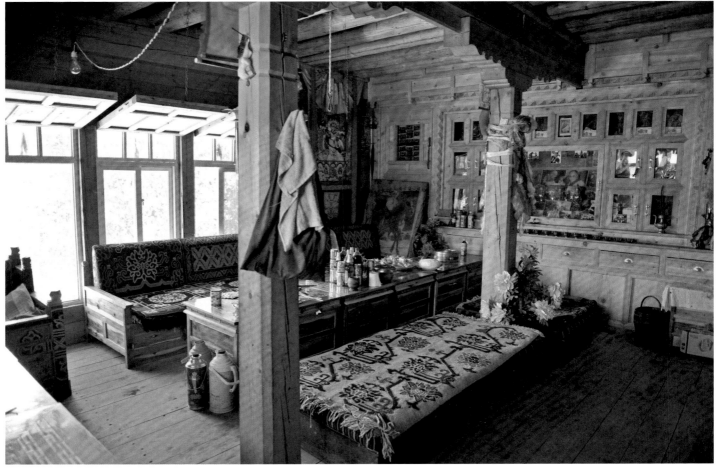

Garzê [Ganzi] Tibetan Autonomous Prefecture, Sichuan Province

Shibajie, Chongqing Municipality

The *underground earth houses* [dikengyuan] in *Nangou Village* in the flat loess area of Henan Province display a unique rustic interior style. They represent a historic cave-dwelling architecture that efficiently utilizes the natural environment. A unit is composed of five to ten caves grouped around a courtyard, with a staircase several meters long that leads to the ground level. The walls of the vaulted rooms were traditionally coated with a layer of white lime for insulation and to lighten the deep, dark space, which has only one side with windows. Today, in many of these rooms, lime is replaced by newspapers. Fresh paint is usually applied only to the rooms of newlyweds. The same applies to the use of Western-style beds with a soft mattress, a non-traditional piece of furniture. Conventionally, people in northern China built *kangs*, brick beds, warmed by an oven underneath.

Although these earth houses are cool in summer and warm in winter, the single side-opening limits the circulation of air and access to sufficient sunlight. The houses are so damp in the rainy season that wooden furniture sometimes becomes moldy. Moreover, due to structural limitations, these caves can only be enlarged in depth, not in width. This limitation does not accord with the modern trend toward spacious living rooms. When their livelihood improved in the 1980s, local people started to view the underground earth houses as backward and impoverished. Many young women refuse to marry into families residing in earth houses. In recent years, more and more brick houses have been built in preparation for marriage. As a consequence, the remaining residents of underground dwellings are mostly elderly people.

The paper-cutting tradition, including the custom of singing while making paper cuttings, has been well preserved in Nangou Village. However, local people no longer paste the paper cuttings on windowpanes or walls, as their predecessors once did. Instead, colorful posters of pop stars, cute, cuddly babies, Buddhist deities, Communist leaders and Christian symbols are common wall decorations. Paper cuttings are nowadays more commercially oriented. The change in subject matter reflects the zeitgeist of a new time.

Even after the end of the Cultural Revolution, clan practices and folk religions did not recover quickly from the severe blows of that disastrous era. Thus, the revival of Christianity came at a propitious time (before 1949, Henan Province was one of the most Christianized areas). The generosity of the churches, such as providing free feasts at Christmas, along with their religious teachings, attracts many people in rural parts of Henan. Local people describe Christianity's popularity with phrases such as: "There is a church in every township. There are followers in every village." In Sanmenxia City, which has jurisdiction over Nangou Village, the number of Christian believers is almost equal to the number of Buddhists. About a third of the residents of Nangou Village are Christians, and 80 percent of the believers are female. Most of the followers converted due to illness or loneliness because their husbands or sons work in distant cities.

The spiritual enrichment that Christianity has brought to the otherwise culturally barren life in rural communities is well received by the peasants. The abundant objects in the interior not only show the various religious and political ideas common over the centuries, but also how quickly people integrate them into their lifestyles.

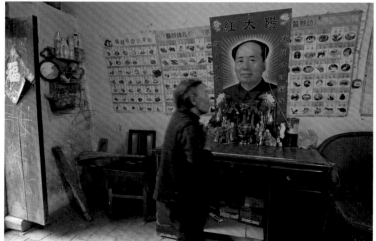

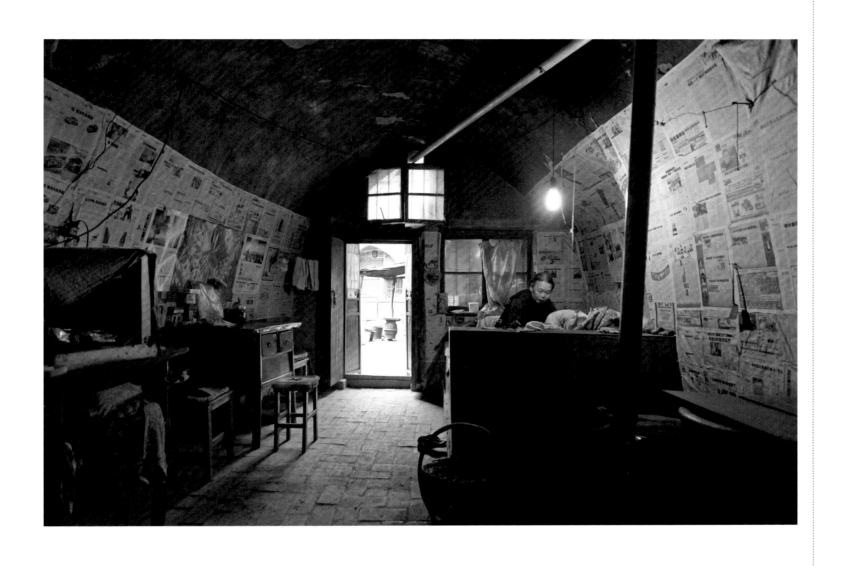

The traditional Hui-style house is probably one of the most representative and well-known types of Chinese architecture. Its densely layered gray roofs and the faded white-painted walls create an idyllic world in the hilly countryside. *Wuyuan County* in Jiangxi Province boasts some of the finest examples of Hui-style homes, which seem to have literally sprung out of Chinese paintings and landed in the lush green landscape.

The name Hui came from an area that was once called the *State of Hui* [Huizhou], including today's southern Anhui Province and neighboring parts of Jiangxi and Zhejiang Provinces. Because the local agriculture could hardly feed the dense population in this hilly area, many men sought opportunities in trading, and their commercial activities finally spread all over the country. Since the tenth century, Hui businessmen have engaged in the bamboo, wood, lacquer and tea trades or operated pawnshops. When the Song Dynasty moved its capital to Hangzhou in the twelfth century, the need to build new palaces and gardens further stimulated trade in Huizhou, and its skilled craftsmanship was in high demand.

During the following centuries, the assets accumulated by Huizhou merchants enabled a splendid culture to flourish. This culture was manifested in the spread of neo-Confucianism, the creation of brilliant arts such as Hui Opera, and handicrafts such as the manufacture of the renowned Chinese *rice paper* [xuanzhi]. However, the most outstanding feature of Hui culture is its unique architectural style.

The distinctiveness of Hui-style architecture extends to its interior spaces. Whereas the houses' exteriors often look similar, their interior spatial arrangements can vary greatly. The integration of 'unroofed areas' into the architecture offers a good example. It can be a skylight for lighting the vestibule, a small *sky well* near the edge of a house or, much less commonly, a courtyard.

Aside from this spatial variety, people in this region usually decorate their vestibule with a standing clock, a pair of vases and a mirror, which together give an impression of and have the same pronunciation as the term *lifelong tranquility* [zhongsheng pingjing].

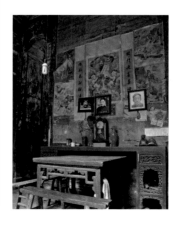

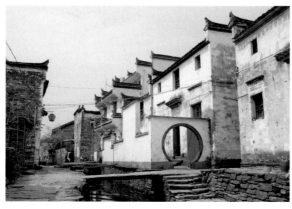

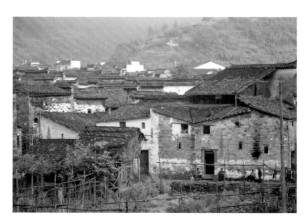

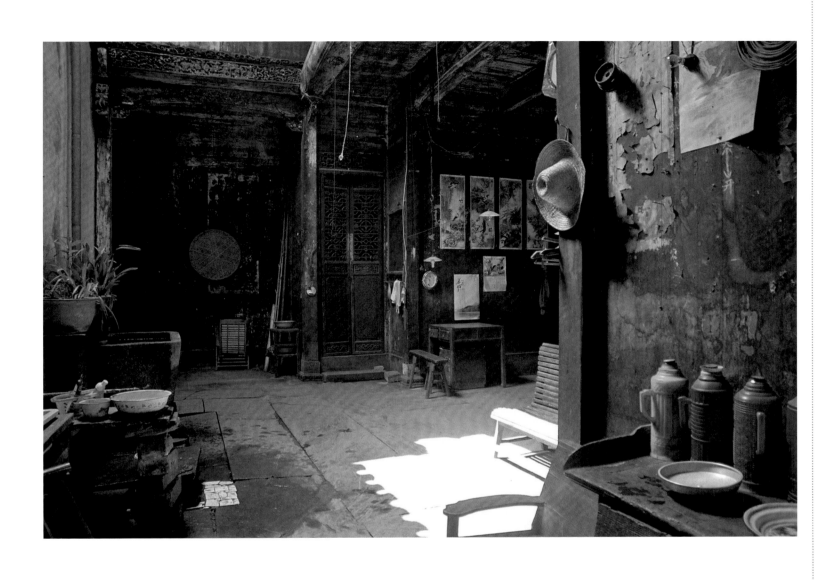

Most houses in Wuyuan County were constructed with only a few small windows, out of concern for the safety of women and children, because Hui traders spent much of their time in other parts of the country. Visitors may be surprised at how dark and simple some of the high-ceilinged rooms are, given the once-splendid exteriors of these houses. Today, the majority of young and middle-aged men work as migrant laborers in distant places. Dogs are also kept to guard the family. A small opening near the main gate commonly serves as the dog's entrance and exit.

The Chinese character *fu*, meaning 'good fortune,' is often seen painted on walls, together with the heads of a deer and a crane as decorations and symbols of longevity. Paintings of land-scapes, birds, flowers and historical tales were commonly placed above the entrance gates of smaller and less magnificent houses, whereas wealthier families favored wood or stone carvings. During the Cultural Revolution, these artworks were either destroyed or replaced by political slo-gans such as *Long Live Chairman Mao* [Mao zhuxi wansui]. The advent of tourism in recent years has encouraged the locals to copy traditional paintings in an effort to restore their villages to their original appearance. However, the wealth and artisanship of Hui culture are gone forever. Near-by cities like Ningbo or Shanghai have become more prominent in China's modernization process.

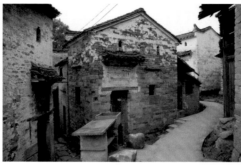

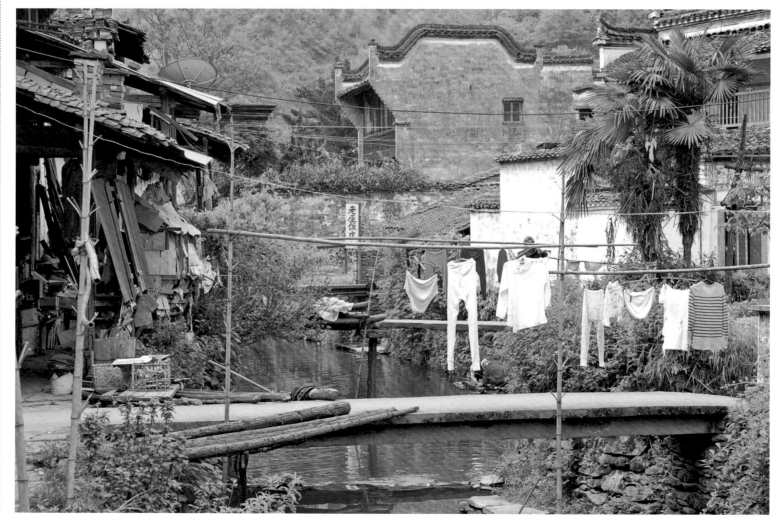

The Confucian-inspired culture in Huizhou promoted patriarchal clanship and reverence for ancestors. In *Wangkou Village,* the exquisite Yu family ancestral hall built in the eighteenth century features complex triple eaves and delicately carved wooden architectural details. As with many of the splendid buildings in Wuyuan County, the façade has been restored, but the extensive damage left by the Cultural Revolution is still visible everywhere inside. In the courtyard of this otherwise neglected ancestral hall, some of the wooden carvings are beheaded and imperial relics litter the ground near an oversized wall painting of Mao Zedong.

Destruction of the
Confucius Temple
in 1968 by a Red Guard
in Qufu, Shandong Province.

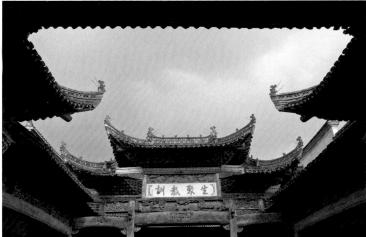

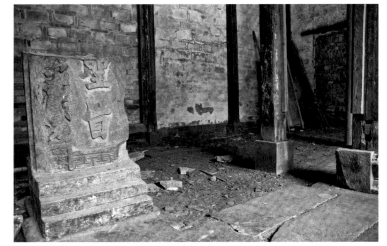

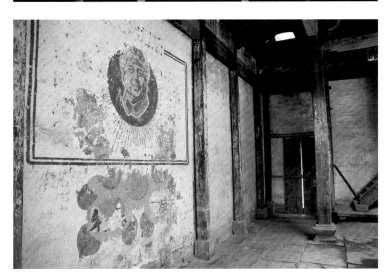

Located on the eastern edge of the Taihang Mountains, *Yingtan Village* in Hebei Province resembles, from a distance, a medieval settlement on a hillside in Tuscany. Most houses were built of salmon-pink local stones in the late nineteenth century. At dawn and dusk in early spring, when this village, surrounded by fallow fields and hills of a faded yellow-green color, is heavily shrouded in fog, a misty, enchanting atmosphere holds sway over a forgotten place.

In one of the oldest houses overlooking the valley resides the *tofu* [doufu, i.e., bean curds] master. His family has been making this everyday product to supply the needs of the village for many generations. Once a week, this elderly farmer in his 70s prepares fresh bean curds using traditional utensils inherited from his father. A blossoming cherry tree adds a touch of unexpected beauty to the otherwise hazy surroundings.

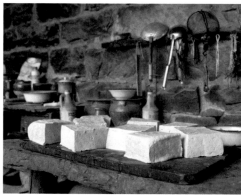

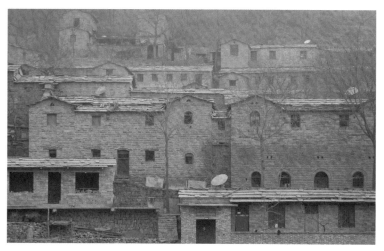
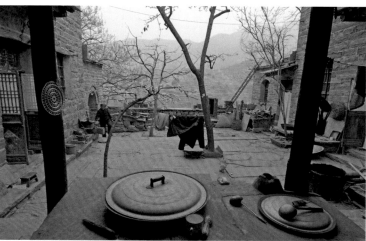

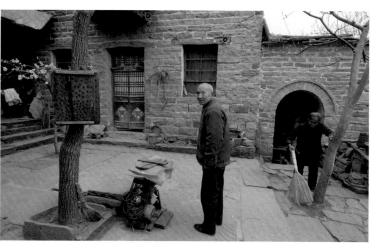
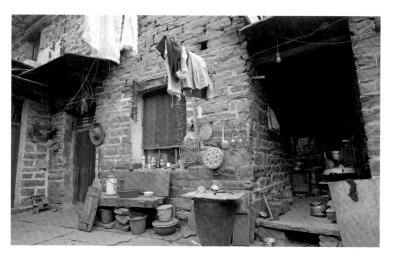

In the tofu master's simple living room, a discolored poster of deities depicting the *Goddess of Mercy* [Guanyin], the *God of Wealth* [Caishen] and the *Three Gods of Good Fortune* [Fu Lu Shou san xing] hangs on the wall alongside family photos. Garbed in a traditional Chinese gown, his grandfather does not look like a farmer, but rather a traditional Chinese scholar. Other photos show members of his family over a period of decades.

As in other parts of the countryside, on the wall there is a *traditional almanac* [huangli, sometimes also called a peasant almanac] of a sort often consulted by farmers. It shows lunar dates and solar cycles, and it offers advice on what is proper or improper to do on a given day. For instance, it might be appropriate to offer sacrifices to the gods, engage in animal husbandry, marry or make wine; but road-work, in contrast, would be inadvisable. In the past, such calendars were profusely illustrated, as shown in the pictured example from 1949. During the Cultural Revolution, the Communists condemned such calendars as a symbol of the *Four Olds*. Today, only elderly people in rural areas still refer to such calendars before engaging in daily activities. They usually purchase them in the market around the Chinese New Year.

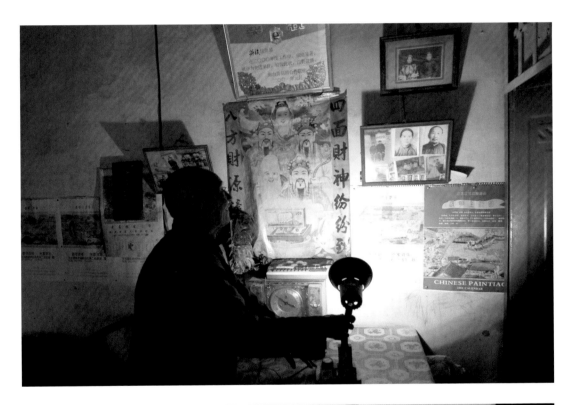

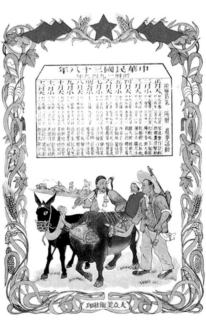

The name Yingtan has a legendary origin. It is said that during the chaotic late Tang Dynasty (618-907), armies set up their *camps* [yingpan] here, due to its advantageous strategic location. Thus, people called the place Yingpan, and in the course of time it became Yingtan. The first family that settled here came from Shanxi Province in the fifteenth century. Over the generations, the inhabitants became wealthier through both business and farming. Today, the remaining residents are mostly peasants. Cotton is an important local crop, so buyers from manufacturers in nearby towns visit this village regularly: They ride their motorcycles around Yingtan and use loudspeakers to announce the purchase of cotton.

The architectural style here is simpler than that of courtyard houses. There is not much decoration besides wooden lattice windows and variously shaped ventilation openings: Cross-shaped, triangular and rectangular holes on top of the side walls are the most common. Whereas the traditional gray stone villages in Guizhou or Hunan Provinces are representative of stone dwellings in southern China, Yingtan Village is one of the very few well-preserved examples in northern China.

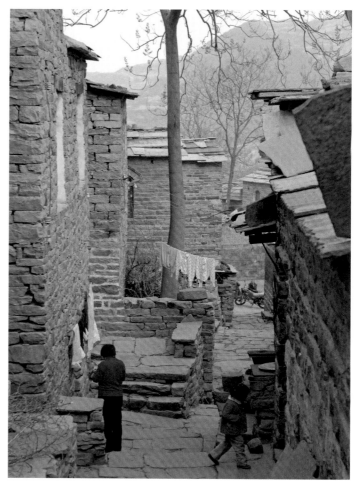

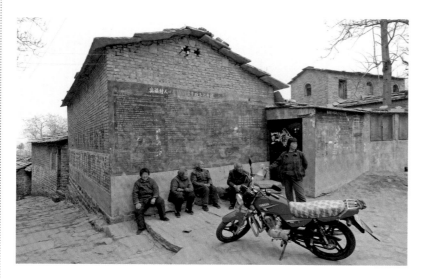

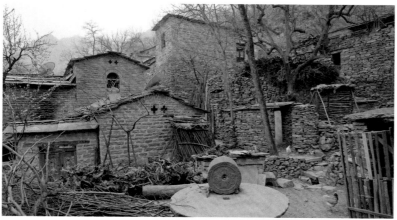

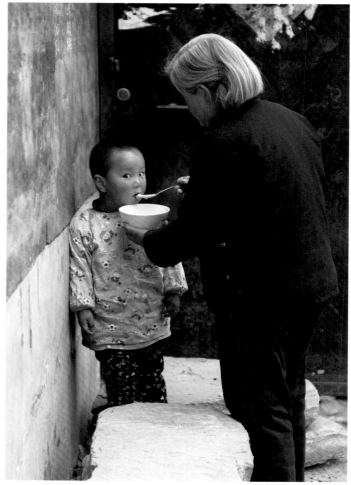

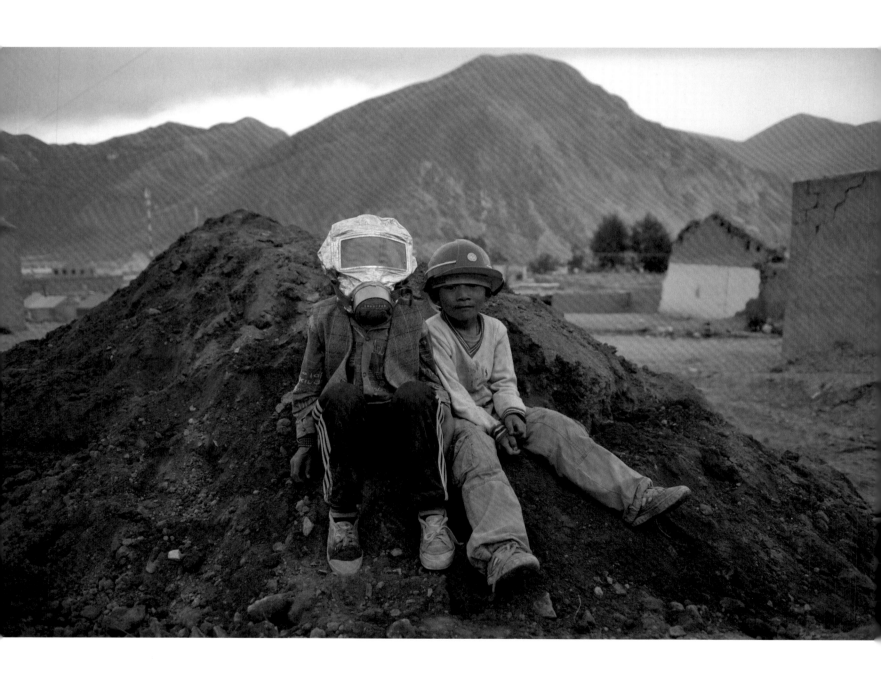

Yushu Tibetan Autonomous Prefecture,
Qinghai Province

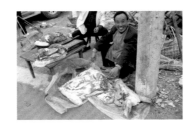

Food, Water, Health and the Environment

Everyday meals in rural China are usually far simpler and less varied than the Western image of Chinese food.

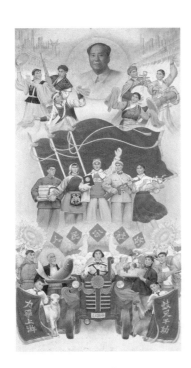

This 1950s propaganda poster proclaims that the introduction of People's Communes was welcomed and celebrated by all ethnic and social groups. Their optimistically assessed efficiency, claimed to surpass that of the traditional production and market system, is reflected in the oversized animals and fruit.

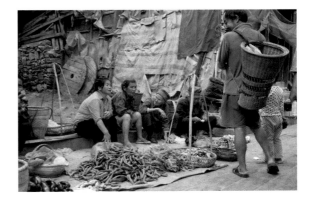

Beijing duck is probably just as exotic for the residents of a remote Chinese village as it is for Westerners. Typical of most rural areas is a largely vegetarian diet dominated by rice in the south and wheat in the north. Because the majority of rural residents are farmers, they consume, above all, products from their land. Besides crops, many families raise poultry or swine for their own consumption. In general, farm diets are self-sustaining, and farmers sell the produce they do not consume themselves. They sell part of their surplus in the nearest market town, and the rest in other Chinese regions through wholesale agricultural produce markets or together with private *agricultural middlemen* [nongcun jingjiren].

Probably the most efficient way to distribute commodities is through the *rural markets* [jishi or ji, chang, jie, xu, dian, depending on the region], where peasants sell their surplus agricultural produce and handicrafts and buy what they do not make at home. The scale and principles of today's rural markets developed during the Ming Dynasty (1368–1644), and the number of markets continued to grow until there were some 58,000 in 1949. This free and efficient market system disappeared for three decades, during which the Communist government administered a centrally *planned economy* [jihua jingji]. Starting in 1958 with the Great Leap Forward, an extensive system of the People's Communes was set up in the countryside. Villages with small-scale peasant economies were converted into *production teams* [shengchan dui] in which all members shared public ownership, responsibilities and the benefits of production. The headline of an editorial in *Renmin Ribao (People's Daily)* on August 27, 1958 – *The bolder man is, the bigger the harvests will be* [ren you duo da dan, di you duo da chan] – quickly became a popular slogan. Consequently, all over the country *satellite fields* [weixing tian] suggesting skyrocketing agricultural production were proudly offered as evidence that the People's Communes were succeeding.

To better organize the rural labor force, *communal canteens* [renmin gongshe da shitang] were set up nationwide. Before 1949, temporary canteens had been operated during busy farming seasons, but this was the first time the private kitchen was completely abolished. There was a call for peasants to donate all their metal cooking utensils to the drive to *Make Steel in a Big Way* [dalian gangtie], because Mao Zedong aspired to surpass British and American steel production.

Guoyu Village, Shanxi Province

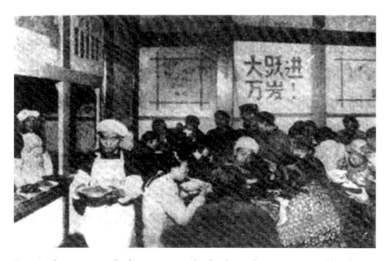

Even in the countryside, from 1949 on the food supply was managed by the state. During Mao's era, communal canteens and state-run *supply and marketing cooperatives* [gongxiaoshe] were the main distribution points where food was transported and provided. The *Great Leap Forward Soup*, a vegetable bouillon, for example, was a regular dish on the menus of many canteens.

Today, some people in the countryside still purchase their basic necessities either in the compact *mom-and-pop stores* or, less commonly, in the semi-privatized *gongxiaoshe* (Pictured). The product range has certainly expanded, but with little regional variation.

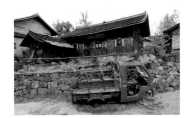

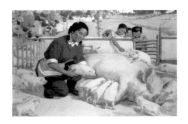

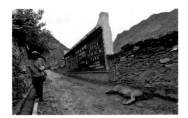

The government's policy towards the countryside has gradually shifted from labor-intensive agricultural development to technology-reliant production in rural areas. This shift has come at the price of recurring food scandals in recent years. Over the years, rural agricultural developments have tended to disappoint those whose optimistic hopes and dreams were encouraged by posters of jubilant peasants.

China's vanishing worlds also contain traces of an abandoned socialist economic policy: The system of the People's Communes was officially disbanded in the early 1980s. Many of these former public buildings are either deserted or used as local factories, while others are now occupied by *village committees*.

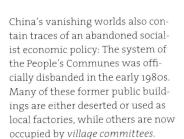

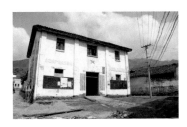

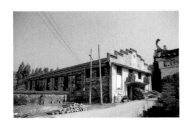

The communal dining system of *food for everyone* [daguofan] replaced the conventional family kitchen, freeing many women to enter the labor force. At that time, more than 3.5-million communal canteens were set up to feed 90 percent of the nation's peasants.

Open your belly and eat as much as you can [fangkai dupi chibao fan] became a widely proclaimed slogan to promote the system. However, this aspiration soon proved impractical and wasteful. Despite the goal to *let everyone eat freely, enough and well* [chifan bu yao qian], the government resorted to pseudo-scientific *methods to increase edible grain and substitute food* [liangshi shiyong zengliang fa] in attempts to expand the inadequate food supply. Nevertheless, according to scholars, between 30- and 45-million people starved to death in the years from 1958 to 1961 in the *Great Chinese Famine* [san nian ziran zaihai, literally *Three Years of Natural Disasters*]. In the early 1960s, the communal canteens largely disappeared, although the system of production teams and People's Communes survived until the early 1980s, when the government partially restored the traditional rural market system. Today, outdoor markets are usually held on designated dates at three-, five- or seven-day intervals, depending on local conditions and customs. Because it offers peasants, above all in remote, isolated villages, the possibility to shop for most of their daily needs, *going to the market* [ganji] is an important activity, particularly for women and children.

However, not only the socio-cultural customs associated with food, but also people's attitudes toward food production have changed in recent years. Before industrialization, farmers still practiced the same farming methods their ancestors had employed for centuries, relying on natural pesticides, livestock manure for fertilizer and cold underground caves and tunnels for storage. In any event, they had no need to worry about factories discharging contaminated liquid waste and gases near fields. As the harvests of many crops have increased tenfold since the 1970s, problems of food safety and sanitation have also increased, although they have been ignored as the nation has concentrated its energies on economic development. A more urgent concern has been to utilize the limited available farmland to feed the nation: Today, China's arable land constitutes less than 15 percent of its territory.

Corrupt local governments have tolerated the distribution of contaminated food and the concealment of unsanitary practices. Before the Internet era, food poisoning was a local problem, and it was easier for interested parties to suppress media reports. The online expression of public opinion and less controlled information exchanges have put pressure on local governments and industries to address these problems more openly. After recurrent food scandals – milk powder contaminated with melanin or nitrite, leeks soaked with deadly pesticides and garlic irradiated for a longer storage life, to name just a few – the public has begun to regard food differently. As a direct result, current farming practices are becoming controversial. On the one hand, there are reports of farmers refusing to consume their own produce due to the contamination of irrigation canals with toxic waste discharged by nearby factories. On the other hand, a small but committed group of farmers (encouraged mainly by NGOs) has begun advocating organic farming and environmental protection on a community basis. Recently these groups have begun experimenting with chemical-free agriculture.

Besides the issue of food safety, water supplies pose an even more urgent environmental challenge. Desertification is a serious problem in many parts of rural China for reasons that are complicated, historical and mostly man made. In the course of centuries of farming along the Yellow River, farmers mismanaged and exhausted the fertile Loess Plateau, once a rich patchwork of meadow steppes and occasional forests. The situation deteriorated even more when the government began to implement aggressive agricultural plans in the 1960s and made them the benchmark for agricultural production. Peasants were encouraged to cut down trees, convert

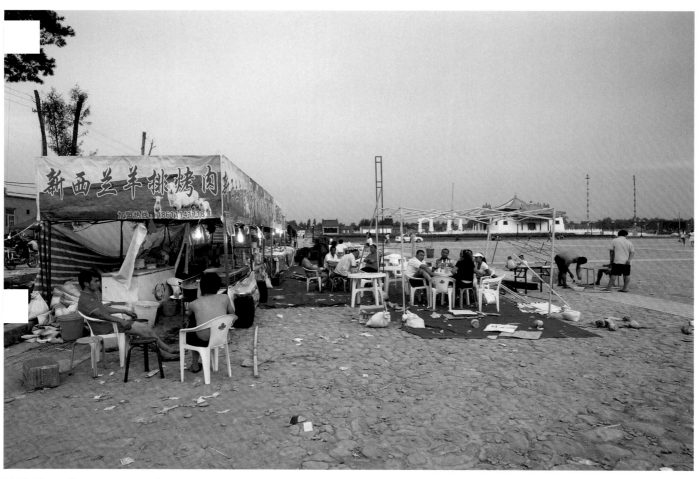

Meidaizhao Village, Inner Mongolia Autonomous Region

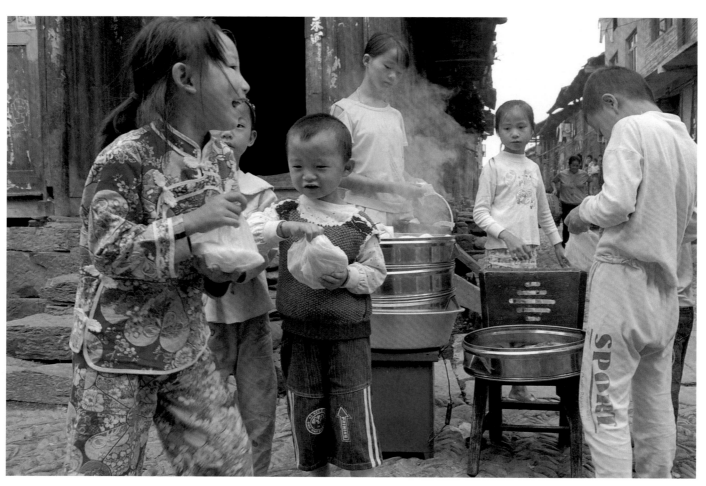

Longli Old Town, Guizhou Province

grasslands into fields and fill in marshes to create more crop-land. Due to excessive logging, over-farming, overgrazing and wasteful water use, desertification has been spreading in the western and northern regions. As a result, severe soil erosion is imperiling the ecosystem and agriculture. In the spring, sand-storms have become regular occurrences in the northern prov-inces and in neighboring countries, including Korea and Japan.

Although the total area of available cropland increased during the Dazhai movement, many farming regions suffer from poor or even ruined harvests caused by recurring severe droughts in the northern provinces or dry spells alternating with floods in the southwest. Consequently, besides its eco-nomic focus, the *Great Western Development Strategy* [xibu dakaifa], launched in 2000, also seeks to reduce over-farm-ing and over-grazing on land in once culturally significant re-gions covering more than 70 percent of China's territory. Al-ready since the early 1990s, the World Bank has supported the 'Loess Plateau Watershed Rehabilitation Project,' which pro-motes sustainable farming and settlement in that area. The authorities are advising many farmers to make more rational

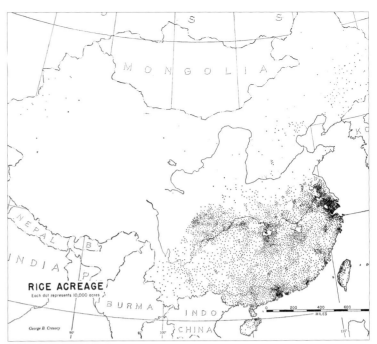

use of land. After more than fifteen years, the project has had at least modest success in protect-ing the environment.

According to studies, about 240 million people in China's rural areas and western regions have only limited access to safe drinking water. A combination of man-made and natural water contamination has exacerbated the regional disparities in water resources between north and south, west and east. The pollution of water supplies is due in part to agricultural chemicals, but mainly to industrial activities. The factories that have sprung up in rural areas since the econom-ic reforms have increased the GDP and the tax revenues of local governments, but they have also

China is by far the largest rice pro-ducer and consumer in the world: 95 percent of all the rice on the Chi-nese market is produced domesti-cally. But, compared to this map from the Republican era (1911–1949), the future prospects are discour-aging, given the shrinking arable land and the increasing popula-tion. However, most observers be-lieve that water rather than land is the actual limiting factor in China's capacity to meet its food-security needs. In any case, in China, which was once proud of its grain self-sufficiency, rice imports in the first half of 2010 were 44.3 percent high-er than in the preceding year. Lest-er Brown thus provocatively asks, "Can the United States Feed China?"

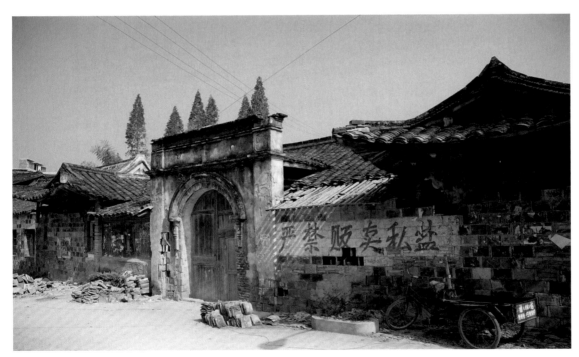

Salt has been a state monopoly in China for more than 2,000 years. Along with tobacco, it is one of the few state-mo-nopoly sectors today. The enormous profits of the salt industry inevitably attract people to risk illegally producing salt. While local government offices are busy stopping illegal producers from stealing their business (The slogan in the photo proclaims "Selling privately produced salt is strictly forbidden"), the central government has to deal with a different salt issue. Iodine deficiency was once a widespread problem in China's interior. In the early 1990s, the government decided that more than 700-million people suffered from a lack of dietary iodine and launched a campaign to solve this problem by iodizing salt. While slogans and posters from this campaign can often be seen in the countryside, the government re-cently concluded that today the problem of iodine over-consumption actually poses a greater health threat.

caused severe water and air pollution. The consequences of environmental pollution may only become known to the public after many years or even decades, but impoverished farmers and fishermen are already suffering from the destructive effects of the failure to correct environmental problems: Fish have disappeared from lakes and rivers, crops have withered, and farmers themselves have contracted health conditions ranging from diarrhea to cancer. Heightened stress and despondency are causing a rise in mental illness and suicides among rural peasants. Whereas in Western countries urban and rural suicide rates are roughly equal, in China the rural suicide rate is three times higher than the urban rate.

In recent decades, cultural landscapes have also been severely damaged by mega-projects legitimated by the principle that *man will triumph over nature* [ren ding sheng tian], which the Communist Party proclaimed during the Cultural Revolution and which still informs central-government planning. The construction of the world's largest hydroelectric project, the Three Gorges Dam, is China's answer to recurring annual floods. However, to make way for the project the government has relocated 1.4-million people, and the numbers will further increase to about four

million in the coming decade. Among them, the most severely affected persons live in rural communities that still practice ancient ways of life in the mountains along the fertile Yangtze River. In 2011, two years after its completion, the Chinese government acknowledged the urgent geological, ecological and social problems caused by the dam, as well as its negative impact on downstream water supplies. Despite endless debates on the Three Gorges Dam, the government is planning more large-scale water impoundment and diversion projects, including the *South-North Water Transfer Project* [nan shui bei diao gongcheng] and the *Bohai-Xinjiang Water Project* [hai shui xi diao, yin bo ru xin].

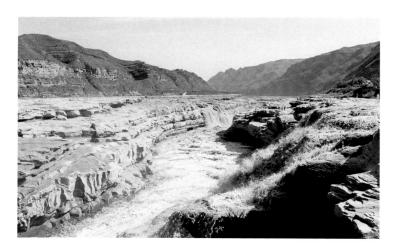

Not only does water pollution pose health risks for the rural population, a deficient health-insurance system prevents peasants from obtaining proper medical care. In the 1950s, China set up a *barefoot doctors* [chijiao yisheng] system to provide medical care to rural communities, but it was staffed with poorly trained or self-educated peasants and rusticated *urban youth*. This system peaked in the 1960s and 1970s, when such medical practitioners provided care at affordable prices. Although often highly regarded by villagers, the payment of these barefoot doctors, like that of farm laborers, was calculated in terms of the so-called *work points* [gongfen] used in People's Communes. Some claim that the system made a significant contribution to health care in the vast neglected countryside, while others insist that the limited skills and obsolete equipment of these practitioners posed health hazards.

Modernization and the economic boom did not bestow the benefits of improved medical services on the rural popula-

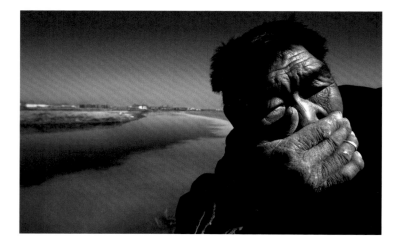

China's two biggest waterways, the Yangtze and the Yellow Rivers, have been heavily polluted since the Opening-up. The 2006 award-winning photo by the photographer Lu Guang (Picture bottom: A sheepherder along the bank of the Yellow River cannot bear the stench from the third sewage. Ningxia Hui Autonomous Region) speaks for itself. While according to Chinese statistics, heavy flooding has so far been better controlled since the construction of the Three Gorges Dam, extensive drought zones have caused problems in recent years. Besides ruining crops and threatening wildlife habitats, these droughts have also raised doubts about the feasibility of China's massive water-diversion ambitions. These are concerns that cause the government headaches, because in the long history of the country natural disasters have often been motors of social and political change.

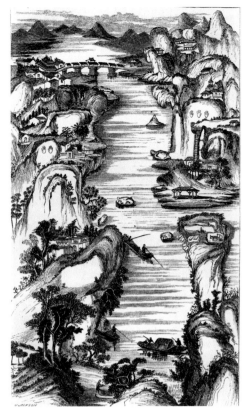

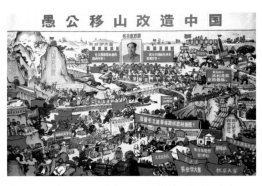

The main character of the Taoist fable *The Foolish Old Man Who Moved the Mountains Away* [Yugong Yishan] became a role model for Chinese peasants during the Cultural Revolution. This fable was interpreted to express the confidence that man can conquer nature at any cost, or, as Mao once said, "Make the high mountain bow its head; make the river yield its way." Although this spirit is no longer enthusiastically promoted by the government, it lives on in the nation's grandiose public-works projects.

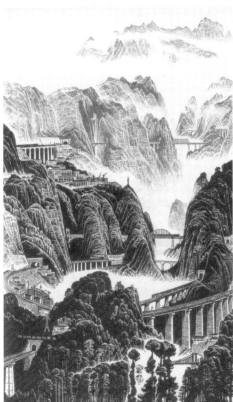

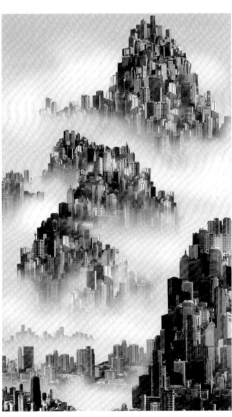

These four illustrations give an impression of how dramatically Chinese landscapes have changed over time – from the imperial epoch to the era of People's Communes, to the Opening-up and finally to the urbanization of the twenty-first century.

In this poster from 1964, people of various ethnic groups seem to be enthralled by the new hydroelectric power station on Xin'an River in Zhejiang Province, the first of its kind designed and constructed entirely by the Chinese themselves. Almost 300,000 people were relocated and more than a thousand villages were submerged after its completion. Later on, this Thousand Island Lake area became a famous tourist attraction.

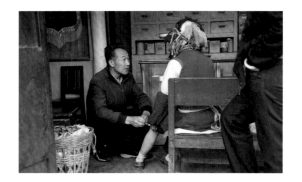

A 2009 governmental survey shows that almost 90 percent of China's rural population has signed up for the NRCMS. According to a 2003 governmental survey, each year more than ten-million rural residents become impoverished due to illness. A Chinese newspaper even estimated that 60 to 80 percent of the patients in the rural interior die at home because they cannot afford treatment in a hospital. In addition, the facilities and medical equipment of most rural clinics remain comparatively backward (Photo bottom middle: The public clinic in Hemu Village, Xinjiang; Photo bottom left: A private pharmacy in the county seat of Daming in Hebei Province; Photo left: A peasant receives an injection in a pharmacy in Shaxi Town, Yunnan Province). One-third of the health-care practitioners employed in public village clinics have no medical degree. Thus, it is still common for people in the countryside to seek help from quacks hawking nostrums in street markets and other charlatans.

tion. To the contrary, the privatization of the health-care system has made medical services too expensive for many farmers. An average medical bill could easily impoverish a rural household. Moreover, the rural-urban health-care gap has worsened, because the affluence of cities naturally attracts the best doctors. Furthermore, there are no adequately equipped clinics in the villages, and people have to travel long distances to reach an urban hospital. Consequently, country people often receive treatment too late. To solve this problem, in 2003 the Chinese government initiated the 'New Rural Cooperative Medical System' (NRCMS) to provide accessible and affordable quality health care for the 900-million rural Chinese. However, the average life expectancy of a rural inhabitant, which is as low as 65 years in less-developed regions, is still five years lower than that of an urban dweller.

Besides the issues of food, water and health care, rural communities are suffering most visibly from improper trash disposal. As China becomes increasingly developed, the side effects of rampant consumerism in the countryside are proving more deleterious than previously supposed. Disposable plastic bottles and bags have replaced conventional reusable containers, and people thoughtlessly discard used batteries and household trash without proper disposal. In rural areas, Chinese law provides only principles instead of specific regulations for environmental protection. Regional governments focus their budgets and energies on urban waste disposal and largely ignore the rural population's needs. In rural villages, we quickly recognize the glaring contrast between the twenty-first-century consumption of modern products and the nineteenth-century waste-disposal methods. Rural communities near cities may well be the ones most severely burdened by urban pollution, as municipalities simply collect urban refuse and dump it on the outskirts of cities. "There is modernized living indoors, while there is a dirty and messy environment outdoors. Polluted water vanishes through evaporation, and rubbish disappears with the wind," is a common description of the countryside, and unfortunately also a deplorable reality.

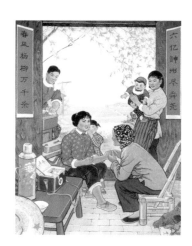

After Mao's complaint in 1965 that the Ministry of Health was serving only 15 percent of China's population and should be renamed the *Ministry of Health for Urban Lords* [chengshi laoye weishengbu], a series of medical reforms were instituted to improve rural health care. The common political attitude towards medical services at that time was reflected in the famous propaganda film *Chunmiao*. It tells the story of how, after seeing an elitist medical doctor neglect the needs of poor villagers, a young woman, Chunmiao, was inspired to become a barefoot doctor to serve her fellow villagers. This system disappeared with the dissolution of the People's Communes. Many barefoot doctors continued to practice on a private basis.

Unclean Food Makes You More Resistant to Illness in the Long Run [bu gan bu jing, chi le mei bing].

"When I cough or sneeze, I use a handkerchief. When I spit, I use a spittoon." (ca. 1950)

"Pay attention to hygiene and promote agricultural production. Eliminate pests and diseases to ensure people's health." (1963)

"Declare War against SARS!" (2003)

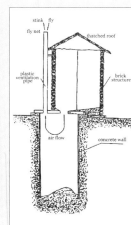

As this often-heard saying in the title implies, some Chinese even defend lower hygienic standards. Consequently, personal hygiene has always been a top priority for Chinese leaders when promoting a strong nation with a healthy population. Already Sun Yat-sen held that as long as the Chinese "lacked personal culture," they would not be respected by foreigners. The regular use of toothbrushes was not and is still not common for many. The founder of the Chinese Republic even had to criticize the commonplace habits of publicly spitting and farting at will.

Hygienic measures have been strengthened since the founding of the PRC. In the 1950s, the *Patriotic Sanitation Movement* focused on eradicating disease, followed by the movement to eliminate the four pests during the Great Leap Forward. Good health was identified with building a strong socialist country. In the 1980s, personal hygiene was equated with 'having culture.' "Keeping one's things and oneself clean" was a widespread slogan at the time. Well into the 1990s and beyond, posters of children washing their hands were a favorite means of encouraging *socialist spiritual civilization* [shehuizhuyi jingshen wenming].

Calls for personal hygiene, relatively distinct from political agendas, have continued. While they are in principle aimed at the whole population, most hygiene campaigns are conducted in urban areas. The government obviously has other priorities in its political education program for 'uneducated' farmers and peasants. Only propaganda for good dental hygiene seems to be intensive in the countryside, although mostly in strongly Muslim areas.

In the last ten years, the government has advocated the use of so-called *sanitary latrines* [weisheng cesuo] in the countryside. Contrary to what the name might suggest, sanitary latrines are still largely based on the principle of dry latrines (Pictured top right). The majority of rural households still use traditional pit toilets. In recent years, these have been blamed for the spread of foot-and-mouth disease, a disease of farm animals, in southern China. The improvement of latrine hygiene in rural areas remains a major public-health issue.

AIDS in the Countryside – Blood Debts

China reported its first AIDS cases in the late 1980s. These were found mostly among intravenous-drug users in China's southwest. In the 1990s, AIDS spread steadily from Yunnan Province into neighboring areas and along the major drug-trafficking routes (Sichuan Province, Guangxi Zhuang and Xinjiang Uyghur Autonomous Regions). During the mid-1990s, tens of thousands of farmers became infected with HIV, particularly in Henan Province, but also in Hubei, Anhui and Shaanxi Provinces. Some peasants in those rural areas sold their blood for small money to state-run blood banks, where contaminated equipment was

not sterilized before reuse. However, much of the current spread of HIV stems from the widespread prostitution now rampant in both urban and rural areas.

Most of China's HIV-positive individuals actually reside in the countryside. Despite governmental funds allocated to HIV prevention, medical personnel willing to work in rural areas do not have sufficient qualifications. Today, the number of HIV-infected persons has been estimated at between 450,000 and 1.5 million, and some estimates are much higher.

 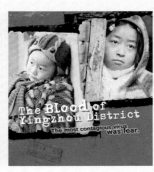 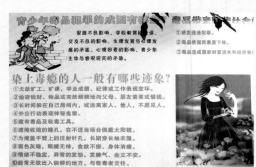

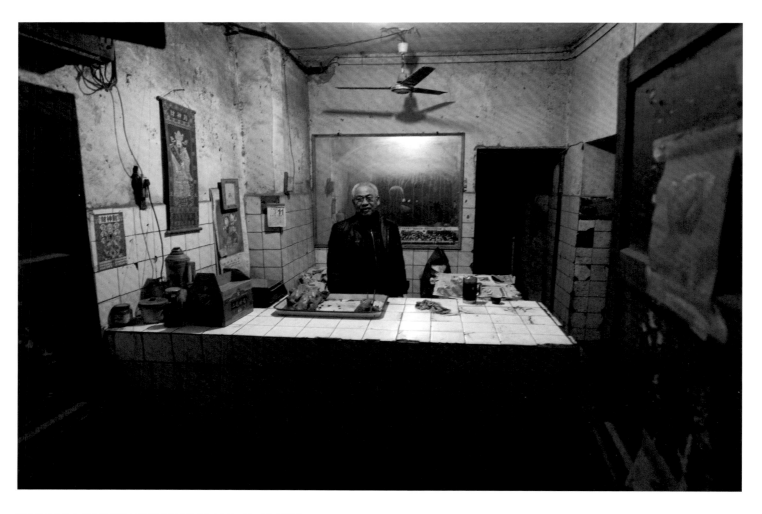

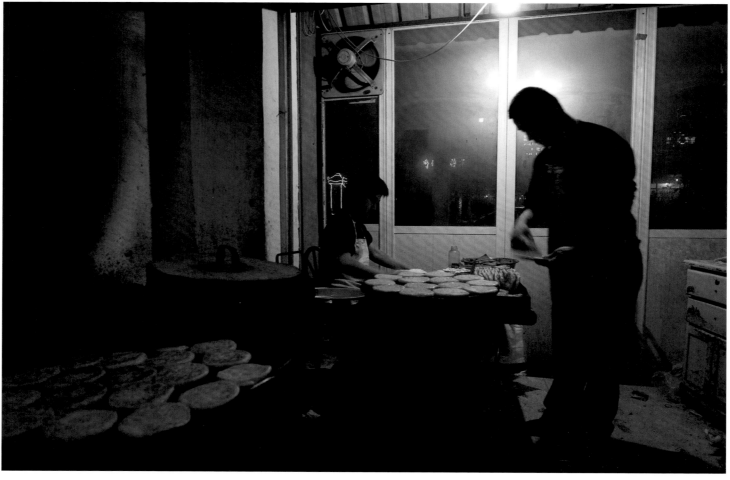

County Seat of Daming, Hebei Province

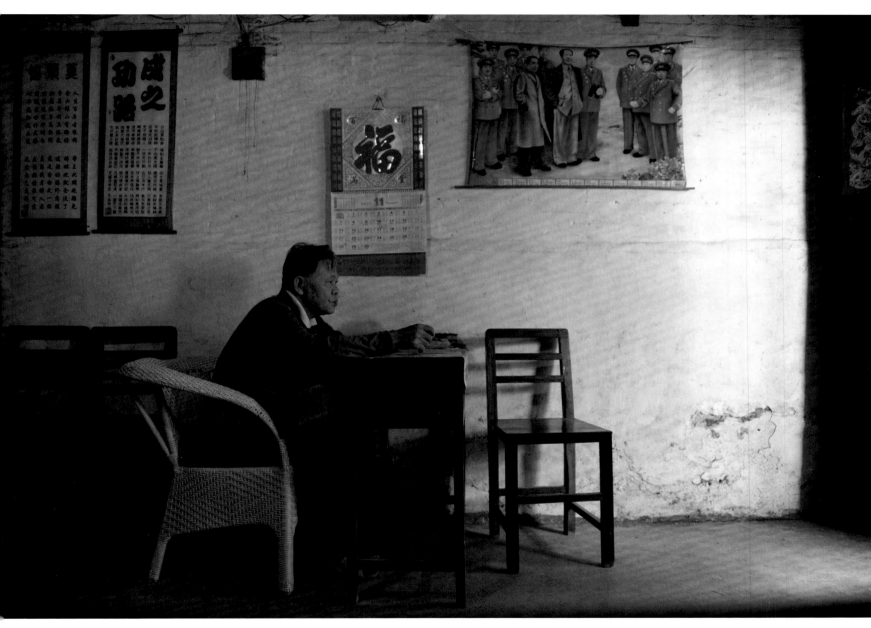

A Chinese medicine practitioner in his clinic,
Xincun Harbor, Hainan Province

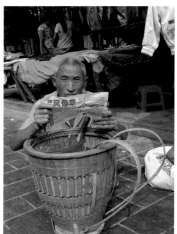

Chadong Town in western Hunan Province became well known in China during the 1930s through the nostalgic story *Border Town* [Biancheng] by the regional writer Shen Congwen. The westernmost part of Hunan used to be bitterly poor and was mainly inhabited by the Miao. For many centuries, this region was a stone in the shoe of the Chinese Empire politically and militarily. During the warlord period (1916–1928), the government called it a *region of bandits* [feiqu] because of its many criminals and warlords. One of the more famous was the Miao chieftain Long Yunfei, who had initially worked for a local warlord in opposition to the government. During the Sino-Japanese War, he devoted all his energies to fighting the Japanese, but he never won Chiang Kai-shek's trust. When western Hunan fell to the People's Liberation Army (PLA), he refused to cooperate and ended his legendary life by suicide. The Communists hung his head on the city wall of nearby Fenghuang Old Town as a warning to potential rebels.

In this Miao settlement, a town market is held nine times a month. Geese are a specialty here. Poultry dealers not only sell goslings and geese, but also offer on-site slaughter services. Vegetables, livestock, snacks, medicines, clothes, books, household appliances and spiritual services are all available. Visiting the market is a memorable experience for all the senses: Sight, smell, hearing, taste and touch. On market days, local people from neighboring villages and towns arrive in all sorts of vehicles.

In the past, the Miao visited the market not only to go shopping, but also because it served a special social function for youth. This so-called *bianbianchang* gave young boys and girls a chance to meet and develop romantic relationships with persons of their own choosing. It was socially acceptable for young couples to marry only after the girl became pregnant. This tradition has been abandoned, as most young people today work as migrants in distant places. Chadong has meanwhile become more assimilated by the Han Chinese, as is most apparent in the widespread use of conventional modern clothing.

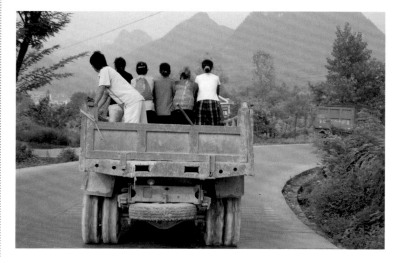

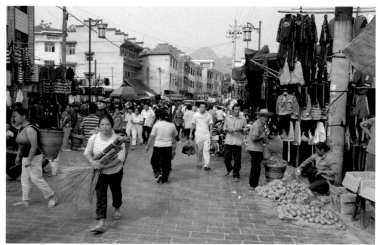

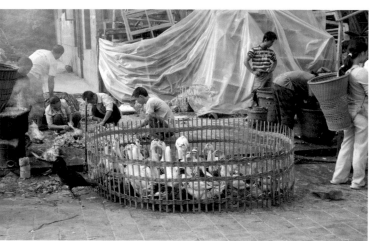

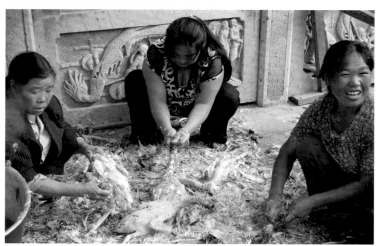

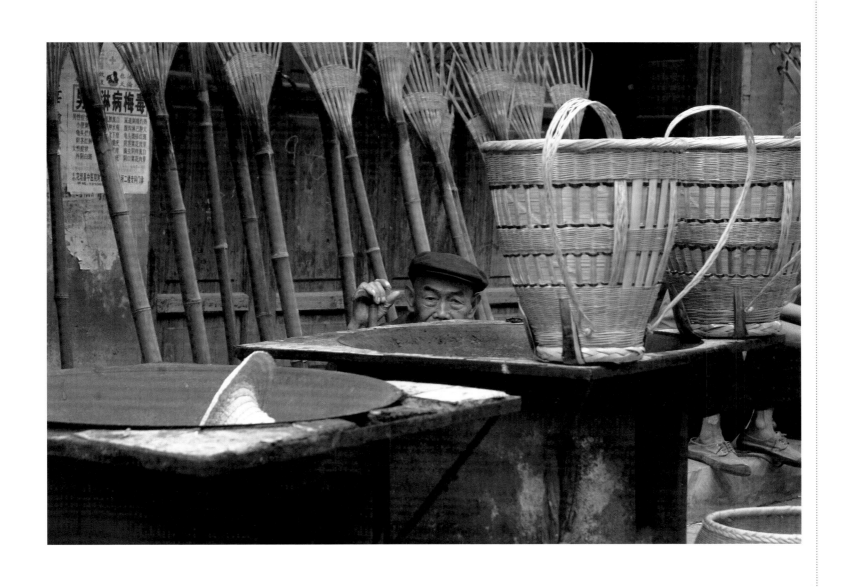

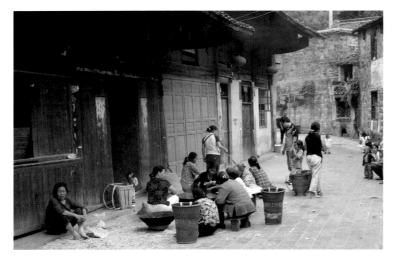

For centuries, the Miao have been considered a spiritual and mysterious minority. Western Hunan Province was famous for *stiff jumping corpses* [jiangshi] that prowl about the region at night and kill living creatures to suck out their life-giving essence. In addition, the Han Chinese believed the Miao, especially the women, to be practitioners of *witchcraft using venomous insects* [gushu], which are abundant in this lush, hilly, humid area. Stories were widespread of Han Chinese travelers being tortured or succumbing to *gu*-related diseases after abandoning their Miao lovers. Lonely elderly Miao women were often suspected of employing sorcery against innocent victims. However, in ancient times such accusations were more likely to be mere superstition and due to a lack of scientific explanations for diseases.

Some traditional rituals have been revived in recent decades. On market days, mothers often bring their toddlers to elderly women who perform blessing rituals using eggs specially prepared in big iron pans in quiet alleys. In addition, a few stands specializing in more alternative services such as 'scientific fortune-telling,' hand electrotherapy on acupuncture points, wart removal or tooth repair create a colorful spectacle.

Market activities reach their climax toward noon. A few people who have bought or sold what they had come for pause for a bite at small market refreshment stands, while most other visitors rush to crowded mini-trucks for a ride back home to their remote villages. A traffic jam that blocks the only exit from Chadong occurs after every market day.

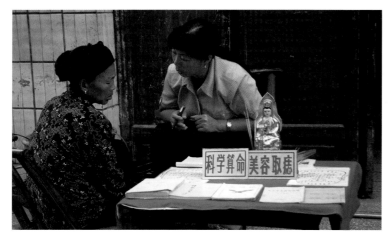

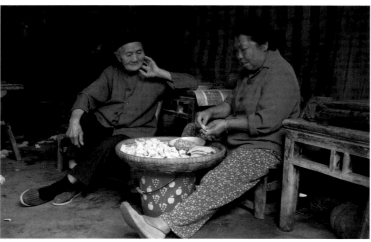

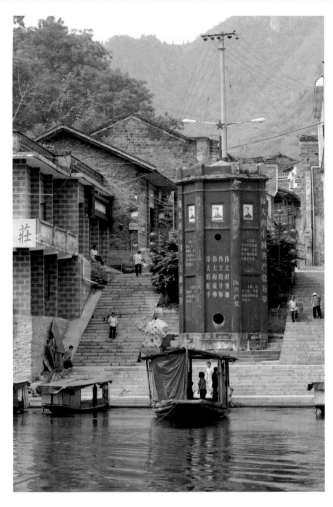

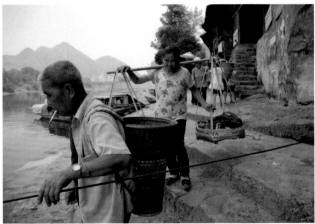

Shen Congwen (1902–1988), the most famous son of this region, was born into an officer's family in Fenghuang, Hunan Province. After a few years of travel with a regional militia, during which Shen personally experienced hunger and hardship, he moved to Beijing, where he wrote his first stories. Because of his limited formal education – Shen himself referred to the colorfulness of everyday expressions as the best school of life – and because of his pride in being a son of the Miao and Tujia ethnic minorities, he was regarded as the most conspicuous modern Chinese author of that epoch.

The recourse to *native-soil literature* [xiangtu wenxue] was a special concern for Shen. He saw in it a way for his country to find its own national roots. In his writings, he revived long-forgotten customs and practices, fairytales, religious myths and stories that were doomed to disappear in the course of China's development. Contrary to Confucian values, the unabashed sexuality practiced by ethnic-minority group members, the shamanism that officials dismissed as superstition, or the *Miao witches* [gupo] were among the themes that Shen often drew on.

In his story *Border Town*, the description of Youshui River gives a vivid impression of the local people's daily lives:

> The creek thus also resembles a crescent, and the mountain path that somewhat shortens the way, its sinews. Boulders form an approximately six-meter-wide creek bed. The water calmly flowing along it is in some places so deep that one cannot touch bottom with a stick, and yet so bright and clear that one can count the individual fishes in it. The water level varies considerably, however. Since there was no money for a bridge, a ferry service was set up. The ferry takes people and horses; it carries over about twenty at a time, and if more come, it has to go across again. A movable iron ring is attached to a bamboo peg on the bow of the boat, and a rope is stretched across the little river. If someone wants to get across, he merely has to hang the ring on the rope and slowly pull the boat to the other side with his hands.

Today, the same rope ferry still carries people back and forth between Chadong and the village on the bank of Chongqing Municipality, where a great red wooden propaganda pillar stands.

After the founding of the PRC, Shen was treated as an enemy by the Communists and fiercely denounced. He survived three suicide attempts and had to give up his career as an author forever. After the Cultural Revolution, he was admittedly rehabilitated, but the government never gave him the honors they bestowed on regime-loyal authors such as Guo Moruo or Mao Dun. Twice, however, Shen Congwen, also called 'China's William Faulkner,' was considered for the Nobel Prize in Literature. Only in the last few years has this outsider among modern Chinese authors enjoyed recognition in his own country, after many of his texts were first reintroduced from abroad.

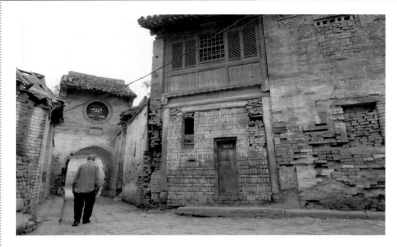

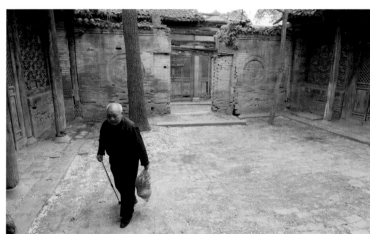

Dayang Old Town in Shanxi Province is rich in coal and iron mines. Its iron-making industry reached a first peak during the early Ming Dynasty (1368–1644). Iron was mainly used to manufacture steel needles. Dayang needles constituted the largest market share in northern China in the seventeenth century and were shipped to places as far away as Mongolia. This sideline work also made possible the survival of numerous families in the area during turbulent times. As the development of the iron industry became even more vigorous in the eighteenth century, the exploitation of iron mines in the hills got out of control. Due to concerns about damaging the *fengshui*, many people pleaded with the government for intervention. An official ban was placed on mining, and several mines were closed – an example of environmental protection based on an ancient philosophy. Dayang needles faced their first serious competition when machine-made needles were imported from the West to China after the Opium War in the mid-nineteenth century, and the Dayang needle industry's decline dates from this time.

The main structure of this comparatively intact old town, with its narrow lanes, courtyard houses and arched gateways with *attic temples* [ge], has not been heavily damaged, although much detailed restoration work would be needed to bring back its past splendor. Moreover, most of the temples either were demolished or are no longer used for religious purposes. For instance, legendary Emperor Tang's Temple in eastern Dayang, built in the tenth century, was replaced by a socialist-style office building. The present-day economy in Dayang Town depends mainly on its coal mines. There is a special railway built only to transport coal from the mines to the factory.

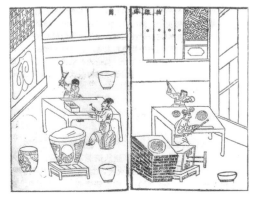

The art of making needles: At the peak of Dayang's needle production, almost every family in the town was involved in this industry.

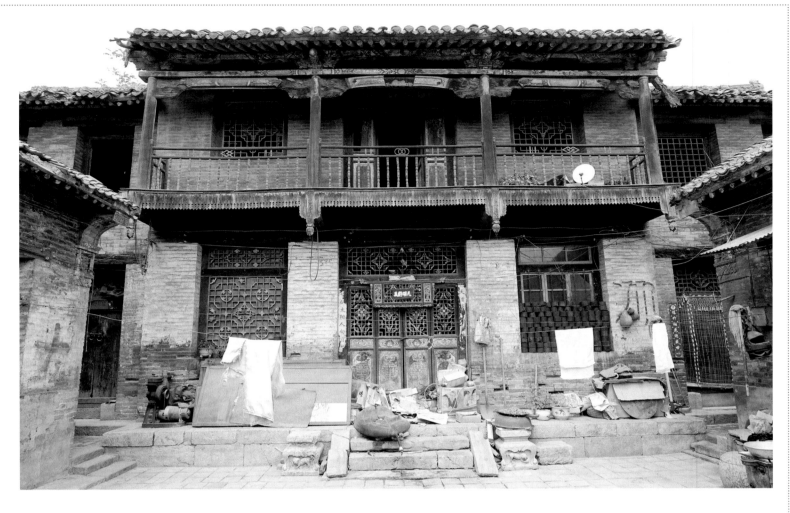

In the late 1950s, the villages under Dayang Town were renamed and divided into six *production teams* in the system of the People's Communes. The production teams were numbered from one to six and had their own farmland, factories and offices. The courtyard house of the Chang family, for example, was confiscated, and the new rulers added a triangular peak with a red star over the main gate. Its thirty-odd rooms were first designated as production-team offices and workshops and later allocated to various families. This house was built in the nineteenth century by a native official who had served as governor of Zhejiang Province, which is probably why he built a verandah terrace, a common architectural feature in that rainy coastal province.

In the mid-1980s, when the system of the People's Communes was abolished, the production teams were again replaced by villages. What remains from that period amounts to a few Communist symbols and deserted workshops. The Chang courtyard house is still home to numerous families, but parts of it are uninhabited and are slowly decaying.

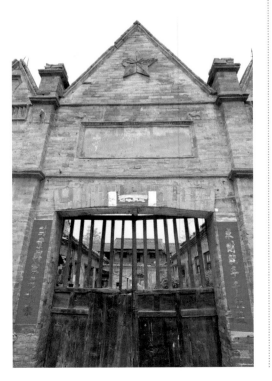

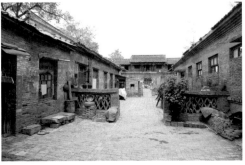

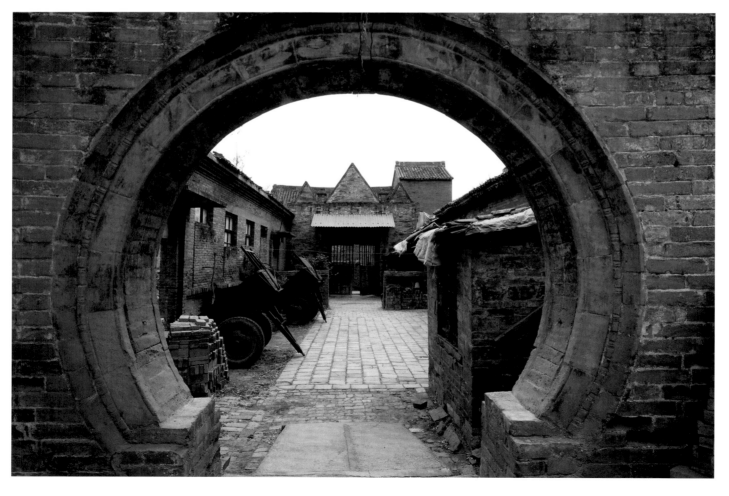

Before 1949, more than thirty temples and sixteen theater stages dotted the area around Dayang. Take the *Guandi* Temple in the eastern part of Dayang Old Town as an example: Its main buildings were built during the Yuan Dynasty (1271–1368), and in the eighteenth century a theater stage was added by the local needle-makers' guild. After the Communists came to power, the statues of deities were all removed. The temple was first used by the state-run *supply and marketing cooperative,* and later as the office of the local People's Commune. In the 1980s, a market with shops was set up in this compound, but it was later closed due to unprofitability. The shop signboards and a billiard table are still scattered around in this once-important temple.

Since Dayang Old Town was designated a national-level historical town in 2008, some restoration work has taken place here. However, it seems that the local officials have not agreed on how to put this temple back in order. The mixture of objects from different periods serves as a vivid illustration of the ups and downs in China's modern history. Another landmark in Dayang is the newly restored old theater stage. Ironically, the socialist-style theater stage with the famous slogan *Let a hundred flowers blossom, pull up the weeds of the old to bring forth the new* [bai hua qi fang, tui chen chu xin] is somewhat rundown and nobody seems to show any interest in it.

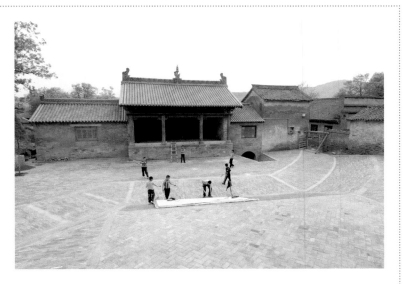

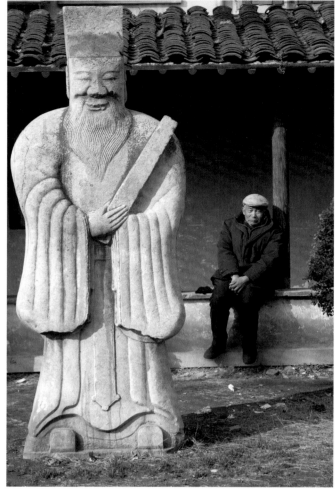

Jiangnan, literally 'South of the Yangtze River,' is the classical name given to the historically and culturally important region encompassing Shanghai Municipality and southern Jiangsu, southern Anhui, northern Jiangxi and Zhejiang Provinces. This area was famous for its dense network of waterways, idyllic landscapes, cultural refinement and exquisite cuisine. The towns and villages in Jiangnan developed a unique lifestyle that was closely linked with water, and the area is therefore called the Oriental Venice. With rapid urbanization, many waterways have been paved over to build roads.

Thanks to its mild, temperate climate, Jiangnan became an economically prominent region as early as the second century. Besides rice cultivation and fishing, the area was renowned for profit-bringing goods such as tea, fruits and silk. Its convenient water transportation – the Grand Canal to the north, the Yangtze to the west and the seaports to the outside world – made possible an extended trading network for these items. Later, several kingdoms and dynasties established their capitals in this area. Many Chinese elites moved here during periods of turmoil in northern China. These political factors further stimulated cultural development in this region. During the Republican era (1911–1949), the introduction of modern printing facilities and the relative freedom of speech encouraged the development of a local newspaper industry. The elites and rich families in Zhujiajiao Town, for instance, founded more than thirty newspapers, all of which had ceased publication by 1950.

Numerous water towns have become popular tourist destinations in the last decade. Unfortunately, tourism and commercialism have had very negative impacts in most places, which consequently disappoint travelers in search of bygone traditional and rustic lifestyles. In less famous old towns like Tongli and Luzhi, although the main streets, packed with shops, are overrun by crowds on weekends, visitors can still discover remnants of traditional daily life in the narrow side alleys. Waterside tea houses run by local families offer a perfect break from the summer heat.

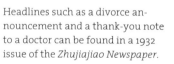

Headlines such as a divorce announcement and a thank-you note to a doctor can be found in a 1932 issue of the *Zhujiajiao Newspaper.*

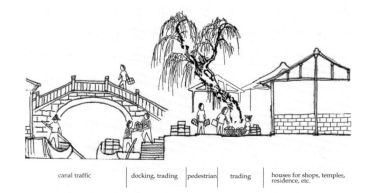

| canal traffic | docking, trading | pedestrian | trading | houses for shops, temples, residence, etc. |

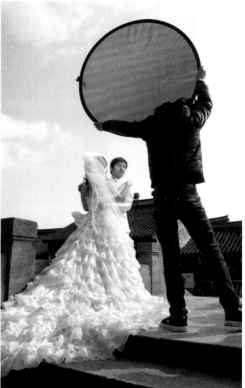

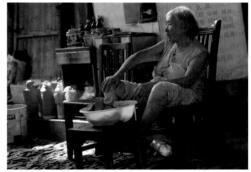

The Jiangnan region is also called the Wu-speaking area. The Wu language is one of the major languages of China. Wu culture extends well beyond the language, including the renowned *Kunqu* Opera and the *Pingtan*, a form of traditional Chinese storytelling and singing. In recent years, *Kunqu* operas performed in a traditional garden in Zhujiajiao have revitalized the arts and aesthetics of the past.

Today the lifestyles of these waterside towns are definitely a mixture of the old and the new. Children still play along the waterways, and people sell freshly picked lotus seeds in the alleys. The unique traditional method of harvesting water chestnuts (illustrated) can still be seen in a few places, although nowadays many farmers tend to harvest them by wading into shallow water wearing a waterproof rubber suit. Local specialties such as various kinds of pastries and braised pork hoofs are produced in bulk, sold mostly to tourists.

Local governments promote tourism as a business without rational planning or wise preservation of folk cultures and traditions. These water towns have served as ideal backdrops for numerous TV dramas, films and even wedding photos, while the traditional lifestyles behind their façades are rapidly disappearing.

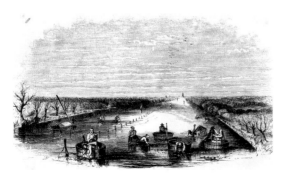

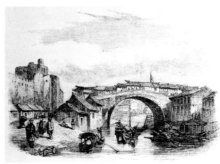

A waterway flowing under a beautiful arched bridge leading into the town of Chinkiangfu (Zhenjiang, Jiangsu Province) in 1842. Nobel Prize-winner Pearl Buck, the daughter of missionary parents, grew up here at the turn of the twentieth century. Today this important transportation hub has more than three-million residents and has become a booming industrial-development center. Most of the cities in the *Yangtze River Delta* [Changjiang sanjiaozhou], e.g., Wuxi and Yangzhou, share the same fate.

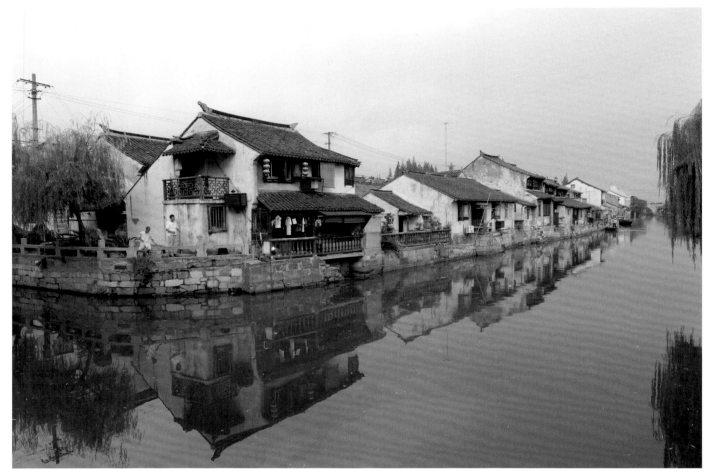

Fengjing Old Town, Shanghai Municipality

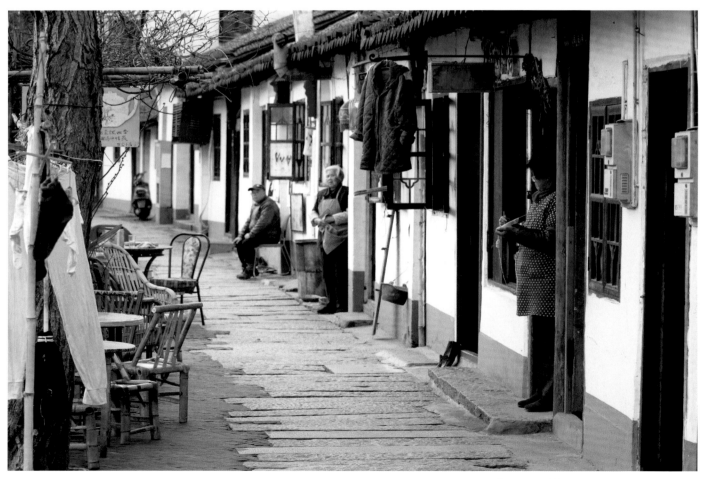

Zhujiajiao Old Town, Shanghai Municipality

In imperial times, *Sanshan Island* in Taihu Lake was famous for its curiously shaped rocks. These stones were once very much favored by wealthy Chinese to create decorative artificial hills in their gardens. For instance, to build the garden of the Summer Palace, *Yiheyuan*, in Beijing, a hundred shiploads of stones were removed from Taihu Lake and transported to the north. In the late seventeenth century, more than 600 families lived on Sanshan Island. After the Opening-up, sideline production was added to the farming-and-fishing economy: Villagers experimented with breeding rabbits for their fur. When disease decimated the rabbit stocks nationwide, its isolated location brought Sanshan Island a windfall profit. New multi-storied houses were built. When the price of rabbit fur fell sharply in the early 1990s, several factories were set up on the island, producing glass, silk goods and metal components. However, they were eventually closed due to high transportation costs and the limited supply of electricity.

Sanshan Island acquired a public electricity supply only in 2000. Today, most residents of this one-village island are still farmers or fishermen. Some of them have opened guest houses offering bed and board to tourists. The many empty, boarded-up old houses attest to the fact that most young people have crossed the lake to find jobs in the more prosperous city of Suzhou.

In 2007, a vast algae bloom spread over Taihu Lake and caused a water crisis for 30-million people in the surrounding areas. Over the last two decades, Jiangsu Province has become a hotbed of industry and commerce. The Taihu Lake basin, which accounts for less than 0.4 percent of the nation's land, produces around 20 percent of the nation's GDP. The discharge of industrial effluent from numerous factories has been going on for a long time, but it took the algae crisis to ring the first alarm bell for environmental protection. A great volume of water was diverted from the Yangtze River to relieve the disaster.

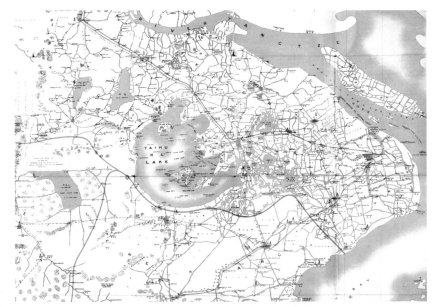

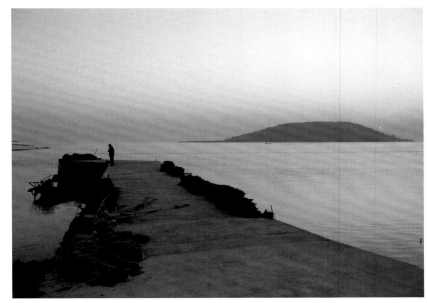

A map of the Yangtze River Delta with the Taihu Lake arounded 1900

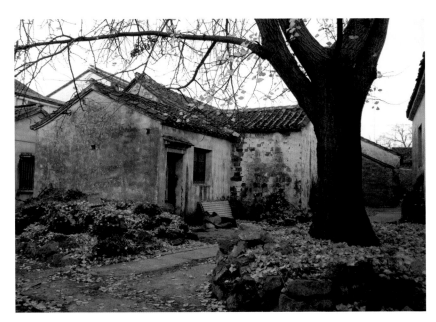

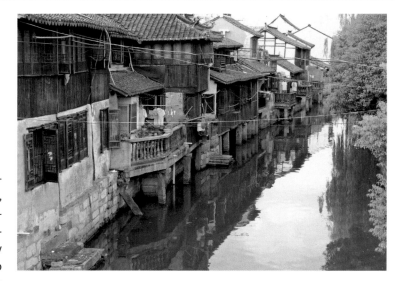

For many centuries, villagers in the Jiangnan region had a tradition of making hand-made embroidery, painting kitchen stoves, dyeing blue calico and making paper cuttings and lacquer paintings. During the Cultural Revolution, when some renowned artists from Shanghai were sent to *Fengjing* in Jinshan County (now a district of Shanghai Municipality), the local farmers were so inspired by the new ideas introduced by these artists that they began to experiment with a new genre of painting. Thus, local artists began to produce paintings of rural motifs in a naïve folk style called Jinshan Farmers' Painting. They integrate techniques from traditional folk arts and crafts into their paintings. The pictures illustrate the colorful lifestyles of the waterside towns, including farming, leisure-time activities and festivals. Although the over-commercialization of this art genre negatively influences its authenticity, this is not the worst problem. As the region becomes more affluent and more farmer-artists leave the countryside for urban areas, many people are concerned that such paintings may finally disappear.

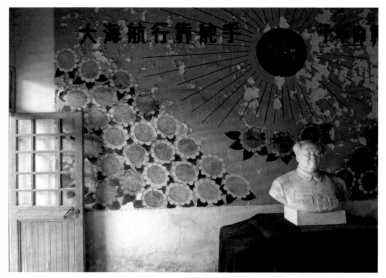

The old town of Fengjing is a less-frequented waterside settlement where noble ancient houses repose in quiet dignity and the former People's Commune has been converted into a museum.

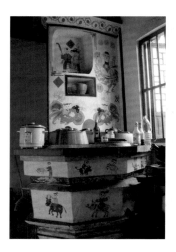

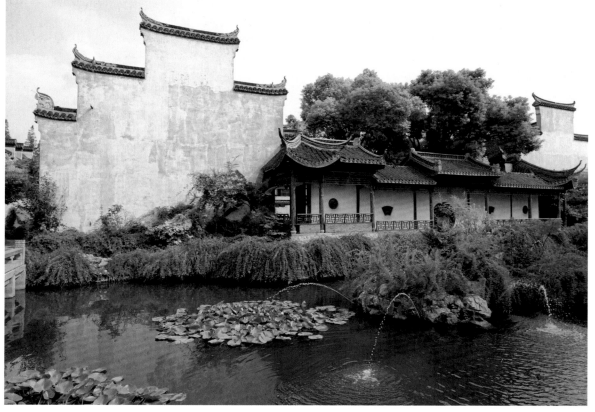

Jinze Old Town is another less-famous waterside town. A Buddhist temple was built here in the fifth century and soon attracted many believers. Thus, a marketplace gradually arose. When rebellions and political turmoil during the Tang (618–907) and Song Dynasties (960–1279) forced troops and a large number of refugees to flee to the Jiangnan area, Jinze grew into a larger settlement. The rich natural resources of this region soon enabled farmers and fishermen to do business and develop their culture. Jinze Old Town once boasted more than forty bridges from different dynasties. An old local saying, *Every bridge has a temple. Every temple has a bridge* [qiaoqiao you miao, miaomiao you qiao], describes a notable practice: It is said that the troops stationed here during the Three Kingdoms period (220–280) set up a temple near every bridge they built. This custom was passed on for centuries, as frequent floods often destroyed the bridges. However, most of the temples have been destroyed.

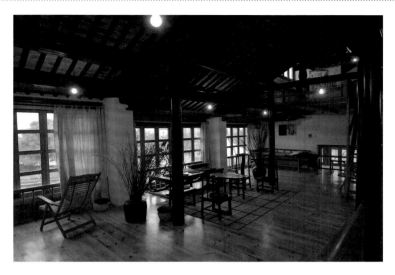

Today, a unique project aims at rebuilding the traditional Jiangnan lifestyle in Jinze. Part of the old town has already been restored by Chinese artists and art patrons. A few years ago, deserted factories built during the 1950s and 1960s were torn down and the area was returned to the original scheme of traditional dwellings. These two-story houses impress visitors with their unexpected modern interior furnishings and fixtures. Activities dedicated to traditional forms of culture occasionally take place here. This privately based project serves as one of the better examples of how to restore traditional Chinese architecture and aesthetics while providing modern comfort and convenience.

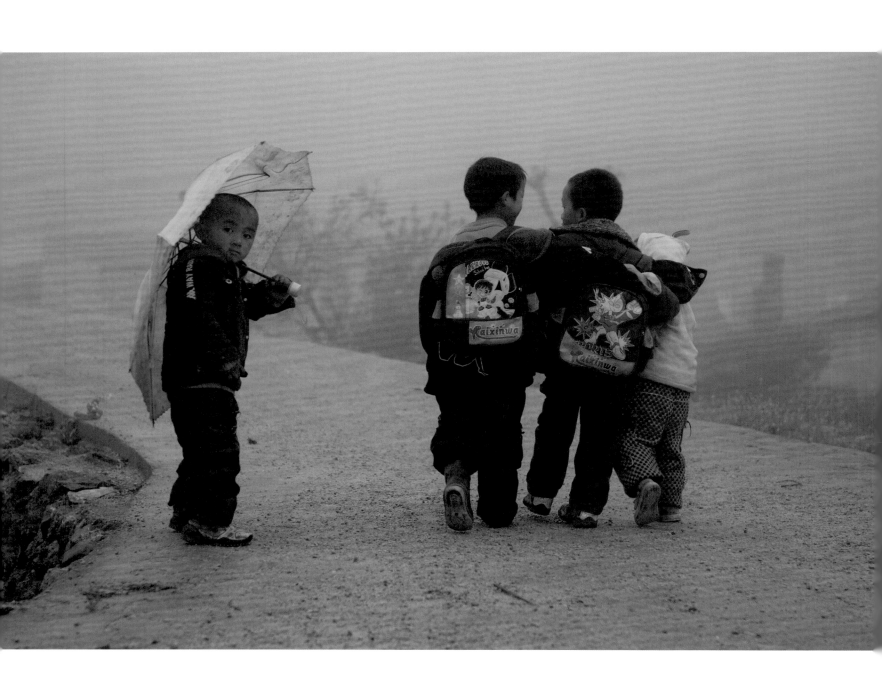

Qingman Miao Minority Village,
Guizhou Province

The *Twenty-four Filial Exemplars* [Ershisi Xiao] have been popular classic Confucian educational material for children since the fourteenth century. Confucianism was criticized during the May Fourth Movement in 1919 and later further denounced during the Cultural Revolution. These filial stories were then used only as negative examples. This illustration depicts the story of a man who tries to catch fish for his sick mother in the depths of winter. Today, only a very few young people have even heard of these stories.

Free Education for All?

*In rural areas, education is widely regarded
as the only way to escape poverty and the only means to
avoid an exhausting life of tilling the land.*

This is in principle true, but a governmental system with low transparency and barriers such as the *household-registration record* [hukou] and *social network* [guanxi] place an invisible ceiling over the upward mobility of the educated rural younger generation, making the reality much more complicated. Nevertheless, many rural parents support their children's studies with far greater effort than we might expect. Not all rural children benefit equally, however. In a popular TV drama, *New Marriage Time*, two sons from a rural family draw straws to decide which of them can go to college. This may overly dramatize the problem, but it is common for many rural children, willingly or reluctantly, to drop out of school at an early age to start work. When a typical family in a poor rural area has more than one child, gender and talent are often the key factors in deciding who will obtain an education.

Rural couples not only support their children, they must also provide for aged parents. This means that families must use their income to pay for many different expenses. The tuition for a primary-school child was about RMB 200 (US $25) per semester in 2005, and various incidental costs could easily double the expenditure. These expenses placed a heavy burden on rural families, whose annual net income per capita at that time was about RMB 3,000 (US $370). According to the latest official figures released in 2006, there are close to 600 *national-level poor counties* [guojiaji pinkunxian], mostly in the western provinces and in areas home to ethnic minorities. In the same year, the central government began to grant tuition and incidental fee waivers to primary and junior-high-school students in rural areas, but attending school is still beyond the

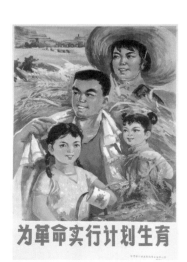

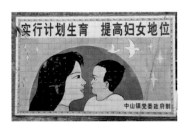

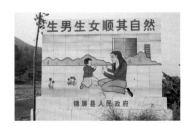

Since the one-child policy became a basic national program for population control in 1978, family planning has never been a passé topic, especially in rural areas. Colorful propaganda paintings are still widespread throughout the countryside. Although the National Population and Family Planning Commission claims that this policy prevented more than 400-million births from 1979 to 2011, there are differences among experts as to its effectiveness and consequences. In 2011, the 'Shaoyang Orphans' scandal over the 'confiscation' of babies from villagers by a local birth-control bureau in Hunan Province shocked the nation. Many of these infants were taken from their parents, and when the required social-maintenance fee was not paid, they were sent to the local orphanage for paid adoption abroad. The fees filled the local government's coffers and in some places even became their main source of revenue.

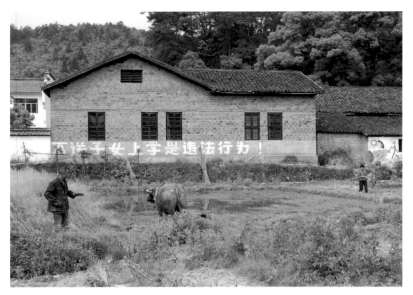

The white-painted slogan on the house façade says, "Not sending children to school is against the law!" In the 1986 educational reform, the National People's Congress instituted a nine-year period of compulsory education for all children. Since then, the central and local governments have launched a series of campaigns to improve school enrollment levels in the countryside. Painted slogans like this are still common in poorer rural areas (Photo: Wuyuan County, Jiangxi Province).

reach of many children in poverty-stricken areas. Furthermore, these waivers have exacerbated the financial problems of some local governments. They make it even more difficult for them to raise funds to pay teachers' salaries. Cash-strapped or corrupt officials have consequently introduced various supplementary fees. In some reported cases, students actually pay more under the new policy.

Unfortunately, some families simply need as many farm hands as possible. For this reason, the government has always enforced its *one-child policy* [jihua shengyu zhengce] less strictly in the countryside. It usually allows farm families to have a second child if their first is a girl. Members of ethnic minorities, who mainly reside in rural areas, are permitted to have even more children. This family-friendly policy, however, has had unforeseen consequences. Poor families see no choice but to force their daughters, who have a much lower status than sons, to drop out of school to help with farm work, household chores or the care of younger siblings.

China still spends less of its GDP on education than most OECD countries. Rural children are the most negatively affected and underprivileged group, especially girls, members of ethnic minorities and children from families living below the poverty line. According to a 2005 report by the Chinese Ministry of Education, 87-million Chinese were illiterate, a fourth of them school-aged and persons in their twenties or thirties. Most illiterate and under-educated persons and communities with inadequate educational systems are located in the poorer and more remote western parts of China. The socialist ideal of a 'free education for all' has shrunk to nine years of free compulsory education for all, and even this has not proved to be an easy promise to keep.

Compared to their counterparts in cities, children in rural areas usually have to travel longer distances to attend school. *Substitute teachers* [daike jiaoshi] lacking formal education and earning even less than migrant workers used to be pillars of basic education in the countryside. In the 1990s, there were more than three-million rural substitute teachers. However, the situation began to change toward the end of the twentieth century. The government has been steadily reducing the number of elementary schools, mainly on the village level, at a rate of 25,000 schools per year. Substitute teachers ended up on the scrapheap after years of dedicated and low-paid service.

There is a vicious circle here. On the one hand, the low budgets of village schools prevent them from employing *officially qualified teachers* [gongban jiaoshi], and the poor working and living conditions of these schools further discourage these teachers from accepting positions in them. On the other hand, the number of pupils in rural schools is declining, because better-off families are sending their children to schools in towns with better facilities and teachers. In addition, a few are following their parents and moving to cities. A decline of two-million pupils annually

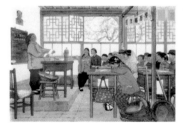

This illustration (Left) of a rural classroom in the 1970s is entitled "The glory of the red sun will shine on later generations forever." Mao's portrait is hung above a blackboard displaying the slogan "Chairman Mao is the great savior of the people." Today, schools throughout China may differ greatly in their facilities, but placards with quotations from important persons with a Communist background, e.g., Zhou Enlai, Lei Feng, Marx and Lenin, are a ubiquitous adornment. The Gutian Congress, specifically the ninth CCP congress in 1929, dismissed any democratic tendencies within the PLA. One of the resolutions pointed out that "the danger of ultra-democracy lies in the fact that it damages or even completely ruins the Party organization." This famous meeting appears as an illustration on a 2007 calendar (Right) distributed free of charge by the Fujian Provincial Government in rural areas. That education is still largely based on Communist ideology is a major obstacle to the slowly developing movement for grass-roots political reform in rural China.

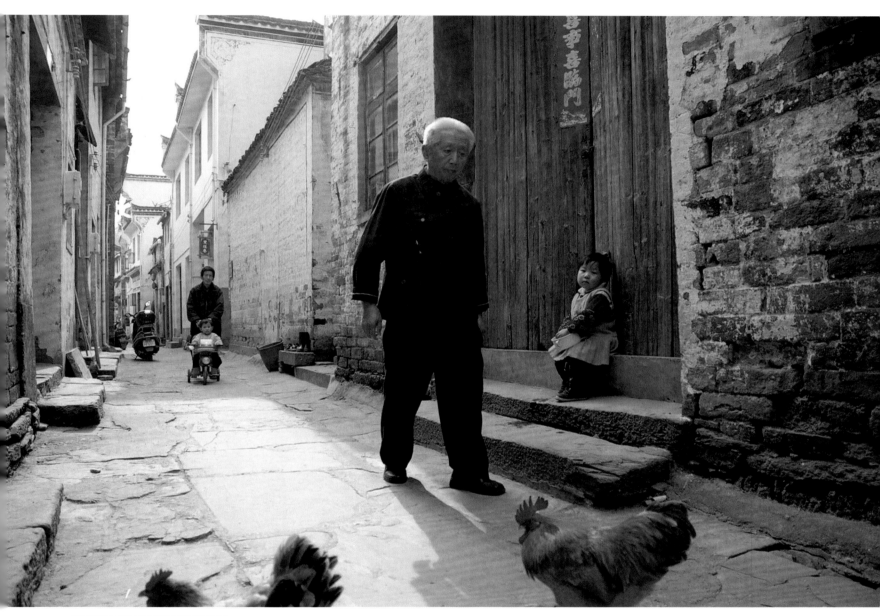

Wuyuan County, Jiangxi Province

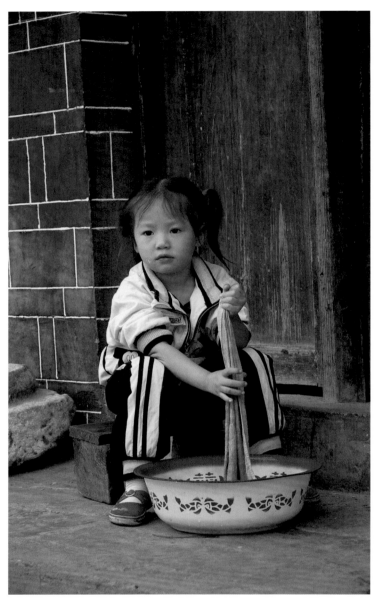

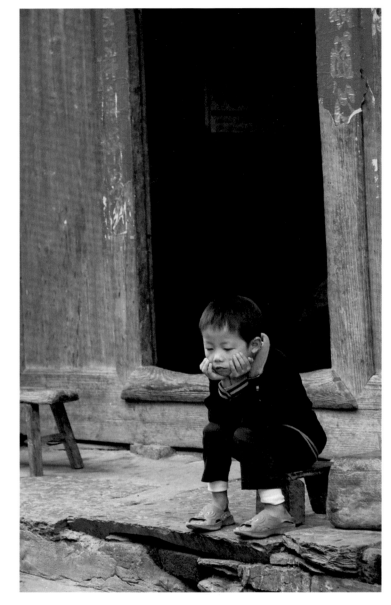

Longli Old Town, Guizhou Province

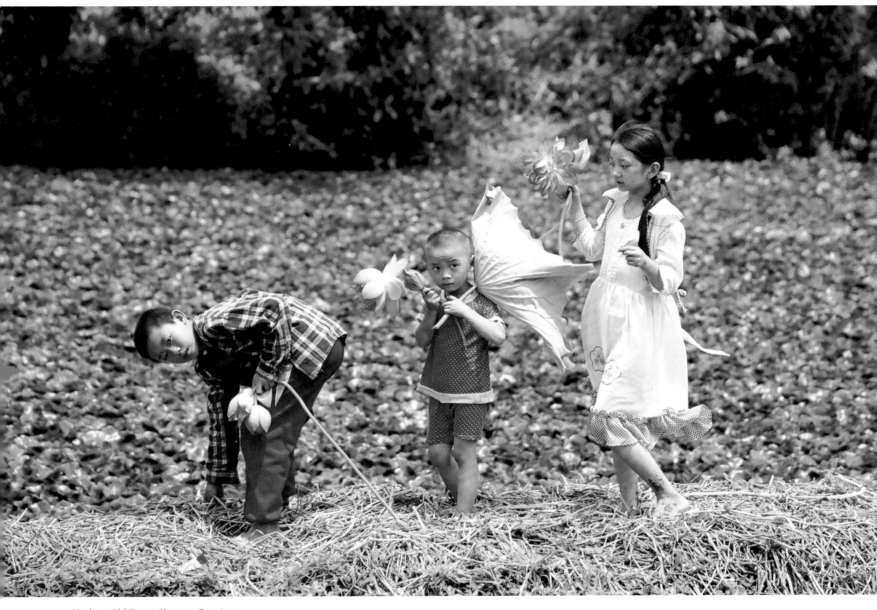

Heshun Old Town, Yunnan Province

in rural areas is forcing many villages to either reduce the scope of their educational programs or completely close their schools. Although nowadays many primary schools in towns offer residential facilities for young rural children, it is far from ideal for them to live apart from their families.

A serious rural social issue is the *left-behind children* [liushou ertong], whose parents work in cities. They remain behind in the countryside with grandparents, or with only one parent or other relatives. The estimated number of such children is at least 58 million, which is about one-fifth of China's children and a quarter of its rural children. Elderly grandparents are raising about 80 percent of these children. Problems caused by such *generation-skipping childrearing* [gedai jiao-yang] negatively affect children's educational achievements, health and psychological development. The two-generation age gap makes it difficult for grandparents to fulfill parental responsibilities. Rural children do not really understand why their parents have left them behind and may feel deserted or wonder if they are unwanted. One often hears stories about the sad fates of left-behind children. In a few extreme cases, children have even attempted suicide as a final despairing act.

Learning about agriculture was promoted enthusiastically in the 1970s, as shown in the poster "A new lesson: Praising the new trend of the education revolution." Today, most farmers want their offspring to become urbanites through education.

Consequently, some *migrant workers* [nongmingong] have decided to raise their children in the cities where they find work. In the 1980s and 1990s, migrant workers moved to cities without their families. Later, after they were 'established,' many brought their families to their new homes. In spite of their jobs and a small apartment they may have bought in the suburbs, they are still ineligible for the *urban*, or *non-agricultural*, *hukou* [fei nongye hukou]. In addition to the lack of social-welfare provisions and adequate health care, this stigmatization creates a major problem for their children's education. Children with migrant backgrounds automatically inherit the location-bound *hukou* status of their parents, making them ineligible for a free nine-year education at the public schools attended by their urban peers. The fees charged for a *migrant worker's child* [dagong zidi] to attend such a school range from RMB 1,000 to 4,000 (US $150–600) per year, which is even higher than some migrant workers' annual income. It has thus become common for their children to attend private schools whose pupils all have a migrant-family background. These schools are usually inadequately equipped and cannot afford to hire qualified teaching staff.

Activists have called on the government to address the problem of unequal educational opportunities. In Beijing and Shanghai, for example, the government now requires some public schools to enroll students from migrant families and assign them to classes with local pupils. However, many urban families dislike such schools. As a result, some schools, wishing to protect their reputation, covertly separate pupils into different classes based on *hukou*.

The challenges for youngsters with an *agricultural* or *rural hukou* [nongye *hukou*] do not end when they move up to higher levels in the educational system – if they ever get there, as almost 90 percent of the rural population has only a junior-high-school education or less. It is also more difficult for them to gain admission to good universities. China's *National University Entrance Examination* [gaokao] is the only basis for admission to higher education. Biased policies, however, discriminate against students with a rural *hukou*, requiring them to meet higher ad-

Political education has been an important policy not only for children, but also for peasants. This 1960s propaganda poster shows peasants and students alike learning the teachings of Mao Zedong from PLA political officers and enthusiastically discussing them in a room with a traditional rural northern Chinese decor. The photo taken by Helen Foster, wife of the famous journalist Edgar Snow, during her travel to the 'Red Areas' in the 1930s depicts a classroom and the 'Lenin corner' of a Red Army detachment. While peasant farmers made up the largest share of Mao's troops, the current migration trend and farmers' complaints about the loss of their sons' labor have resulted in difficulties in recruiting soldiers, even from poor, remote rural areas. In 2002, the PLA's recruitment quota still required 66.8 percent of its soldiers to come from the countryside.

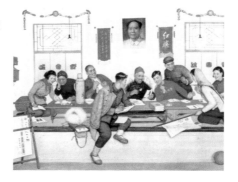

For decades, 'Big White Rabbit' milk candies have probably been the most famous and popular Chinese snacks. This Shanghai-based brand was originally founded by a Chinese capitalist in 1943 with the name 'ABC Mickey Mouse.' After 1949, the brand was renamed for patriotic reasons. These milk candies were one of the few luxuries available from 1950 until the beginning of the 1980s. When there was a serious shortage of milk powder during the Great Famine (1958–61), 'Big White Rabbit' was considered a nutritional supplement, and many rural families used their connections to obtain the candies for their toddlers. The candies were even presented to US President Nixon during his 1972 visit to China. Although sales began to decline in big cities starting in the 1990s, 'Big White Rabbit' remains popular in rural areas. As with these snacks, the range of children's toys available in many parts of the countryside has grown in recent years. Unlike toys made from natural materials (Picture right) in the past, modern plastic toys leave their footprint on the environment.

mission standards. For parents with a rural *hukou*, it is highly desirable that their children attend a good university, as doing so offers benefits going beyond just a good education and a diploma. Due to high admission standards and other factors, the share of rural students at some universities has dropped to just 17 percent, down from over 30 percent in the 1980s. Today, the increased tuition and living expenses of a university student can easily add up to RMB 50,000 (US $7,700) over four years. Many farmers describe the situation as follows: "If a child does not attend a university, poverty can be expected. If a child does attend one, poverty begins immediately."

To understand the attractions of education for rural Chinese, one has to know the role played by the *hukou* system. A student receives a temporary *hukou* permit from the city where his or her university is located. After graduating, the student can obtain a permanent *hukou* only under certain conditions. If a student does get one, it entitles him or her to important social-welfare benefits, including health insurance and pension rights. However, for students with a rural background, the pressure is multifaceted. Many of them suffer feelings of inferiority due to negative comparisons with their urban peers, who can afford a better material lifestyle. Moreover, they are less likely to find a job than their urban peers, who have a 'better' background. In the last few years, the Chinese media have increasingly reported on the destinies of rural students, and occasionally on their tragedies, e.g., some commit suicide or resort to criminal activities.

Given the mainstream pressure on young people to study at universities and become good 'urban citizens,' we cannot but notice an unanticipated new trend. Before the 2009 international financial crisis, migration was completely rural-to-urban. University graduates seldom returned to rural areas. However, because of the intense job competition and expensive housing in cities, a small group of Chinese 'migrants' has begun to have second thoughts. A large investment in education no longer guarantees a job and housing under the government's system of *work allocation* [fenpei gongzuo], as it had until the mid-1990s. Additionally, the land granted to holders of a rural *hukou* is becoming attractive again, either because it provides a 'guaranteed' place of one's own, or for speculation on rising real-estate prices.

Although the majority of rural residents still hope for a better life in urban areas, the beginning of a *counter-urbanization* [ni chengshihua] movement has become apparent. A group that also reflects this trend is the *new urban youth* [xin zhiqing], consisting of graduates who wish to leave urban life behind by reclaiming their original rural *hukou*. The government's continuing ef-

"Successors of the Socialist Cause"

Marxist and Communist thinking is still omnipresent in schools all over the countryside. Schools throughout the country look almost identical.

The slogan "Be determined to become a useful person and revive Chinese culture" is written on the façade of the school building.

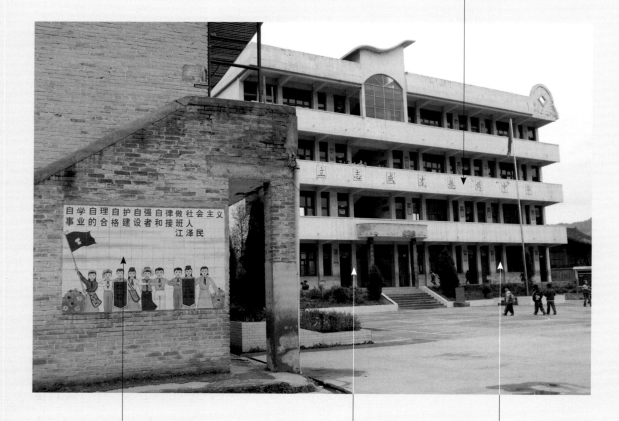

An example of an elementary school located in the Qiandongnan Miao and Dong Autonomous Prefecture of Guizhou Province.

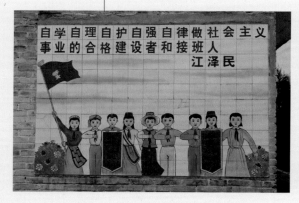

On the tiled painting, a quotation from former president Jiang Zemin is written: "Learn by yourself, take care of yourself, protect yourself, become strong by yourself and discipline yourself in order to be a qualified builder and successor of the socialist cause."

The sign reads "School is my home. Greening the environment relies on everybody."

Photos of renowned Communist Party officials, such as Zhou Enlai and Deng Xiaoping, hang on walls throughout the corridors.

Some experts predict that a third counter-urbanization trend will occur in big cities over the coming years due to pressure on quality of life and job competition. Although the *new urban youth* [xin zhiqing] are currently a major issue only in Zhejiang and Guangdong Provinces, they are heatedly being discussed in the media.

forts to establish a better social-welfare and health-care system for rural communities also make the urban *hukou* less attractive. Furthermore, villages close to larger cities consider land assigned to the holders of a rural *hukou* to be a gold mine.

Ever since the government introduced the *household-registration system* in 1958, the transfer of a person's *hukou* has been a one-way street, i.e., from an agricultural to a non-agricultural life. However, the problems of unemployment in the cities and the continuing influx of workers from the countryside have led a few cities to introduce a new policy for urban *hukou* holders who want to switch to a rural one. Although this policy is intended to inject some much-needed vitality into rural areas, the drain of rural residents continues. The economic boom in coastal urban areas has been built on the labor of poorly-educated migrant workers. Many cities are denying these workers basic rights, including the right to equal education for their children. Although in the last decade the government has begun to reform the household-registration system, discrimination persists.

Published in the *Renmin Ribao* in 1968, this picture displaying the slogan "We have hands too. We do not idle in the cities," proclaims the socialist ideal of *urban youth* moving to the countryside to take part in agricultural labor. This movement was above all politically motivated, but at the same time it was intended to solve unemployment problems in the cities.

In China's contemporary history, there have so far been two big migrations from urban areas to the countryside. During the early 1960s, as a result of the Great Famine, many unemployed urban workers moved to villages to help with agricultural work. Later, during the Cultural Revolution, young students were sent to the countryside to "learn from peasants." Life and work in the countryside were portrayed as eventful, meaningful and exciting. However, most *urban youth* experienced their stay in the countryside as very harsh and not, as Mao said, a "vast expanse of heaven and earth in which we can flourish." In addition, hundreds of thousands of families were tragically torn apart. Some considered the movement simply a disguised 'education through labor.' Some of the rusticated urban youth later married into the villages and remained in the countryside. The majority who managed to return to the city by drawing on personal connections found it hard to reintegrate into city life.

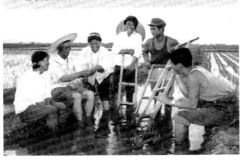

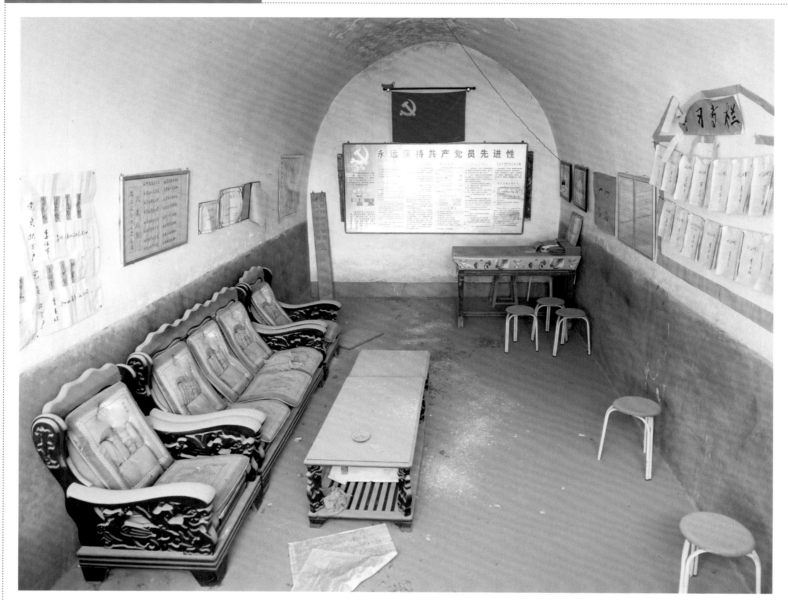

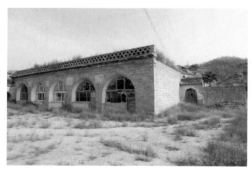
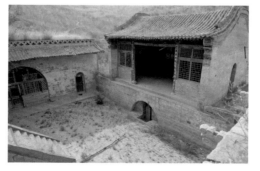
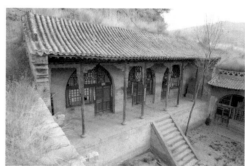

The elementary school in *Lijiashan Village* in Shanxi Province was closed a few years ago due to a lack of funding and students. Long before its closure, the school had only two teachers and one class with pupils of various ages. One of the teachers was employed as a temporary staff member and received a salary of only RMB 300 (about US $40) per month. His son, who dropped out of senior high school to work as a migrant worker in the capital of Shanxi, earned twice as much. In the summer of 2010, all that remained of the school were dusty arched rooms and some furniture. The brightly painted yellow desks and benches look as though someone had kindly donated them shortly before the school's closing. Today, students have to walk five kilometers to Qikou Old Town to attend school.

Not only has the Lijiashan school been abandoned, an old temple composed of vaulted cave-style rooms with an ornate brick theater stage stands desolate on the edge of the village. This Taoist temple was built in the form of a small courtyard house and is the only religious building in the whole village. The entrance and doors are all locked, except during the Chinese New Year, when performances take place here to entertain the last residents of this once-prosperous locality.

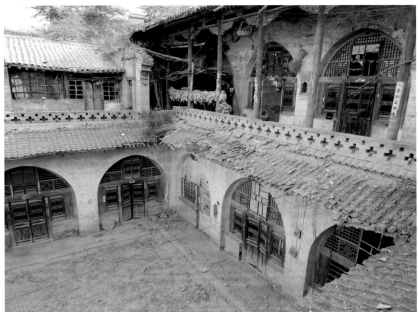

Lijiashan Village got its name from the biggest family clan, the Li, which settled here in the fifteenth century. The locality prospered through camel breeding and transportation services, as nearby Qikou Town became the most important regional commercial center. The collapse of the local economy in the early twentieth century was directly mirrored by the decline of Lijiashan Village.

A beautiful but dilapidated courtyard is carved into the side of Lijiashan's hilltop, just some hundred meters away from the old temple. This remarkable architectural jewel, with its spacious rooms and a U-shaped corridor, is only inhabited by an old couple. The husband is bedridden, while the wife gathers wild fruits and vegetables for a living. When we try to climb up the temple wall for a closer look, the woman slowly approaches us. She is holding a small bunch of dried daylilies in her rough and tanned tiny palm and can barely speak clearly what she wants to say. Her wrinkled face resembles a sun-baked Chinese date, and her hunched back seems to be burdened with heavy, forlorn stories. Her offspring have all moved away in search of better work opportunities. Sadly, the couple's pitiable living conditions suggest that the children are either not doing very well themselves or do not care about their parents.

Lijiashan used to be very remote, which kept the traditional architecture and lifestyle very much intact. A road to the village was completed in 2010, in hopes of attracting more tourists.

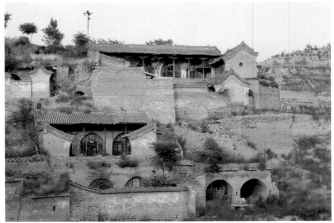

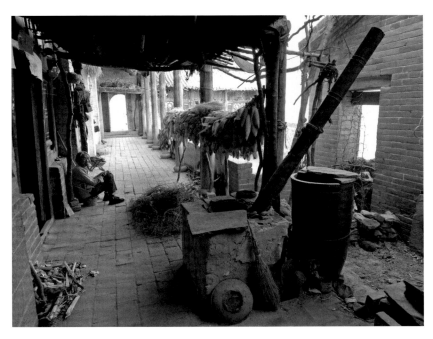

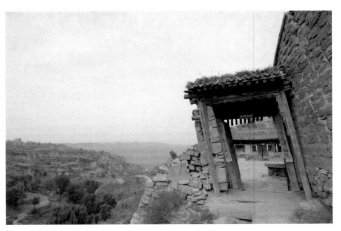

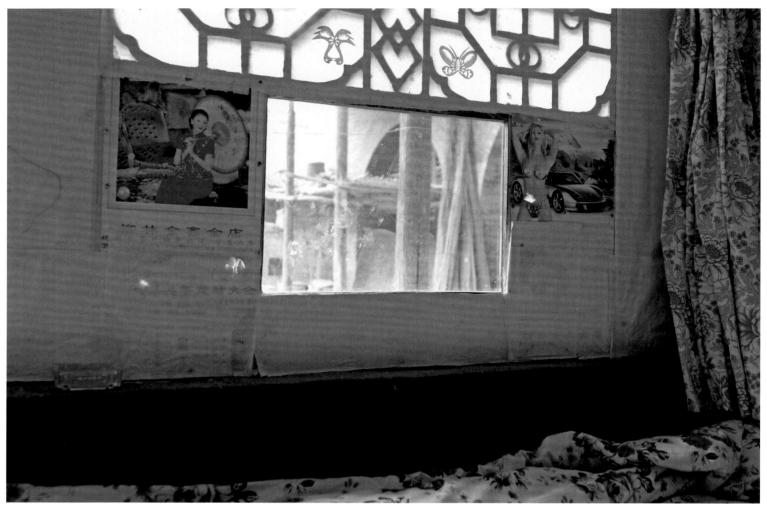

The traditional aesthetics found in a wealth of architectural details suggests the former wealth and rich history of this village. Although there are still no new brick houses in Lijiashan, the influence of modern lifestyles is visible everywhere – from the tourism banners on the walls to plastic utensils and commercial calendars in homes. Still, old artifacts may perhaps once again be revived for tourism purposes, after having been neglected for so many decades.

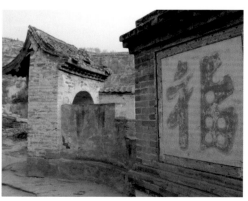

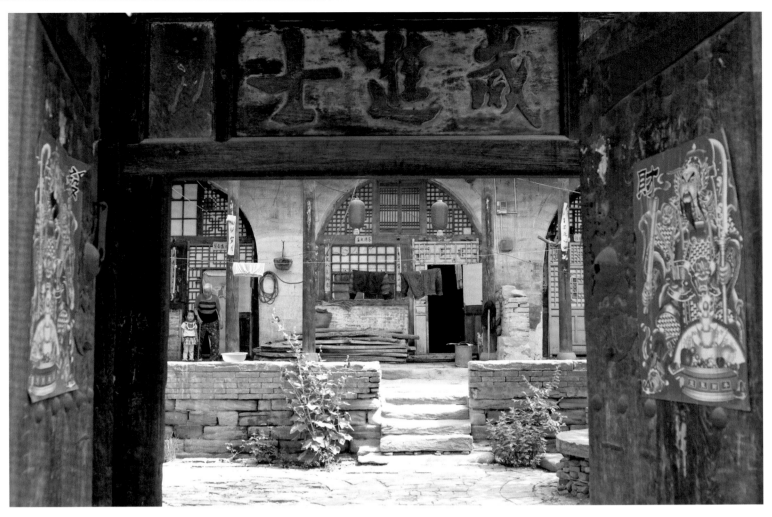

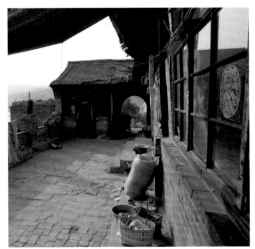

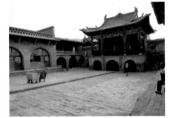

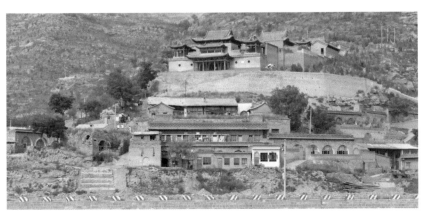

The development of *Qikou Old Town* was the driving force for regional prosperity. The place lies on the eastern bank of the Yellow River opposite Wubao Old Town in Shaanxi Province. Both localities once boasted of their military and strategic significance. Qikou became an important commodity port for trade between northern and northwestern China in the middle of the Qing Dynasty (1644–1911). Due to the notorious submerged reefs and the narrower water channels in this part of the Yellow River, goods such as grain, oil, salt, furs and medicinal herbs were transported from the northwest via water routes and unloaded in Qikou for road transport to cities like Taiyuan, Beijing and Tianjin. In return, porcelain, tea and silk were transported to the northwest. Horses and camels were in great demand to meet transportation needs.

When the Beijing-Baotou Railway was completed in the 1920s, the importance of Qikou as a trading hub slowly waned. Soon afterwards, the economic reforms in the Republican era (1911–1949) replaced the old local currency with a new one at an unfavorable exchange rate. This change destroyed the traditional private banking system of Shanxi Province, which was China's most important financial center for nearly 500 years. Commerce in Qikou was finally ruined when the Japanese invaded the region in the late 1930s. Most merchants fled, never to return.

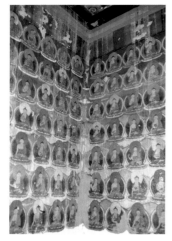

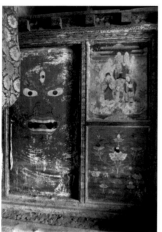

Ezhi Monastery in the Tibetan region on the border of Sichuan and Qinghai Provinces is a secluded, holy place, almost unknown to the outside world. The monastery stands on ruins believed to be those of the ancient capital of the legendary Gesar's Kingdom of Ling (around the twelfth century), between the upper courses of the Yangtze and Yalong rivers. This ancient Tibetan Buddhist monastery houses and educates many lamas, young monks and pupils. Apart from a group of orphans, most of the pupils are sent by impoverished Tibetan nomadic families to study Buddhism and the Tibetan and Chinese languages.

Until well into the twentieth century, there was hardly any form of institutionalized education in Tibet, except the very few schools that trained boys for governmental positions. Education was for many centuries basically religious education, because the members of the priesthood and aristocracy feared that secular schools would jeopardize Tibet's cultural and religious traditions. Some foreign groups opened such schools in Lhasa during the first half of the twentieth century, but according to Chinese statistics the illiteracy rate in 1951 was still 90 percent. Since the turn of the twenty-first century, the government has devoted much funding to the establishment of public schools. However, not all Tibetans welcome this 'gesture,' due to the concomitant Sinicization. The Tibetan-inhabited areas in China – besides the Tibet Autonomous Region, Qinghai, Sichuan and Gansu Provinces – are still considered the regions with the highest illiteracy rates in the country. Today, there are estimates that 90 percent of the young Tibetans who live in Indian exile left their homeland because of the lack of educational opportunities.

Because of the famous *Epic of King Gesar*, Ezhi Monastery became a sacred pilgrimage destination for Tibetan nomads. Many come from far away to pray and receive blessings. Faded ancient murals and colorful silk tapestries decorate the otherwise dark interiors of the temple halls. Some older paintings depict hunting scenes and Buddhist characters. Han Chinese-inspired landscape themes and figures reflect the more intense exchanges with the Chinese Empire from around the fifteenth century. Some paintings luckily escaped the ravages of the Cultural Revolution because they were hidden under coats of mud. Preservation and restoration are urgently needed, but the monastery lacks the necessary funds.

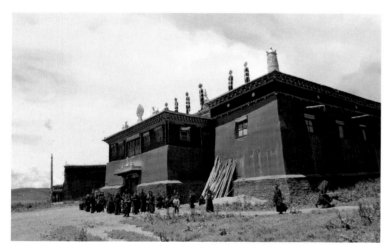

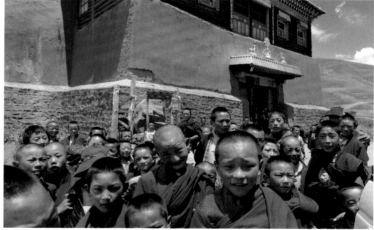

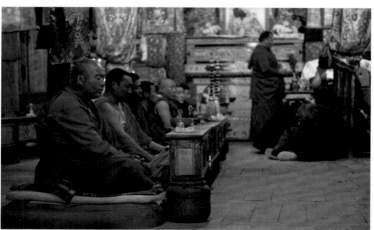

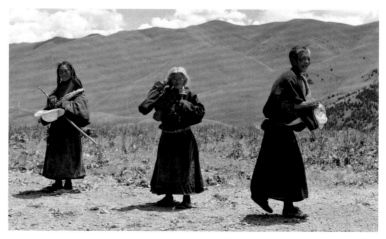

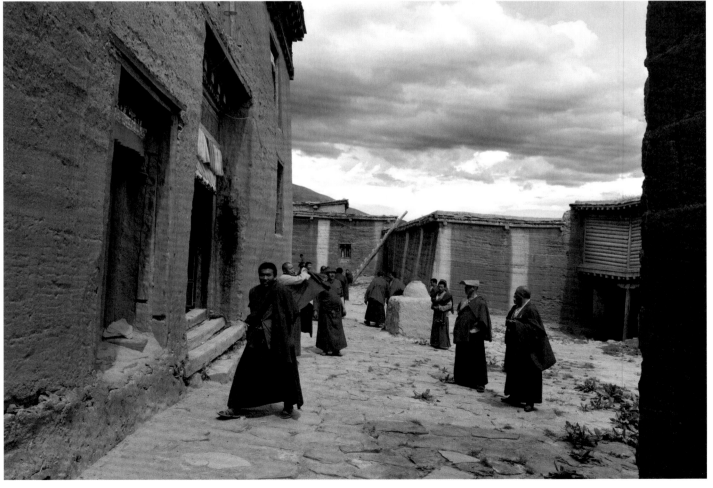

Rows of cloister cells for monks in the traditional Tibetan style adjoin the main temple buildings and altogether form a small village. Still, due to the lack of rooms, some of these pupils have to make beds on the floor in the temple halls or commute for dozens of kilometers. When this school was founded in 2006 by the principal lama of Ezhi Monastery, he had to visit family after family to persuade them to send their offspring there for education. Currently, about 150 students are enrolled, and the number is growing. This monastery and its school are mainly supported by donations.

There is only one shop in this place that stocks snacks, drinks and groceries. Though electricity was introduced in 2010, there are not many household appliances other than light bulbs, mobile phones and radios. A special crew of monks prepares simple meals, mostly based on buckwheat, potatoes, rice soup and small servings of cabbage, in the smoke-blackened communal kitchen. This select group can excuse itself from the regular chanting and thus enjoy greater freedom than the others. If weather permits, monks from temples in this valley often gather at the river to bathe, do their laundry and hold a convivial picnic under the crystal-clear blue sky.

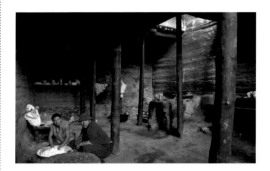
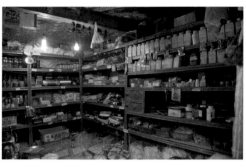
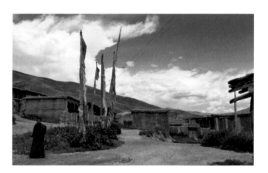

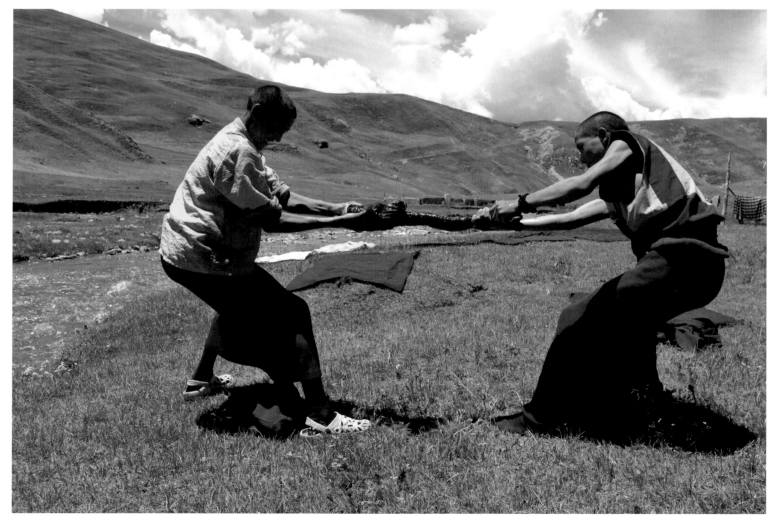

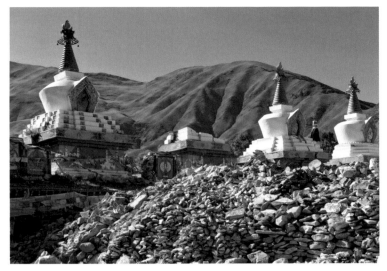
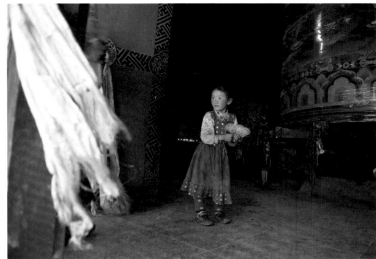

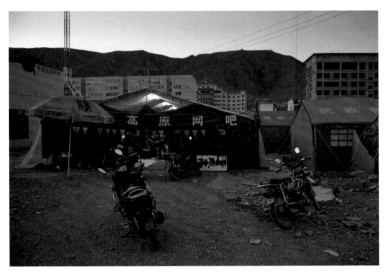

A few hundred kilometers northwest of Ezhi Monastery lies *Yushu County* in Qinghai Province. With its remote, rugged terrain, it is regularly shaken by earthquakes. The area, largely inhabited by Tibetans, was severely afflicted by the devastating earthquake of April 2010. Many local people blame coal-mine operators for angering the God of the Mountain and causing this disaster. Three months after the earthquake, people still lived amid ruins and rubble. Until today, there is still a popular saying: "The earthquake is a natural catastrophe, while recovery is a man-made calamity."

Broken stones were piled on the side of the street leading to Gyêgu [Jiegu] Town, the county seat. When the temples were demolished during the Cultural Revolution, the painted temple stones were used to build People's Communes and governmental offices. In the 2010 earthquake, these buildings collapsed, and the colorful stones reappeared.

Most buildings in Gyêgu became too dangerous to occupy after the earthquake. Thus, activities take place either outdoors or in tents. Tents were set up not only as accommodations, but also to house temporary shops and restaurants. An Internet café called the Plateau Internet Bar was reopened in a huge tent with more than a hundred seats. Its patrons are mostly youngsters who play online games.

Due to the predominant ordinary brick houses in Gyêgu, outsiders who pass by may well be unaware of its long history. This former trading town on the mountainous and perilous ancient *China-Tibet Trail* [tangbo/tangfan gudao] played a significant role in the relationship between the Chinese Tang Dynasty and the *Tibetan Empire* [Tubo or Tufan] in the seventh century. After repeated threats and attacks by the Tibetan King, the Tang Emperor sent Princess Wencheng with valuable dowries from Xi'an through this area to Lhasa. Her marriage to the Tibetan King was part of a peace settlement. It is widely believed that Princess Wencheng and the Nepalese wife of the King introduced Buddhism to Tibet.

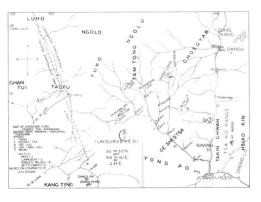

A 1920s map of the Tibetan-inhabited border area in today's Qinghai and Sichuan Provinces shows the great fault and earthquake region along the north-south axis.

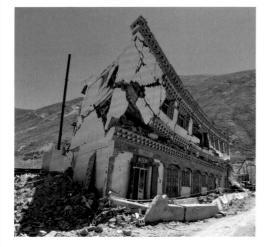

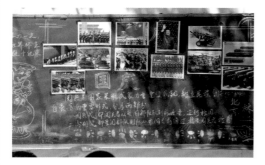

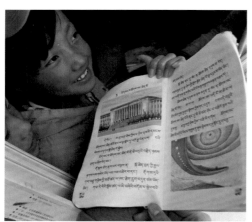

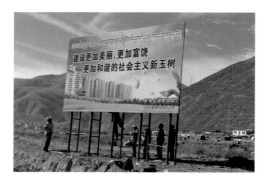

Most school buildings were seriously damaged during the earthquake. Simple temporary shelters were set up as classrooms. Donations such as winter clothes and instant noodles were sent to the school from all over the country. The Chinese authorities rejected offers of aid from foreign organizations on the grounds that its own army troops, fire departments and police forces were adequate for all the rescue and recovery work. The Dalai Lama's request to visit Yushu to comfort the survivors was turned down. Although a few foreign organizations were later allowed to enter the quake-stricken area, their activities were greatly limited. Many locals speculate that the real reason for the government's dismissive attitude was fear of a loss of face if the underdevelopment of this Tibetan region became widely known. Before the quake, most local people lived in traditional mud-brick houses, as they had for centuries. The unstable frameworks of these houses may be one reason for the great number of casualties.

The quake not only took thousands of lives, it also deprived some families of their source of income. Before the quake, this little girl's mother, whose husband was bedridden, supported her whole family. When she died in the earthquake, the husband and their three children became destitute. They had originally been nomads until a recent policy encouraged Tibetan herdsmen to settle in towns. Since the wife's death, the family has depended on help from relatives. In summer, the two school-aged sons gather wild medicinal herbs in the mountains to earn small sums of money.

A three-story hotel building, for instance, still stood on its foundation but was so badly damaged that rescuers could not determine how many guests had died on the collapsed second floor. As in all places struck by natural disasters, the government is usually quick to claim that it is in control of the situation. Propagandistic educational billboards on the "Unity of all ethnic groups," "Army and locals hand in hand" or the rebuilding of Yushu in an even "More beautiful, rich and harmonious way" sprang up like mushrooms. The school's bulletin boards displayed photos of the National Day's military parade and the World Exhibition in Shanghai. School classes continued with the usual program of patriotic education.

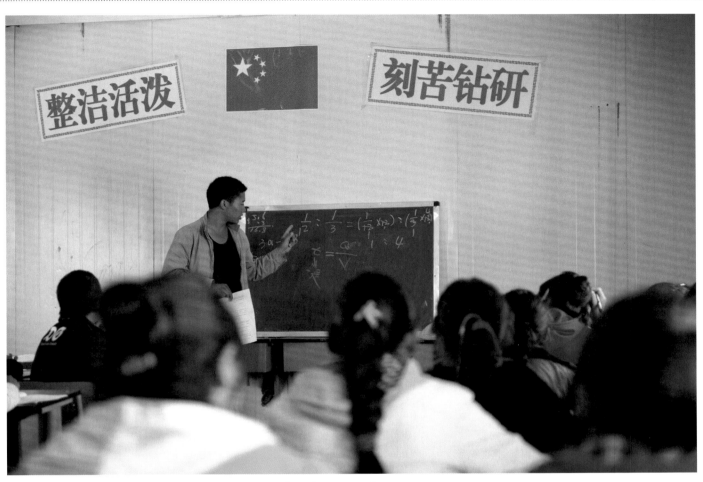

"Be neat and outgoing – be enduring and assiduous." Gyêgu [Jiegu] Town, Qinghai Province

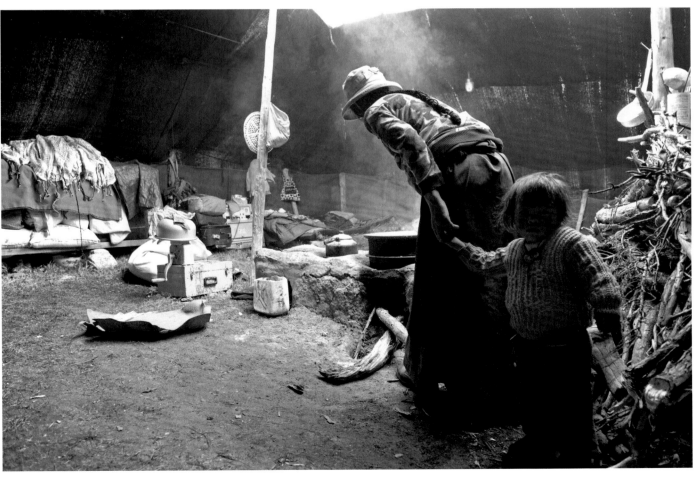

Garzê [Ganzi] Tibetan Autonomous Prefecture, Sichuan Province

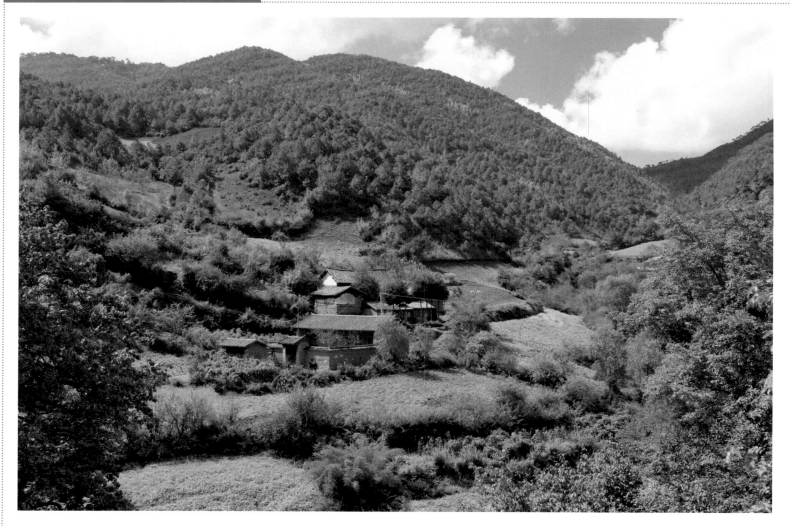

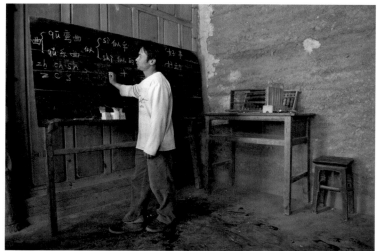

In the remote mountains of northwestern Yunnan Province, many villages still rely on traditional means of transportation to reach the outside world. *Mapingguan Village* in the Dali Bai Minority Autonomous Prefecture is no exception. The residents of this isolated village are mainly descendants of tax officials from imperial times.

This settlement was originally an outpost for collecting taxes on the salt trade. It was founded in the fourteenth century on the ancient *Tea Horse Caravan Trail* [cha ma gudao], which stretched from Sichuan and Yunnan to Tibet, Burma and India. Tax officials were sent from Shaxi Old Town in the valley to this important outpost. A community with houses perched on the green hillside slowly expanded over time. Salt, essential for the preservation of food, was quite rare in Yunnan Province and therefore a precious commodity. The peak of development in this region was reached when the government, during the Ming Dynasty (1368–1644), established several new salt mines and tax offices. The extensive spider-web-like network of the Tea Horse Caravan Trail promoted not only commerce, but also cultural and religious exchanges among different ethnic groups.

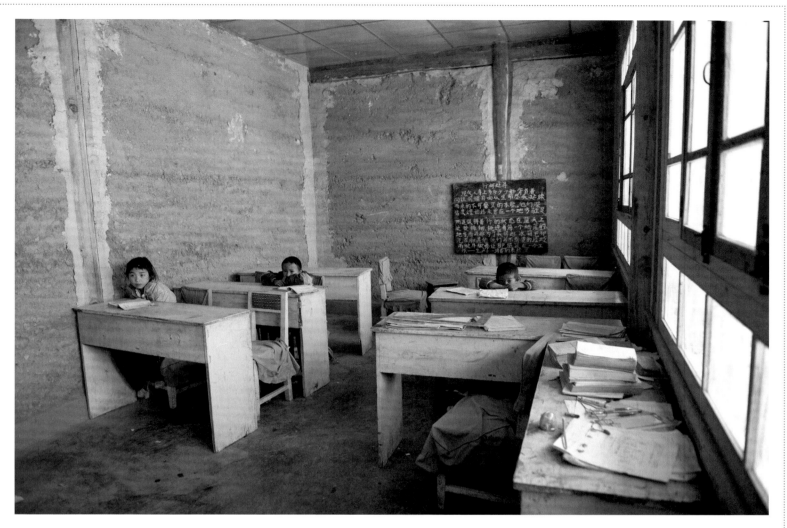

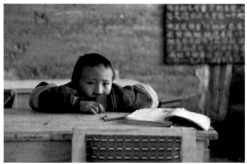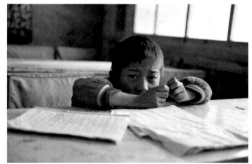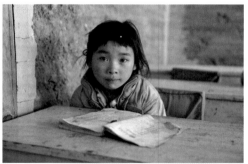

Today, the villagers still depend on this centuries-old trail to maintain contact with the modern world. *Horse caravans* [mabang] continue to follow traditional routes. When markets are held in the valley, horses depart loaded with potatoes and beans and return laden with daily necessities. The trek of several hours from the village at an altitude of 2,800 meters down to the valley below makes life hard, and more and more people are leaving the village.

Like in many remote rural areas, the elementary school in Mapingguan is staffed with only one *substitute teacher* [daike jiaoshi] for the remaining three students, while a few years ago there were still more than a dozen pupils. The teacher receives only a meager monthly salary and helps his parents with the farm work in his free time. In spite of the financial attractions of working in the city, he has chosen to stay here because of his parents and his attachment to the land. When visitors pass through this village, he makes use of his lunch break to cook for them and earn some extra money. In the near future, the pupils of Mapingguan will attend boarding schools if their families' financial situation allows.

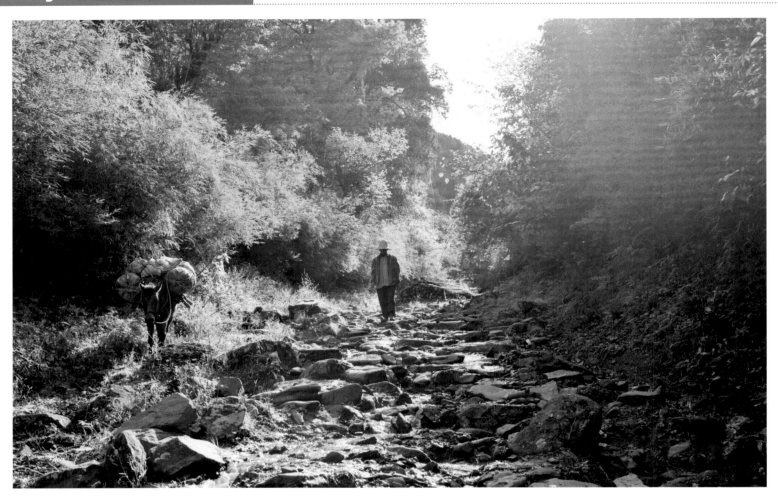

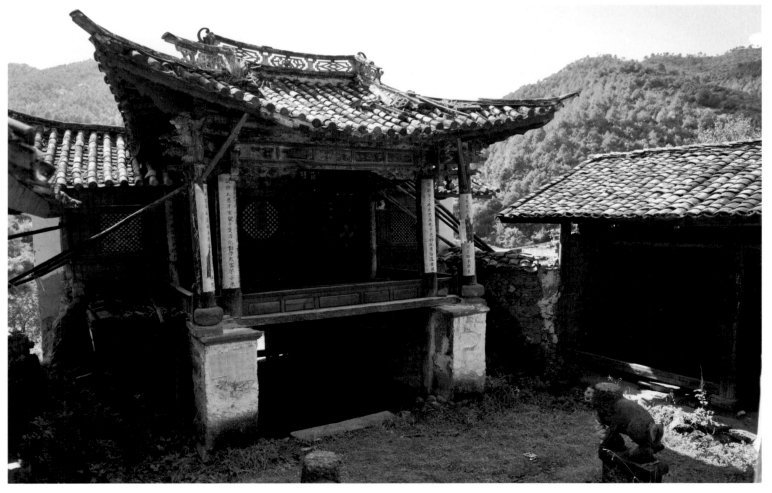

About thirty families still live in Mapingguan, which has only one modest shop. The traditional houses are built of wood, stones and mud. One of the more prominent buildings is the watchtower, protruding from the second floor of an ordinary house. It was used as a lookout post to observe incoming caravans from afar. All the caravans had to go through the covered bridge to transport salt to the closest distribution center, Shaxi. Thus, the tax assessor's checkpoint was set up on this bridge. Due to tax revenues and the busy trade, a *village temple* [Benzhu miao] with an elaborate theater stage, which is common in Bai Minority areas, was set up here. Traditional costumes for theater performances were brought in from as far away as Kunming. Except for two lonely stone lions guarding the deserted garden, nothing in this empty temple reminds today's visitors of this once-prosperous village. The temple is open only during the Chinese New Year for local opera performances.

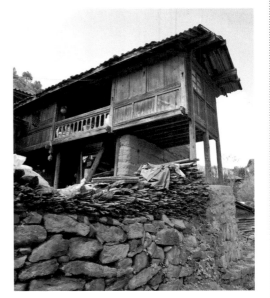

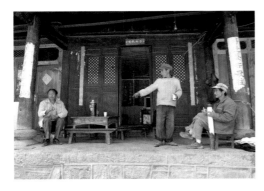
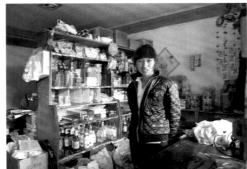
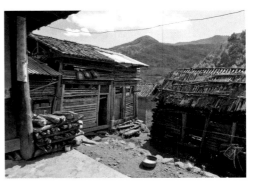

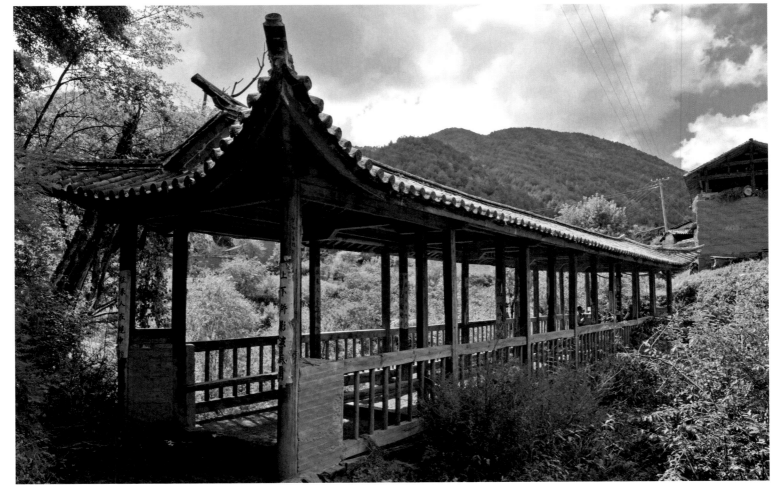

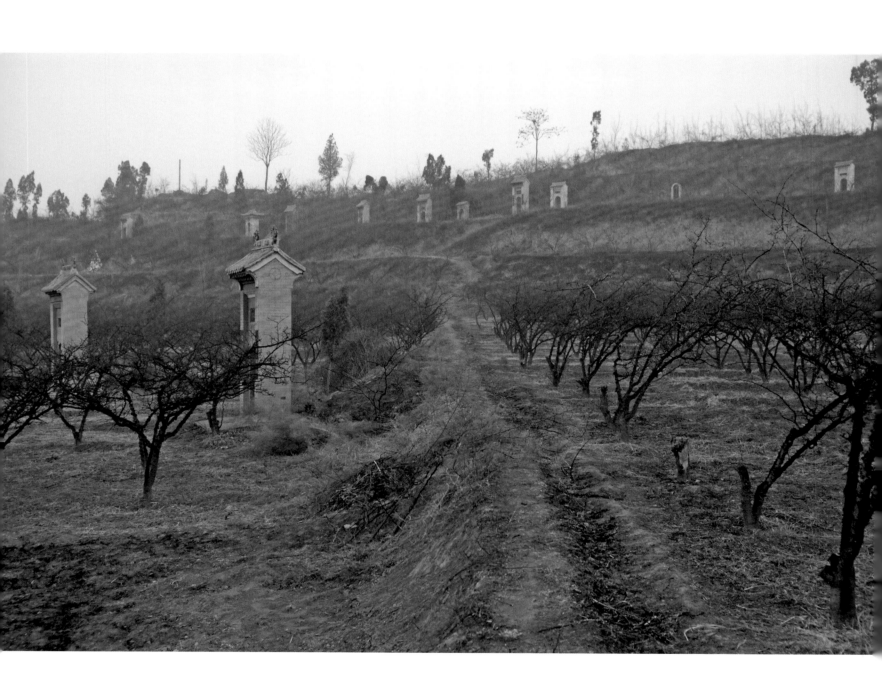

Dangjia Village,
Shaanxi Province

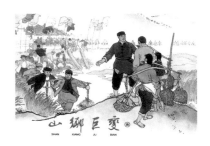

The propaganda-style cartoon series *The Great Change in the Countryside* [Shanxiang jubian] tells the story of how a village and its people in Hunan Province were affected by the land reform in the 1950s.

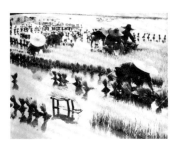

The traditional labor-intensive method of rice-seedling transplanting is still practiced in the hilly or poorer regions of China, though the stools pictured are rarely seen. In many fields in the plains areas, the use of mechanized equipment has allowed farmers to plant by broadcasting rice seeds.

The Demise of the Farmer

This chapter does not recount the tragic destinies of individual peasant farmers, nor does it describe the rural massacres committed during the Cultural Revolution.

Rather, it spotlights the inevitable demise of a traditional occupation handed down for millennia in the rural areas of China. Until very recently, China's large rural population supported itself chiefly through farming, supplemented by *rural sideline production* [nongcun fuye].

Although the 1950s land reform redistributed land ownership, as had previous land reforms, it did not change how the rural population made its living. A late-1920s study of farm households in the Lower Yangtze Delta provides some of the earliest evidence of a *surplus rural labor force* [nongcun shengyu laodongli]. It showed that most peasants were already engaging in a variety of non-agricultural activities to supplement their incomes. Nevertheless, the emergence of a surplus rural labor force as an acute problem was delayed, first by political turmoil and war, and later by the Communist government's policies. China's system of the People's Communes and comparatively late industrialization help explain the concealment and the sharp rise of a rural labor surplus. Rapid industrial progress due to economic reforms has had a variety of consequences for both the rural labor force and the countryside. It was like suddenly flinging open the gate to paradise for millions of desperately poor peasants, a gate far too narrow to admit all those clamoring to enter.

Guangdong Province was the first region to benefit from the Opening-up policy, and it attracted many investors to build factories. The villages and peasants of this area were among

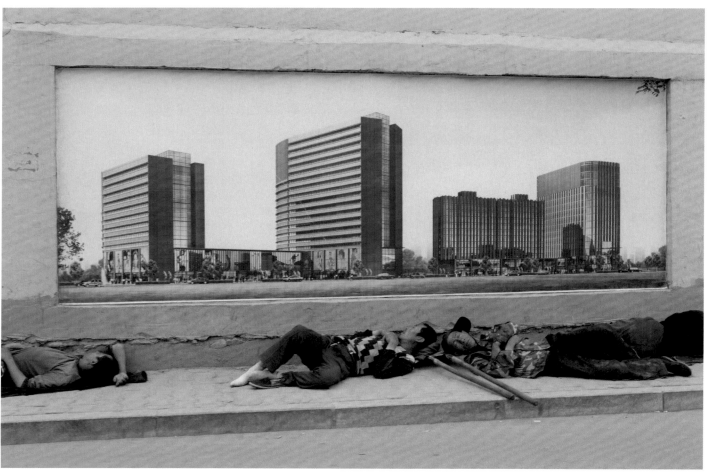

E'erduosi City, Inner Mongolia Autonomous Region

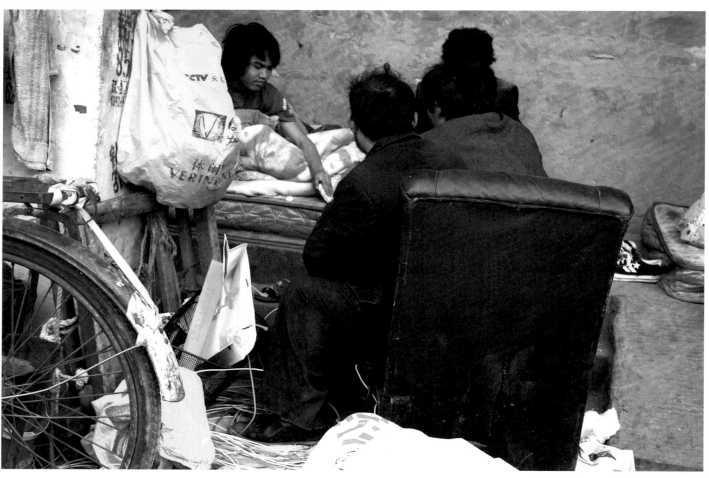

Shanghai Municipality

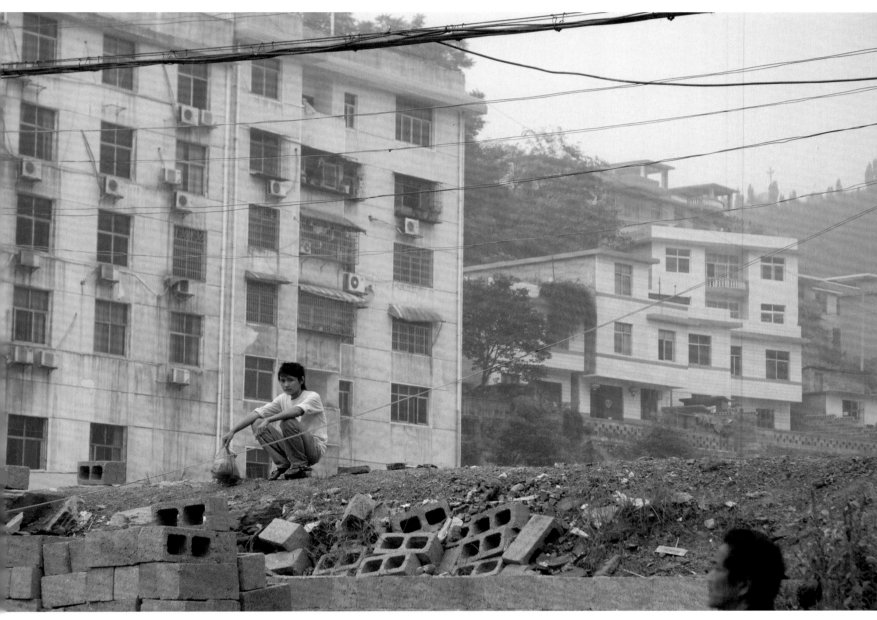

County Seat of Baojing, Hunan Province

A cartoon published by Xinhua News Agency about the crisis of farmers who have lost their land: "How is the future generation going to make a living?"

As of 2006, RMB 1 trillion had been invested in the framework of the *Great Western Development Strategy*. Infrastructure projects in the less-developed western areas of the country, including six provinces and five autonomous regions, are its main component.

The illustrated poster warns migrant workers to beware of prostitution and AIDS.

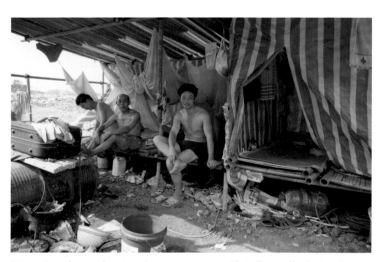

Migrant workers only return home once a year, if at all, usually during the Chinese New Year celebrations. This extended separation puts heavy pressure on their family and marital situations.

the first to make way for industrialization and abandon farming. Soon, more provinces along the East Coast followed their example and enticed middle-aged farmers from the interior provinces to leave their homes and land to become migrant workers in factories and on construction sites. Today, when wandering through villages in rural parts of China, we get the impression that most of the residents are either elderly persons or children. When asked about this, villagers tend to express a positive attitude toward *working in town* [dagong]. They often criticize young men who stay at home and work on farms as untalented or even lazy.

One result of this rapid urbanization is that the number of floating migrant workers surpassed 200 million in 2008 and is expected to reach 350 million by 2050. Most of them are engaged in low-paying, high-risk jobs. However, recent studies show that *Generation Y migrant workers* [xinshengdai nongmingong], i.e., those born in the 1980s and early 1990s, expect more and tolerate less than their fathers, a clear result of being accustomed to better living conditions. Consequently, in some regions employers are unable to find enough workers to fill exhausting, underpaid jobs. However, a lack of skills hinders these workers from getting better jobs. Presently, China is at a turning point where a labor surplus and a labor shortage go hand in hand. An often-repeated comment will surely be heard for years to come: "When one lives in a village, one thinks of moving to the county seat; in the county seat, one thinks of moving to the provincial capital; in the provincial capital, one thinks of moving to Beijing or Shanghai; in Beijing or Shanghai, one thinks of moving overseas."

The rural workforce's migration has several social and psychological consequences for both migrant workers and their families. Their rights are often, and easily, violated by employers: They face meager incomes, delayed payment, hazardous working conditions and long hours of overtime work, just to name a few abuses. Migrant workers are vulnerable to abuse because of their rural *hukou*, as well as their legal ignorance and fear of losing their jobs. In 2003, the Internet and media focused popular attention on the fate of a young university-educated man from the countryside falsely accused of working illegally in Guangzhou and beaten to death by law-enforcement officers. Thanks to netizens and human-rights activists, the public has increasingly learned that the reported abuses are often just the tip of the iceberg. It is consequently becoming supportive of the need to protect the rights of migrant workers. Furthermore, some migrant workers are starting to learn about and fight for their rights, or even to provide legal counseling to their peers.

In past decades, industrialization and urbanization have steadily encroached on the rural landscape and greatly transformed the countryside. Developers and speculators have joined in

A set of poker cards designed by the Office for Labor and Employment Management of Xuan'en County in Hunan Province promotes the understanding of basic rights and provides information about common issues faced by migrant workers. Images from top to down: Package wrapper "Notice for Migrant Workers;" migrant workers enjoy the same rights as their urban peers; migrant workers should not engage in illegal activities.

the competition for rural land. Real-estate developers sometimes resort to illegal measures like hiring thugs to intimidate villagers with threats and blows so that they will give up their land, i.e., its usufruct. Even when the local government is involved, there may still be threats to the rights and safety of villagers. In fact, there are many reports of casualties resulting from violent disputes between villagers and local governments or developers. The latter often work hand in hand, further aggravating the situation. They have pressured farmers into accepting large-scale infrastructure or tourism projects on their land, be they a power plant or a golf course, with the promise of future employment and increased income. Unfortunately, these promises are often deceptive. Adding to the problems is that industrial development often goes together with a total neglect of the environment, which results in the pollution of local farmland and water needed for agricultural use.

Due to economic progress and the *Great Western Development Strategy*, these rural problems have been 'transmitted' from the coastal regions to inland areas. Northern Shaanxi Province and the Inner Mongolia Autonomous Region provide examples of this transmission. Coal deposits and oil reserves are abundant there, and since the 1990s a large share of former agricultural land has been bought up by private and semi-governmental developers for mining and infrastructure development. Unfortunately, with limited education and vocational skills, many farmers find it hard to adapt to a non-agricultural job. Some simply live on their compensation until it runs out, while many others fail in attempts to find new sources of income.

The income model of rural households was traditionally based on farming with supplementary rural sideline production, including handicrafts, food processing and transportation. Before 1949, sideline production such as sericulture or papermaking brought significant extra income to rural households. After the PRC was established, the government denounced household sideline production as a *tail of capitalism* [zibenzhuyi weiba], and it was taken over by the *production teams*. Because the People's Communes began *Go in Big for Industry* [da ban gongye], rural sideline production declined in subsequent years. Only after the start of economic reforms was it again greatly stimulated and industrialized. By the mid-1980s, its output even surpassed that of agriculture. Meanwhile, an increasing amount of rural sideline production evolved using efficient machinery in workshops or factories, and it was no longer thought of as part-time work. In other words, the traditional multifaceted work model of rural households is largely disappearing.

The levy of agricultural taxes and its abuse have been a hot topic in the last few years. Even though the central government abolished agricultural taxes in 2006, farmers are still heavily burdened by various 'special' fees, quasi-taxes charged by local government bureaus. For instance, irrigation fees or charges for public welfare are a common substitute tax. A 2009 official report indicated that farmers' average annual net income had reached an historic high of RMB 5,000 (US $735). However, rural residents still earn less than one-third of their urban peers' average income, and the rich-poor gap is widening. Moreover, even if we leave aside the fact that local governments are accustomed to falsifying statistical data, inland farmers generally earn two to three times less than their counterparts in the coastal provinces.

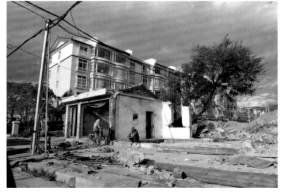

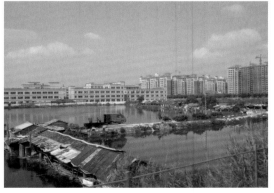

Urbanization comes at a price: Although the government's *small-town development* [xiao chengzhen jianshe] policy has been implemented energetically in the last few years, the wealth gap between cities and rural areas has been steadily widening.

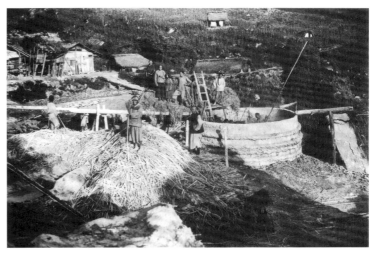

In 2009, due to the global financial crisis, many migrant workers lost their jobs. However, those from Meiyuan Village in Yunnan Province were able to draw on their traditional handicraft skills to find alternative employment. Members of the Bai Minority have been famous since the Tang Dynasty (618–907) for their outstanding stone- and wood-carving craftsmanship. Many Bai artisans from this area participated in the construction of the Forbidden City in Beijing. These traditional skills were revived after the 1980s, and the local government has begun to encourage them in recent years. Currently, about 80 percent of the households in Meiyuan Village are involved in stone carving. A craftsman can earn around RMB 10,000 (US $1,500) per year producing carvings for private houses, temples, parks and cemeteries.

The Italian missionary Leone Nani took this photo of a local workshop during his stay in Shaanxi Province between 1904 and 1914. The workers are preparing a mixture of bamboo and wood in a cistern for manufacturing paper.

Two steps of traditional sericulture are shown in these old woodcuts: Mulberry leaves are the preferred food of silkworms and were raised for this purpose; and the cocoons are submersed in boiling water to separate the silk fibers.

The range of sideline production in today's rural communities is shrinking due to industrialized production. Still, there are small-scale business activities in many parts of the country, such as apiculture (Dayang Old Town, Shanxi Province). In Hainan Province, the main growing area for rubber trees in China, many farmers collect latex to sell to factories.

Furthermore, the trend toward *industrialized agricultural operation* [nongye chanyehua jingying] by larger companies with capital advantages poses a threat to small farms owned by individual peasants. Because peasants may not be able to afford the necessary farm machinery or technology, they cannot compete against these enterprises in either product quantity or quality. Despite advocacy for the integration of individual peasants into these agricultural enterprises, traditional farming is doomed to decline, as increasing numbers of *farm workers* [nongye gongren] are employed.

The harsh living conditions and lack of prospects in rural areas have also resulted in tragic cases of forced labor and prostitution. In poor rural areas, men and women, mostly uneducated but yearning for a better life, are often seduced by the deceptive enticements of criminal organizations. For the past few decades, women have often been abducted and sold into forced marriages, for example in remote parts of Yunnan and Guizhou Provinces. Moreover, increasing numbers of women are being sold to brothels in Chinese cities, as well as in neighboring countries such as Thailand and Malaysia, or even in Europe. Besides *human trafficking* [renkou fanmai], reports of young women being sold by their families or even working 'willingly' as prostitutes are not uncommon, especially in impoverished ethnic-minority villages near the borders of neighboring Southeast Asian countries. Ignorance, poverty and desperation to leave the countryside are among the causes of such tragedies. Young women are an extremely vulnerable group in this society, which considers everything a potential commercial commodity.

Although the Communist Party vowed to eradicate prostitution after 1949, it has been increasing sharply since the Opening-up. Many young women from poor rural areas are enticed to work in bars, hairdresser shops, karaoke bars, and massage parlors in cities, only to later find themselves trapped in the sex industry.

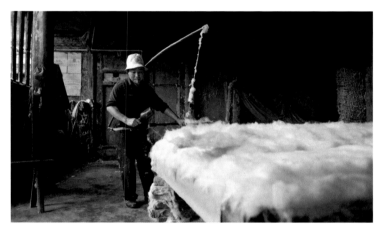

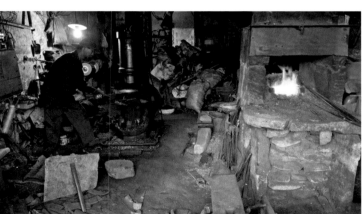

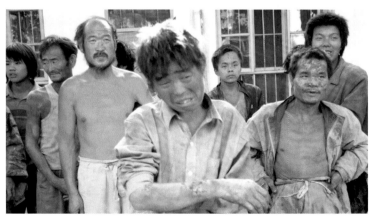

In Pianyan Old Town, Chongqing Municipality, the government has been successfully encouraging its residents to change to the *hukou of small cities and towns* [xiao chengzhen hukou] in order to speed up its urbanization plan. For four decades, the man (Top) has specialized in making cotton quilts and can earn up to RMB 20,000 (US $3,000) per year. His current workroom is located in a deserted temple hall. The smithy (Bottom) has been run by the same family for three generations. It stands between several residential houses. His neighbors seem to have adjusted to the noise and ashes leaking out through his door, which is never closed during working hours. The smith works full time and produces most of the iron goods and farming tools needed in the community.

The Italian missionary Leone Nani documented the harsh working conditions of miners in Shaanxi Province in the early 20th century. Although officially outlawed, there are occasionally still reports of slave labor. In 2007, for instance, a China slave scandal in Shanxi Province shocked the world. Thousands of people, including children, had been forced to work as slaves in illegal kilns and mines which had operated with government complicity according to Chinese media. Some of these people have brutally been tortured by the owners of the brickyards.

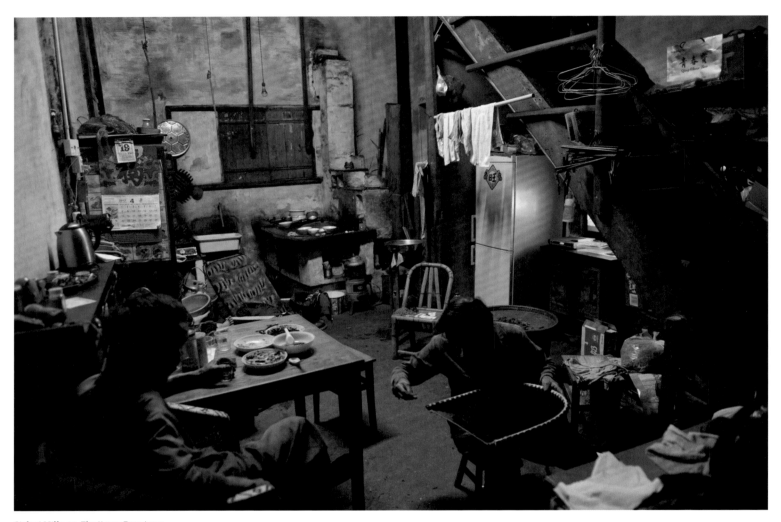

Sizhai Village, Zhejiang Province

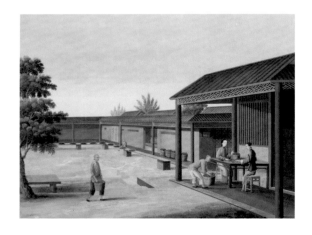

An illustration from the 1820s shows tea farmers bringing in the leaves from the fields for sorting. This labor-intensive procedure is still done by hand today in workshops or at home. A farmer couple in Zhejiang Province may earn up to RMB 10,000 (US $1,500) in the month of tea production, whereas their usual monthly income from grain and vegetable farming amounts to RMB 2,000 to 3,000.

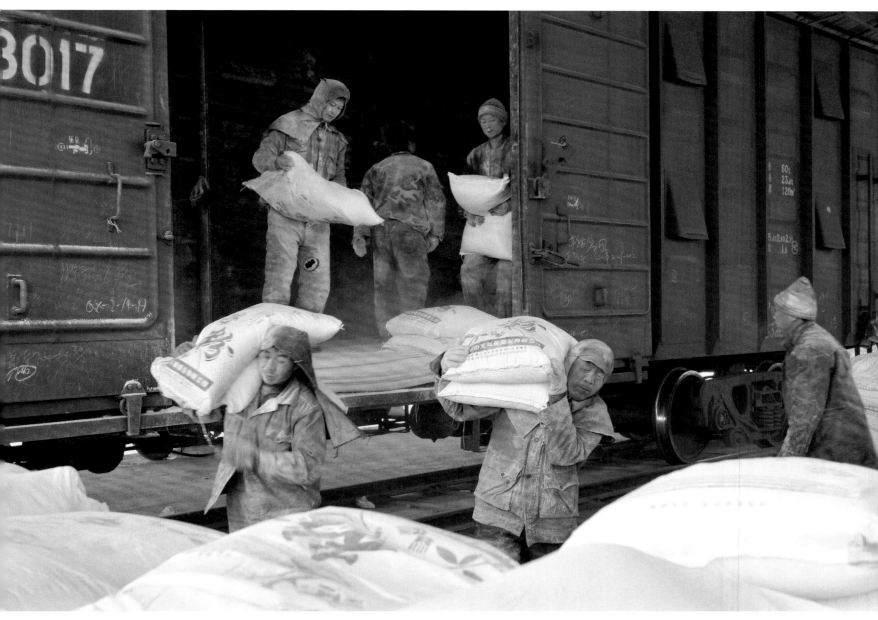

Songjianghe Town, Jilin Province

153

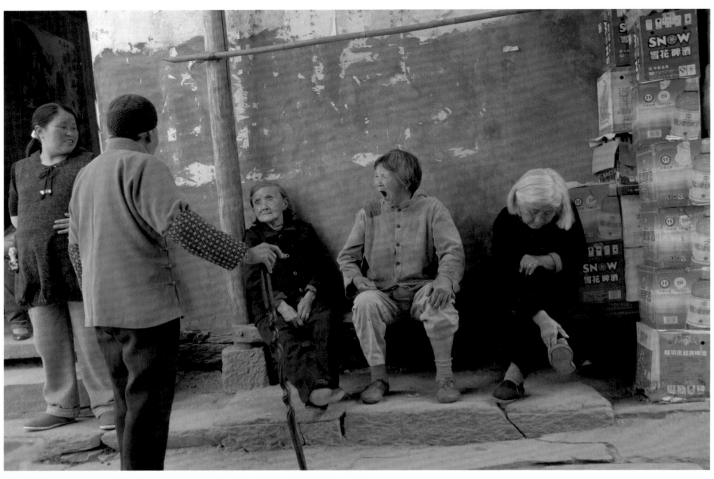

Wuyuan County, Jiangxi Province

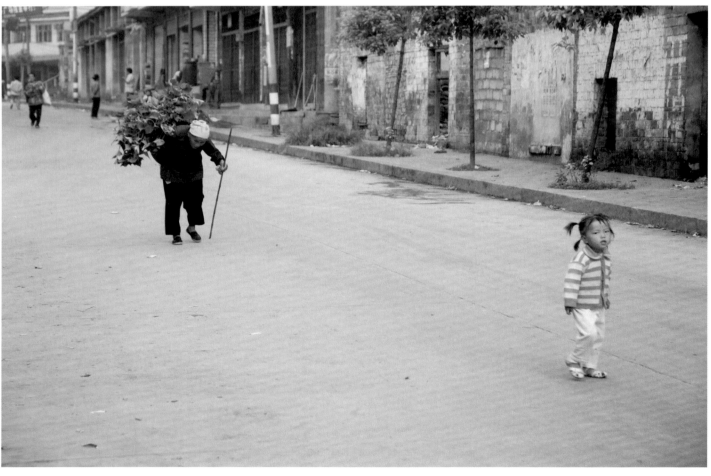

Shanjiang Town, Hunan Province

Tanghe Old Town, Chongqing Municipality

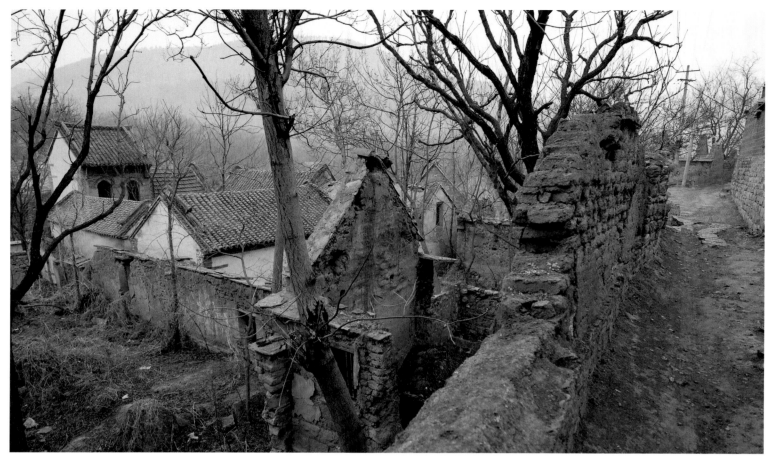

Ruins of deserted houses,
Zhujiayu Village, Shandong Province

The consequences of the rural population's aspirations for a better life are also shown by the decreasing numbers of persons residing in traditional houses. Most of the earlier migrant workers plan to return or have already returned to the countryside for their 'retirement' because they cannot afford to retire in cities. It is common for them to build a new house with better sanitary facilities while letting the old one fall into disrepair. However, a 2010 survey shows that only one percent of Generation Y migrant workers wants to return home later to take up farming. Most members of this generation still hold an agricultural *hukou* but actually have no farming experience. Hundreds of villages are gradually being abandoned and rural landscapes depopulated. The countryside has preserved its vitality only where tourism flourishes. The operation of *rural guesthouses* [nongjiale], China's version of bed and breakfasts, is one of the few new industries that have recently emerged in rural areas. Some young people have returned home to open their own shops, restaurants and guesthouses, or to work as tour guides. Only the elderly stay on in the traditional houses that their children would readily trade for modern housing.

In recent years, the countryside has been marketed as an idyllic place to escape from busy city life. Numerous travel books and websites cater to individual tourists, a relatively new phenomenon for the Chinese, who usually travel in groups. Therefore, most of the guest houses listed in such books are located in places already patronized by mass tourism, such as Lijiang or Guilin. In contrast, staying in *nongjiale* in less-frequented villages offers an experience of the authentic rural lifestyle.

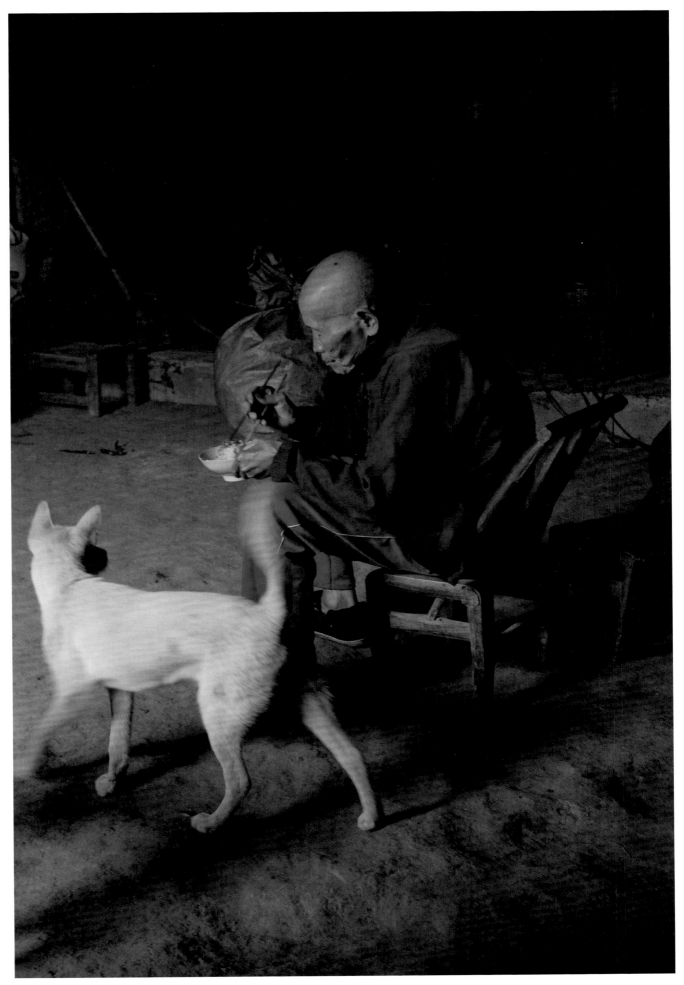

Shangqiantan Village, Hunan Province

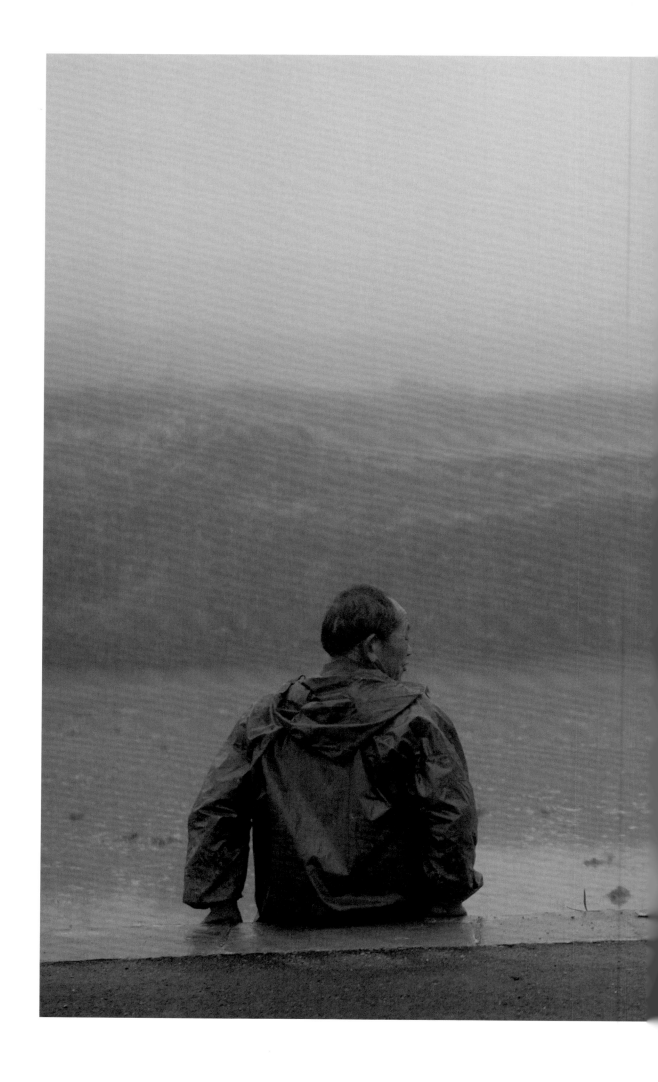

Qingman Miao Minority Village,
Guizhou Province

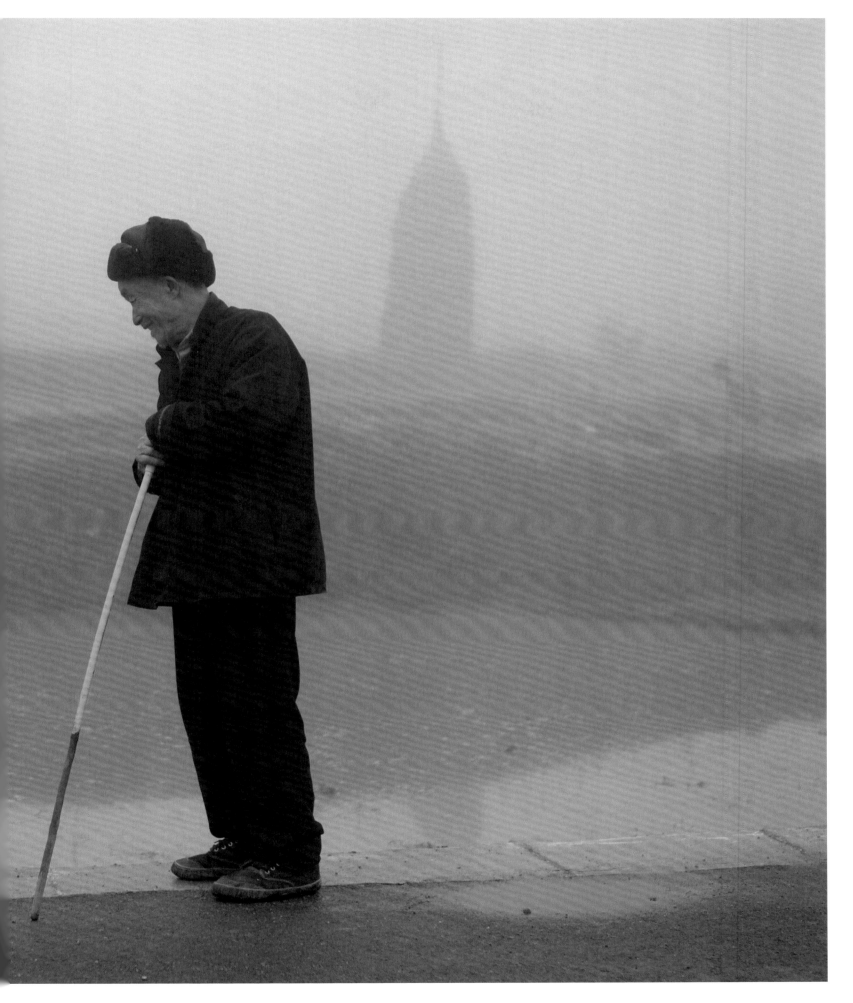

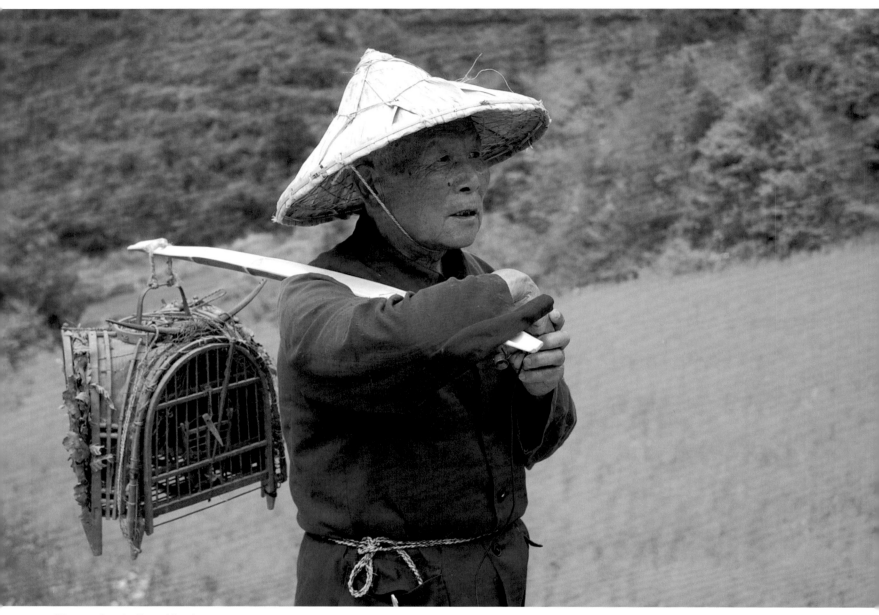

Wuyuan County, Jiangxi Province

Zaoziping Manor, Chongqing Municipality

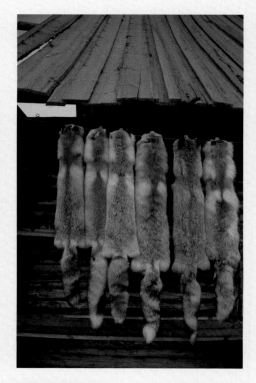

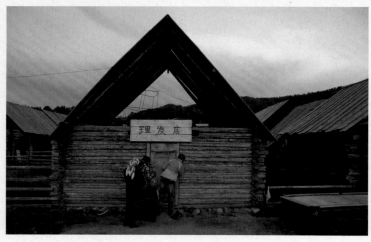

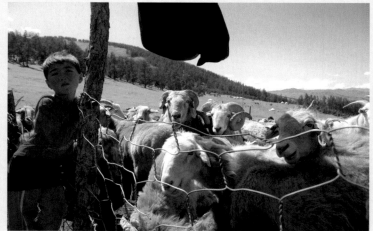

In the far north of the Xinjiang Uyghur Autonomous Region live the Tuvans, an ethnic group of Turkic origin that has been ruled during most of its existence by other peoples. While most Tuvans today are inhabitants of the Russian Federation (in the Tyva Republic) and Mongolia, about three to four thousand are counted in the Altai Mountain area of China's northwest. They migrated to this region from Siberia many centuries ago. According to official Chinese classification, the Tuvans are an ethnic subgroup of Mongolians.

Traditionally, the Tuvans are nomads, and their subsistence depends mainly on hunting and herding. Though a national nature reserve in this alpine grassland was established in 1986, the tourism industry in the vicinity of the famous Kanas Lake has developed rapidly in the past decade. This process threatens not only the sensitive balance of the ecosystem in a region with a distinct ecology, but also the indigenous culture of the Tuvans. Experts predict that the Tuvans in China may disappear within a couple of generations.

Like the Kazakhs, the Tuvans usually stay in log cabins during winter time. Every spring, they pack up their yurts and other basic necessities to start their nomadic sheep and cattle grazing. Traditionally, the Tuvans were adherents of Tengriism, a Central Asian religion that incorporated elements of shamanism, animism, and ancestor worship. In the course of history, many Tuvans have, like the Mongolians, adopted Tibetan Buddhism as their religion.

The biggest of the three remaining Tuvan settlements in China, *Hemu Village*, lies in a scenic valley surrounded by mountains. The quiet river meanders through the village and forests of silver birch. A light veil of moist fog floats in the air at dawn. When shepherd boys lead sheep and cows back home along the slightly dusty paths immersed in the golden light of sunset, the scene evokes a typical picture of rustic Siberian Russia more than anything else. Indeed, after the October Revolution broke out in 1917 in Russia, some White Russians found their way even into this remote area. But when the Sino-Soviet relationship deteriorated in the late 1950s, they all fled, leaving behind only the practice of apiculture. Today, many Tuvans in Hemu produce a precious local white honey and breed red deer for pilose antler, which is used in Chinese medicine.

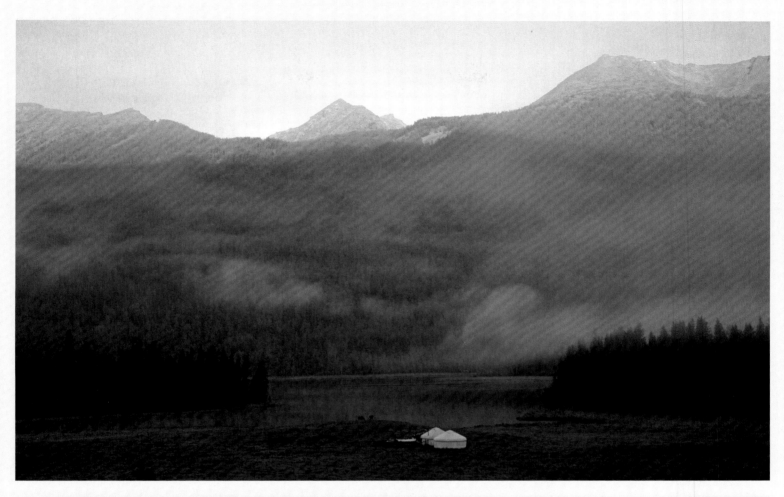

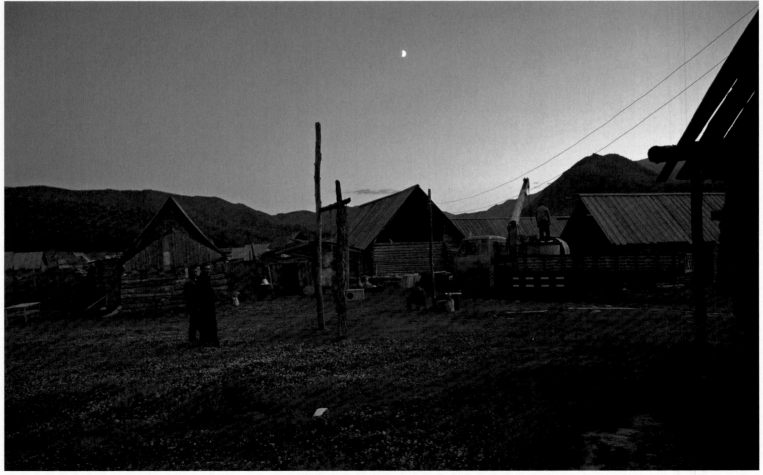

Wubao Old Town in Shaanxi Province was once a prosperous place on a cliff above the Yellow River. Due to its strategically advantageous topography, a military stronghold was established here as early as the Tang Dynasty (618–907). Wubao was known as 'copper town' for its defense capability and gradually developed into a county seat in the thirteenth century. An old map from the nineteenth century shows that at that time, besides the county government, nine temples, a staple warehouse, a school, an office for educational affairs, an ancestral hall, a police station and separate prisons for men and women were located inside the town walls. When a highway pass-

ing the foot of the hill was built, the Nationalist government moved the county seat to the more conveniently located town of Songjiachuan. During the Sino-Japanese War (1937–1945), Wubao was severely attacked, but the Japanese Army did not succeed in crossing the Yellow River here.

Although Wubao was officially listed for heritage protection in 1982, it has not avoided falling into disrepair. Weeds cover the ruins of former courtyard houses and the deserted streets. The only modern-looking building in Wubao is the white-tiled cultural-preservation office whose rusted gate seems to have been locked for a long time.

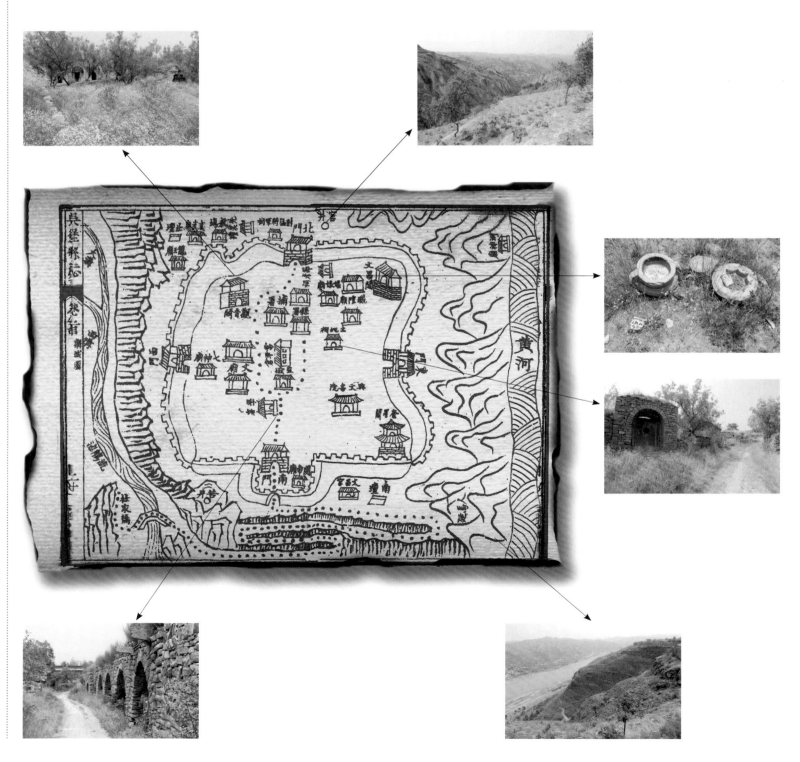

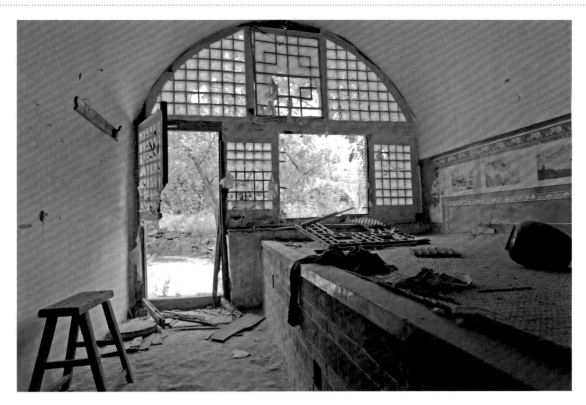

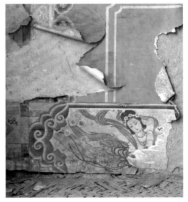

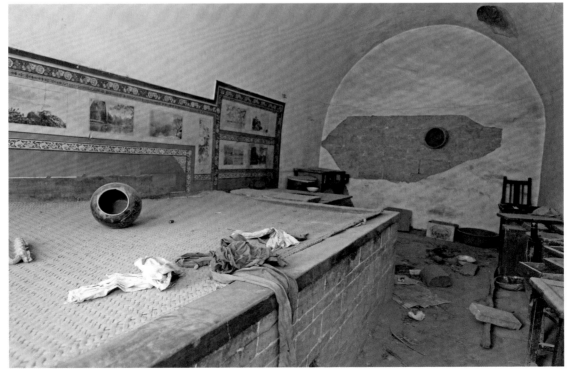

A deserted cave dwelling in Wubao Old Town

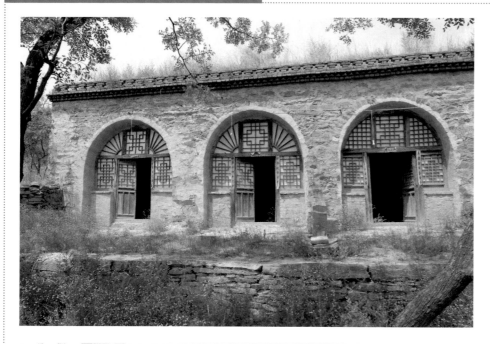

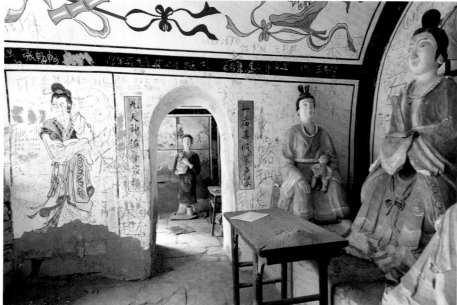

The temple of *Niang Niang*, the Goddess of Fertility, was famous for blessing women with children. According to the inscription on a stele erected during its last renovation in 1994, the temple was largely destroyed during the Sino-Japanese War and fell into disuse. Except for the temple structure and fragments of decorations, no traces remain from earlier times. Until a few years ago, a temple festival was still held periodically and attracted peasants from neighboring areas.

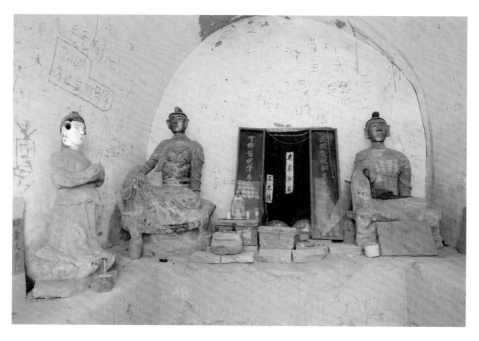

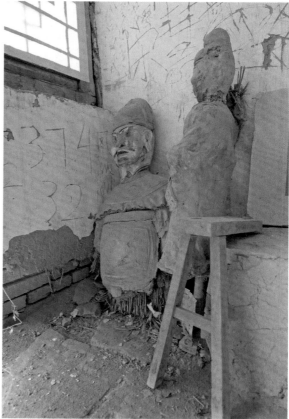

After the highway to the new county seat was completed in 1935, Wubao Old Town was downgraded to village status. Poor road construction uphill further isolated it. The stony hills around Wubao make farming difficult and unprofitable. Besides a small plot of land for planting vegetables, only jujube trees seem to grow well here. Most villagers have moved away during the past decades. Until a couple of years ago, a self-educated farmer in his eighties surnamed Wang collected abundant historic materials from this peculiar place where his family had lived for centuries. In 2010, a married couple and the man's brother, keeping body and soul together by collecting wild jujubes, were the only residents of Wubao.

"Six major drug criminals are brought to trial" is one of the headlines in the newspaper glued on the window.

167

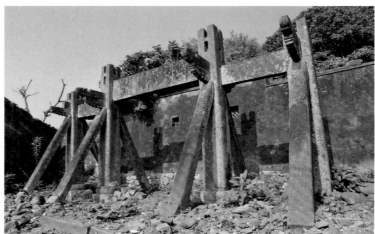

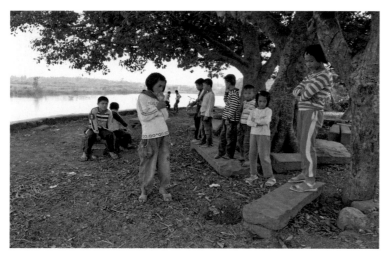

More and more people are leaving *Luoyi Village* and *Meitao Village,* located at the foot of volcanic mountains in Hainan Province, for urban areas. Luoyi Village was first set up during the Song Dynasty (960–1279) as an *imperial postal station* [yizhan], where official couriers could stay overnight, get supplies or change horses. Later on, the hamlet grew into a farm village with 6,000 residents. Some natives, encouraged by the Confucian tradition of *cultivating both the land and the mind as the family discipline,* passed the *imperial examination* [keju kaoshi]. This history explains why some precious cultural traces are left on an island once regarded as a barbarian backwater and place of exile for political prisoners and disgraced officials.

Nowadays, life in Luoyi lacks the grandeur of the past. Most remaining villagers cultivate rice and vegetables throughout the year, but they cannot improve their living standards with their meager income. The many residents who have left Luoyi and Meitao rarely return, except for the yearly ceremony paying respect to their ancestors. Many traditional dwellings built of volcanic stone and wood are no longer occupied, and the historic architecture is at risk of crumbling into dust. Old cemeteries were destroyed during the Cultural Revolution, and the gravestones were used to pave alleys and the lakeside square. Other cultural relics, such as the *monumental gateway* [paifang], had a similar fate and today stand there equally neglected.

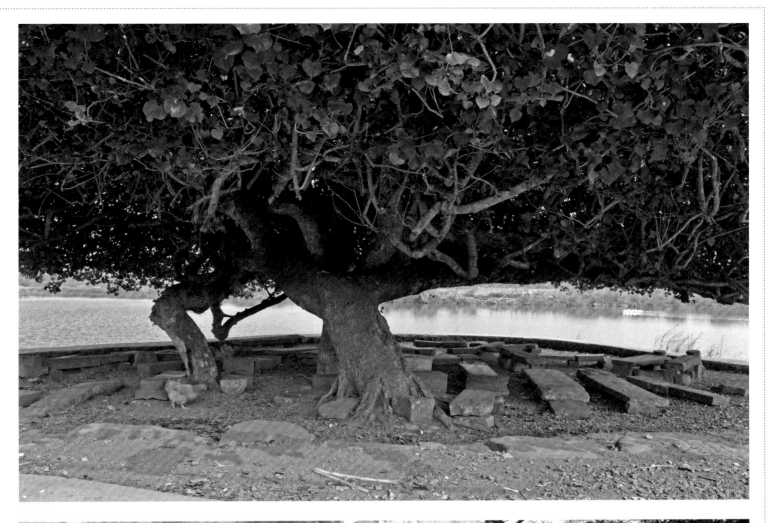

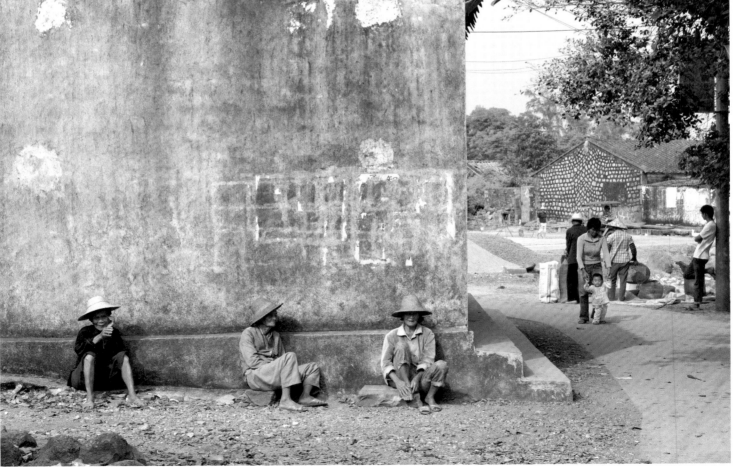

Meitao Village, Hainan Province

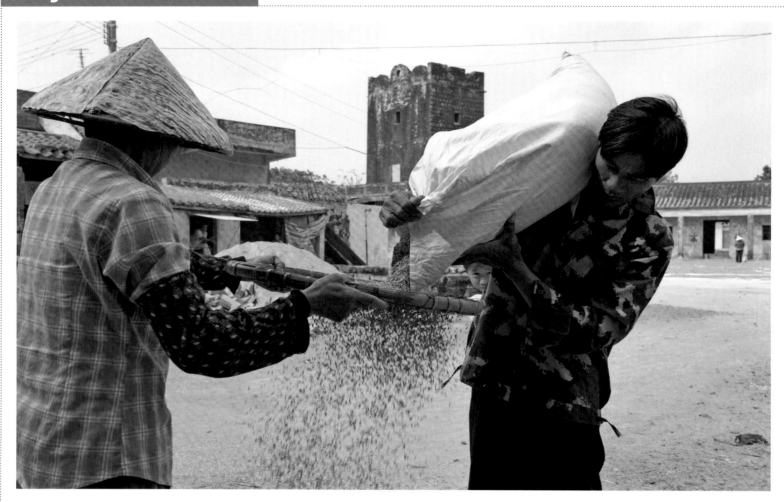

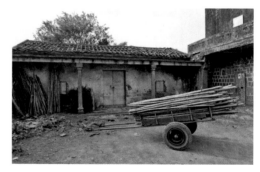

Any 'landmark' buildings in villages, towns and county seats are usually local-government offices. In Meitao, the village committee's building is adorned with decorative Roman columns as a symbol of modernity and wealth. The meeting room, with a Mao Zedong portrait on the wall, boasts some more modern furnishings, unlike the otherwise sparse interiors.

A gray fortified watchtower built around the turn of the twentieth century stands nearby in a ramshackle condition. It was erected with the support of overseas Chinese to prevent Meitao from being ransacked by pirates, who frequently looted seaside villages. Inside the watchtower, pages of the *Los Angeles Times* from the early 1940s were used as wallpaper. People suspect that the newspaper was brought here by the Japanese Army, which occupied the island between 1939 and 1945. The lower building next to the tower was once the *village cultural bureau*, which played an important role in promoting peasant culture in the 1960s and 70s.

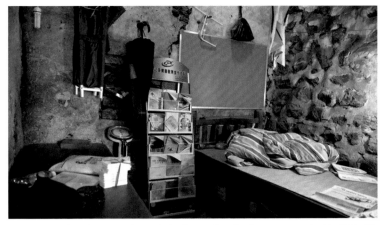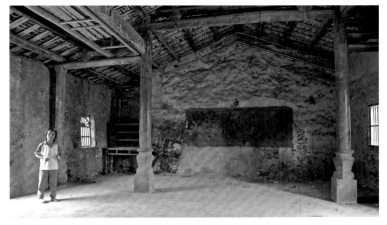

The *village clinic* [cun weishengshi] is located in the former ancestral hall. It offers affordable basic health care to the residents, as stated on a poster in the consultation room. Another part of the ancestral hall was cleaned out in the 1960s and has become the gate of an elementary school.

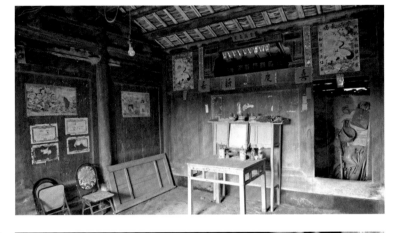

While many old houses have become entirely deserted, this family, which moved into a new building in the nearby town, occasionally returns to its former home. The red couplets were posted some months ago when a traditional wedding was held. Some people commute between the town and their farmland, while others who found another job rent out their acres.

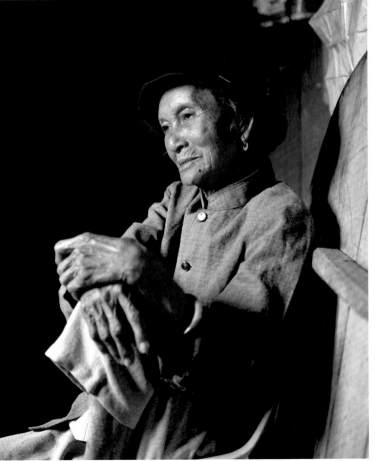

The remaining occupants are mostly women, elderly persons and children. The resident of this room with a red mosquito net is a woman in her seventies. Her adult children have all left the village as migrant workers. She earns a living by farming and raising poultry in a room previously used by her children.

The remote *Huangtu Township* in southwestern Hunan Province was off limits to foreigners until 2007 due to its military sensitivity. For centuries, the region has been inhabited by the Dong Minority and is famous for its fir trees. It is believed that the ships of the famous fifteenth-century seafarer Zheng He were built of timber from this area. Thanks to an improved irrigation system, the Dong here became richer during the Qing Dynasty (1644–1911), when the most magnificent buildings were built. After the First Opium War (1839–42), the region became impoverished because of corruption and exploitation. Due to its inconvenient accessibility, the Dong in Hunan lead a more impoverished life than their peers in the south of Guizhou Province.

Besides forestry, farming is the major occupation of the Dong, who call themselves Kam. Contrary to the ordinary Han Chinese practice, they cultivate glutinous or sticky rice, which is locally known as *Kam rice*, or 'good rice.' Other economic activities include carpentry and the manufacture of silverware and wickerwork.

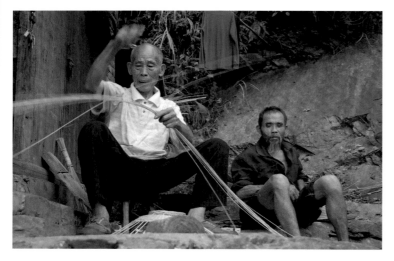

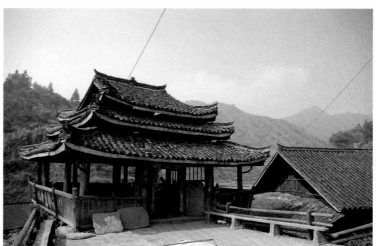

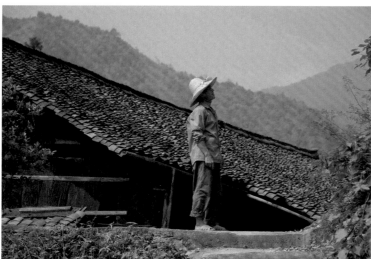

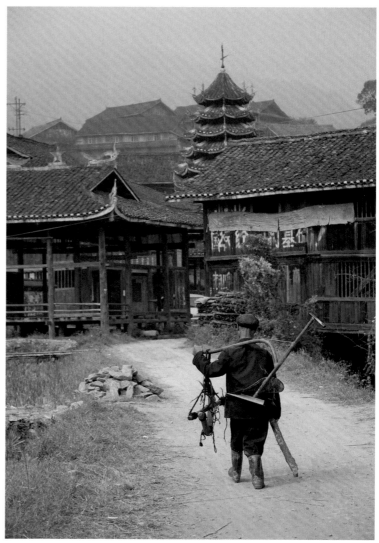

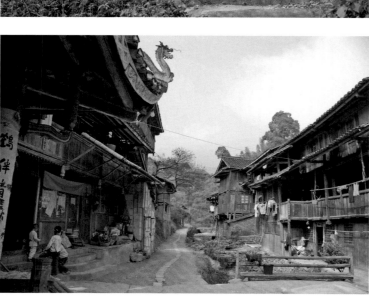

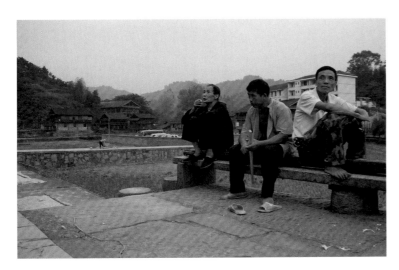

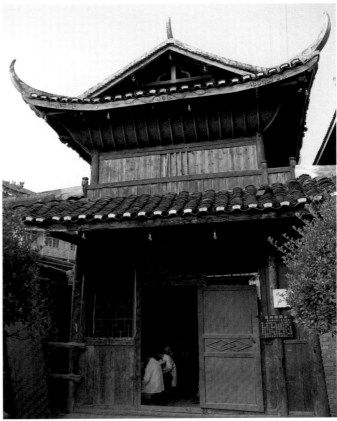

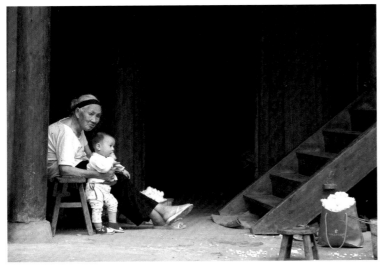

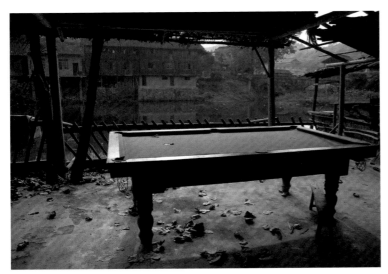

Huangtu Township is now dotted with poor Dong villages near hillsides and rivers, and most young people have moved away to work in urban areas. For those remaining behind, there are two very popular spots to take a rest: One is in the open spaces, such as around the square or the village bridge, and the other is in the beautiful traditional two-story wooden *building for honoring seniors* [chongyang lou]. Elderly villagers like to gather here to play card games or chat. In accord with Dong custom, it is only frequented by men. The billiard table set up for youngsters is rarely used.

The worship of *Guanyin*, the Buddhist Goddess of Compassion, became popular in China around the sixth century. Originally depicted as male, this deity gradually evolved into a goddess, reflecting her maternal love and mercy as understood and preferred by believers (Zhujiayu Village, Shandong Province).

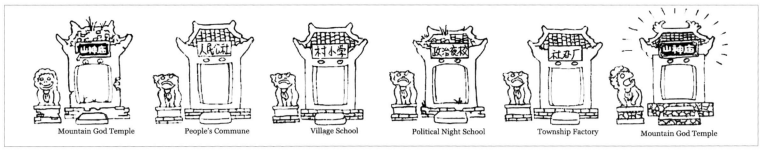

| Mountain God Temple | People's Commune | Village School | Political Night School | Township Factory | Mountain God Temple |

This illustration vividly illustrates the alternative uses of temple buildings over the last few decades.

Of Soul, Spirit and the Supernatural

In many ways, searching for the vestiges of traditional
Chinese society is still easier in rural areas than in big cities,
where life is increasingly modern and globalized.

This also holds for the religious revival, which in the past few years has increasingly drawn the attention of both experts and laymen. Dozens of books and articles have discussed this topic, mostly in terms of the great void left by the 'death of Communist ideology' or the revival of religion despite oppressive Communist Party measures. In short, one could say that the government no longer considers religion the "opium of the people" (Karl Marx), but still sees it as a potential source of instability.

The Chinese Communists started their war on religion almost immediately after founding the PRC, with its strongly atheistic ideology. They regarded religion as an evil, a survival of feudalism and Western colonialism. Not until the Opening-up did the government relax its pressure, permitting a widespread revival of religious faith and practice. The reasons for the revival were diverse: The end of the Communist ban on freedom of worship, popular disillusionment with Marxist ideology, and the resilience of religion and tradition despite decades of oppression. Many Chinese began to worship in temples again, and church services attracted increasing numbers of believers.

Religions in China are usually classified into three categories: The official (Buddhism, Taoism, Islam, Catholicism and Protestantism), the unofficial (underground Protestant and Catholic churches, unofficial sects, and Tibetan Buddhists and Xinjiang Muslims who challenge Beijing's sovereignty) and the popular (folk religion). The major religions in China are also referred to with colors: 'Red' (officially permitted religions), 'gray' (religions with an ambiguous legal/illegal status) and 'black' (officially banned religions).

The religious revival, although pragmatically tolerated by the still atheistic Communist Party, has posed formidable challenges to the leadership. While the government continues to liberalize the economy, it favors 'state-sponsored' religious activities and still suppresses 'independent' religious organizations. Furthermore, it is

Almost all Chinese temples and ancestral halls were desecrated during the Cultural Revolution. Most of them were used as warehouses, stables or People's Commune offices. Some have slowly regained the splendor of their original appearance, but many still bear traces of past political upheavals. Historical movements like the *Smash the Four Olds* campaign and the current trend toward urbanization have reduced the importance of clan membership and ancestor worship in the countryside.

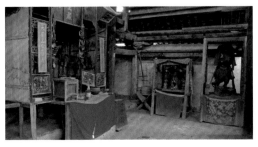

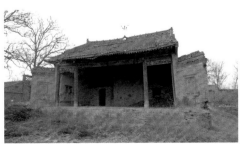

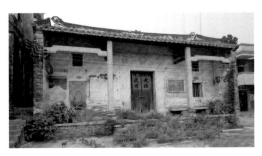

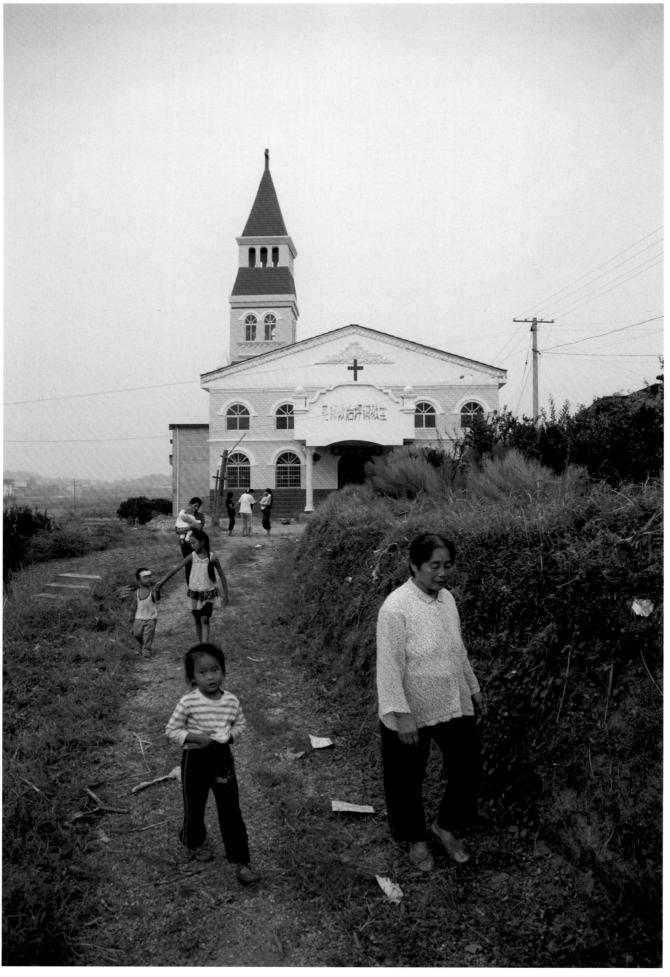

Houping Town, Hunan Province

Catholic missionaries were the first evangelists to begin working in China, followed by Russian Orthodox priests and Protestants. Due to their tolerant attitude toward the practice of Confucian rites, the Jesuits were welcomed by the Kangxi Emperor (1661–1722). The 'Wordless Book,' a Christian evangelistic book for preachers, was popular and facilitated the missions' success. However, the growing influence of the Dominicans and their fight against 'Confucian idolatry' finally moved Kangxi to ban Christian missions. Missionary activities were only resumed in the nineteenth century. Hebei, Shanxi and Henan were among the favorite provinces in which to set up churches and missionary schools. In times of political turmoil, Chinese Christians were often regarded as traitors by non-Christian Chinese.

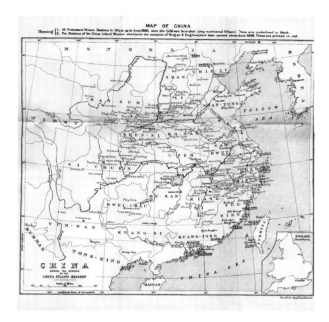

rather vague in defining exactly which religious activities are prohibited and what is tolerable superstition, and this vagueness suggests that the government is deliberately keeping the population in the dark to better exert control.

In many ways, rural China is especially susceptible to the religious revival. There are several reasons for this development, which has a number of characteristics. First, consider Christianity. Some observers have noted that Christianity is more vigorous today than at the peak of Protestant evangelism by Western missionaries in the 1920s. Even though the Communist Party has created an array of state-run organizations to control and manage religion, everywhere in rural China there are increasing numbers of adherents of so-called *underground churches* [dixia jiaohui], sometimes also called *house churches* [jiating jiaohui]. Experts have estimated that in some provinces, the underground church has twice as many members as the official church.

Second, *folk religions* [minjian xinyang], or *Shenism* [shenjiao], have also become very popular in rural areas. This category includes the various ethnic religious traditions that for thou-

This magnificent Catholic church seems oddly out of place amid simple Chinese houses in the county seat of Daming in southern Hebei Province. The first group of Christian missionaries in Daming was not appreciated by the local government and was suspected of collaborating with criminals. The large brick Gothic-style cathedral in Daming was built by French missionaries in 1918 and served as the center of the parish. In the 1940s, there were about 40,000 converts in this area, including many farmers. Oddly, their numbers increased during the Sino-Japanese War: After the 1920s, Daming was transferred to missionaries from Hungary, which maintained excellent relations with the Axis powers. Thus, the Japanese did not view them as enemies, and locals easily found shelter in the church. After the Communists took power, all foreign missionaries and nuns were expelled, and the church property was confiscated and used as a government warehouse. Several Chinese Christian members of the diocese were imprisoned and died during the Cultural Revolution. It was not until the 1990s that the church resumed its former religious activities. With growing numbers of believers in recent decades, the need to build new churches also increased. Many of these rural churches are co-financed by overseas Chinese Christians.

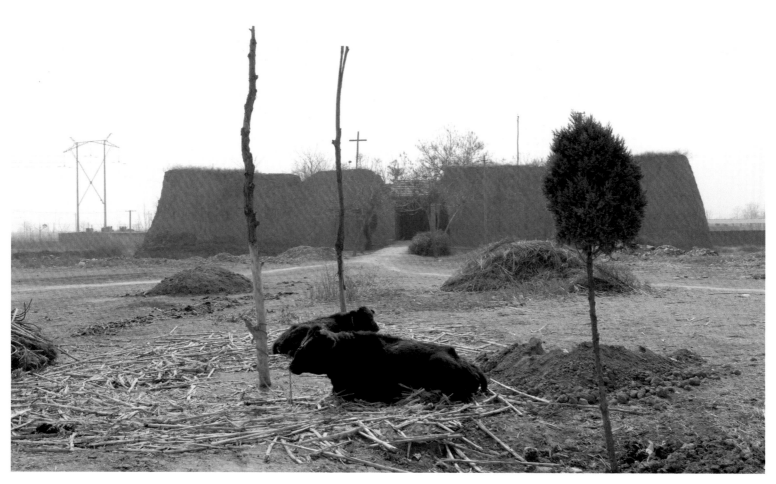

Despite the obvious architectural diversity, Christian churches throughout the countryside share two similarities: They all offer shelter to those in need, and they are usually cleaner and tidier than most rural residential houses. This church in Niuzhuang Village in eastern Shaanxi Province, typical of the Loess area, is surrounded by the remnants of an old mud wall. It was built to protect local Han Chinese from rebel Muslims during the Dungan Revolt in the late nineteenth century. As with other rural churches, the door is open only when mass is celebrated. Most of the time, the sacristan, like other villagers, is busy with his farm chores and cows.

The tradition of building roadside shrines for the *God of the Earth* has been popular for centuries. Already in the nineteenth century, Western travelers were often enchanted by this rural custom, which reminded them of portrayals of Saint Christopher in Europe.

sands of years constituted the majority belief system in China, not only for the Han Chinese, but also for many ethnic minorities. Among the folk *deities* [shen], there are nature deities, national deities, regional deities, and gods inspired by cultural heroes or legendary animals. These deities are worshipped as demigods and are closely linked with Chinese mythology. Since the early 1980s, ancient temples and ancestral halls have been restored throughout the countryside. Fortune telling is also on the rise again, along with occult 'healing' practices. Older women usually provide these services and, in addition, perform 'miracles' by directing spiritual forces. Among the most powerful and widespread deities or saints are *Guan Yu*, the bearded hero and general of the Three Kingdoms period (220–280 AD); *Tudigong*, the God of the Earth; *Cai Shen*, the God of Wealth; and, in coastal areas, *Mazu*, the Goddess of the Sea. Chinese folk religion has strong ties to *Taoism* [daojiao], but over the course of the centuries, the latter has tried to assimilate local religions.

There is another reason why rural China is in many ways at the forefront of the religious revival. The two largest minority areas, the Autonomous Regions of Xinjiang and Tibet, are home to ethnic minorities that integrate religion into the core of their culture: The Uyghurs with Islam,

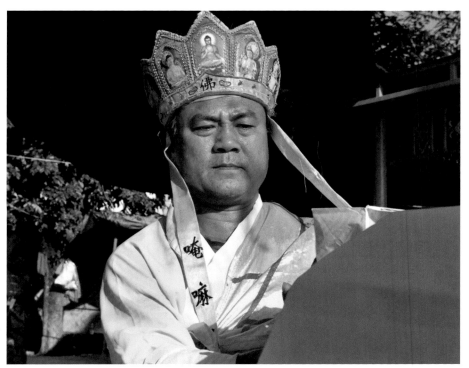

In coastal areas, the sea has a great influence on people's daily lives and thus also plays an important role in the local folk religion. The accidents that befell fishing boats at sea were often attributed to malevolent sea ghosts, as in the story told in this old illustration. *Mazu*, the Taoist Goddess of the Sea, has been commonly worshipped by fishermen in the southeastern provinces since around the fifteenth century. According to legend, Mazu was born the daughter of a fisherman and was endowed with special powers. Once when her father and brothers were caught by a violent typhoon at sea, she sank into a trance and saved their lives at the cost of her own. Sanjiang Temple at Xincun Harbor in Hainan Province is one of the temples dedicated to Mazu. Although it has a large number of local followers, it is threatened with relocation for tourism development.

Luoyi Village,
Hainan Province

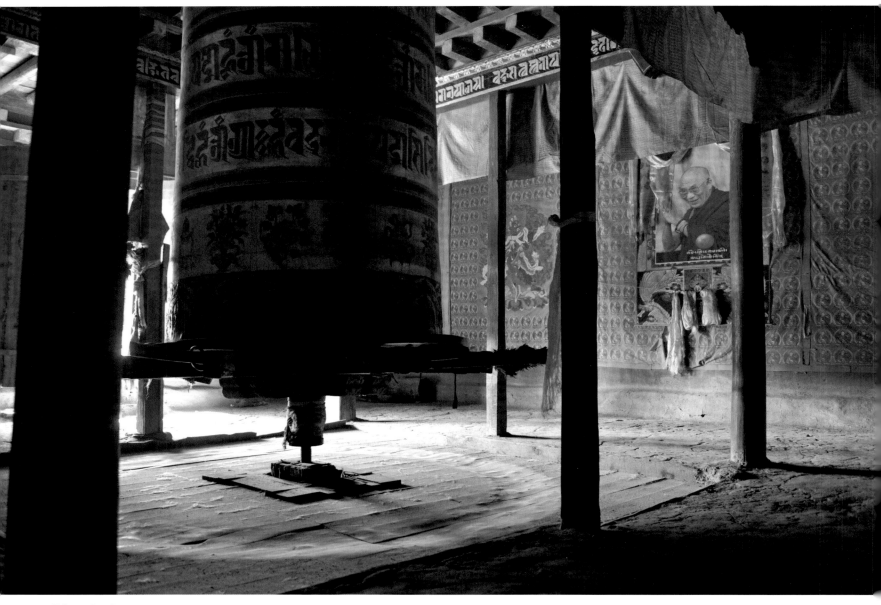

Sichuan Province

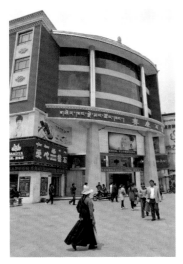

and the Tibetans with *Tibetan Buddhism* [zangchuan fojiao]. Since the founding of the PRC, Tibetan Buddhists and Xinjiang Muslims have been under strict governmental surveillance to a degree that has created a vicious circle: The tighter the government control, the more some Tibetans and Uyghurs resort to 'illegal' activities. The government itself has pointed out that for the sake of a *harmonious society* [hexie shehui], a revival of religion in these two sensitive regions is in the interest of all residents. However, the Communist Party could not prevent some members of both minority groups from resorting to violence to express their outrage at the Sinicization process that Han Chinese migrants from the interior of China continue to advance.

Today, one senses a climate of uncertainty and fear in many Tibetan regions. The government is trying to win the respect of the indigenous population by introducing numerous benefits of the 'civilized' world, but Tibetans continue to deplore their tragic history, their fate, their loss, and especially the suppression of Tibetan Buddhism. The present Chinese government is trying to make amends for the terror and brutality of the past through the restoration and construction of historical buildings like temples and golden pagodas. However, many centuries-old wooden monasteries, precious Buddha figures, priceless *thangkas* and wall-painted frescos, yellowed manuscripts of Buddhist scriptures, antique prayer wheels and other ritual artifacts have been lost forever, leaving behind a devastated cultural landscape as a silent witness to past injustice.

A similar feeling of desperation is perceptible in rural parts of Xinjiang, home to the Uyghurs. Many Uyghurs, above all the young, feel that discrimination has left them no prospects for the future. After 1949, there was a massive influx of Han Chinese into their region. According to a 1953 PRC census report, there were only about six percent Han Chinese in the population, while today the figure has risen to over 40 percent. As in Tibet, the government policy is to promote economic development and ensure social stability by sending Han Chinese technicians, engineers and workers to the 'new territory' (this is what 'Xinjiang' literally means). This process chiefly started with the establishment of the *Xinjiang Production and Construction Corps* [Xin-

While Lhasa, with its estimated 10,000 to 30,000 inhabitants in 1959, was considered chiefly rural at that time, it has changed rapidly in recent years. Today, with a population of more than one million, it resembles in many ways numerous other large Chinese cities.

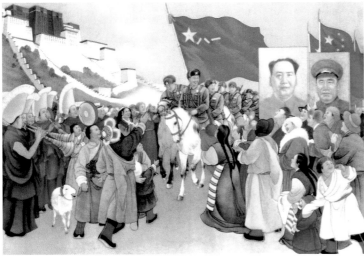

Tibet has long been a controversial issue for both China and the West. Soon after the Communists 'liberated' the Roof of the World in 1951 (Illustration bottom left), the battle of words over this sacred region began to escalate. While the Chinese government was quick to proclaim its stand against a "corrupt and brutal theocracy based on serfdom and slavery," most Westerners cherish a romantic view of Tibet as a magical and mysterious land. This dispute has continued for decades in political discussions and propaganda. In the early 1990s, Beijing warned Tibetans against spreading "unhealthy thoughts" Twenty years later, the government continues to denounce the "Dalai Lama clique" for dividing the Motherland. Today, the situation in Tibet is still extremely tense, especially after the 2008 Tibetan unrest in Lhasa and many parts of Sichuan, Gansu and Qinghai Provinces. The '3–14 Riots,' as the Tibetan unrest is called by Chinese, is an unresolved issue that cannot be discussed publicly. The recurring self-immolation of monks and nuns in Tibetan areas of Sichuan points to the wide-ranging effects of the government's firm determination to maintain stability. Visitors to monasteries are often surprised to find a rather museum-like atmosphere, with freshly-painted temple halls and opening hours as in a public building. Nevertheless, the soul of Tibet, with its many religious artifacts and rituals, such as holy sky burials (Photo: Luqu County, Gansu), continues to be revered by locals as well as many Westerners.

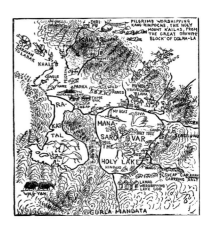

Many secret religious societies continued to be active even after the founding of the PRC. It is believed that in 1949, they had even more members than the Communist Party. The groups were consequently regarded as a serious threat to the new regime. Although their activities were suppressed in the following three decades, their ideological and organizational principles have survived. The expression *evil religion* reappeared in the 1990s, and illustrated propaganda remains the most effective and common means to warn peasants to beware of these societies.

jiang Shengchan Jianshe Bintuan], a unique economic and semi-military governmental organization, in 1954, on the orders of Mao Zedong. As in other parts of China, the campaign to *Smash the Four Olds* [po sijiu] has had disastrous consequences for the history and traditions of this cultural landscape. Besides the destruction of mosques and desecration of holy sites, some of which were converted into livestock pens, traditional values such as hospitality or trust were severely compromised.

Finally, the religious revival in rural areas also came about because of the growing popularity of cults and sects that belong to the category of banned or illegal organizations. Despite the government's vigorous efforts to fight them, they continue to flourish. China has a long tradition of secret societies that are mainly created to offer alternatives to family or professional bonds and to satisfy the longing for lost identities. In non-Christian milieus, the *Falun Gong* movement founded the *Practice of the Wheel of Law* [falun dafa] in 1992. It combines Taoist meditation with Buddhist doctrines and has, especially since its prohibition and nationwide persecution, become the most well-known sect abroad. According to expert estimates, in the 1990s the government was fighting to stamp out nearly 10,000 sects in Hunan Province. Besides Falun Gong, other banned religious organizations include the *qigong*-based *Zhong Gong*, which boasted almost 40-million followers in 2003, the *Goddess of Mercy Dharma sect* [Guanyin Famen], and the *Immortal True Buddha sect* [Lingxian Zhen Fozong].

Less popular compared to Taoist- or Buddhist-inspired sects, but still a big headache for the government in rural areas, are the illegal Christian sects. The so-called *Shouters Faction* [Huhan Pai], for instance, could boast of roughly 200,000 followers in 1983, and despite government crackdowns it still had over 50,000 in 1996. Some sects, such as the *Religion of the Main God* [Zhushen Jiao] or the *Resurrection Way* [Fuhuo Dao], have been stamped out by the government; others continue to survive underground, for example the *Spirit Church* [Lingling Jiao] or the *Established King* [Beili Wang]. Among the shared characteristics of all these sects are their hierarchical structure, a personality cult centering on the sect leader, rigid control of sect members, and claims to possess supernatural powers.

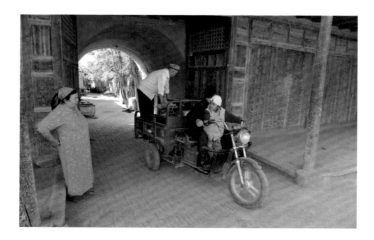

While the majority of Uyghurs and Tibetans live in regions officially assigned to these ethnic minorities, the majority of the Hui Muslim Minority has set up settlements all over the country. During the Tang Dynasty (618–907), Muslim merchants entered Chinese territory via Central Asia on the Silk Road and left their traces in Gansu and Shaanxi Provinces. Soon, traders also settled along the coastline in places like Fujian or Guangdong Provinces. It is therefore not surprising that flourishing mosques were built in even more 'traditional' Chinese provinces like Henan and Anhui Provinces. The Hui are usually considered by many Chinese to be less doctrinaire and fanatical than the Uyghurs. In general, they seem to be more content with the status quo. This might be why they have been allowed to build modern mosques all over rural Gansu, Ningxia and Inner Mongolia in the last two decades. While in the course of modernization Islamic style architecture has gradually disappeared in urban areas, distinctive Muslim lifestyles are by no means disappearing in rural areas. The *Three Mas of the Northwest* [Xibei San Ma], Muslim generals of the Ma clique during the Warlord Period (1916-1928), are still greatly revered by the Hui. Even today, some villages in remote areas of northwestern China have the reputation of being unsafe for outsiders at night.

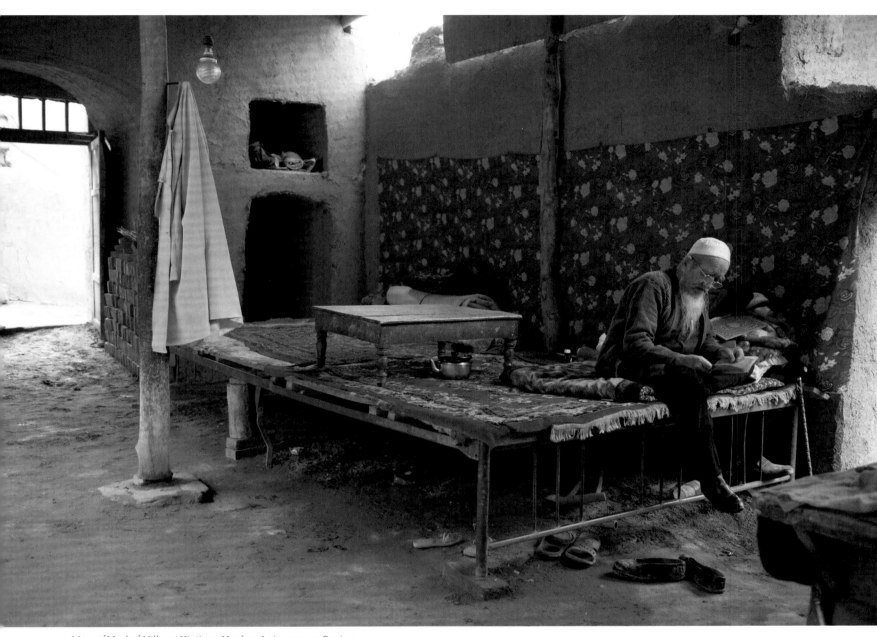

Mazar [Mazha] Village, Xinjiang Uyghur Autonomous Region

A 1990s poster proclaiming a famous Party slogan: *Uphold science in order to eradicate superstition.*

Developing a policy for minorities and creating propaganda to support it were crucial to the Communists' success in unifying the vast country. Its success was, however, mainly a result of employing carrot-and-stick tactics.

For the central government, the problem with these sects is less their often-hostile attitude towards the Communist government than the fact that in many rural areas religion competes with and in some cases is even gradually replacing *township* [xiang] and village governments as institutions enjoying legitimacy, popular support and a reputation for helping the needy. According to the government, another problem is the ties between religious sects and criminal elements. Experts maintain that shamanism and religious cults have revived kinship organizations, and flourishing criminal gangs appear to be joining forces with these cults to resist central state power.

Whenever the government finds it necessary to warn the masses against *evil religions* [xiejiao], it uses the propagandistic style of regimes that fear freedom of belief and religion. Article 300 of the Chinese Penal Code refers to organizations of evil religions. In this legal framework, slogans and warnings are posted on walls and billboards throughout the countryside. As with other sensitive topics, they reveal a lot about the problems the government faces in different regions. Propaganda is, in the government's eyes, above all people's education. Using Marxist methods, the government tries to counterattack these evil religions using 'scientific principles,' as suggested by the slogan to *Uphold science in order to eradicate superstition* [chongshang kexue, pochu mixin].

Less controversial nowadays – compared to the religious revival – are the renaissance of ethnic diversity and the regime's response to it by permitting ethnic festivals. While the typical traditional Han Chinese festivals, such as the Dragon Boat Festival, the Moon Festival or Tomb-Sweeping Day, suffered severe setbacks during the Cultural Revolution, the harm done to the festivals of ethnic minority groups was much greater. There were official efforts to destroy all forms of ethnic variety and compel ethnic assimilation. The government prohibited the teaching and study of minority cultures and declared them treasonous.

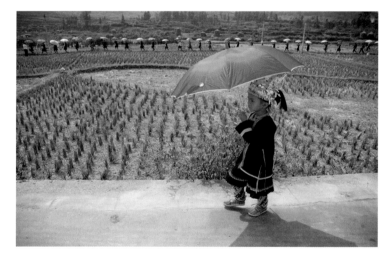

The *Lusheng* Festival is an important celebration for the Miao and Dong Minorities in Guizhou Province. In the course of time, this festival, although of an indigenous religious origin, has lost much of its spiritual meaning in favor of its social and entertainment functions. Like many other folk festivals, it has been used successfully to promote local tourism (Photos: Liping County, Guizhou).

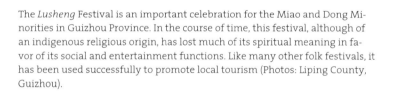

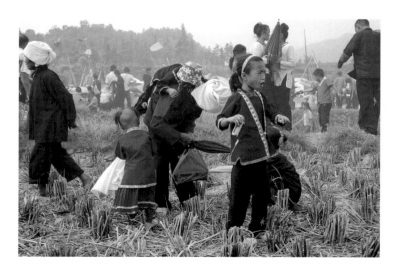

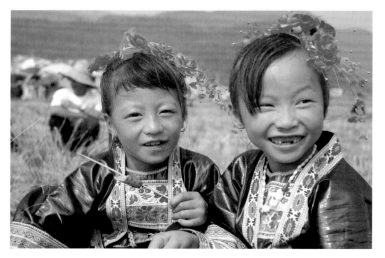

Only with the Opening-up did the situation improve for ethnic minorities. Although there was no change in the official doctrine of the Chinese nation's homogeneity, the policy of regional autonomy for ethnic minorities became more tolerant. This also meant that the management of cultural knowledge and practices, including languages, religion and education, has been transferred to local leaders in their respective minority areas. The central government has gradually realized that a more moderate approach to minority issues could win support and approval from local populations. At the same time, the regime became aware that it could benefit from showing the outside world a pluralistic nation where ethnic nationalities preserved their unique cultures, vibrant traditions and ancient religious beliefs – colorful aspects of the nation's heritage that were condemned to extinction during the Cultural Revolution. In today's China, whether it is the Dai Water-Splashing Festival, the Yi Torch Festival or the Miao Lusheng Festival – all these festivals are again an important element of minority identity. Their festive activities contribute to the cultural vitality of peoples that many Han Chinese once regarded as backward or even uncivilized.

Today, when the government's policy proclaims a *harmonious society* and good relations between ethnic groups, one could easily forget that the same Communist Party formerly tried to destroy the distinctive features of ethnic-minority cultures. Many Chinese are inclined to equate the Cultural Revolution with Mao Zedong alone. Thousands of Red Guards and members of the rusticated *urban youth* from county seats and cities were active in almost all the rural communities, where they implemented the doctrines and plans of Chairman Mao, inciting peasants to violence and hatred. All that is left of the Cultural Revolution's reign of terror are scars in the minds of people and the relics of a fanatical movement: Fading Mao portraits on walls, decapitated Buddha statues, dilapidated temples or ceramic tiles bearing patriotic slogans such as *The Sun Rises in the East* [dongfang shengqi hong taiyang].

Fortunately, and perhaps surprisingly, religious practices on a more down-to-earth level have rebounded from Mao's attack on local cultures and traditions. The reason is that folk traditions and popular religions do not exist *per se;* they are continually produced and reproduced in social and cultural activities. For instance, both holding a traditional funeral and organizing a temple festival are social events that involve ritual practices and help keep folk religions alive. The hosting of such events naturally plays a key role in rural China.

Scholars have taken the position that *how* popular religious activities are organized is not specifically religious. In rural areas, the same social skills and organizational bodies are employed in planning and implementing both secular and religious activities. When we study the relationships on the local level between the peasant society, the elites (e.g., the head of a temple) and the state (e.g., the head of a village), we may be surprised to find that they all play roles within the sphere of popular religion. In other words, in the peasant world politics and religion often go hand in hand, contrary to the oversimplified view of outsiders who regard the state and the people as opposing forces.

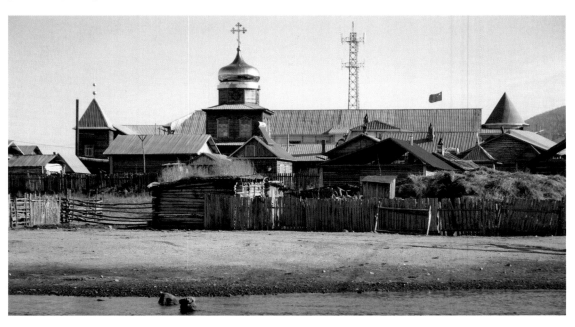

Enhe Village, Inner Mongolia
Autonomous Region

Life after Death

The funeral has always been an elaborate life ceremony for a Chinese – involving troupes of musicians and performers of rituals, the scrupulous selection of a grave site according to fengshui guidelines and specialized stonemasons to build the *dwelling for the deceased* [yinzhai, in contrast to the house for the living, yangzhai]. The burning of paper money, colorful paper houses and paper figures is also a common funeral ritual. Chinese traditionally believe in life after death, and they accordingly burn these paper objects to ensure the deceased's comfort in the afterlife.

During the Cultural Revolution, the customs of holding elaborate funerals and building ornate tombs were considered survivals of feudalism. Not only were many funeral rituals and preparations discontinued or greatly simplified, but many stone tombs were also dismantled to make paving stones. As the policy on religion relaxed and the economy grew steadily after the 1980s, many traditional funeral rites have been revived in combination with modern elements. Paper home appliances, such as TV sets, washing machines and even iPhones, along with paper servants in traditional Chinese costumes, are common objects burnt today. Sometimes *professional funeral weepers* [zhiye kusangren] and provocatively dressed singers (or even striptease artists) are employed to evoke the desired atmosphere or to attract passersby. Occasionally, a funeral tends to become more of an entertainment event. Some Chinese believe that the more attention a funeral attracts, the more blessings the deceased will enjoy. Often the same troupes that perform at funerals also entertain guests at weddings.

This large poster on the altar was made for the last rites of a family's elderly grandmother. In this photomontage, the woman is reunited with her husband, who had passed away decades before. The scenic background with the renowned Chinese Karst topography is decorated with images of cranes bearing her soul to heaven. In addition, it is popular in Shaanxi and Shanxi Provinces to prepare dough offerings for the deceased. Colorful and delicate *dough figures* [mianmomo] are created on occasions such as New Year's celebrations, weddings, birthdays and funerals (Photo: Bailiang Town, Shaanxi).

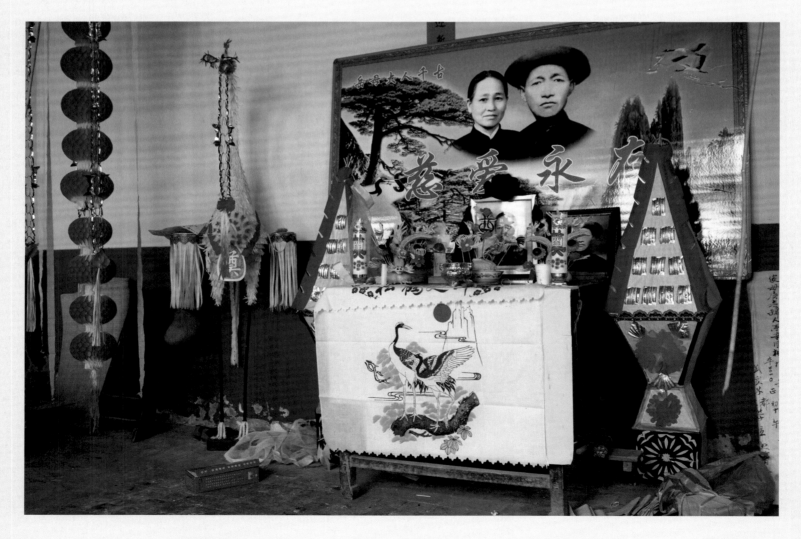

Generous with death, stingy with life.

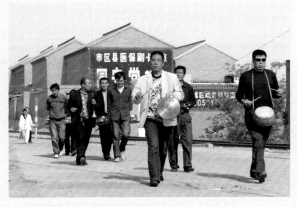

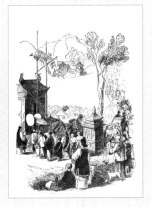

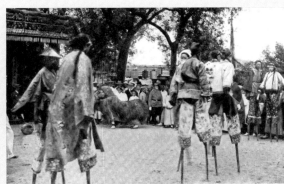

The illustrations depict conventional wedding and funeral scenes. Although quite different in nature, they shared similar formal procedures. The photo, taken shortly before the fall of the Qing Dynasty in 1911, shows stilt walkers performing at a funeral 'festivity.' Today, funeral processions are usually simplified, while in rural areas it is still common to hold an accompanying performance or banquet.

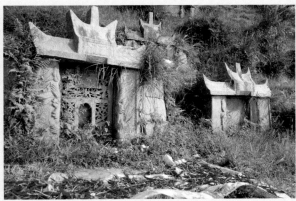

For more than two decades, the Chinese government has actively encouraged cremation over interment. In places where the population is dense and land resources are precious, interment is officially prohibited. However, it is often hard to enforce this regulation in rural areas, as Confucian thought has long considered interment the only dignified form of burial. Some local governments even take advantage of this regulation to charge an interment fine. In addition, many believe that the *fengshui of grave* sites [yinzhai fengshui] has a great influence on later generations. Therefore, many rural families still prefer to build a grandiose cemetery, as illustrated in a *Nongmin Ribao (Farmer's Daily)* edition (Top left), often decorated with religious carvings and statuary. All across China, the Tomb Sweeping Day [Qingmingjie] in spring remains an important time for families to get together in remembrance of their ancestors.

Accompanying the religious revival, *shops specializing in funeral paper goods* [zhizhapu] can be found in many villages and towns. Handmade paper goods are carefully crafted by a local master.

Mt. Changbai, a volcano in Jilin Province, is a sacred mountain worshipped for centuries by Manchurians, Koreans and various other ethnic groups. With an altitude of 2,744 meters, it is the highest mountain in northeastern China and the Korean Peninsula. The name Changbai literally means 'forever white.' Koreans, who call the mountain Baekdu, believe their ancestors originated here.

The Changbai Mountain Range is also the mythical birthplace of the Manchu Qing imperial family's forefathers. When the Qing Dynasty was founded in 1644, the Emperor proclaimed several preferential policies to attract Han Chinese immigrants. This policy was intended to relieve the suffering of refugees in northern China, which had been severely devastated by the flooding of the Yellow River. However, two decades later, Emperor Kangxi, concerned about the preservation of Manchurian culture and *fengshui*, as well as the exploitation of forests, mines and other resources, issued a *quarantine decree* [fengjin zhengce] to discourage Han Chinese from moving to Manchuria. He also prohibited hunting, fishing, felling trees and cultivating the virgin soil on the slopes of the mountain range. In the end, for two centuries the area became an exclusive reserve for the Manchu imperial family and its aristocracy.

In the past two decades, many South Korean tourists have visited this area to worship the holy mountain. In fact, some Koreans still insist that Mt. Changbai belongs to Korea. China only finalized the border with North Korea in 1962, dividing the peak and Lake Tianchi. For the Chinese, Mt. Changbai plays an important economic role with its rich forest resources, traditional medicinal herbs and mining. Ginseng roots, marten fur and deer antlers, for instance, are the famous *three treasures of the northeast* [dongbei sanbao]. In addition, income from domestic tourism has greatly increased since the opening of an airport and the promotion of a ski resort in the area.

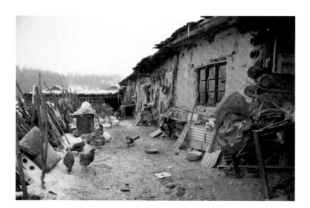
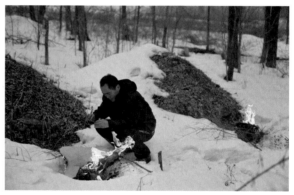

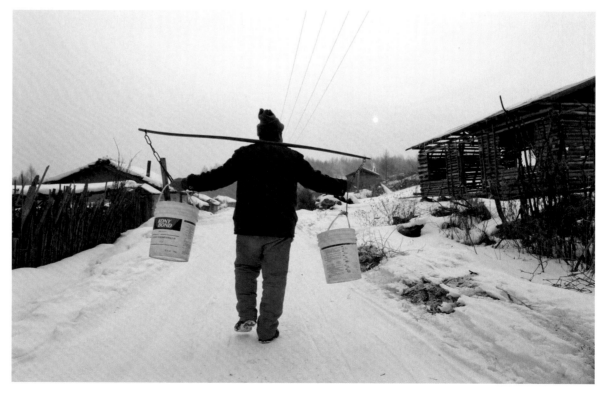

Mt. Changbai, Jilin Province

A painting of Mt. Changbai from the *Manchu Veritable Records*: "The Yalu River originates in the south of the mountain" is written in Manchu, Chinese and Mongol characters. Ginseng, dubbed the king of herbs, has been cultivated in this region for more than a thousand years. Those resembling the shape of a human body are considered the best.

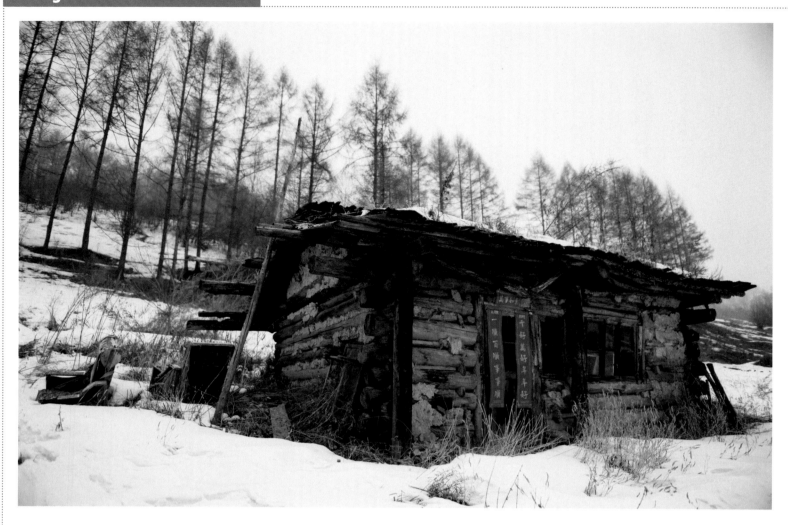

When the quarantine policy was relaxed in the late nineteenth century in order to stem the threatening advance of Czarist Russia, a larger share of Han Chinese from the impoverished Hebei and Shandong Provinces moved northward. Due to political turbulence and wars, more and more people fled to this area until the early Republican era (1911-1949). The migration ceased only when the Japanese army invaded northeastern China in 1931 and soon thereafter set up the Manchukuo puppet regime. The total number of Han migrants to the Manchus' historical homeland is estimated to be several millions. This migration is called *chuang Guandong*, literally 'crashing into the east of the pass.' The 'pass' refers to the Shanhai Pass at the eastern end of the Great Wall. As a result, today most local residents in Manchuria (now consisting of the provinces of Liaoning, Jilin and Heilongjiang) are their descendants.

Villagers in this area observe the tradition of visiting their family tomb at dusk on Lantern Festival Day during the Chinese New Year celebration. The ceremony is a simplified version: After they burn paper money and ignite a string of firecrackers, villagers dig a pit in the snow and light a red candle. Making *snow lamps* [xuedeng] to commemorate the ancestors has long been a ritual of Manchurian Shamanism that was later adopted by the Han Chinese.

The migrants not only embraced the Manchus' religious rituals, but also adopted their housing style, which is common all over Siberia. *Gudingzi Village* is one of the very few villages where traditional wooden houses are still well preserved and inhabited. The whole-timber architecture is the most distinctive feature: A wooden fence, logs as walls and pillars, wooden boards used for the roof, and a hollow tree trunk as a chimney. The spaces between logs are chinked with clay. The limited range of available local materials, the isolated location, the simple construction and their good heat insulation have contributed to the long-lasting popularity of these primitive but practical wooden houses. Today, a few wealthier families have built modern-looking brick houses in the surrounding villages or moved into towns. There are only about thirty families left in Gudingzi.

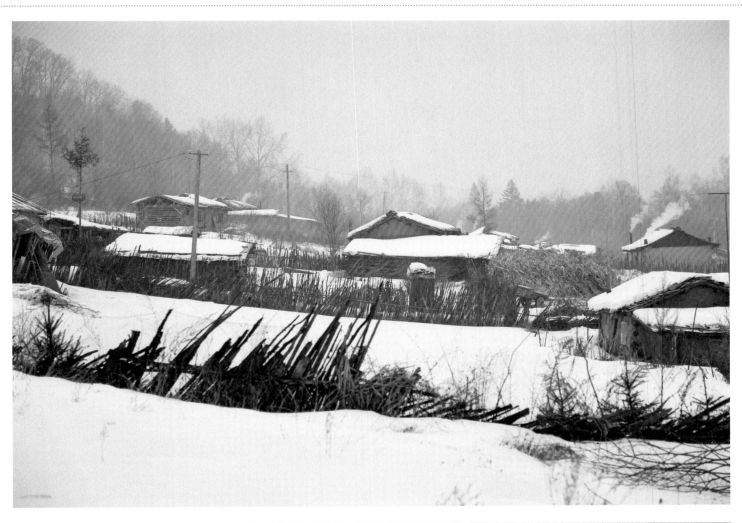

A neo-Confucian academy was founded by Ju Xi on the Song-shan Forestry Farm at the foot of Mt. Changbai in 2005. Ju Xi was born in a small town a few dozen kilometers away. During the Cultural Revolution, his high school education was interrupted, and while reading Marxist literature he was attracted to philosophy in general. In the 1970s, he was accused of being 'politically problematic' and imprisoned for three years. Later, while working as an electrician, he privately studied the teachings of Con-fucianism and Taoism. Now his goal is to revitalize traditional Chinese philosophies with innovative thinking. He holds regular summer courses in his simple one-man academy, and numerous people from Hong Kong and Taiwan have attended in the past few years. In addition to philosophy, he is also an engaged amateur broadcaster. His rooms are stocked with an odd collection of electronic components, with which he builds and improves his own broadcasting equipment.

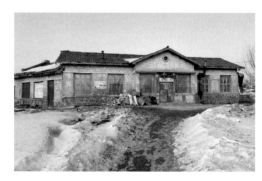

The Protestant Christian church in *Manjiang Town* was established a few years ago. Although this is the only officially recognized church in this region, underground churches also flourish and attract even more believers. These underground churches are doing well because of their longer history and a slightly relaxed attitude on the part of the local officials. The current official pastor and his wife originally came from Meihekou some hundred kilometers away and were formerly migrant workers in the logging industry of a village near Manjiang. After they converted, the husband went on to attend a local theological school and later returned to Manjiang to serve as a pastor. Many Christians from the neighboring villages come here on foot to attend Sunday services. The pastor and his wife also visit the villages in their parish on a weekly basis to hold additional gatherings.

A few shabby socialist-style buildings line the quiet snow-covered main street. The public health clinic on the main intersection of Manjiang Town is one of them. It bears the slogan: "The whole society supports the one-child policy." Outside the town stands yet another relic of the socialist past – a former state-run *supply and marketing cooperative*. This store still stocks everyday wares, but it has long been privatized.

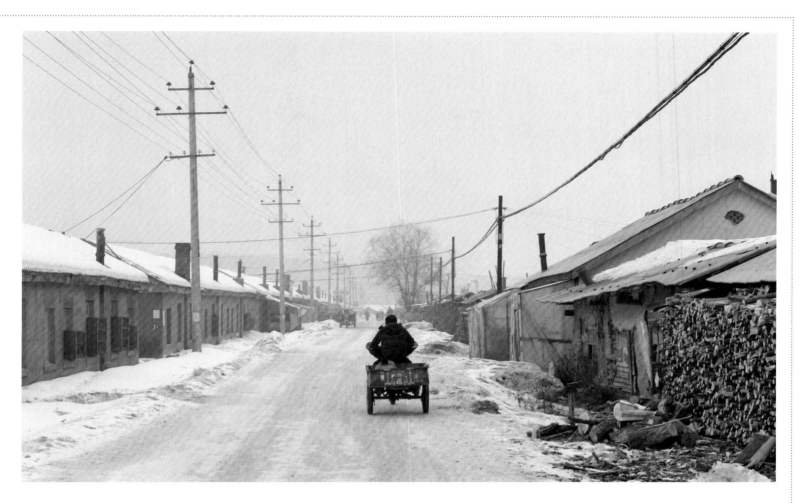

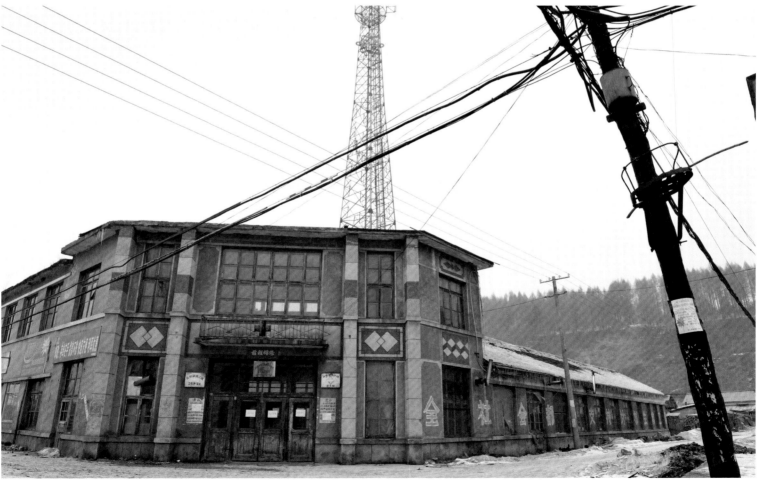

Manjiang Town, Jilin Province

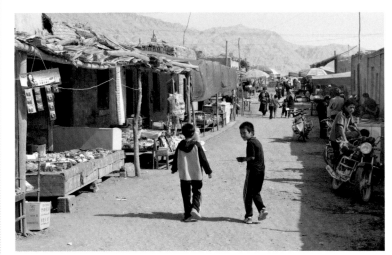

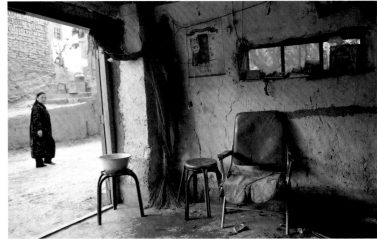

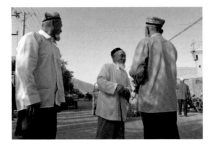

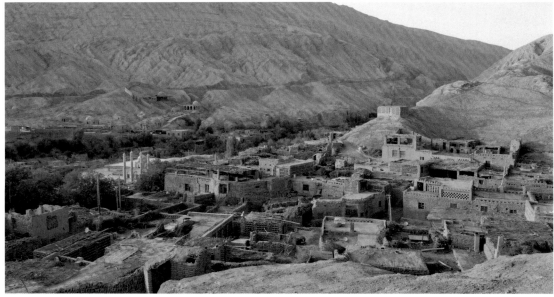

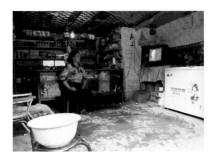

Mazar [Mazha] Village in Tuyugou Township of Xinjiang Uyghur Autonomous Region is a well-preserved traditional place on the route from Turfan [Tulufan] to the Taklamakan (literally 'he who goes in never comes out') desert. In fact, the name Tuyugou originates from the word 'cul-de-sac' in the Uyghur language, and Mazar literally means 'cemetery of the saints.'

Legend has it that after the founding of Islam in the seventh century, five of Mohammed's disciple-missionaries journeyed eastwards and converted a shepherd, who became the first Muslim in the then-Buddhist region. Taking this first conversion as an auspicious omen, the five missionaries and the shepherd settled down here to continue their religious activities. After their deaths, people built an Islamic-style cemetery with a domed mausoleum to commemorate them. This place was of strategic importance as it lay at the junction of the route from China to what is now Pakistan. Later on, Mazar came to be known as the 'Oriental Mecca' in Central Asia. According to notes from the German archeologist and explorer Albert von Le Coq (1860–1930), a large number of Muslims from India and Arabia made pilgrimages here in the early twentieth century.

Due to its location on the Silk Road, the area around Turfan was exposed to a variety of cultural influences emanat-ing from Central Asia, Persia and India. Numerous Buddhist grottos, such as the famous Bezeklik Thousand Buddha Caves (fifth to ninth centuries), and many monasteries were founded around this fertile oasis. Unfortunately, many of the murals were later desecrated by local Muslims, because Islam forbids visual portrayals of sentient beings. In those cases where the eyes and mouths were not gouged out, European explorers removed entire intact murals and shipped them to Europe. The Red Guards finally sounded the death knell for these marvelous cultural relics.

Today, most of Mazar's traditional village structure, with its earthen buildings winding up the hills, is still intact. Except for a few white poplars, mulberry trees and the grandiose green-white mosque with its minarets thrusting into the sky, Mazar is submerged in a sandy, grayish-brown landscape. At dusk, however, the last rays of sunlight flood the valley with a golden haze. The remaining inhabitants still lead the lives of their ancestors: They cultivate grapes, breed sheep, shop at Tuyugou Township's local market a few kilometers away and center their leisure activities on their family and religion. A small, and the only, *mom-and-pop store* opened a few years ago to serve customers on non-market days.

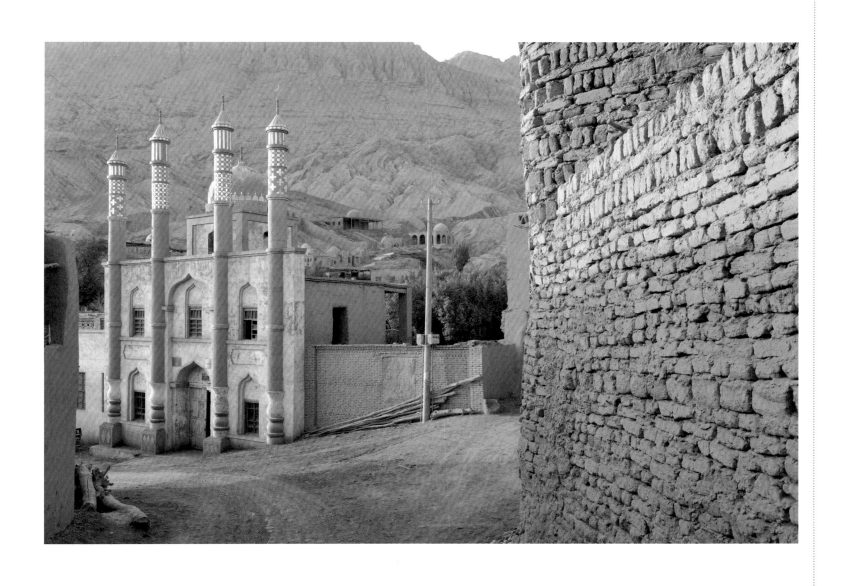

Summer is the most pleasant season in Mazar: Grapes and melons ripen – these are the most abundant agricultural crops in this region. All daily activities, including cooking, eating and sleeping, take place outdoors. People move their beds into the covered garden or under a tree. Sometimes they simply spread out carpets on a large wooden platform, which serves as a family dining area and communal bed. Grapes for raisins are stored and dried in simple earthen rooms with ventilation openings.

Similar to other rural communities in the interior, the village must cope with a steady outflow of young laborers. Many young couples have moved to neighboring cities, but they bring their children back to visit their families, more often during the warm summer months. When not tending to their farms, elderly men spend much of their time reading the Koran or discussing everyday issues, while women occupy themselves with household chores. For Muslims here, besides the observance of religious holidays, the three most important events in life are circumcision, weddings and funerals. The man seated at the table has just received an invitation from his neighbor to attend a grandson's circumcision celebration. He takes the opportunity to explain this tradition to his own grandson, who will also go through this ceremony in a few years.

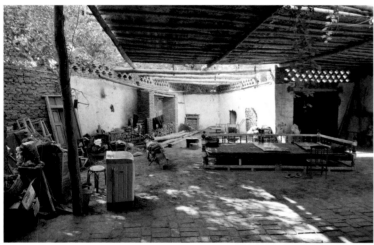
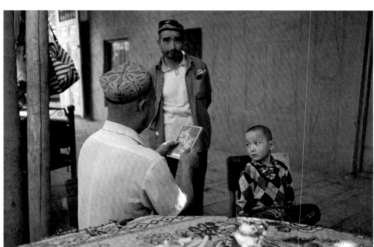

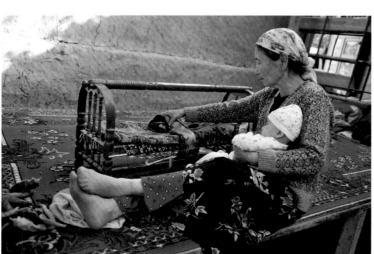
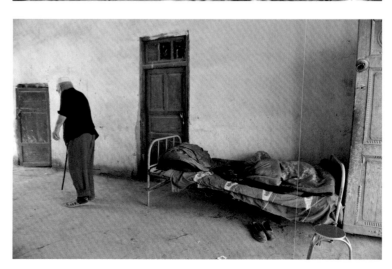

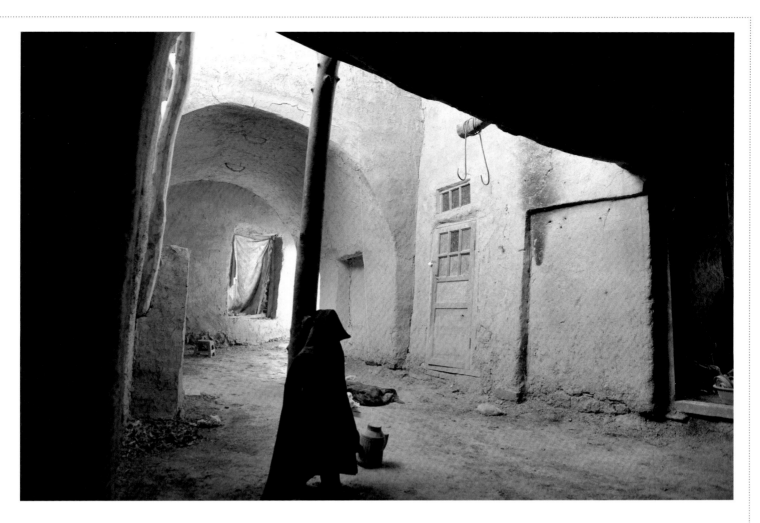

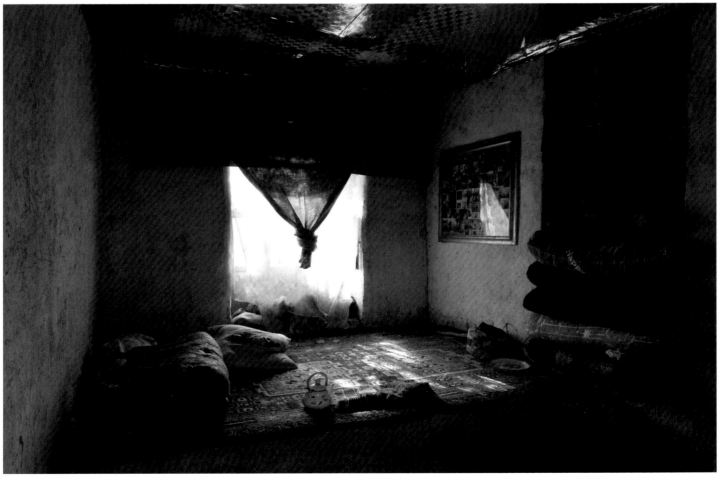

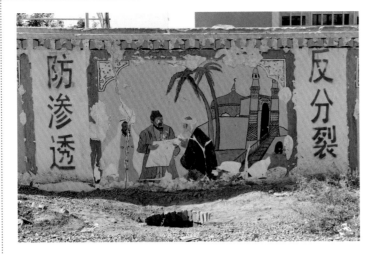

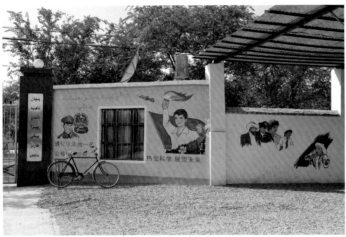

Though the Uyghurs in Xinjiang are Muslims, according to the official classification they do not belong to the largest Muslim group, the Hui, but rather constitute a separate ethnic group. Since the Communist government took power in Xinjiang, it has been trying to promote unity among all ethnic nationalities. This policy has obviously not been very successful, as the recent riots in Xinjiang showed in the summer and autumn of 2009.

Contrary to official government pronouncements, the Autonomous Region is still far from stable, especially in the southern part, where Uyghurs make up a large majority. Beijing continues to proclaim "the unity of the Motherland" and to warn against "terrorists" and "separatists." Propaganda slogans that sound strange to Western ears proclaim: "Against separation. Be aware of infiltration" and "Three things not to be separated: The Han are inseparable from the minorities. The minorities are inseparable from the Han. The minorities are inseparable from each other." Such slogans are omnipresent in rural areas outside the capital, Urumqi [Wulumuqi]. Due to political tensions, non-Muslims and Westerners are forbidden to enter mosques in the countryside.

Xinjiang came under Beijing's control only in the eighteenth century. The strategically important region known in Western historiography as Chinese Turkestan was annexed by China in 1884 and became a province called Xinjiang. The name 'Uyghur' had actually not been in common use for centuries up until the early twentieth century, when the Soviet Union suddenly began applying it to non-nomadic Turkic Muslims in that area. Chinese Communists adopted this designation and applied it to groups of urban dwellers and farmers alike who led a traditional sedentary Central Asian lifestyle.

The greatest lure of this vast area, which makes up one-sixth of China's territory, is its abundant oil resources. Because of its geographic location, Xinjiang is one of the most politically sensitive regions in China. Changes in its relationships with neighboring countries resulting from the USSR's breakup are dramatically visible. Xinjiang also borders not only on politically unstable countries like Afghanistan and Pakistan, but also on India, with which the PRC has unsettled border disputes.

Also employed to promote unity are measures like awarding recognition plaques to *civilized households* [wenming hu] that comply with the government's policy on the ten aspects of *spiritual civilization* [jingshen wenming], including obeying the one-child policy, following the law and meeting hygienic and moral standards.

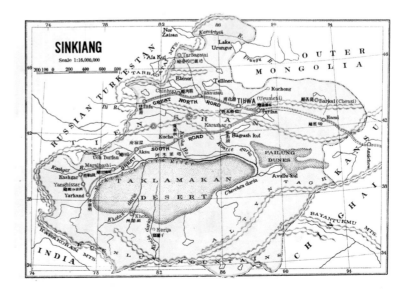

A map of Xinjiang around 1910

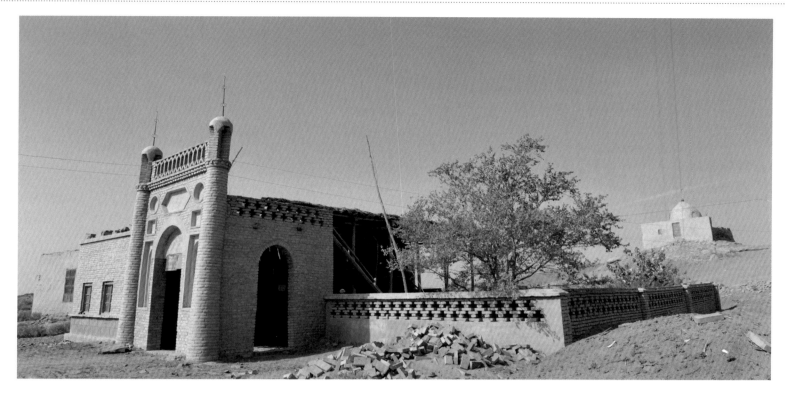

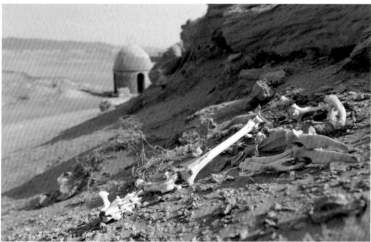

Dikaner Village is the last inhabited settlement on the edge of the Kumtag desert, a section of the Taklamakan. When the Swedish explorer Sven Hedin arrived there in the late nineteenth century, a local native guided him and helped him discover relics of the long-lost Kroran Kingdom [Loulan]. Hedin excavated some houses and found many manuscripts and texts in ancient languages. This long-forgotten kingdom was already known to exist in the second century BCE and came under the control of the Han Dynasty in 77 BCE. In 2010, the grandson of Hedin's guide was still living in this village and had inherited the dual professions of farmer and desert guide.

As desertification becomes increasingly severe, the continued existence of Dikaner Village is becoming more uncertain. Most farmers here earn their living cultivating grapes, but sand has already blown in from the desert to cover the streets and fields. The borderline between the village and the desert is in fact no longer very distinct. Water resources have also become scarce. Many people have opted to leave for other places with better living conditions. Although dozens of adobe houses still survive, many are no longer inhabited. Those who remain lead a hard life struggling against the spreading desert.

The grandiose wooden three-story Derge Parkhang [Dege yin-jingyuan], a Buddhist scripture-printing temple, was built in the traditional Tibetan style with red walls by Derge King Tenpa Tsering in 1729 in *Derge [Dege] Old Town* in Sichuan Province. Legend has it that the pious king once heard the mysterious chanting of sutras seemingly coming from nowhere while taking his daily stroll in the valley at sunset. He took this as an omen from Buddha to build a temple. Thanks to his open policy on religion, the sutras of various Buddhist sects were collected there. The Parkhang still owns over 210,000 Buddhist scriptures and wooden printing blocks, some of which date from the sixteenth century, and a library containing more than a thousand rare ancient books about Tibetan Buddhism. There are specially designated areas and rooms for printing, storage, drying and washing.

In the eighteenth century, the Kingdom of Derge fell under the control of the Qing Empire, but it maintained some independence until the early twentieth century. During the Cultural Revolution, Red Guards from Lhasa and the county seat destroyed many temples in Derge and intended to demolish the printing temple as well. It is said that a local official secretly informed Premier Zhou Enlai about this plan and gained his support to protect the building and its printing blocks and books.

Today, Derge Parkhang, located in the Garzê [Ganzi] Tibetan Autonomous Prefecture of Sichuan Province on the border of Tibet, has become a popular pilgrimage destination. Many believers travel there from far away – sometimes more than a thousand kilometers – and even undertake dangerous journeys on foot to pay their respects. Every day, from dawn to dusk, there are numerous Tibetans circumambulating the

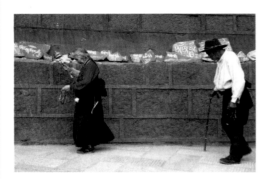
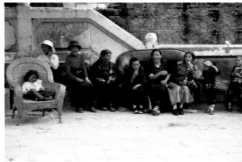
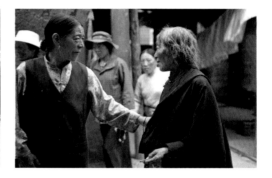

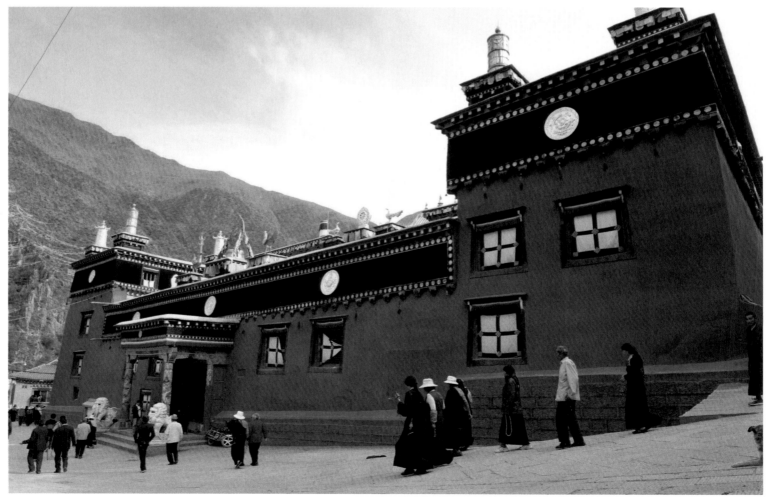

building clock-wise with a prayer wheel, doing the *kora*, the pilgrimage circuit. Due to the climatic conditions in this area, the printing period is limited to only a few months each year, from March to September according to the Tibetan calendar.

The Derge Parkhang, along with the printing houses of Labrang Monastery, Narthang Monastery in Shigatse [Rikaze] and Potala Palace in Lhasa, has long been one of the most important Tibetan printing temples. The contents of these scriptures include the *Tengyur* (an historical collection of Tibetan commentaries on Buddhist teachings), monastic disciplines and prayers. Even today, these scriptures continue to be printed using traditional techniques. Each step is carried out by hand – from carving the woodblocks and producing the pigments to manufacturing the paper. The prints are supplied to many monasteries, libraries and Tibetan colleges. All the scriptures are printed with black ink, with one exception: Out of re-

spect for the *Great Treasury of Sutras* [Dazangjing], all its texts are printed with red cinnabar ink.

There are about a hundred devotees working here. Some experienced workers, teamed in pairs, can print a text in less than five seconds. All the printed sheets are then placed on the top floor to dry. To prevent fire, neither lamps nor candles are allowed inside the printing temple. It takes an artisan about two days to engrave one wooden block in the dim natural light streaming in through the windows. In the past, the king would fill the indentations of carved blocks with gold dust as payment to the handicraftsmen. Today, these artisans earn about RMB 60 (US $9) for a single printing block. All the workers are pious believers. For many of them, working in the Parkhang is a matter less of the relatively meager wages and more of accumulating good deeds. It is common to hear the printers humming prayers while working

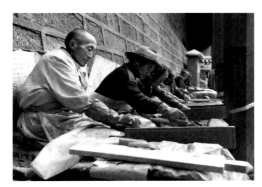
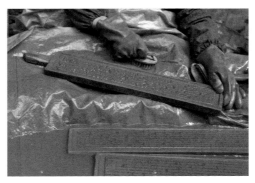
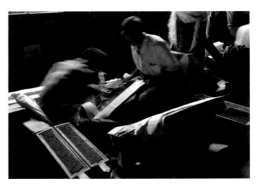

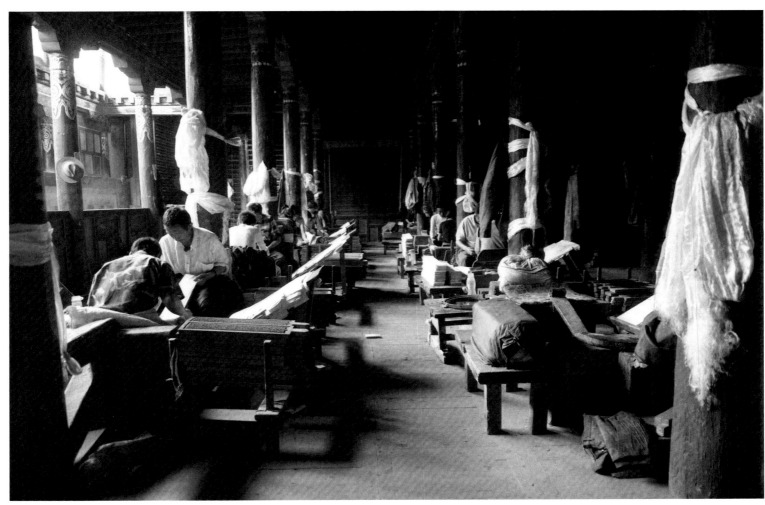

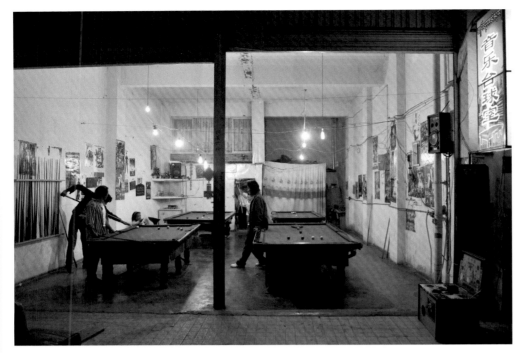

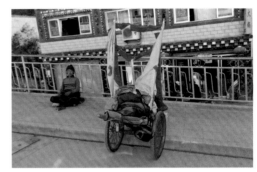

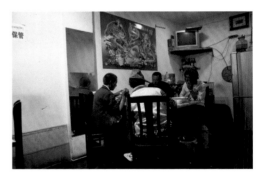

On the road to Derge, travelers often catch sight of pious pilgrims on their way to Lhasa, a journey that can take several months to complete. These devotees walk and prostrate themselves at regular intervals, even on sandy and dangerous mountain roads where large trucks inch up to passes at an altitude of 6,000 meters. Although improved road construction has brought the once-isolated Roof of the World closer to the Chinese heartland, Tibet's topography remains a last natural barrier against too-rapid modernization. The topography of the land shapes Tibetans' devotion to their religion and puts their faith to a concrete test. However, it would be wrong to assume that due to its sacred status there is no entertainment or modern life in Derge.

Only a few hundred meters from the printing temple, aside from a few pilgrims resting on the edges of the streets,

there is a lively hillside town: Jewelry boutiques, supermarkets, eateries, hostels, pool halls and hairdressing salons are abundant in this small community, meeting the needs of pilgrims, monks, tourists and afflicted persons who have come in search of traditional Tibetan medicines and treatment to restore their health. A few jewelry shops are owned by members of the Bai Minority from Yunnan Province, famous for their great skill as silversmiths. In the last few years, many Han Chinese have come here from the heartland to set up businesses: The continuing Sinicization is visible in recruiting announcements for the enrollment of Tibetans in universities and advertisements for modern consumer goods. Even today, many Tibetans employed in Derge still come from poor nomadic families.

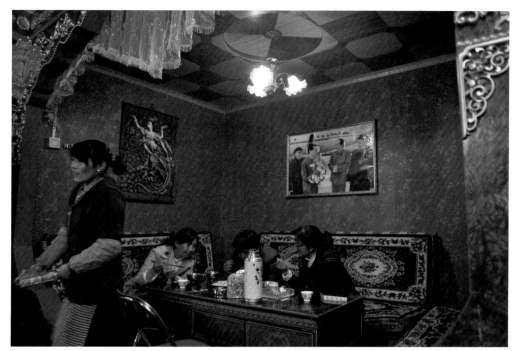

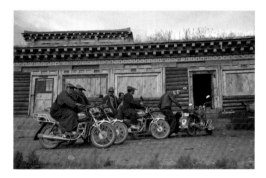
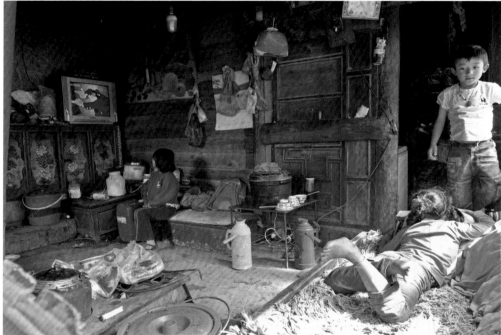
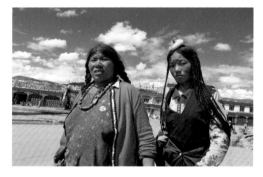

In recent years, individual Chinese travelers have gradually 'discovered' Tibet and areas inhabited by Tibetans as a natural paradise. They usually arrive in this exotic world in big all-terrain vehicles, often lacking cultural and religious sensitivity. As a result of the riots in recent years, state control has become harsher in Tibetan-inhabited areas, and the flow of information from the outside world is heavily censored. Stifling tensions can be felt everywhere, and stories of brutal suppression are secretly confided only to trusted outsiders. In many monasteries, the number of monks and nuns has decreased. Nonetheless, Tibetan Buddhism flourishes in many unexpected corners. Travelers often encounter pious believers, like the monk devoted to carving the mantra *Om Mani Padme Hum* all day long, or the two nuns waiting for hours beside a mountain path, expecting a *tulku*, a reincarnated Lama, to pass by.

Tibetans in general are eager to learn more about foreign countries. Thousands of Tibetans left their country after the 1959 uprising and the self-exile of the Dalai Lama and during further waves of exile. The largest Tibetan diaspora lives in India, which many young Tibetans see as the only place to obtain a proper religious education. Until now, television, cell phones and, occasionally, the Internet are the chief media with which Tibetan town and village residents can make contact with the outside world. However, people complain that the service for mobile phones and the Internet has been interrupted or even more severely restricted during and after political tensions.

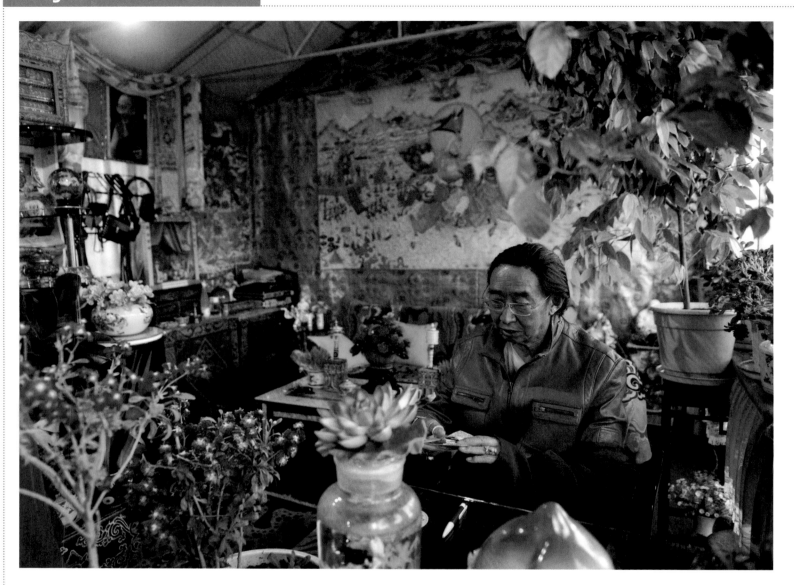

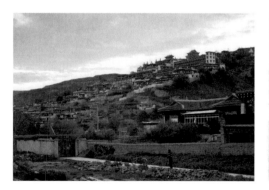

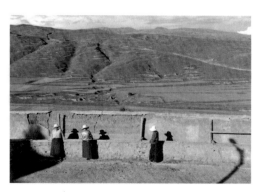

The world of a *tulku* in the green mountains around Garzê: Lamdark Rinpoche, a horse enthusiast, is such a spiritual authority due to his karmic merits acquired over countless lifetimes. It is estimated that before 1959, a few thousand *tulkus* lived across Tibet. Presently, there are only about 500 *tulkus* found in Tibetan-inhabited areas. The Chinese call them *huofo*, literally 'Living Buddha,' a term rarely used outside of China.

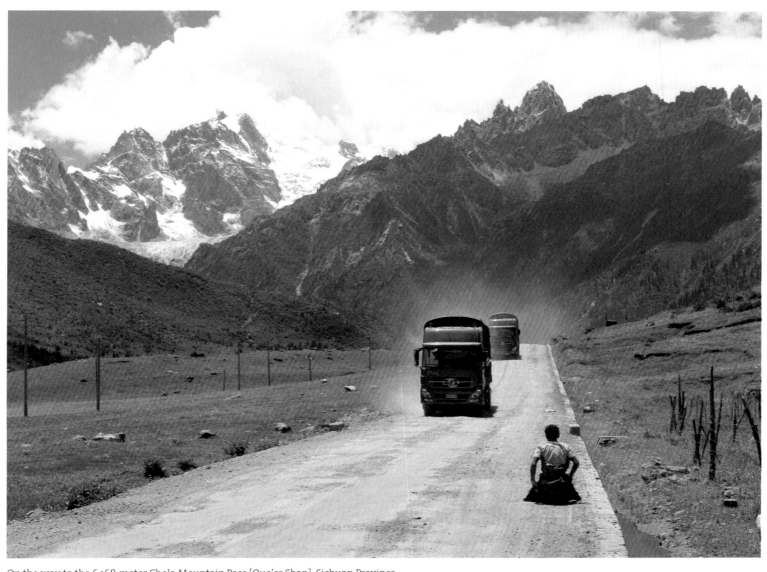

On the way to the 6,168-meter Chola Mountain Pass [Que'er Shan], Sichuan Province

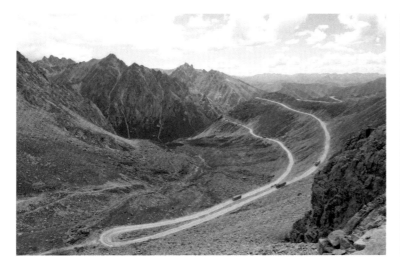

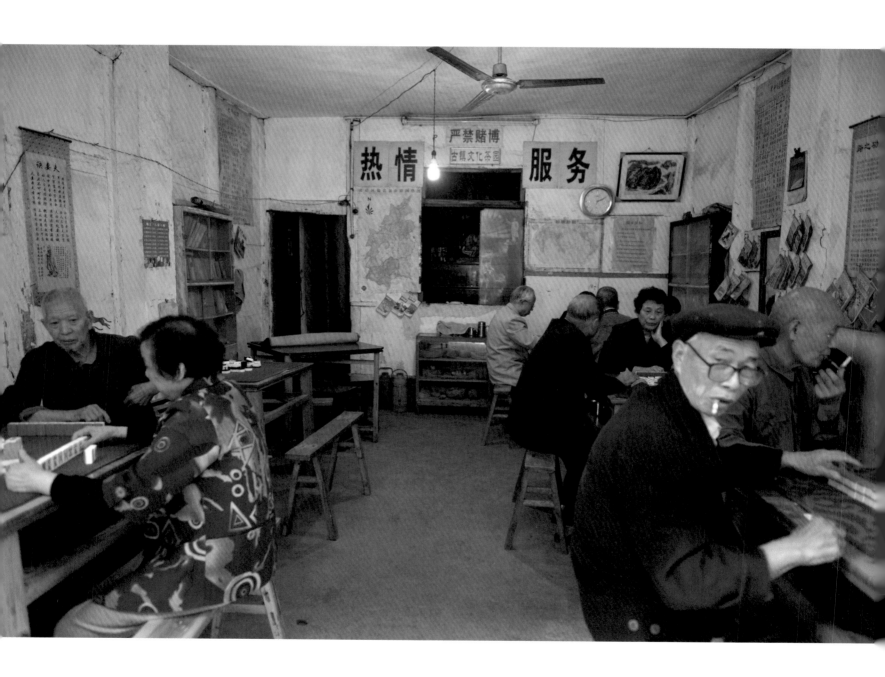

"Warm service. Gambling is strictly forbidden."
Pianyan Old Town, Chongqing Municipality

This propaganda poster from the 1970s depicts a joyful festival day in the grasslands, probably in Inner Mongolia. The details are worthy of note. The man holds a thermos bottle, a luxury item until the 1960s. The crop-spraying equipment on a woman's back is meant to show off advanced socialist technology. While watermelons might have figured in a true story, bananas and peaches definitely served a propagandistic purpose at that time.

Entertainment as a Refuge

Despite the modernization of lifestyles and values, festivals today are still the most exciting events in many rural villages.

Although most of these festivals have a religious origin, their form and performance practices often have more to do with celebration than with pious ritual. Whether a person is a Buddhist or a Christian, a Tibetan or a Han Chinese, lives in northeastern Jilin Province or on the tropical island of Hainan, traditional festivals inevitably play a pivotal role in life, as the atmosphere is contagious in small communities where daily life is governed by routines. During the *Smash the Four Olds* movement, the government banned the rituals performed in such celebrations, but since the 1980s villagers all over China have taken the initiative to revive their old traditions.

It is especially hard to obtain an overview of traditional festivals because they differ from place to place and between ethnic groups. However, when we look closely, we can usually find a logic connecting festivals with local traditional lifestyles. For instance, Tibetan and Mongolian nomads celebrate *equestrian festivals* [mahui]. The Miao people, who live in remote mountainous areas, bring youngsters from different villages together for dating games at the *Sisters Festival* [Jiemeijie]. Villagers who live on the arid Loess Plateau usually celebrate the birthday of the *Dragon King* [Longwang], who controls the rain, and the residents of earthquake zones ranging from Qinghai to Yunnan worship the *God of the Mountains* [Shanshen].

Temple festivals [miaohui], which usually honor the respective village deity's birthday, are probably the only nationwide celebrations aside from the New Year's festival. The date of a local temple festival is chosen based on the lunar or local minority calendar, and the celebration typically combines theatrical performances with a temporary market. The main

During the Sisters Festival, Miao girls and women wear silver hair ornaments and necklaces with traditional costumes. Parents begin collecting this jewelry for their daughters at a young age, and it later becomes part of their wedding dowry. This refined and delicately designed jewelry is handmade by local silversmiths.

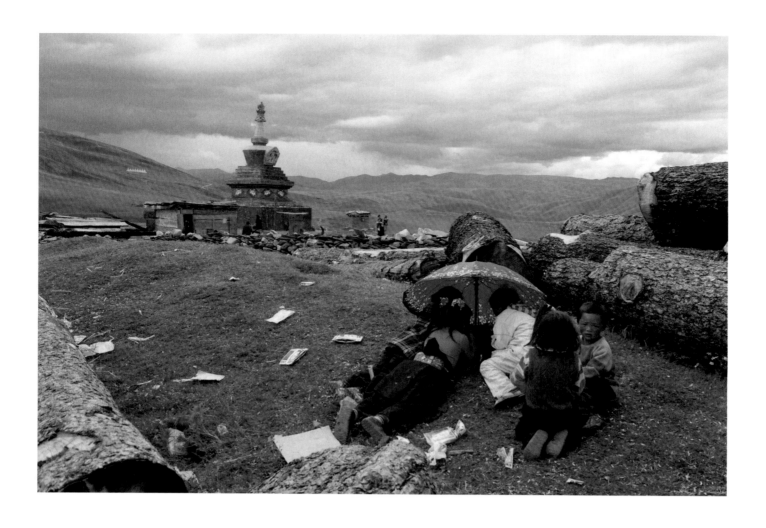

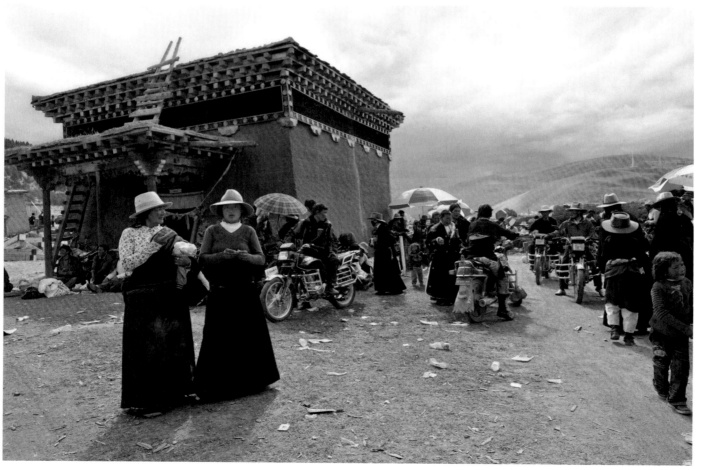

Temple festival, Manigango [Manigange] Town, Sichuan Province

Pianyan Old Town, Chongqing Municipality

Xin Village, Guangxi Zhuang Autonomous Region

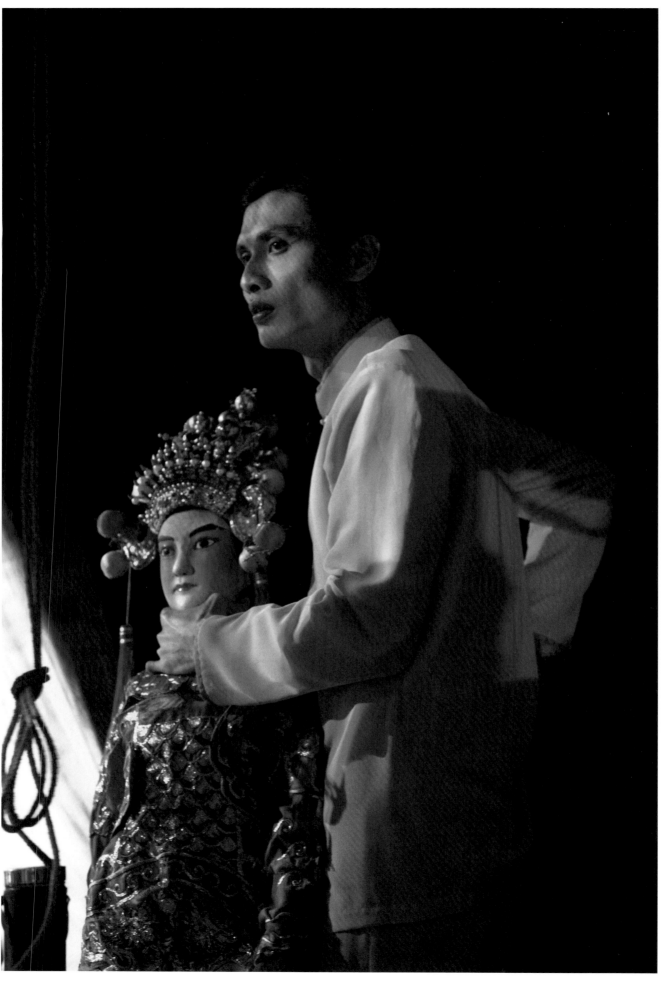

Wood puppet theater, Bocheng Village, Hainan Province

The Chinese have long been considered die-hard gamblers: Lotteries, both legal and underground, have become a popular 'epidemic' in rural areas in the last decade. Lottery tabloids containing verses, idiomatic expressions and illustrations suggesting winning numbers are widespread. Although the Hong Kong-based lottery *Mark Six* [liuhecai] is forbidden on the mainland, it is a popular underground game among farmers. The underground lottery has been condemned by the state media as a 'spreading cancer.' More and more peasants spend all their leisure time studying the lucky numbers, and many have gambled away life savings acquired through heavy labor. Not infrequently, farmers turn in desperation to criminal activities or even commit suicide because of their gambling losses.

source of financing for this kind of annual festival is the villagers' own contributions. The *village committee* [cunmin weiyuanhui] organizes the activities, and the chief participants are people from the village and the surrounding countryside.

Except on these special days and in the winter, the daily life of the majority of people in rural China ordinarily centers on agricultural work. This does not mean that they are incapable of enjoying life, however. In today's countryside, there are both traditional and modern leisure activities to choose from, ranging from local opera, paper cutting and playing Mahjong to watching television and surfing the Internet. Until the early 1950s, in spite of domestic turbulence, people in the countryside lived as their ancestors had done for centuries: While life revolved around farm work, their free time was enriched by occasional local festivals, folk handicrafts or arts, card games and social gatherings at dusk. In the late 1950s, however, there was suppression of traditional rural lifestyles and cultures in the name of Communist ideology. Rural social gatherings are a good example. People in 'old China' not only enjoyed chatting after a hard day's work, but also exchanged information about farming, families or market prices and discussed important village issues, such as building or renovating the ancestral hall and organizing local festivals. Many parents also brought their toddlers to such gatherings. Children learned social skills through these early experiences.

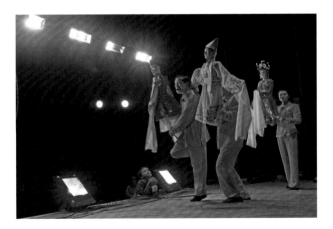

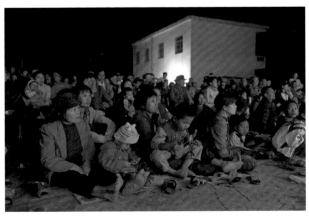

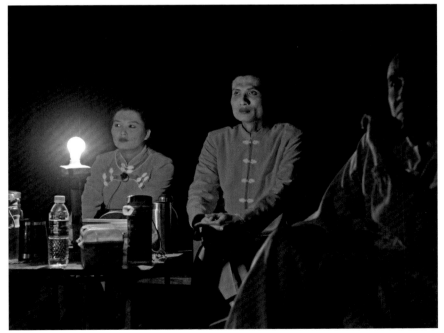

The Lingao County Wooden Puppet Troupe performs in a small village in Hainan Province. Though the authentic 'wizards of wood' currently still attract an enthusiastic peasant audience, the commercialization of this traditional performance art is foreseeable, given Hainan's ambitious tourism-development plan (Photos: Bocheng Village, Hainan).

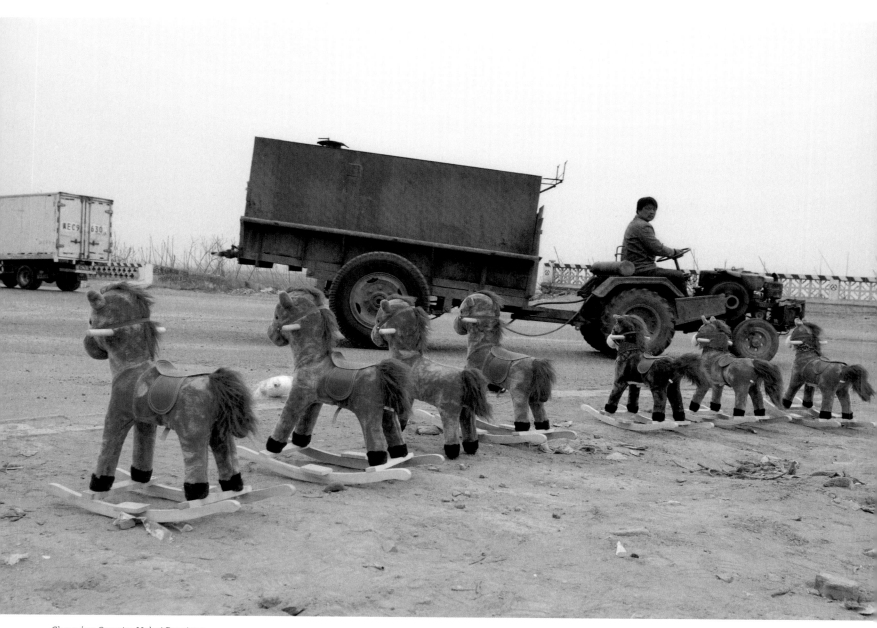

Cheng'an County, Hebei Province

During the Cultural Revolution, Jiang Qing, Mao's wife, introduced *model operas* to replace traditional ones. The *Red Women's Detachment* [Hongse Niangzijun], which premiered in 1964, tells the heroic story of poor peasants overthrowing the local landlord on Hainan Island with the help of female soldiers.

Landlords and rich peasants were considered class enemies and forced to accept insults while admitting their imaginary crimes in public. Brutal violence was usually involved, and around two-million landlords lost their lives in these sessions.

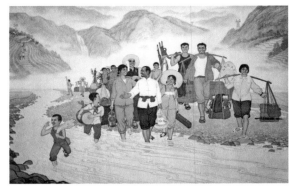

Itinerant theater troupes [biandan jutuan] were ardently promoted as an effective instrument of political propaganda in rural areas from the 1950s to the 1970s. Today, due to widespread boredom with excessive propaganda, theater performances in the countryside are generally entertainment-oriented and meant to keep audiences amused.

During the Cultural Revolution, informal social gatherings were replaced by Marxist *study meetings* [xuexi hui] and *struggle sessions* [pidou hui]. Similarly, all traditional performances and theatrical offerings were treated as belonging to the *Four Olds* and strictly prohibited, except those that could be 'corrected' and adapted for propaganda purposes. The Communists learned a great deal about the mobilizing power of small theaters from experiences during the Sino-Japanese War (1937–1945) and later the Chinese Civil War. Thus, local-level amateur troupes became the most important media to popularize every new economic and political policy among the peasants.

In 1960, there were more than 244,000 amateur peasant theatrical companies throughout China. Contrary to the common belief that most theater troupes were disbanded during the Cultural Revolution, the example of Yunnan Province tells a different story: Whereas 60 percent of troupe personnel in cities were dismissed and the rest performed in the newly established revolutionary *model operas* [yangban xi], in rural areas amateur theater continued to thrive. *Village cultural bureaus* [cun wenhua shi] administered cultural activities, and amateur peasant actors actively participated in the performances. Along with other propaganda messages, the performances effusively praised the rural peasant's 'virtues and excellent spirit.'

Traditional entertainment only reemerged from obscurity in the late 1970s. In the countryside, enthusiastic performers and captivated audiences welcomed a new peak period of diverse traditional performances in the 1980s and 1990s. Given the vast size of China, there are a great variety of different regionally centered performances and pastimes, for instance the *Yangko dance* [niu yangge] in the northern provinces, ethnic cloth weaving and embroidery in the southwest and *wooden puppet plays* [mu'ou ju] in the south. After revolutionary model operas celebrating socialism and denouncing the *old society* [jiu shehui] had monopolized the stage for nearly two

Up until the late 1970s, almost all entertainment activities were managed by *village cultural bureaus* run by the Party's local committees. Among other activities, they organized model opera performances or printed teaching materials containing patriotic songs, poems and plays. Many of those cultural bureaus have since been closed (Photo: Shenyun Township, Hainan Province), while a few survive as a kind of rural library.

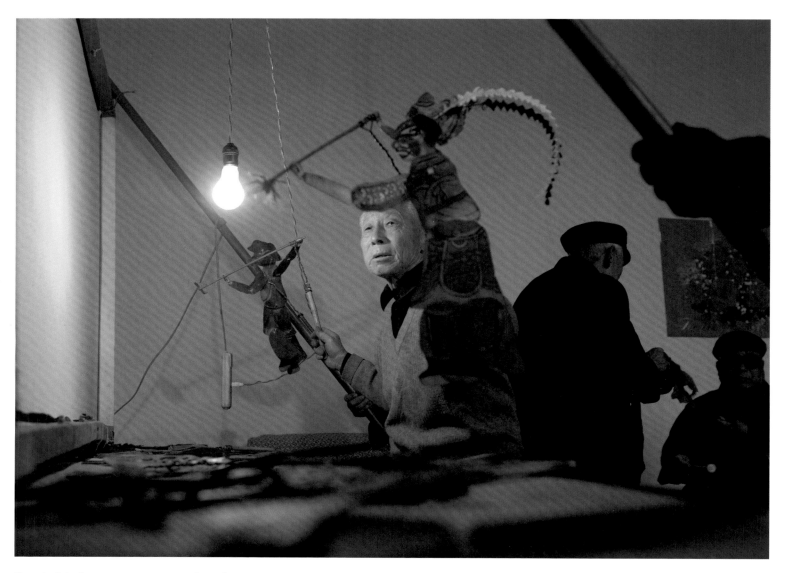

The art of shadow puppetry originates from the Han Dynasty (206 BCE-220 AD). When the Emperor's favorite concubine died, his court officials cut her silhouette out of donkey leather. Legend has it that, using an oil lamp to make her shadow move, they managed to summon back her soul. Shadow plays became popular as early as the eleventh century. Only a very few leather shadow puppets survived the Cultural Revolution. The 80-year-old farmer Shen Guorui still performs occasionally as the master of a shadow play troupe. During the Cultural Revolution, he secretly preserved the heads of some old figures, such as that of *Guan Yu*, a celebrated general during the Three Kingdoms period (220–280 AD). Elderly performers lament the loss of those exquisite artworks (Photos: Xiyaopu Village, Hebei Province).

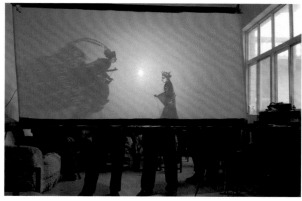

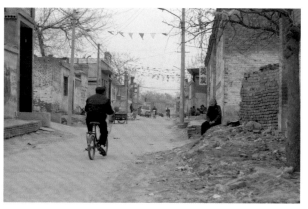

The future prospects of the delicate wood puppets in the simple home atelier of the sixty-year-old farmer Lu Zhaoxing are rather gloomy. The Heyang marionettes, carved artworks with a centuries-old history, are a dying tradition. The peasant handicraftsman earns his living mainly by farming, but he complains about the lack of interest in this folk art on the part of the local government (Photos: Pulu Village, Shaanxi Province).

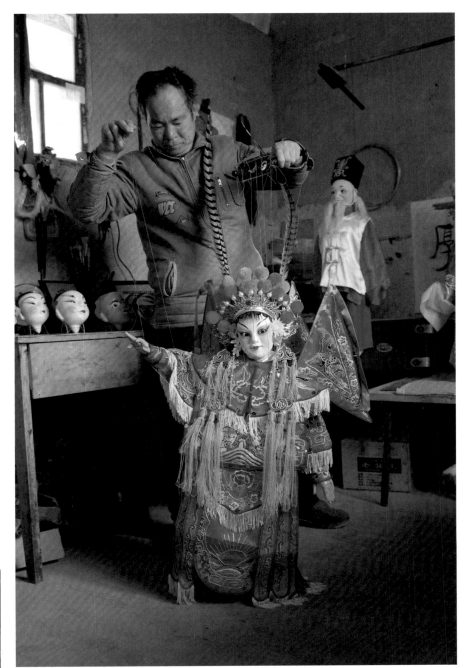

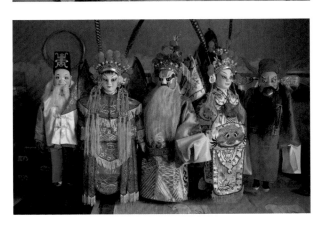

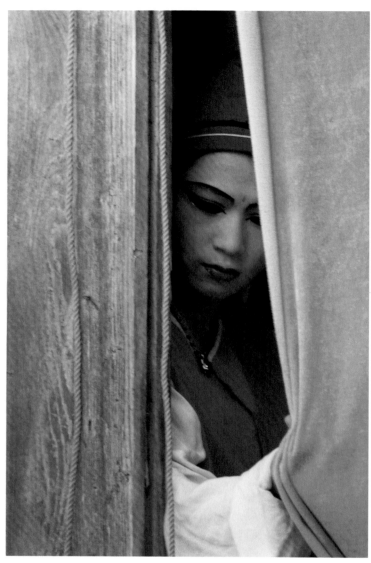

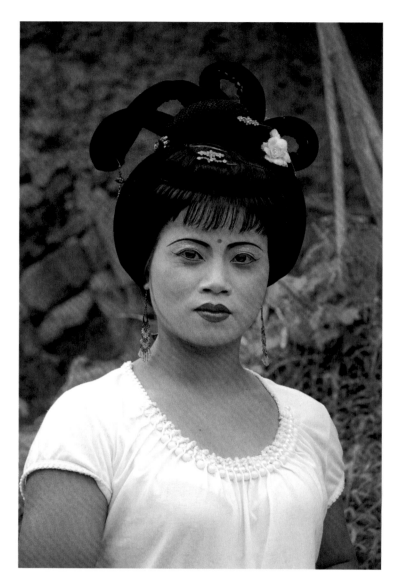

Yue Opera performance at a village temple,
Xu'aodi Village, Zhejiang Province

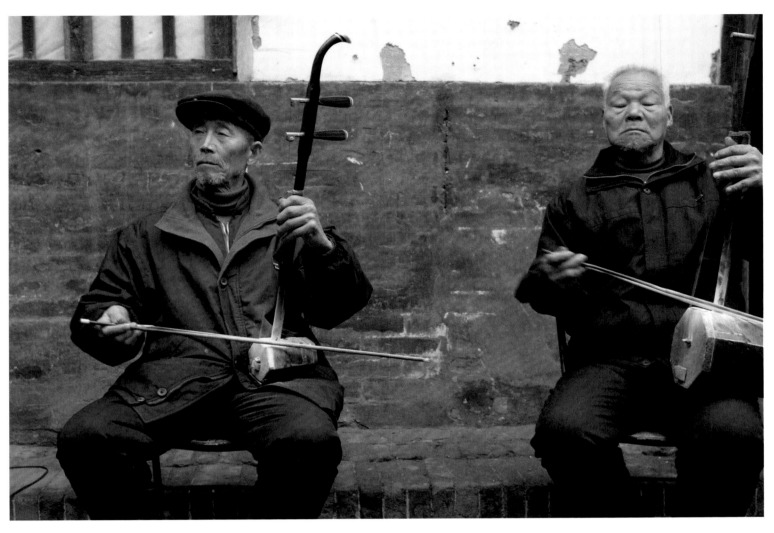

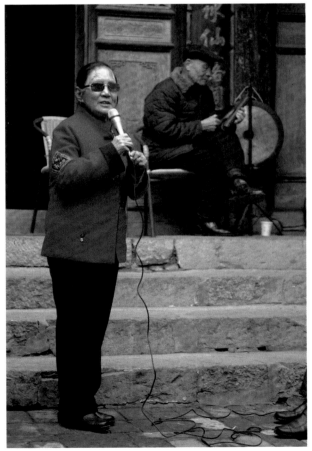

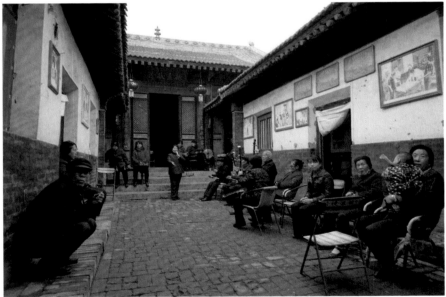

Performing *Qinqiang*, the traditional Shaanxi Opera,
Dangjia Village, Shaanxi Province

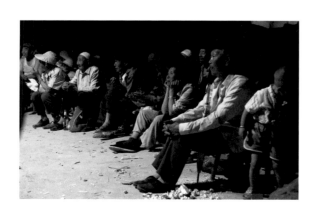

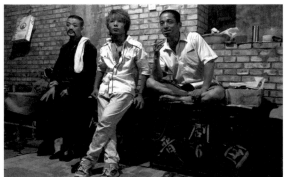

Traditional *Shanxi Opera* and modern performances during the festival of the Dragon King Temple
Yangjiagou Village, Shaanxi Province

Although the art of woodblock printing came into existence around the tenth century, this technique became a popular socio-political instrument in China only at the beginning of the twentieth century. During the Sino-Japanese War (1937–45), woodblock printing proved to be a cheap and efficient propaganda medium. Even after 1949, the Communists made further use of wooden printing blocks. For instance, the print on the left reads "Workers, farmers and soldiers criticize Lin Biao and Confucius." Later, this technique was replaced by the more vivid and colorful machine-printed posters. The 1965 poster "Electricity reaches our village" depicts a glorious innovation in rural areas in a way that did not quite match reality but was meant to keep peasants hopeful. Forty-five years later, Siemens celebrated the centennial of its first hydro-electric power plant in China with a similar setting.

Drinking with friends is among the favorite social activities in the countryside, but according to surveys alcohol abuse is only a minor problem compared with many other countries. A few drinking maxims from the *Imperial Cookery Book of the Mongol Dynasty* give some less well-known tips for sensible drinking and moderate alcohol consumption (Photo: Yingtan Village, Hebei Province).

decades, people began to revive traditional plays. Likewise, during the Cultural Revolution, *shadow plays* [piying xi], a common form of theatrical performance in the more arid parts of central and northern China, were banned, and most of the leather puppets were burned. In the late 1970s, many former theater apprentices who had been working as farmers endeavored to revive the public performance of shadow plays. Though the stage properties and puppets were not as sophisticated as in the old days, the long-awaited crowds were highly enthusiastic.

Today, financing and recruiting interested young people to learn and pass on theatrical skills and knowledge remain the two most difficult problems for performing-arts groups in the countryside. The older generation still earns its living in agriculture, and performers only come together to rehearse in their free time. The only occasions when they receive payment to perform are during the New Year's Festival and perhaps at occasional weddings. With the increased migration of middle-aged and younger people to urban areas, it is usually hard to find new recruits to learn and later be able to take over the roles of the old masters. China has a rich *non-material cultural heritage* [fei wuzhi wenhua yichan], and the government is making efforts to rediscover and support rural cultures. Nevertheless, many complain that the financial aid to local troupes is inadequate, for reasons including official misuse of funds.

Much like theatrical performances, *paper cutting* [jianzhi] and *woodblock printing* [muban hua] were not entirely outlawed during the Cultural Revolution, but were rather adapted for use as convenient propaganda tools. Traditional motifs yielded to political ones that could be used to promote the latest Communist slogans. These artworks were easy to reproduce and transport nationwide. In Nangou Village on the Loess Plateau, for example, a fifth of the inhabitants inherited the traditional practice of paper cutting. This inexpensive and uncomplicated art form is a favorite pastime during long, cold winters, and the arid climate helps to prolong the life of paper artworks. Traditionally, the patterns portrayed auspicious motifs such as bats, butterflies and the Chinese character of *double happiness* [xi] for newlyweds. The filigree works were attached to doors or windows, which is why they are also called *window flowers* [chuang hua]. People used to attach numerous paper cuttings to the white, vaulted walls of their loessial caves before every Chinese New Year.

Traditional performances and entertainment are again gradually losing the hearts of rural audiences, as modern lifestyles increasingly leave their mark in the countryside. Due to economic

The Dragon Book

RULES FOR DRINKING

1. GET intoxicated, but don't get helplessly drunk. Drunkenness causes life-long ill-health.
2. Don't lie in a draught when drunk—this brings on fits.
3. Don't lie in the sun when drunk—that way lies madness.
4. Don't lie in the dew when drunk—rheumatism will result.
5. Never force yourself to eat, and never get angry, when you are under the influence of drink or you will break out in boils. Washing the face in cold water has the same effect.

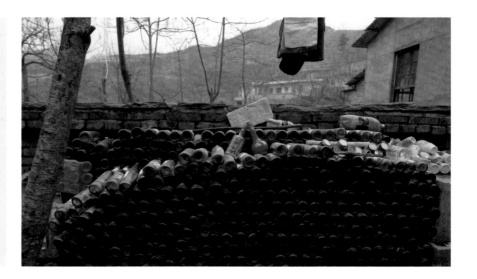

development from the late 1980s onward, the vast Chinese countryside has seen the development of an electrified landscape. At first, the supply of electricity was irregular and expensive, and few families could afford any household appliance beyond a light bulb. Gradually, television became the most popular of the modern novelties, and whole villages would gather after dinner at the home of a family that owned a television set. By the early twenty-first century, the electrification of households had spread throughout most of the country, with only the most remote areas lagging behind. Today, almost every rural family has at least one TV set, and many have installed satellite dishes to compensate for poor cable service. According to a 2006 survey of eight villages in four provinces, more than 80 percent of the residents opt to watch television in their free time, and the average viewer spends nearly three hours per day in front of the TV.

Chinese Conjuring Extraordinary.

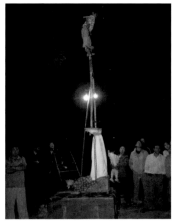

Before the arrival of the television age in the countryside, peasants throughout rural areas enjoyed the festival-like atmosphere of outdoor entertainment. Popular performances included local operas as well as acrobatics, traditional art forms that gradually gave way to pop music and dance shows (Photo: Jinggangshan, Jiangxi Province).

Broadcasting since 1995, Channel 7 of China Central Television, China's state television network, offers military and agricultural programming. Its most popular rural community-centered program, *The Big World of the Countryside* [Xiangcun Da Shijie], offers rural entertainment shows and agricultural information, and it serves as a free communication platform to promote local cultures and products. Despite these efforts, most television shows focus on urban lifestyles and thereby exert a great influence on the rural population's values, in particular on the young. In the few cases where TV dramas include characters from rural areas, they tend to be portrayed as ignorant, uncouth bumpkins. The televised images of a better and more modern urban lifestyle encourage contempt for and the abandonment of traditional rural lifestyles. In addition, many critics blame the popularity of TV for undermining local customs and cultures in the countryside. Consequently, traditional village performances do not draw crowds as large as they once did.

Moreover, in the last decade the Internet has become more popular and accessible in rural areas. Although there continues to be an urban-rural digital gap, we can usually find an Internet cafe in every county seat. The central government is committed to improving web access for the

Lingshi County, Shanxi Province

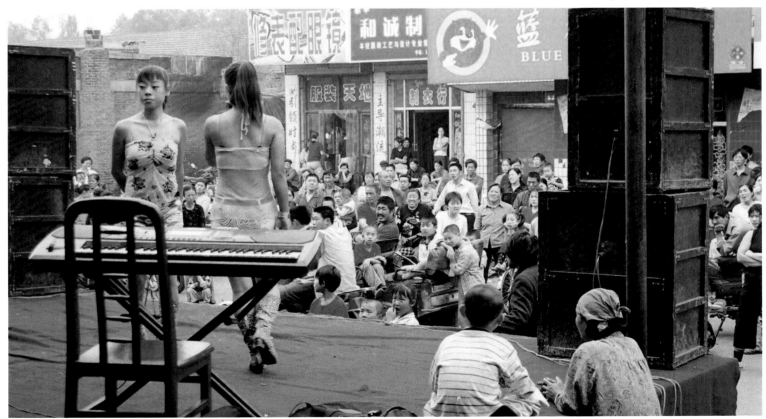

Pianyan Old Town, Chongqing Municipality

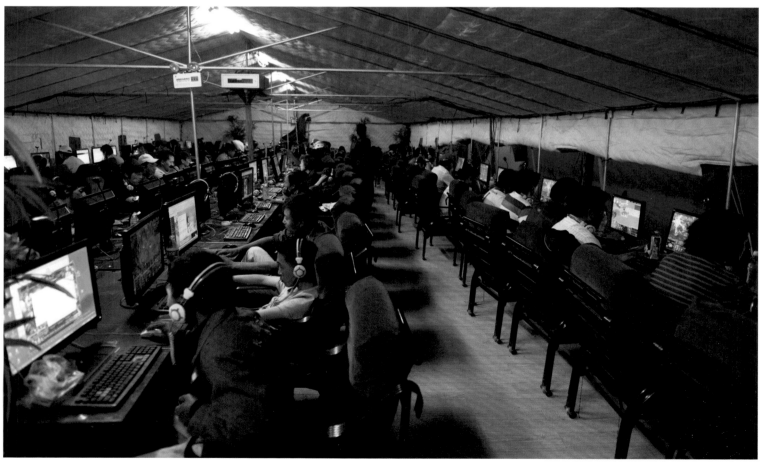

Gyêgu [Jiegu] Town, Qinghai Province

'rural poor.' According to its figures, 15 percent of the rural population surfed online in 2010, and their major interest is in web entertainment, such as music, video games, news and films and TV. Take for example the popular online card game *Fight the Landlord* [dou dizhu]. The name alludes to the class struggle that occurred during the Cultural Revolution, when peasants were encouraged to violently humiliate their landlords. Among the most enthusiastic online players are members of China's *Generation Y,* born after 1980, who did not personally experience the Cultural Revolution. Thus, the name does not suggest any negative historical connotations for them.

Naturally, the younger generation makes up the largest share of rural *netizens*: About 70 percent are less than thirty years old. Due to the lack of infrastructure and facilities, many users surf on a mobile phone or in an Internet cafe. As a win-win strategy, the government is trying to increase the demand for consumer electronics in the domestic market and improve peasants' living standards. Since 2007, there has been a subsidy policy, *Popularize Household Appliances in the Countryside* [jiadian xiaxiang], which offers a 13-percent discount on computers and other electronic devices.

Happy Farm [kaixin nongchang] is another increasingly popular online game among youngsters. Its players cultivate various agricultural products on their own virtual farms, while the greatest success often results from stealing harvests from other players' farms. Rather surprising is the encouragement of unethically taking advantage of others.

Unlike television and the Internet, there is little demand for newspapers in rural areas. They are neither published nor distributed in villages and are often only available in county seats. A few newspapers do focus on agriculture and rural communities, but the most widely available newspaper is still the Party's mouthpiece, the *Renmin Ribao*. The lack of newspapers serving the interests and needs of rural communities is an acknowledged problem for the government's policy of *Building a New Socialist Countryside*. Within the scope of this policy, newspapers are strongly encouraged to address the *Three Rural Issues* [san nong wenti] and educate the rural population accordingly. However, the government's goal to promote newspaper reading in rural communities seems to be little more than a pious wish. According to a study published in 2007, only 2.9 percent of the rural population reads a daily newspaper. In general, uninteresting content, inconvenient availability, limited educational levels and low incomes remain the main barriers. Newspapers are often used as wallpaper in village homes and are much less important and effective as media.

Despite the digital gap, educational levels and limited incomes, a few farmers have never ceased to dream. Some peasant artists create genre paintings depicting their daily life, while others construct fantastic machines or robots as a pastime: In spring 2010, the famous Chinese artist and curator, Cai Guoqiang, organized the exhibition 'Peasant da Vincis' in Shanghai. *Peasant scientists* [nongmin kexuejia] are a special group among their peers. They have the same average earnings and education as others of their class, but differ in having a technically creative imagination. Putting together an airplane from bamboo and constructing a submarine out of a discarded oil drum are just some examples of their inventiveness.

Meidaizhao Village,
Inner Mongolia
Autonomous Region

Shehuo processions are commonly held in the northern provinces around the time of the *Lantern Festival* [Yuanxiaojie], which marks the end of the Chinese New Year celebrations. *Shehuo* goes back to a sacrificial ceremony for animistic gods that arose several thousand years ago as the Chinese evolved from hunters and gatherers into an agricultural society. The word *she* not only means community, but also refers to the *God of the Earth* in classical literature. *Huo* refers to the *God of Fire* [Huoshen]. Both were important deities in ancient times. The processions expressed farmers' hopes for an abundant harvest and blessings to protect against disease. Most *shehuo* processions consist of stilt walking and acrobatic performances.

Ponan Village in Shaanxi Province boasts of an unusual and dramatic variant called *bloody shehuo* [xue shehuo]. It is marked by shocking performances that portray cruel punishments – chopping off heads, gouging out eyes, evisceration, amputating limbs, and so on – meted out to notorious scoundrels in Chinese history, such as the evil official Qin Hui and the unfaithful husband Chen Shimei. The actors all wear heavy makeup, and some are splattered with animal blood and organs to make the brutal torture seem more real. The characters are paraded through the main village street on farm trucks and tractors.

The *xue shehuo* in Ponan Village is said to have originated around the sixteenth century. The precise reasons for this unique procession are unknown. Some believe that presenting these gory stories during the festival is meant to warn farmers against wrongdoing and remind them of virtues like uprightness or self-restraint, especially in a time when many consume far too much alcohol and do no constructive work during the winter. Others suggest that such public portrayals of punishments meted out to wrongdoers provide balance, i.e., a psychological compensation, in an unfair society. *Shehuo* processions were banned during the Cultural Revolution, but the popularity and renown of *xue shehuo* have increased greatly since the 1980s. The procession is now officially recognized as an intangible cultural heritage.

The *bloody shehuo* in Ponan attracts many spectators from neighboring villages and towns. Watching the audience is as interesting as viewing the ceremony itself. The exuberant atmosphere pervades this tiny village in the Loessland in a very unusual way. During the parade, some 'executioners' deliberately and slowly move their torture instruments back and forth through the bodies of the scoundrels to intensify the horror. But this cruelty does not rob spectators of the pleasure of seeing the villains receive their just deserts.

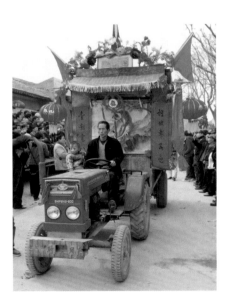

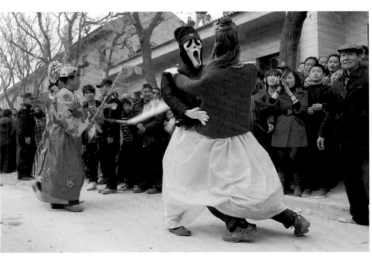
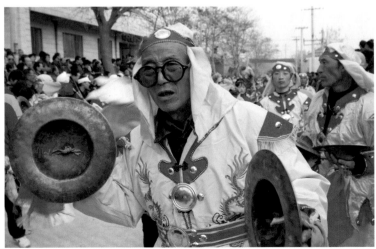

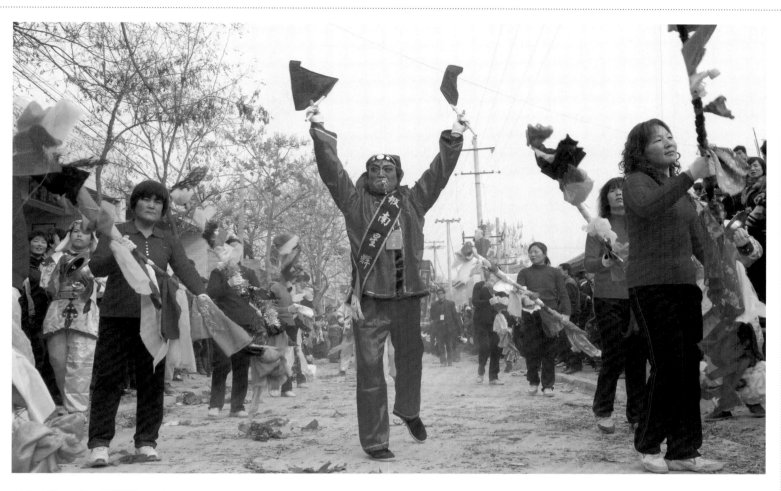

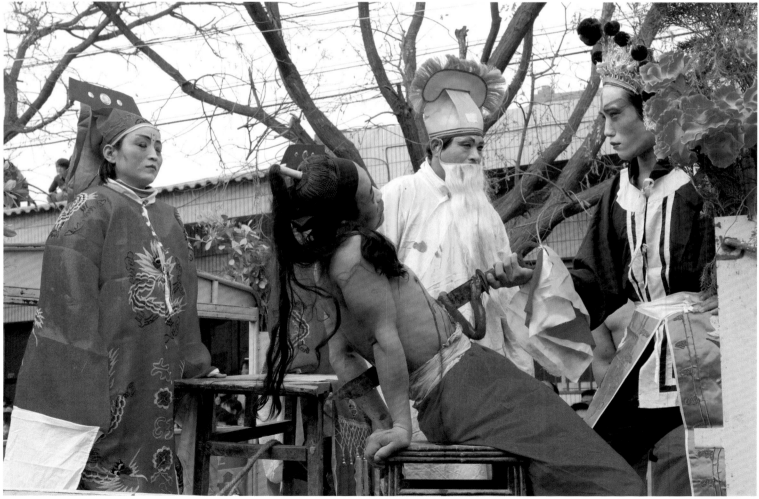

On the western bank of the Yellow River, not far from Ponan Village, lies *Donglei Village*. Its residents celebrate the Lantern Festival with an even more archaic ritual called *Topping the Gongs and Drums* [shang luogu]. It consists of ancient dances in combination with strong rhythmic percussion music and an aggressive competition between two village teams. The first settlements in this area can be traced back to as early as the fifth century BCE. Every year, the flooding of the Yellow River took many lives and destroyed much farmland. Thus, the ancient inhabitants of this area created a dancing and competitive ceremony to appease the *God of the River* [Heshen] and drive out evil spirits.

Shang Luogu is composed of three parts with different percussion rhythms and a gradually intensifying physical competition. The game starts when the two teams parade to the village center from opposite directions bearing flaming torches and accompanied by the sounds of ecstatically beating drums. When both teams arrive at the center, the music grows louder and more provocative. Finally, the strongest man on each team puts the heaviest drum, made out of hard wood and thick leather and with a diameter of sixty centimeters, on his back and tries to place his own drum on the other's. Chasing, shouting and fighting dominate the scene. Since victory is an omen for a good year, the combatants make every effort to defeat the other team. The game lasts until midnight, and the outcome often exacts some physical price. Policemen often have to calm down the crowds in order to prevent the spectacle from getting out of control. An ambulance is stationed just outside the village in case there is any serious accident.

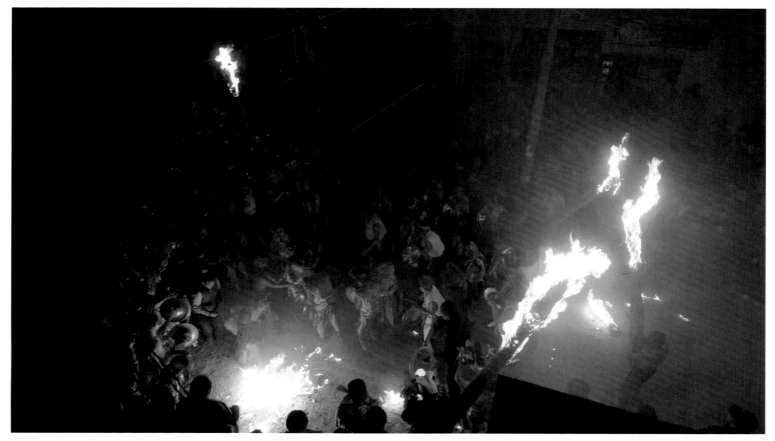

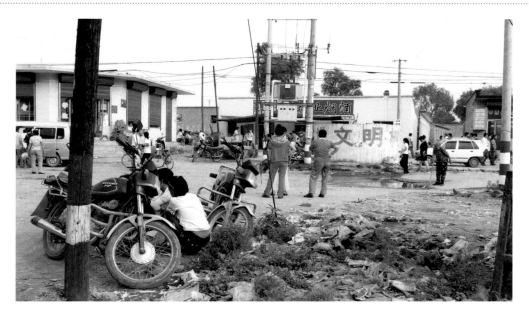

Temple fairs in China are usually combined with a temporary open market and several celebration activities. The annual temple festival of the lamasery in *Meidaizhao Village* of Inner Mongolia Autonomous Region falls on May 13th in the lunar calendar and attracts many traders, vendors and visitors from the surrounding region. This lamasery was an important center for spreading Tibetan Buddhism in Inner Mongolia. As more and more people settled around the lamasery, a village of the same name was founded.

At the temple fair market, vendors not only ballyhoo wares ranging from local products, plastic toys and clothes to oddly constructed scalp-massage devices, but also tout services such as portrait photography using kitschy props and on-the-spot mole and corn removal treatments. Though the all-pervasive wind-borne sand soon makes most foods look stale, local people visit the market with joyous hearts. But for the locals, the cheerful atmosphere provides a chance to temporarily escape from dull everyday routines in a once-romantic rural settlement that has long since lost its charm: The village lies only a few kilometers away from the truck-jammed Beijing-Lhasa Highway. Most trucks transport coal from nearby mines and processing factories to Hebei Province and the more developed areas of the country.

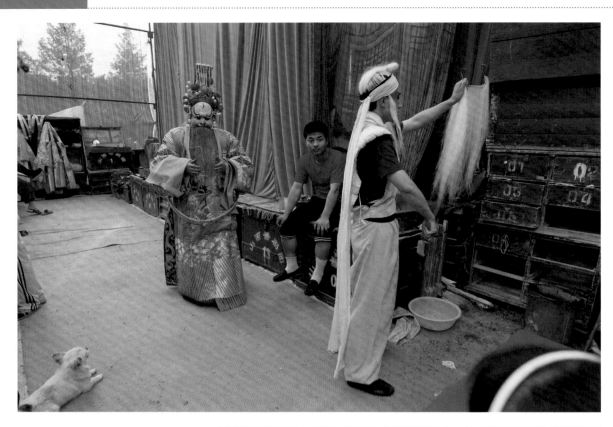

The theatrical performance is naturally another focus of the temple fair. An *itinerant theater troupe* from bordering Shanxi Province is invited to perform for a few days. This troupe, with a dozen members, traveled over 600 kilometers in two buses, bringing along several huge wooden boxes full of props and costumes for their performances. Some of the performers spend the night backstage, while others take their rest in sleeping bags in nearby school classrooms. These actors and musicians tour the countryside for up to eight months per year, and many see their spouses and families only occasionally. One of the actresses has brought her kindergarten-age daughter with her on this trip. The child, whose father is also an itinerant actor in a different theater troupe, must otherwise stay with her grandmother.

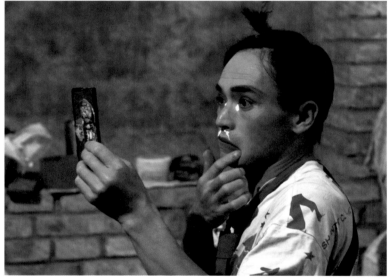

The *Shanxi Opera* [Jinju] was introduced to Inner Mongolia in the early Qing Dynasty (1644–1911). Along with the flourishing activities of Shanxi businessmen in trade and commerce, it became popular throughout northern China. Many of these rich entrepreneurs had their own theater troupes. The performance of a *Jinju*, on the one hand, offered some comfort for these homesick traveling businessmen; on the other hand, it attracted the attention of potential clients. Today, not only in Shanxi, but also in northern Shaanxi, Hebei and Inner Mongolia, *Jinju* has become the mainstream opera form, often enriched with some local touches. In Meidaizhao, performances usually begin in the afternoon and last several hours, only interrupted by a dinner break. In this dusty place, which is normally plunged into impenetrable darkness after sunset, the lit-up palace of the open-air theater is a magnet for most villagers. Following a faint torch beam and carrying their own stools, they flock to the scene and for a few hours enjoy a 'One-Thousand-and-one-Nights' fantasy world.

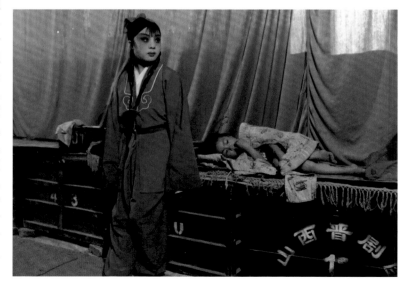

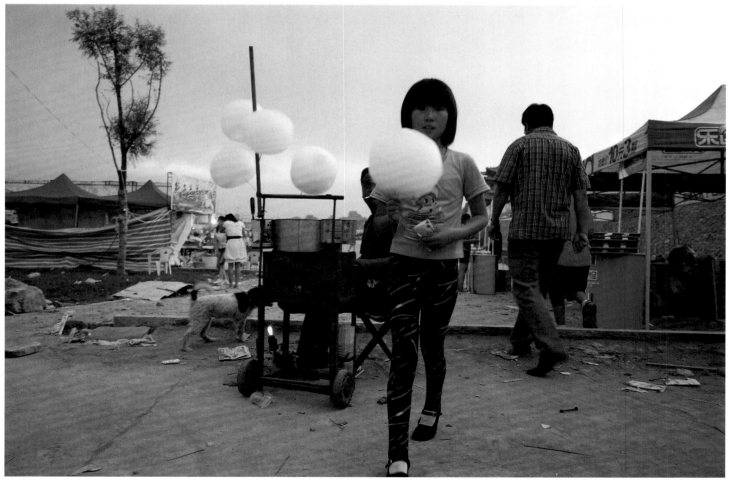

The first Mongol settlement in this area can be traced back to the sixteenth century. A descendant of the famous Kublai Khan, Altan Khan, who founded Meidaizhao, posed a powerful threat to the Han Chinese Ming Dynasty (1368–1644). The relationship between the two countries had always been rather tense, especially since the Ming government decreed stringent rules for trading Mongolian livestock and Chinese textiles and pots. After several requests by Altan Khan to the Emperor in Beijing went unanswered, he sent his armies across the Great Wall and seized the outskirts of the capital in 1550. The Chinese Emperor was finally forced to sign a peace treaty granting the Mongols special trading rights. This treaty not only increased the political, economic and cultural exchanges between the Chinese and the Mongols, but also attracted Chinese farmers to cultivate land in the border areas.

The introduction of Tibetan Buddhism into Mongolia is usually credited to Altan Khan: During an expedition to today's Qinghai Province, he was very strongly drawn to this religion. He even converted to Buddhism in later years, bestowed for the first time the title of Dalai Lama upon the visiting Tibetan Gelugpa leader, and founded the monastery of Meidaizhao. The architecture of this once very significant monastery is a mixture of Mongolian, Chinese and Tibetan styles.

In the following decades, Tibetan Buddhism became widespread throughout Mongolia. The introduction of Buddhism and the outlawing of Shamanism helped to further civilize the nation. Cruel practices, such as livestock sacrifices and the immolation of women on their husbands' funeral pyres, were abolished. Later, the area around Meidaizhao to the north of the Ordos Desert became an important cultural and economic hub, where traders exchanged Mongolian horses for Chinese silk. However, its declining importance, accompanied by increasing desertification, has made this area rather drab. Only on evening strolls in dim moonlight can visitors imagine the mirage-like former splendor of Meidaizhao.

The lamasery was largely destroyed during the Cultural Revolution. Luckily, the frescos in the main hall were relatively undamaged, as it was used as a food warehouse. The temple fair was resumed in the 1980s, but people still lament the loss of religious customs: Older villagers still recall the impressive traditional mask dance in the temple ceremony, which vanished in the political upheavals.

A village fair with an open-air theater somewhere in northern China around 1900

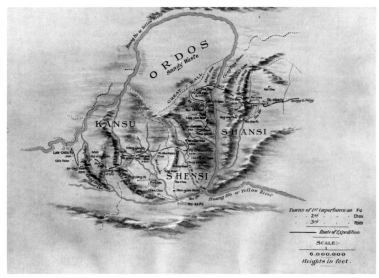

A 1926 map of the Ordos Desert

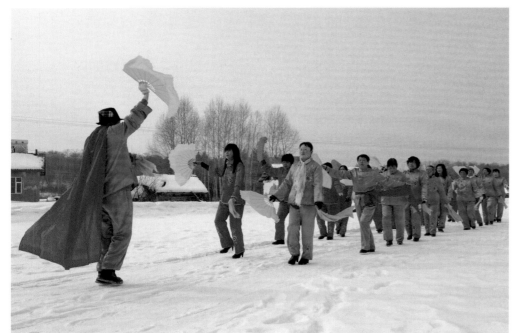

Niu yangge, literally 'move to the rice-sprout song,' is a popular traditional entertainment in northern China. It was originally performed as a ritual to honor the God of Agriculture. Around the turn of the twentieth century, when many Chinese, especially from Shandong and Hebei Provinces, settled in areas beyond the Great Wall, this folk dance was brought to the northeastern provinces. The immigrants' offspring carried on the tradition. During the spring planting season, women and children used to sing while working in the fields. Later, dancing and theatrical performances were added, and the *yangge* dance became an ecstatic performance during the Chinese New Year celebration. Although there are various forms and stage props for this folk dance, it uniformly expresses joy and pleasure.

During the Yan'an era (1936–1947), the Communist Party employed the *yangge* dance with great success to disseminate socialist ideas, although the traditional content was totally changed. Later, the modified dancing style again effectively stirred peasants' enthusiasm for the land reforms and other policies. When the Cultural Revolution began, however, this dance was banned due to its feudal and religious origins. The *yangge* dance has gone through a period of revitalization, but it is difficult to recreate its authentic form. Although there is nowadays no political ideology attached to it, the current music and choreography are in fact based on the revolutionary model.

In *Changsong Village* of Jilin Province, most *yangge* dancers are women. The only male acts as the lead dancer. When asked why the other village men did not join them, the women replied that their husbands were off working. However, it turned out that they actually preferred getting together in a grocery store to play cards or Mahjong.

Quite a few families in this village are Christian. They regularly gather on the heated *kang* in the home of a retired couple. In this household, only the wife has been converted. Her husband is still a convinced atheist who spent his entire career serving the local government. While his wife claims she has brought him closer to God and promises to make him a believer in two more years, he sits quietly at the dining table listening to her and blushing, but with a contented look.

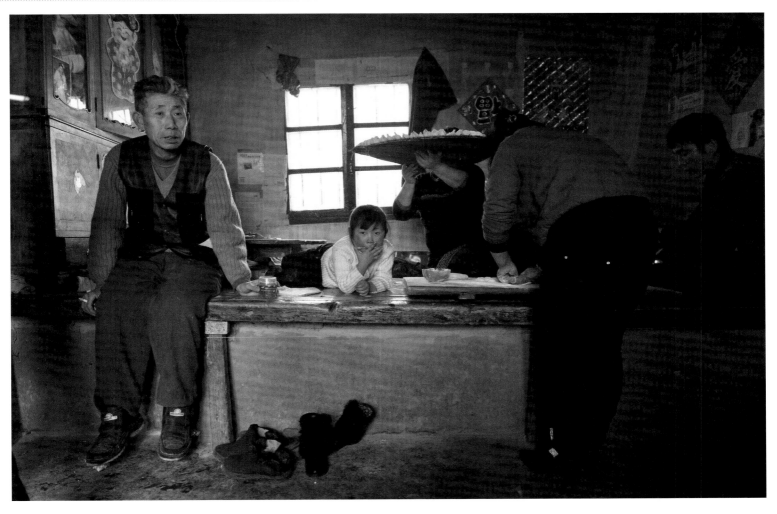

At the *yangge* lead dancer's home

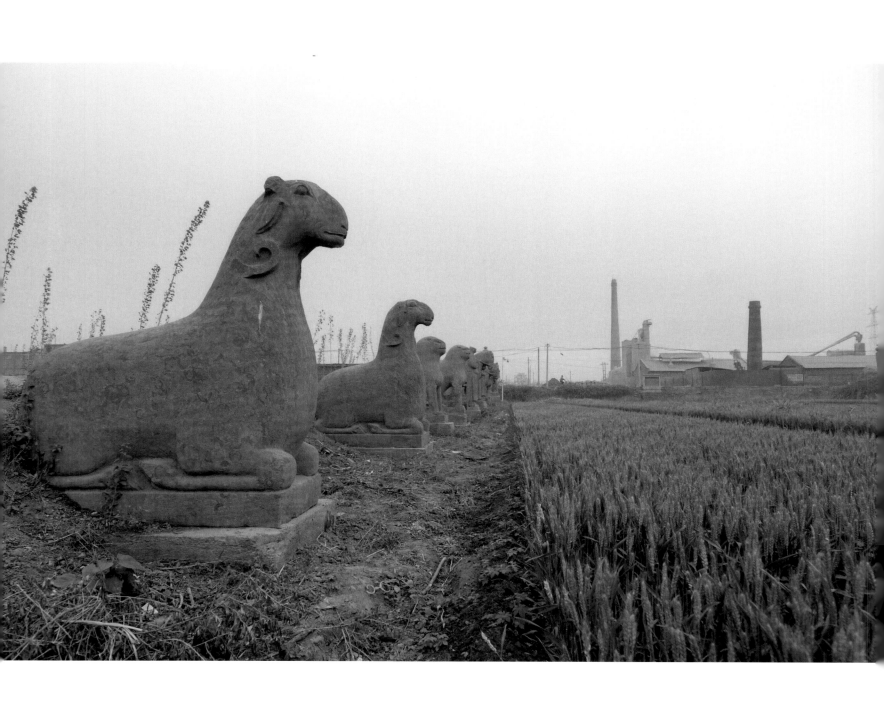

Imperial tombs of the Northern Song Dynasty (960–1127) in Baling Village,
Henan Province

The fengshui of graveyards had been of utmost importance for imperial families for a long time. The construction of monumental gateways, a temple hall dedicated to the late emperor, and a grandiose pathway guarded by *stone officials and animals* [shixiangsheng] belong to the standard setting of imperial graveyards as depicted in an old map. These animals not only function against evil forces, but are also symbols of the late emperor's power. The rise of a lucrative illegal tomb-raiding industry has become a serious problem, especially since the Opening-up.

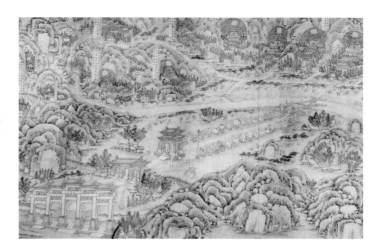

Preserving the Cultural Heritage

*China's economic boom of the last two decades
has created many opportunities for cultural preservation,
but it has also caused unconscionable destruction.*

Cultural-heritage preservation is a relatively new concept in China. The cultural heritage includes both the physical heritage, such as ancient houses and villages, and intangibles such as handicrafts and traditional operas. A common characteristic of both the tangible and intangible is that they were generally widespread in China before 1949. Many traditional activities were banned during the Cultural Revolution. Since the 1990s, economic development has further alienated daily life from rural traditions.

In recent years, foreign and Chinese organizations have both contributed to an increased awareness of Chinese cultural heritage. Whereas the Chinese government lavishes money on prominent, frequently visited sites such as the Forbidden City or the so-called Old City of Xi'an, in rural areas foreign funding plays a much more important role in preserving the cultural heritage. This has to do chiefly with the local governments' meager budgets and a development-oriented mentality. In addition, the preservation and presentation of a cultural-heritage site always depend on both history and politics. It is significant that the interpretation of a cultural site in China is sometimes controversial due to its different meanings for the local community and the government.

The preservation of historical architecture and communities is a complicated issue, because in the past the government's policy of *redevelopment of old town areas* [laocheng gaizao] simply meant replacing old houses with new ones. Due to large-scale development projects be-

Gravestones scattered in fields, thrown into ponds or used as paving stones are visible signs of a scarred cultural-historical landscape throughout the countryside. Most passersby seem indifferent to what these stones say of individual destinies. Willingly or reluctantly, they have apparently come to terms with a political system that does not want to delve too deeply into its own recent history.

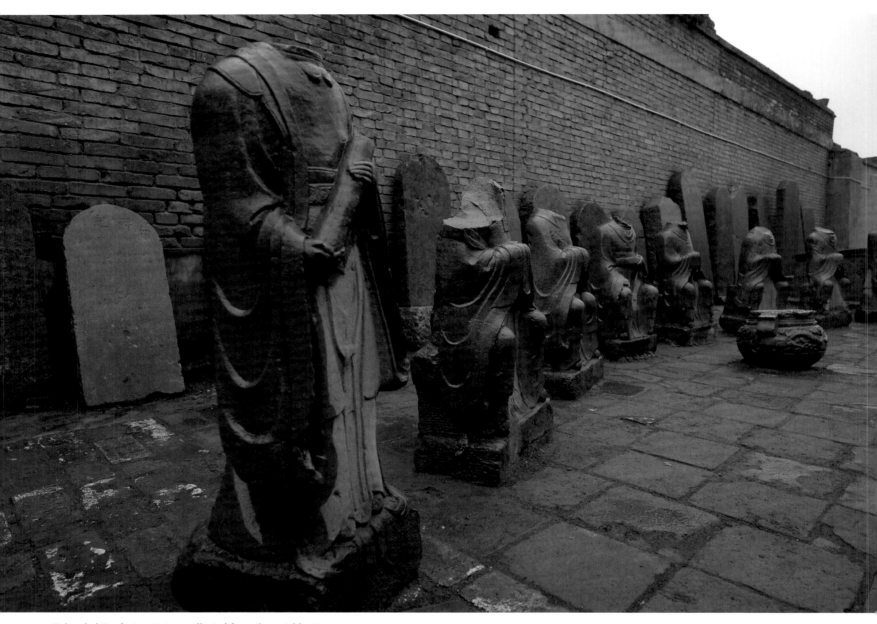

Beheaded Confucian statues collected from the neighboring areas,
Confucian Temple, Hancheng City, Shaanxi Province

ginning with the Opening-up, the situation deteriorated further. The popular slogan from the early 1990s, *A new image every year and a complete change every three years* [yi nian yi ge yang, san nian da bian yang], vividly describes this trend in the reconstruction of towns and cities. Ancient houses are considered outdated. One of the first things people in rural areas did and still do when they earn enough money is build a new house or move into a new apartment in town. In the last few years, the government and some individuals have increasingly begun to realize the historical and tourism-promoting value of cultural heritage. Still, traditional dwellings in villages and towns face threats not only from low-quality brick houses, but also from over-commercialized tourism development.

Indeed, the main value of cultural heritage for local governments lies in promoting the tourism industry, which has proved a mixed blessing. Too many historical villages are spoiled by profit-minded local officials, tourism-development companies and hordes of tourists who litter them with trash. Since local governments usually lack the knowledge and funding to manage culturally sensitive or even ecologically oriented tourism on their own, they rely heavily on cooperation with private companies. In a common cooperation model, the local government provides land and access to historical sites, while the private investor builds additional tourist facilities such as hotels and imperial theme parks, often featuring tasteless, pseudo-traditional architecture.

Farmers usually receive modest compensation for their land, but they are not actively integrated into the tourism industry. Profits from visitors' admission fees are mostly divided between the local government and the managing company. The investors' ultimate goal is to maximize profits for the duration of their contract with the local government, rather than to contribute to historical preservation and sustainability. Unfortunately, when tourists encroach on daily life in rural areas, villagers often feel cheated or exploited if they do not share in the profits from the tourism industry. The consequences of this widespread pattern are poorly planned tourism developments and discontented villagers who understandably react negatively to tourists.

The main difficulty in preserving the rural cultural heritage is the strong ties between local officials and private investors: The government's priority is to encourage and stimulate domestic consumption to keep the economy growing. This priority is in line with the interests of developers and builders. This profit-oriented alliance contributes to the vanishing of authentic rural cultures (Photos: Fenghuang Old City, Hunan Province). An even more advanced development has been taking place in Chinese cities, with theme parks showcasing artificial traditions such as the China Folk Culture Villages in Shenzhen (Picture bottom right).

Thus, as their names have become more widely known, many once-unspoiled towns and villages have started to look like entertainment complexes. Fenghuang Old Town in western Hunan Province can serve as an example: Similar to the orientation of a Disney theme park, this idyllic ancient minority town has been adapted to serve the interests of mass tourism. The hometown of the great author Shen Congwen has become a kitschy open-air museum where tourists pose for photos in rented costumes reminiscent of imperial times. The characteristic traditional *hanging houses* [diaojiaolou] along the riverside are preserved and used as guest houses and restaurants. The unique lifestyle, its community culture and the enchanting atmosphere that once characterized this waterway transport town have been lost forever. There is

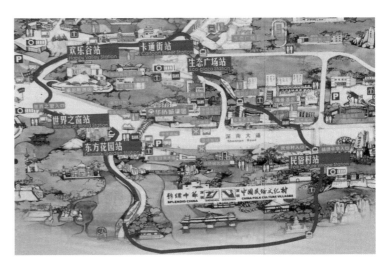

241

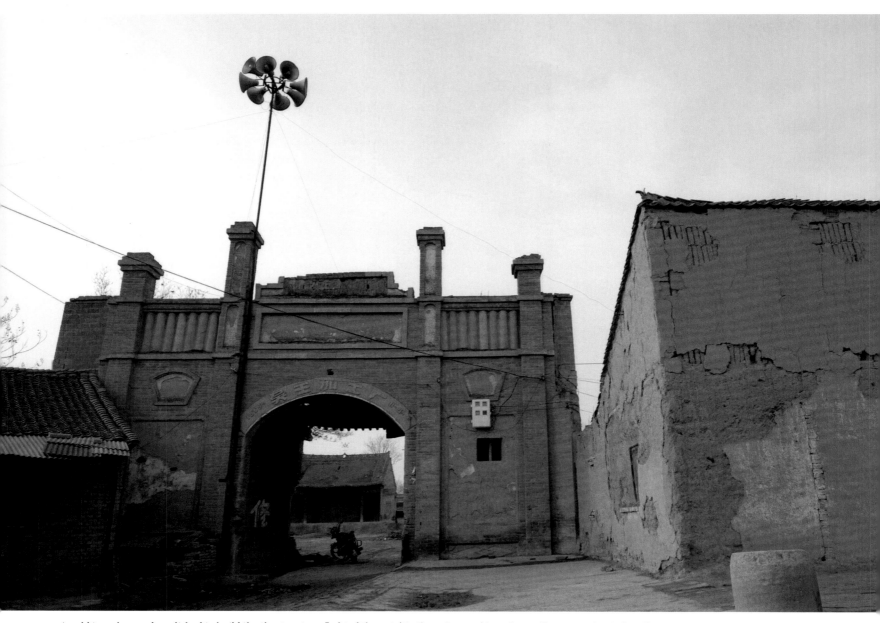

An old temple was demolished to build the theater stage (behind the gate) in the 1960s, and in 1969 a mill was constructed on the site. Today, neither the theater stage nor the mill is in use. Wuwang Village, Shanxi Province

Among the country's greatest assets in promoting its cultural heritage, besides the architectural relics of Imperial times, are the 55 ethnic minorities living in China's territory. Adventure excursions to minority areas, attending indigenous festivals or enjoying performances of traditional songs and dances are a top priority on any travel agent's itinerary. These standard programs often have more to do with fun and entertainment than with any real interest in rural traditions or heritage. For the purposes of tourism, and in some official travel brochures, minority women are often portrayed as radiating an exotic, even erotic sensuality, while Han Chinese women tend to be depicted as responsible, mature, maternal persons. This mindset echoes Mao's view that the more civilized Han Chinese should educate the more primitive ethnic minorities and work together to modernize the country.

If all decisions regarding the collective memory of China's past were made entirely according to orthodox Communist ideology, China would soon lose all of its traditions and historical heritage. Since 2005, the government has been actively supporting the *red tourism* industry, a project that promotes 'Mao's heritage' and the national ethos and precisely defines certain places and routes as a must for patriotic education. The characters on the red banner proclaim "Thoroughly develop massive patriotic educational activities nationwide," and in the spirit of this slogan, schools, institutions and the Chinese military regularly arrange *red tours* for their members. Many sites are located in the poor, land-locked countryside. The heritage attributed to some traditional sites lies oddly and solely in their patriotic meaning. For example, an exquisite old courtyard house may be presented merely as a *base for patriotic education* because Communist leaders once spent a few hours at a meeting there.

little chance that Fenghuang's application for the UNESCO World Heritage List will ever be approved.

In 2003, the Chinese government set up a cultural-heritage preservation program, *Chinese historic towns and villages* [Zhongguo lishi wenhua mingzhen, mingcun]. A new list of villages and towns is added every one or two years. Until 2011, 169 villages and 181 towns were listed as protected by this program. Besides the material heritage, a governmental program to preserve the *non-material cultural heritage* [fei wuzhi wenhua yichan] has also been initiated on various administrative levels. Its ten main categories include folk literature, traditional music, dance, drama, oral performing arts, acrobatics and contests of skill, folk art, handicrafts, traditional medicine and healing practices and folk customs. Nationwide, more than a thousand activities are included in this program. This seems like a great number, and the central government claims to provide annual funding amounting to hundreds of millions of renminbi. However, local people complain that the available funding is far too modest to preserve their heritage, and that corruption is inevitable.

In addition, the selection of heritage sites is not based on cultural considerations alone, but is also influenced by ideology and politics. At some heritage sites, for instance, signs proclaim that they are *bases for patriotic education* [aiguozhuyi jiaoyu jidi]. Naturally, these promotions offer only selective narratives of a multi-layered history. Similarly, the recent promotion of *red tourism* [hongse lüyou] "to rekindle the long-lost sense of class struggle and proletarian principles" indicates that the Communist Party is still instrumentalizing the sites for mass propaganda. It comes as no surprise that revolutionary sites designated as part of the national heritage may be centers of conflict and controversy due to tensions between national and local memories and identities, as occurs in Tibet, for instance.

Wuyuan County, Jiangxi Province

Today, relics of the Maoist era can hardly be found in big cities undergoing rapid development or in planned urban *façade beautification projects* [mianzi gongcheng, literally *face projects*]. Although visitors may still occasionally come across survivals of these artifacts in the countryside, mostly in the homes of nostalgic peasants, their meaning has changed dramatically in the course of time. In some popular rural tourist destinations, propaganda paintings from the 1960s and 1970s are updated with modern slogans like "Revolution is no crime. Chasing after girls is justified," advertising trendy commercial products.

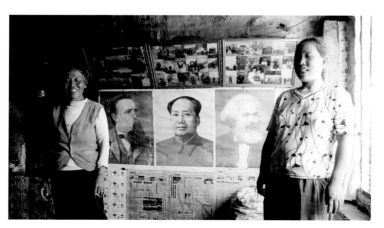

Likewise, there are ongoing discussions of the past's political landscape, as more and more relics of Mao's era are disappearing. There is a debate over whether to preserve the political wall paintings and slogans that remain from that era when renovating old houses. Some experts advocate preserving these political icons as part of China's history, others favor restoring the original appearance of historical buildings, while still others feel embarrassed by reminders of their Great Leader's mistakes. The Cultural Revolution was a taboo topic until recent years and is still a sensitive issue in many regards. It is not surprising that very few political traces from this era remain in the ancient villages that have been restored during the last three decades. However, all these architectural layers carry meanings from bygone times. Only very few places have retained political relics after restoration.

Leaving politics aside, the effectiveness of lists designating sites for cultural-heritage protection is unfortunately limited. The changes that have occurred in Lijiang Old Town in Yunnan Province, registered as a UNESCO World Heritage Site in 1997, illustrate an obvious tragedy. This once-sleepy old Naxi Minority town, first made known to the outside world by the Austrian-American explorer Joseph Rock in the 1940s, has seen an influx of tourists in the last ten years, accompanied by a steady commercialization and transformation of its culture and lifestyles. Consequently, the town's centuries-old traditional social system has dissolved.

To build tourist facilities, developers persuaded many Naxi farmers to sell their land for very modest compensation. Unfortunately, after selling their land some farmers were unable to find new jobs. The unemployment issue may only be

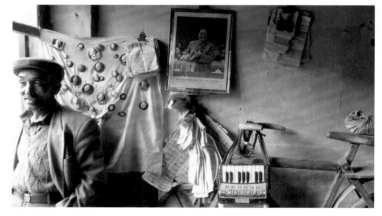

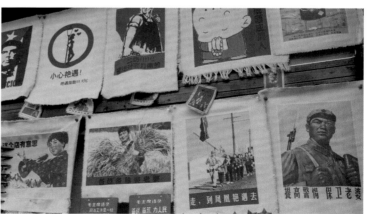

transitional, since these farmers could still receive vocational training and adapt to a modernized lifestyle. But the authentic local culture that has been sacrificed to commercialization is irretrievably lost, without leaving any traces. Today, guest houses, restaurants, shops or pubs, mostly run by Han Chinese, occupy almost every building in Lijiang Old Town. Most tourists come here in quest of an exotic rural surrounding with a variety of entertainment possibilities, and not because they want to understand minority lifestyles or a lost past.

According to locals, less than 40 percent of the houses in Lijiang's Old Town are still occupied by Naxi natives, mostly elderly people. Many have moved into the new town and rent out their old courtyard houses, as everyone does in times of business expansion, leaving behind only a few nostalgic memories. As the once-charming town becomes even better known to the outside world (international flights to Lijiang are being planned for 2012), this UNESCO site may well be left with only historical architectural facades, but no living traditions.

In summary, preserving cultural heritage in rural China still faces many challenges. Although the attitudes of the government and the public have changed in the past few years, the high priority assigned to rapid modernization does not bode well for preserving this rich cultural heritage. The desire to increase domestic consumerism, even at the cost of cultural heritage, is shared by the government and tourism and real-estate developers. As a result, legal protection and enforcement are weak. Moreover, public awareness of culture and tradition lags far behind the pursuit of a richer material lifestyle. To be fair, there are some exceptional cases where villages work on a sounder basis with the local government and private investors, but mostly in places where the residents are better educated or where an international partner supports and sets the standards for cultural-heritage preservation. Thus far, the development of China's mass-tourism industry has been blatantly destructive. It strongly threatens the country's cultural landscapes and its heritage with over-commercialization and artificialization.

The area around Lijiang and Dali was for a long time a *Forgotten Kingdom*, as the Russian explorer Peter Goullart's 1957 book describes it. When Lijiang was devastated by a major earthquake in 1997, it was quickly granted UNESCO World Heritage Status to support its reconstruction. Unfortunately, the continuing over-development of Lijiang has not just produced increasing numbers of speculative real-estate projects and five-star resorts, but also attracted Chinese tourists hoping to have romantic affairs with local Mosuo women. The Mosuo Minority's traditional society was based on a matriarchal system, and women could take multiple partners. Their original lifestyle is now being threatened by mass tourism. One of their main settlement areas is located around Lugu Lake, about 260 kilometers north of Lijiang.

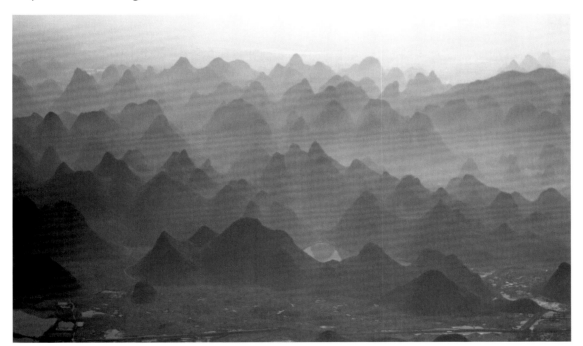

Guilin's beautiful Karst topography has made it one of China's most famous tourist attractions. The tourism boom of the last two decades has dramatically changed both the cultural landscape and the local lifestyle: The traditional practice of farmers along the Li River employing cormorants for fishing has declined to a mere commercial performance. As this scene is often used in tourism-promotion campaigns and was even featured in a 2008 BBC documentary on China, many people are misled to believe that this is still a common practice. In addition to tourism, real-estate projects are an even bigger source of profits. With the constant expansion of its urban areas into the countryside, a population of five million and an international airport, Guilin has urbanized rapidly in the past decades. Many observers suspect that the local government's ambitious development plans for more real-estate projects and highways are the real reason why Guilin has not applied to become a UNESCO World Heritage Site.

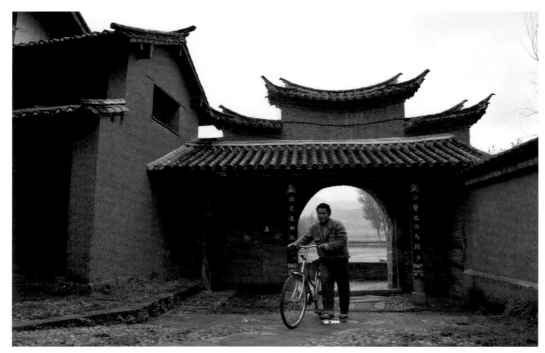

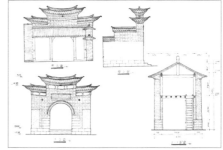

Shaxi Old Town in southwestern Yunnan Province, with an altitude of 2,100 meters, began as an important stop-over and trading center on the *Tea Horse Caravan Trail* [cha ma gudao] that linked the Chinese Tang Empire (618–907) with Tibet, Burma and India. The main population group in the Shaxi Valley is the Bai people, a Sino-Tibetan ethnic minority. The Bai established their own Kingdom in the tenth century and remained independent until they were subjugated by the Mongol Empire in the thirteenth century. Yunnan became part of China, and the Bai were assimilated in the course of history.

The development of the salt industry around Shaxi during the late Ming Dynasty (1368–1644) further stimulated the expansion of the trail. Shaxi soon turned into the local salt-distribution center. Today, Shaxi and its Sideng Square are identified as the last surviving stopover and marketplace on this branch of the Tea Horse Caravan Trail. This trail was previously known as the South Silk Road until Chinese researchers renamed it in the 1990s on the basis of what had once been its most important trading products – Pu'er Tea and Tibetan horses. In due course, the refreshingly new name was soon adopted by the tourism industry and shaped a new cultural identity in this region.

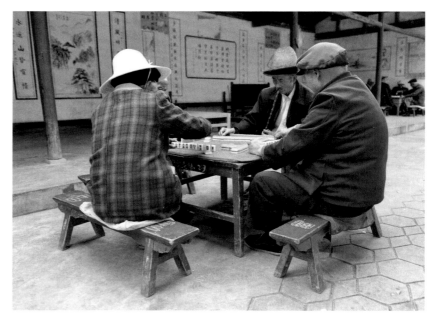

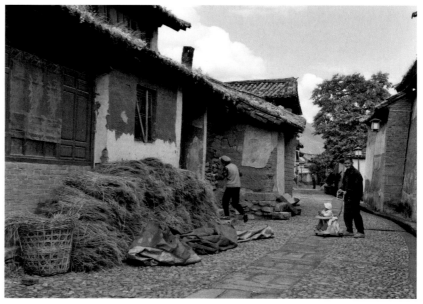

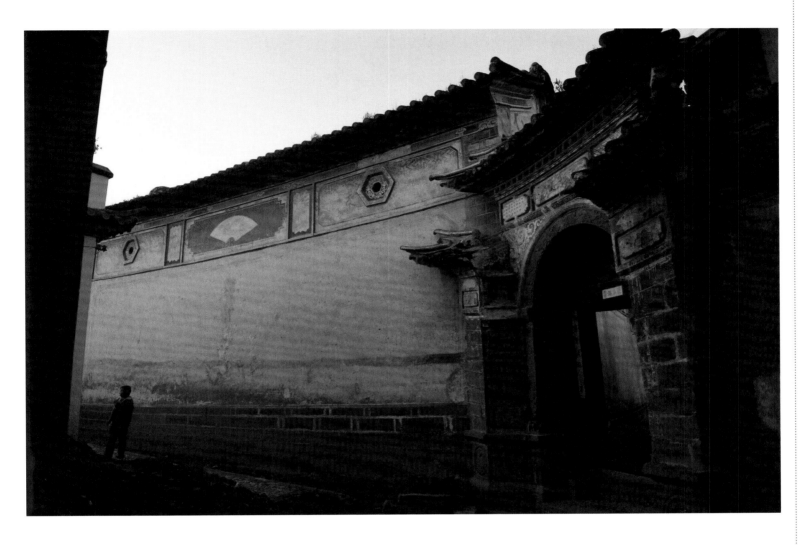

The main town structure and the splendid courtyard houses of Shaxi are magnificent remnants of its former glory and prosperity. During the Sino-Japanese War in the 1940s, the Tea Horse Caravan Trail served as an important transportation route for the Allies to transport international relief to the Chinese home front. After 1949, the PRC restricted free trade between Tibet and its neighbors. Later, the introduction of modern transportation finally put a permanent end to traffic on this trail. After the Opening-up, due to its remote location in the foothills of the Himalayas and the lack of profitable mines, Shaxi was largely spared from the modernization trend. Agriculture remained the main economic sector, and the average yearly income was about RMB 3,000 (US $450) in 2007.

A restoration project funded by international organizations and the Chinese government was initiated, and basic infrastructure like sewers and stone-paved streets was completed in 2006. According to cultural-heritage experts, Shaxi is among the finest examples of a preservation project in China. However, it is unclear whether Shaxi will be able to avoid the fate of Lijiang, with the negative effects of mass tourism and over-commercialization.

The burden of human portage:
Tea porters in 1908.

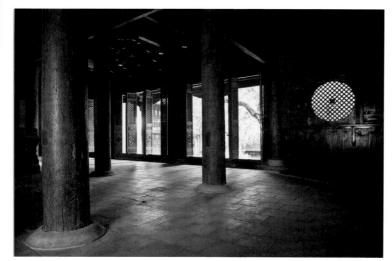

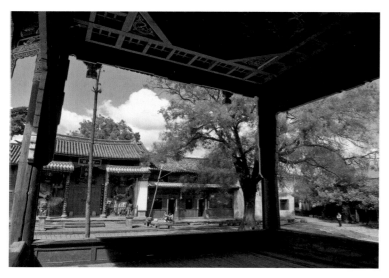

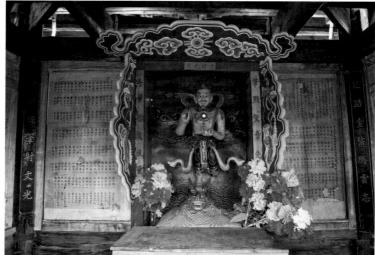

The main square of Shaxi, surrounded by a temple, a theater stage and numerous shops, was the center of local activities. The Bai integrated Buddhism into their indigenous belief in the village god *Benzhu,* animistic deities and other legendary heroes. The Xingjiao Temple, built during the Ming Dynasty, boasts a mural of a female *Sakyamuni* (Gautama Buddha). This rare feature recalls a matriarchal society in ancient times. Across from the temple stands an intricately designed theater stage in a pavilion style.

For centuries, the Bai have been renowned for their fine architecture with its exquisite stone and wood carvings. In the Shaxi Valley, construction and handicraft work remain the most important occupations after farming. The rooms beneath and near the theater stage functioned as shops, while the attic above the stage was dedicated to *Kuixing* (Pictured), the Taoist *God of Literature.* In the process of assimilation, the Bai were deeply influenced by Confucianism and Taoism and thus also revered their culture and scholars. When caravans arrived in the town from all directions, traders and porters alike went to the temple and prayed for a safe journey and later took in a theater performance.

Shaxi did not escape the havoc of the Cultural Revolution, and many priceless religious and historical objects around this square were badly damaged or destroyed. The Red Guards relentlessly smashed the temple gate and statues, but fortunately a layer of white plaster had been smeared over the murals when the room had been used as an interim classroom for an elementary school. Preservation work has been done by the *Shaxi Rehabilitation Project,* promoted and financed by Western organizations as well as the Chinese government. The Xingjiao Temple, the theater stage and the wood-frame shops around the square have been renovated carefully to restore their previous appearance.

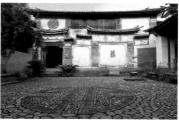

A previous caravan inn near the main square in Shaxi has been renovated into a comfortable guest house with up-to-date facilities. The original structure is preserved – with beautiful courtyards, horse and camel stables and rooms for traders. A reasonable development of tourism to revive the local economy is one of the stated aims in this restoration project.

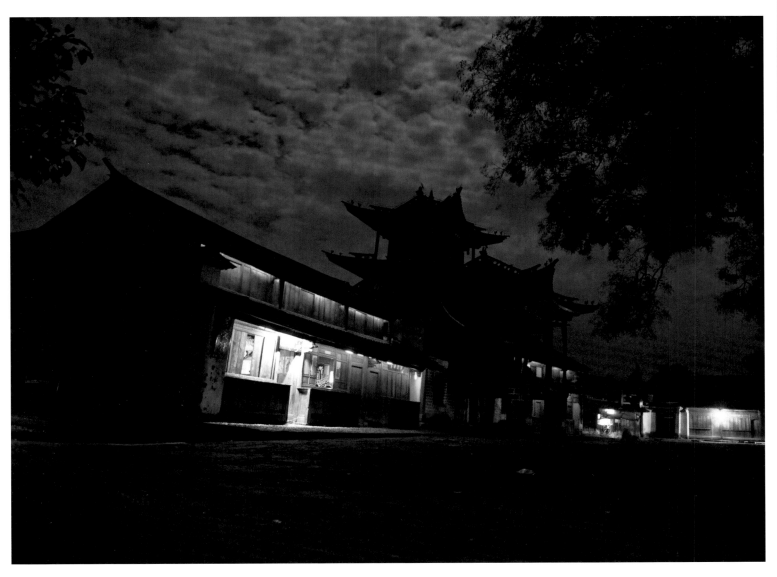

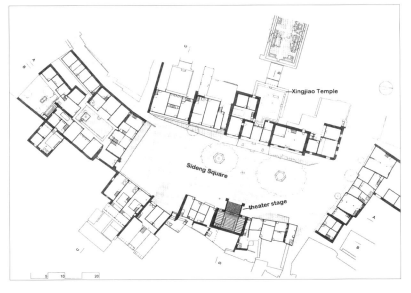

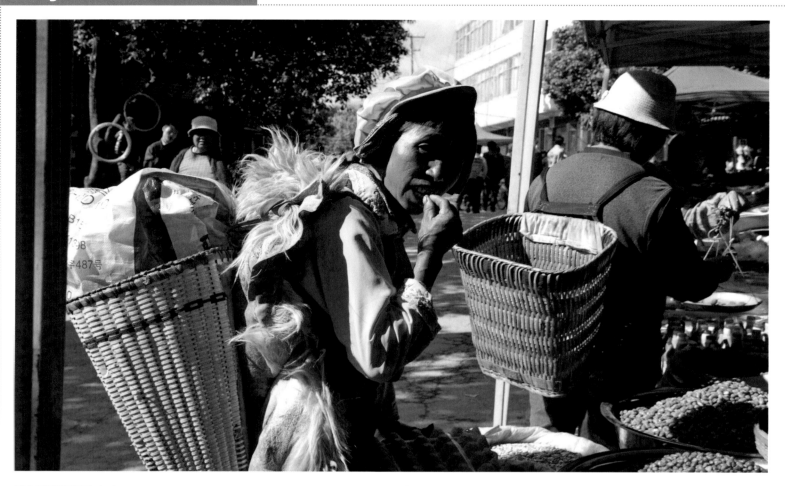

The Sideng market was held regularly for many centuries until 1949, when the traditional rural market system was replaced by the centrally planned economy. Later, the market was relocated to the shops on the newly built central avenue outside the old town. Today, the tradition of weekly markets has been revived, and villagers belonging to various ethnic groups from the surrounding areas gather every Friday to buy food and other goods or get special medical or beauty treatments.

For thousands of people living in the valley, the Sideng market has again become their most convenient one-stop open-air shopping center. Villagers, mostly middle-aged and elderly women, usually leave their homes up in the mountains around dawn, wrapped in sheepskins to protect them from the frosty air. In the old days, tea, horses, salt, herbs, spices and furs were the most important commodities, whereas now local farm produce, daily household necessities and clothing make up the largest share of purchases.

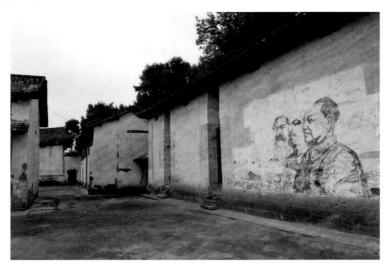

As with other places located on important trading routes, be they Mazar Village in Xinjiang, Qikou Old Town in Shanxi Province or Chikan Old Town in Guangdong Province, in the past Shaxi owed its prosperity largely to its geographical location. These places were all pivotal in the Middle Kingdom's centuries-old trading system, as they linked even far-flung regions with the political center. Chinese emperors considered an efficient trading system an important facet of their political power and prestige. Its focus was not only interregional, but also included trading with neighboring countries. The imperial court expect-

ed all countries wanting to do business with China to pay tribute, which also represented a form of submission, legitimizing China's superiority.

Aside from commerce and politics, the exchange of cultures and religions made places such as Shaxi a melting pot of ideas and thoughts, a predecessor to today's cosmopolitan world. The turbulence and upheavals of the twentieth century led to the collapse of this spider-web-like trading network. Political ideology by far outweighed economic concerns until the Opening-up. However, former trade hubs such as Shaxi have long since lost their attractive power and lapsed into oblivion. In their place, new cities on the coast or in areas rich in natural resources have suddenly appeared on the horizon. The only chance for reviving forgotten places with their rich history and culture is to turn them into cultural heritage sites.

One of the government's main problems in this frontier region is drug smuggling from the adjacent countries of Burma, Laos and Thailand. Similar to the destiny of many ancient trading routes all over the world, the Tea Horse Caravan Trail no longer meets modern transportation needs and might easily be misused by wily traders. Although Jianchuan County, where Shaxi is located, has no direct border with neighboring countries, anti-drug signs and slogans, e.g., "The absolute prohibition of drugs benefits both the nation and the people," can be seen throughout the countryside.

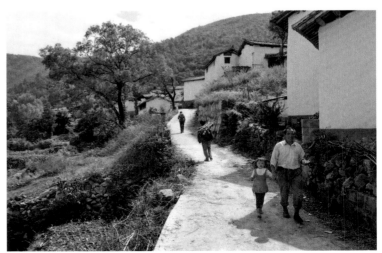

Shangzhuang Village in southern Shanxi Province was granted the status of a national-level historic and cultural site in 2008. What distinguishes Shangzhuang from other rural places is its vernacular architectural kaleidoscope: A range of historic buildings spans five centuries since the fifteenth century, reflecting the aesthetics and social needs of different times. Since Shangzhuang was included in the national preservation program, a large-scale restoration project has been implemented. Experts from Beijing have visited the place and made proposals for its preservation and tourism development. Unlike Shaxi in Yunnan Province, Shangzhuang has a relatively accessible location and boasts of rich mining resources. Thus, its inhabitants do not have to rely on tourism as their main source of income. But because Shanxi Province has been engaged in heritage preservation for more than a decade and profited from this image, the threat of mass tourism is also imminent in Shangzhuang.

Shangzhuang became famous when its native Wang Guoguang was appointed Minister of Finance to facilitate the economic reform of the Ming Dynasty government in the sixteenth century. When Wang retired, he not only built a grandiose courtyard house as his residence, but also set up private schools to promote education in a rural surrounding. The oldest buildings preserved in Shangzhuang today were constructed by the Wang family in the typical simple design style common in the Ming Dynasty.

Rare traces from Mao's era, such as the *Great Leap Forward Gate,* with a triangular top, or a 1950s wall painting encouraging "the planting of seedlings," can still be found in Shangzhuang. Experts are still arguing about whether or not such political remnants should also be preserved.

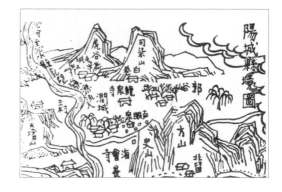

This map from the eighteenth century shows the excellent fengshui location of Shangzhuang, which was called Baixiang at that time.

The Fan family manor was built just after the fall of the Qing Dynasty (1644–1911) by a successful official and businessman. Fan Cifeng was a valued assistant to the well-known Shanxi governor and warlord Yan Xishan. In 1938, Fan was arrested by the Communists and soon thereafter executed on charges of betraying China to the Japanese Army. It is still unclear, however, whether Fan was really executed for aiding the enemy or instead for impeding Communist development and activities in this area. According to villagers, his wife threw herself into the family well, and many family members were either killed or tortured during the Cultural Revolution. Later, when a newly built street cut through this manor site, the haunted ground around the well became a popular gathering place for villagers. As with other places in China, the family tragedy and its history were literally paved over. Furthermore, the current explanation sign at the entrance of Fan's manor mainly tells about its architectural elements without a single word on the fate of its previous owners.

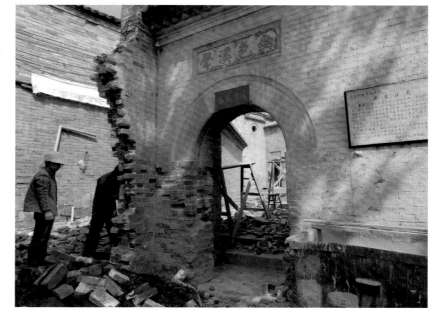

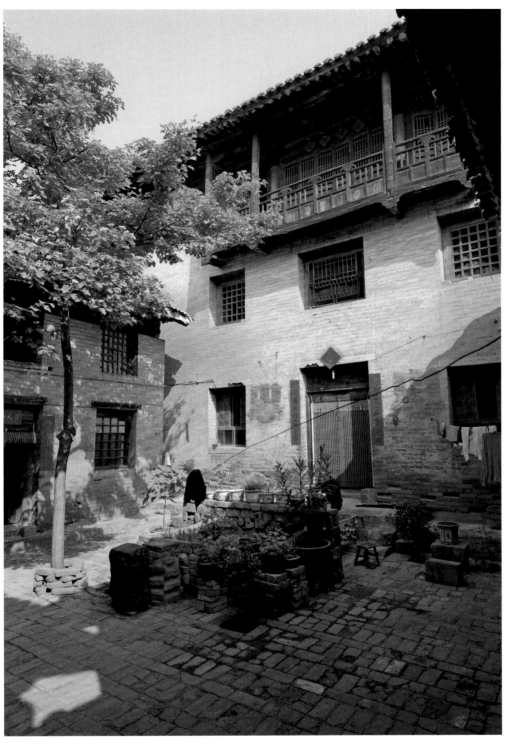

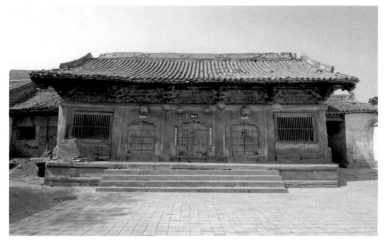

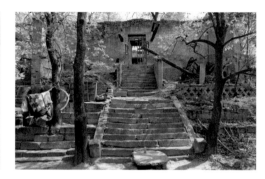

Some fifty kilometers northeast of Shangzhuang lies another quiet, quaint hamlet, *Lianghu Village*. The earliest still-existing building is the Yuxu Temple, originally built in the twelfth century. The *teapot-shaped doors* [humen] resemble both a Buddhist stupa and a typical Islamic mosque. This style is believed to have been imported via the Silk Road in the sixth century. The *humen* shape later gained more and more popularity in China: It has been applied not only to temple decoration, but also to furniture design.

The twentieth-century upheaval in Chinese politics also inevitably devastated Lianghu: During the Great Leap Forward, the bell over the village gate was melted down for steel production, and many steles were destroyed to build the nearby Zhangzhuang Dam. However, a lot of unexpectedly delicate stone carvings can still be found in many residential houses, beside symbols of Mao's era.

Among the problems with the approach to cultural-heritage preservation have been its top-down character and the lack of mechanisms that grant local residents a certain degree of involvement. Only with their participation in management, documentation and interpretation can cultural protection be ensured and local traditions kept alive. In Lianghu, a retired teacher has enthusiastically spent much of his time collecting and recording the histories of old buildings in his village, such as the once-majestic Dawang Temple, with its long flight of stairs leading to the entrance. Although its splendor is long gone, this place exudes the charm of the past in a still-authentic setting amid a silent, arid surrounding on the Loessland.

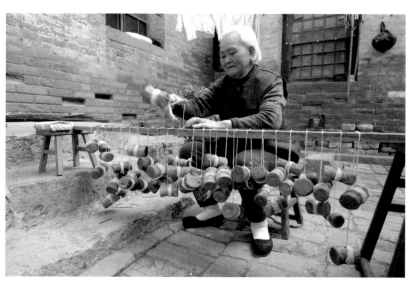

Local residents are accustomed to draping their doors with bamboo curtains that screen out some of the wind-blown dirt and sand while still admitting sunlight. These curtains are regularly recycled and restored: Intact bamboo strips are taken apart and cleaned while thick new cotton threads are used for weaving.

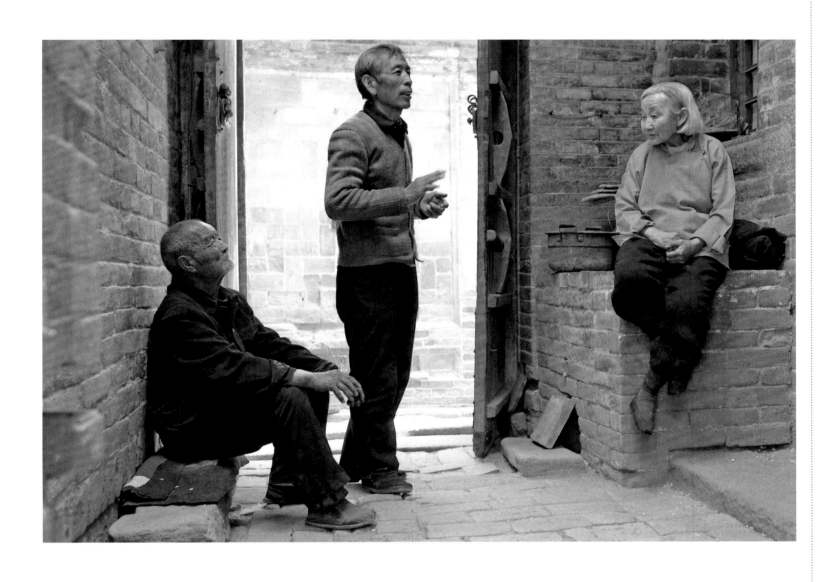

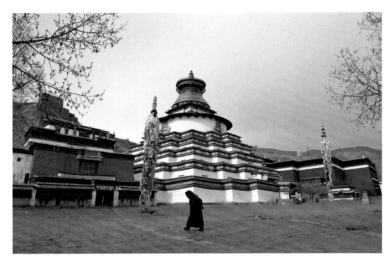

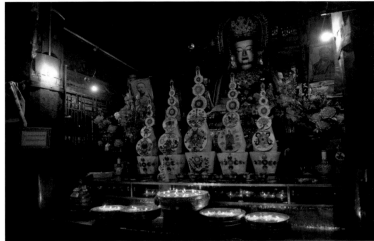

Gyantse [Jiangzi] Town in Tibet Autonomous Region, with an altitude of 3,977 meters, was once Tibet's third-largest city, behind Lhasa and Shigatse. Even though its historical significance had waned by the late fifteenth century, it continues to be an important transportation hub and trade center for wood and woolen products. The main overland route between Lhasa and Kathmandu passed through Gyantse for centuries. A *dzong*, the famous Tibetan fortress, was built atop the rugged hills in the early fourteenth century. Several decades later, the nearby Pelkor Chode Monastery and the vast nine-story *Kumbum*, a structure of Buddhist chapels, were added to this rugged landscape. The monastery used to house more than a dozen religious centers of the Sakya and Gelug (Yellow Hat) sects, while only two Gelug sect colleges remain today. Han Chinese and Nepalese influences are reflected in its refined architectural details, murals and statues. The pyramid-like Kumbum was designed with polyhedron bases and rounded tops to represent a three-dimensional *mandala*, a model of the Buddhist cosmos.

The town and the monastery were partially destroyed three times: In 1904, Gyantse served as a military base for Lieutenant General Francis Younghusband on the route from India to Lhasa during the British invasion of Tibet. The town once again became a military target when the Tibetans revolted against Chinese dominance in the 1950s, and also during the Cultural Revolution. Although the physical damage done to the monas-

tery has mostly been repaired, the number of monks declined sharply from more than 1,500 before 1959 to less than 80 in 2008 according to unofficial sources. However, its holiness and religious importance for Tibetans have persisted.

Recently, the rapid development has become evident in the newly built town, with its wide streets and modern buildings. As with other places in Tibetan areas, popularizing Chinese culture has long had priority on Beijing's agenda: After a national conference on Tibet in 1994, Shanghai began a series of Aid Tibet [yuanzang] campaigns, and by 2011 it had collected RMB 1.5 billion (US $230 million) to develop Gyantse into a modern city. The current Party secretary of Gyantse County was transferred from Shanghai Municipality and is currently drawing on his 'Shanghai experiences' to plan a blueprint for Gyantse's future. Under such leadership, the preservation of Gyantse's cultural heritage and authenticity is uncertain.

Tibet has not only long fascinated Western explorers and travelers, but, due to its strategic position in the Himalayas, it has also been viewed by many as a contested military object. Around the turn of the twentieth century, not only the Chinese Empire, but also Russia and England tried to gain a foothold on the Roof of the World. Even Nazi SS Reichsführer Himmler, fascinated by Asian mysticism, was interested in Tibet and dispatched the 'German Tibet Expedition Ernst Schäfer' to Tibet's highlands.

> *Gyantse, or 'The Dominating Peak,' enjoys all the advantages of an ideal Tibetan town, as it possesses a commanding Jong [Dzong] or fort on an upstanding rock to defend the town and its fertile fields in the well-watered valley which surrounds it. It was thus one of the earliest settlements of the Tibetans and the stronghold of petty kings, who had their castle on the rock.... Its central position at the junction of the roads from India and Bhotan, with those from Ladak and Central Asia, leading to Lhasa, well adapts it to be a distributing trade centre. (Waddell, Lhasa and its Mysteries, 1905)*

MAP OF ASIA SHOWING POSITION OF TIBET

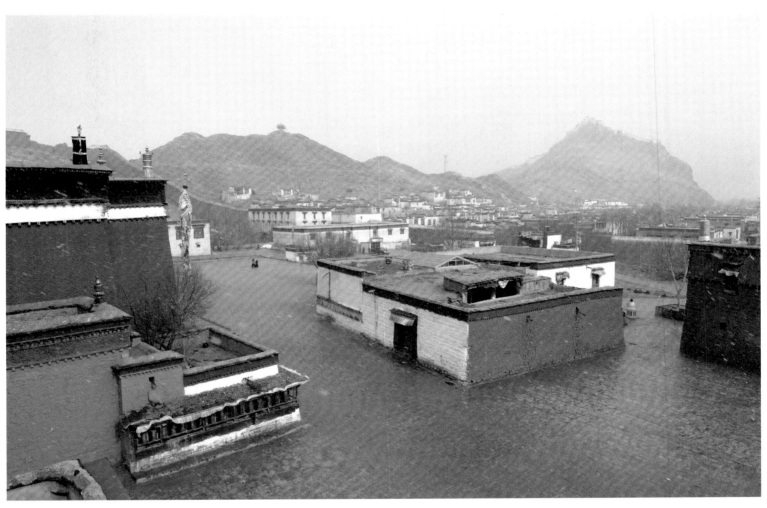

View of the Pelkor Chode Monastery in Gyantse, Tibet Autonomous Region

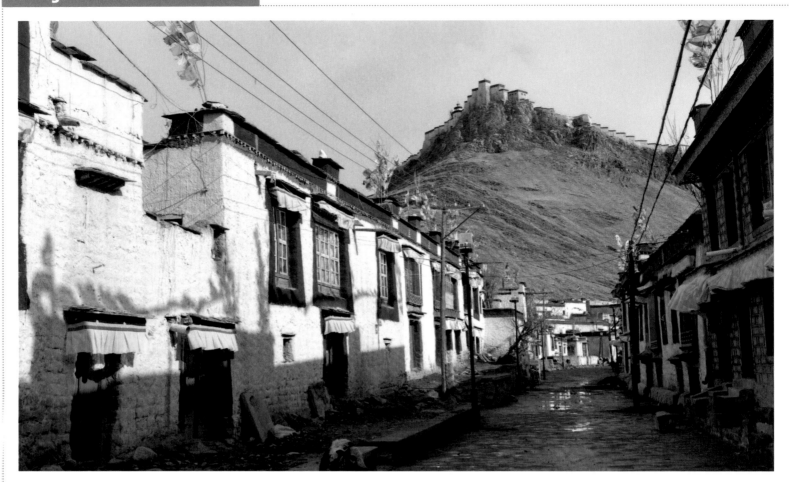

The atmosphere of an authentic Tibetan lifestyle mingled with a modern-day spirit still survives in the back lanes of the Pelkor Chode Monastery. On the muddy roads, sparse, fragmentary stone pavements left from the old trade route remind visitors of its past glory. Traditional white-painted adobe houses, each clinging tightly to the next, form a labyrinth-like space. The connected house roofs merge into a seemingly endless path and are ornamented with washed-out, colorful prayer flags. Most residents lead a pastoral life, mainly relying on farming and grazing. Residents of the old town of Gyantse, as in other areas of Tibet, like to decorate their homes with bright colors. In addition to the more commonly seen religious paintings, politically inspired posters have found their way into otherwise still traditional surroundings.

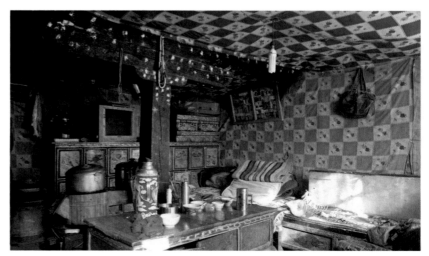

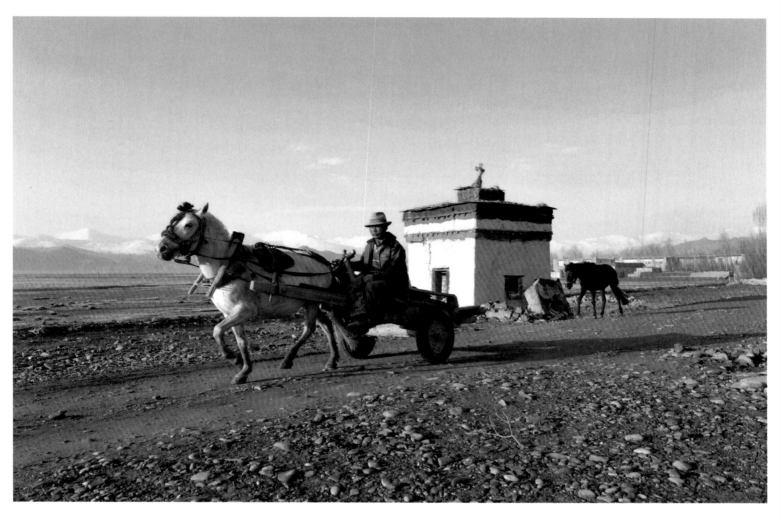

The villages and hamlets around Gyantse are committed to agriculture, as well as the traditional handicraft of weaving woolen carpets. *Tsechen* [Ciqing], five kilometers northwest of Gyantse, is a traditional village with a monastery and a ruined fortress.

The view of the valley is spectacular, and it is hard to associate it with the major battle fought here during the British expedition in 1904.

> *The plain is broad, open, well cultivated, and dotted all over with villages and groves of trees. What a relief to see trees again! They meant plenty of firewood, and comfort to the half-frozen force. The transport officers, and indeed everybody, were elated at the prospect of getting plenty of grain and forage for the animals. (Ottley, With Mounted Infantry in Tibet, 1906)*

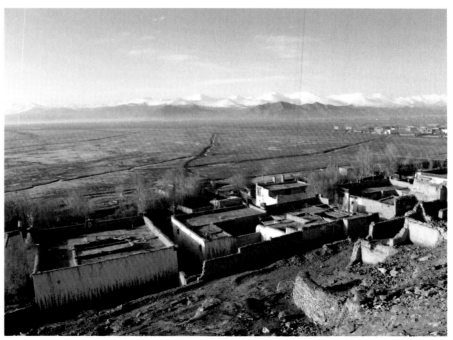

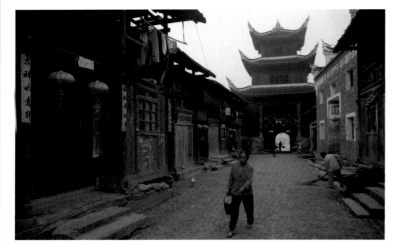

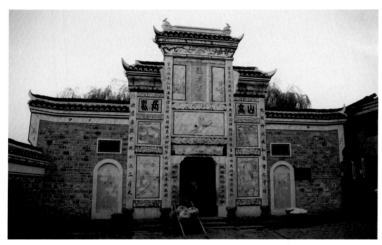

Longli Old Town in Guizhou Province, located in a fertile valley, is surrounded by various minority settlements scattered across the nearby hills. However, its structure and architecture are similar to those of a traditional Han Chinese town. Historically, this area, with its rugged topography, was considered a poor, barbarian and unruly backwater, as it belonged to minority tribes that used to revolt against the imperial government. Starting in the late fourteenth century, Ming Dynasty emperors set up numerous *military stations* [juntun] to project their control and hegemony into the newly conquered territory. Longli was one of the major garrisons, with more than a thousand soldiers, officials and their families. The military personnel was recruited from Anhui, Jiangxi, Zhejiang, Jiangsu and Hubei Provinces – a reason for Longli's Han-style town design and the once-prominent Confucian, Buddhist and Taoist sites.

Numerous Han settlements were set up in Guizhou with the purpose of supporting security, farming and business in this period. As a result, the number of Han Chinese residents exceeded that of the ethnic minorities in the first half of the nineteenth century. Later, Longli developed into a relatively large settlement with a high town wall and more than twenty gravel streets.

As in other minority areas, the Han immigrants kept their own culture. Intermarriage was rare until the 1950s. The old Confucian academy, with its grandiose and richly painted gate, was responsible for fostering classical Chinese philosophy and traditions, as well as enabling local students to pass the imperial examination. The former academy is named after the famous Tang Dynasty poet Wang Changling (698–756), who was exiled to this area, and it currently houses a primary school. The Chinese settlers also brought with them the tradition of performing *Han operas* [Hanju] on special occasions. However, the theater stage that used to be the most exuberant place during the Chinese New Year's celebration was destroyed in the *Smash the Four Olds* movement of the 1960s. So were several temples and many genealogy books compiled over the course of centuries.

This painting illustrates a battle scene of Qing Dynasty Chinese soldiers against the Miao of Guizhou and Hunan in 1795. The Miao were accused of robbing villages in the border area of Hunan, Guizhou and Sichuan Provinces.

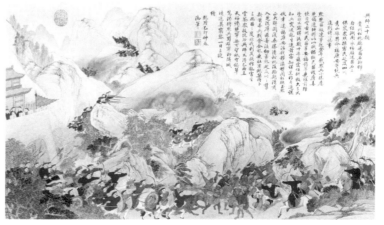

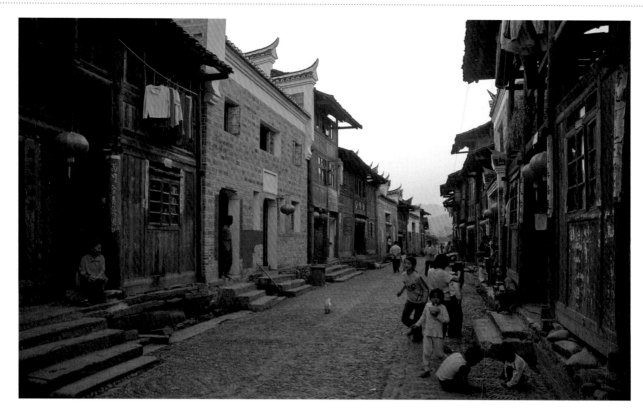

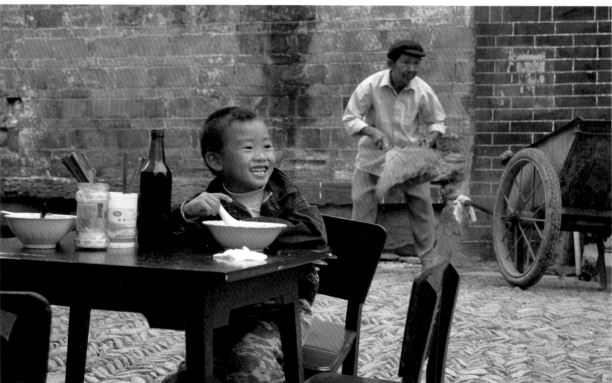

Even though the Miao and Dong Minorities are no longer rebellious against the central government, *Building a Harmonious Society*, as claimed by a red banner on the city wall, continues to be a core issue in Longli, as it is throughout China. Some residents like to decorate their interiors with the famous propaganda poster of the *Ten Marshalls of the PLA* [shida yuanshuai] riding on horses, as if to revive Longli's historical role as a military garrison.

In recent years, the government has cooperated with a European institution on four eco-museum projects in Guizhou Province, including one in Longli. The aim of this eco-museum is to present the identity of this unique place through traditional customs, lifestyles and other elements of cultural heritage, with the involvement of the local community. Currently, there are nearly 4,000 farmers living in Longli, far more than originally projected. The most urgent problems therefore include not just the need for heritage protection, but also the lack of sufficient residential housing.

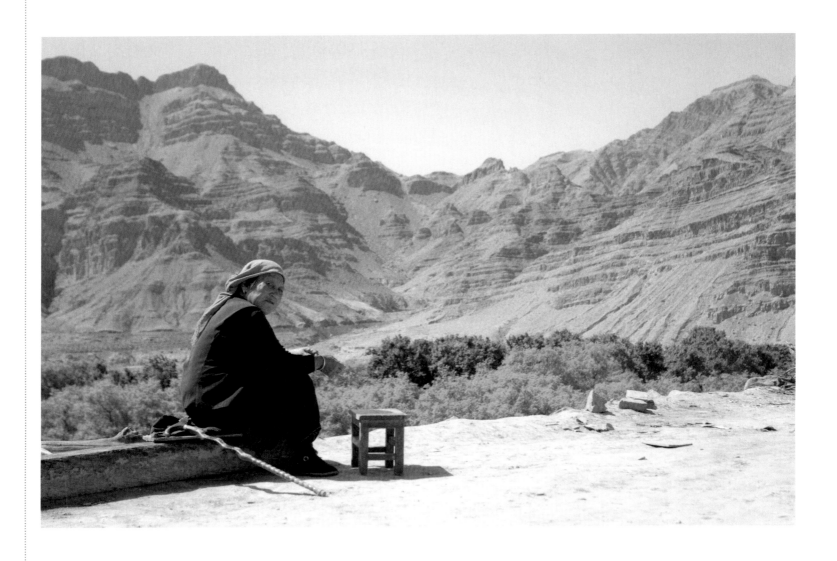

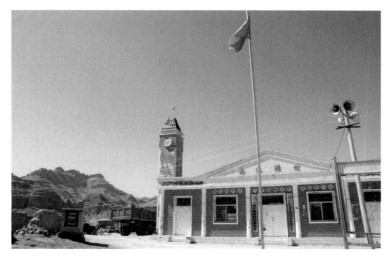

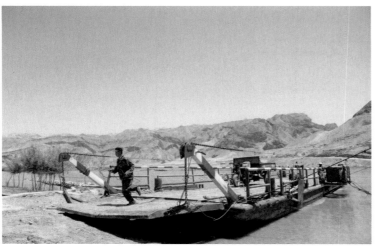

The Xianbei were a militant pastoral nomadic Mongol tribe that once posed a major threat to China. Their sub-tribe, the Tuoba, established the Northern Wei Dynasty (386–535) and took control of northern China. Later, Sinicization was so vigorously enforced by the Northern Wei emperors that the Xianbei finally assimilated into the Han Chinese.

Several Chinese anthropologists have argued that descendants of the Xianbei still exist. Some residents of *Nanchangtan Village* on the border of Ningxia Hui Autonomous Region and Gansu Province are convinced that they are these descendants. It is said that members of the Tuoba sub-tribe later served as high-ranking officials in the Western Xia Dynasty (1038–1227). When Genghis Khan's Mongol army destroyed that kingdom, some of the Tuoba escaped and settled in this unusually fertile area bordering the Yellow River. Having bid farewell to their former glories and dramatic history centuries ago, Tuoba descendants returned to a traditional and rustic way of life. They breed sheep and produce woolen products, much as their

ancestors did. Additionally, pears and jujube fruit are cultivated near the riverbank. These descendants are both nourished and in a sense 'isolated' by the Yellow River. Settlers along this river tended to become sedentary, most likely because – contrary to, for instance, the Nile, the Mississippi or the Euphrates Rivers – this waterway is almost impossible to navigate on account of its high mud content.

In 2008, Nanchangtan Village received the status of a national-level historic village. The true value of this place lies in its history, location and seclusion rather than its plain architecture and ancient trees. To this day, outsiders are only able to reach this oasis village with a simple ferry service over the Yellow River. Its village committee is keen to develop tourism with outside investment. This desire makes us ponder what will be preserved here when the traditional lifestyle is encroached upon by commercialization. This idyllic place easily makes one forget that, only a few hundred kilometers downstream, China's Mother River has become one of the most polluted rivers in the world.

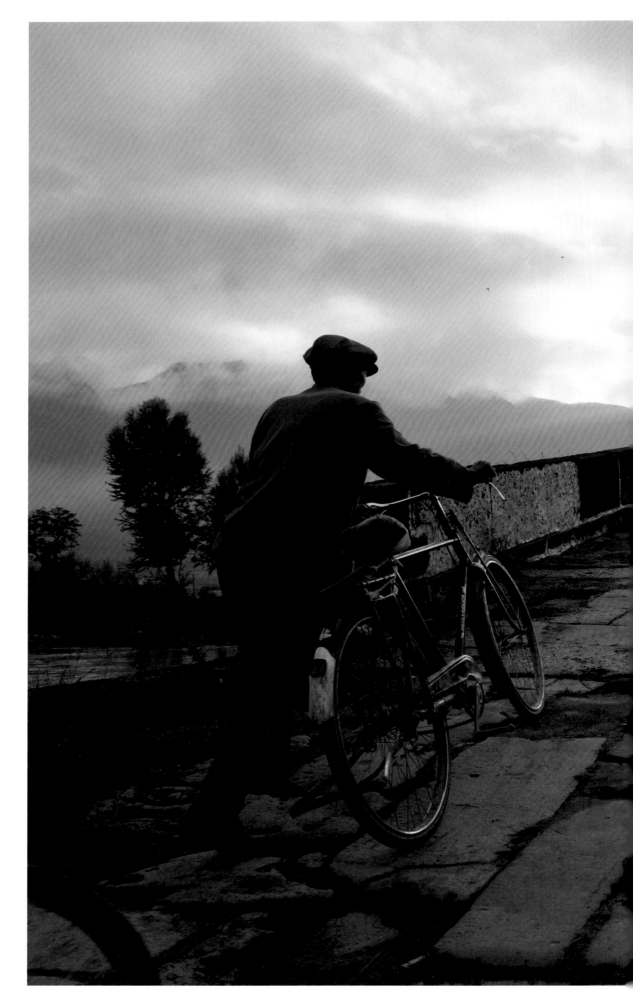

Yujir Bridge, Shaxi Old Town,
Yunnan Province

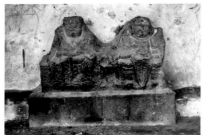

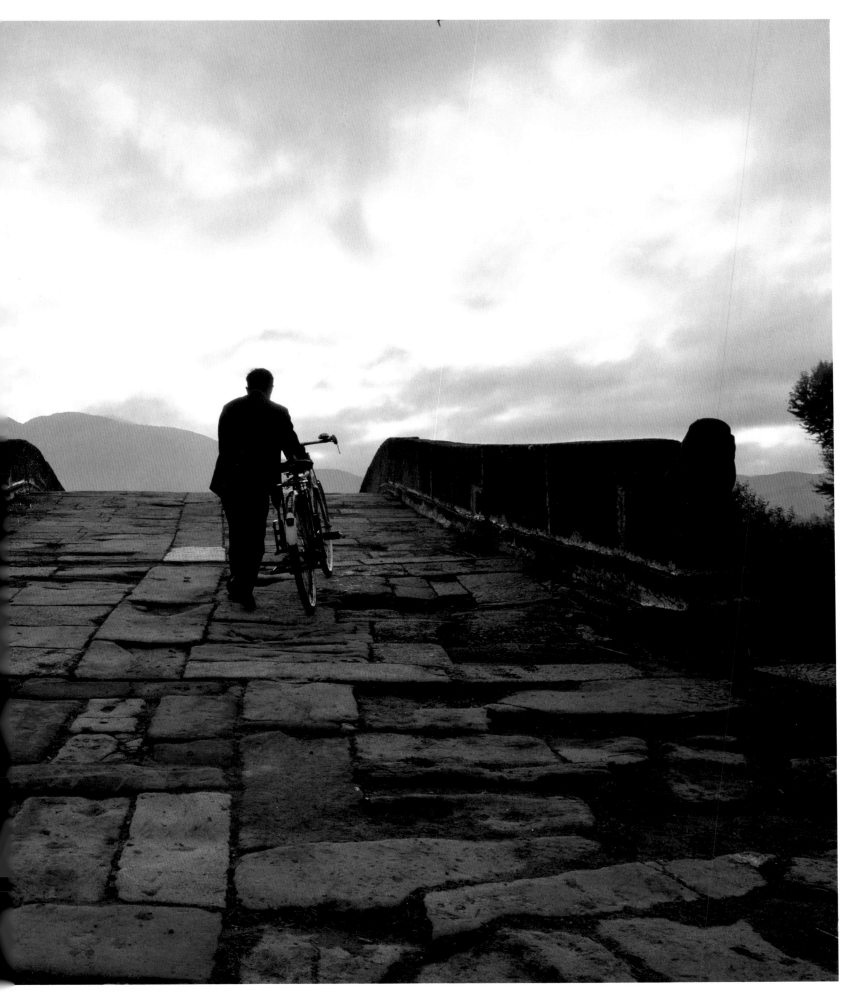

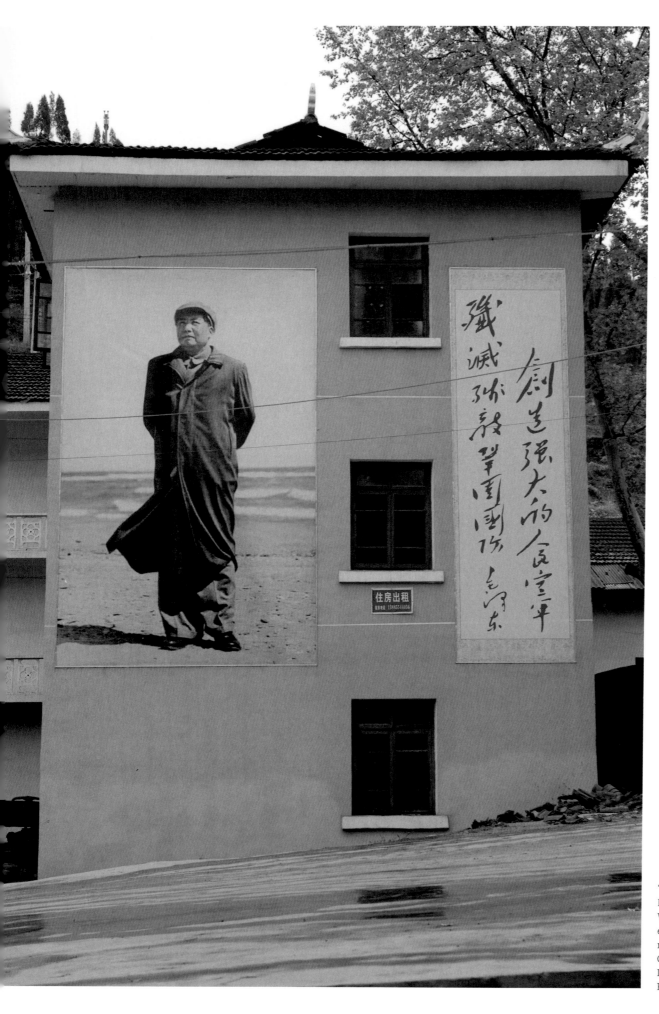

創造強大的人民空軍
殲滅殘匪敵軍國防 毛澤東

住房出租
13885716656

"Create a strong People's
Liberation Army Air Force.
Wipe out the remaining
enemies and solidify
national defense."
Qiandongnan Miao and
Dong Autonomous
Prefecture, Guizhou Province

How to make propaganda paintings: During the 1960s and 1970s several Chinese instructional booklets were published on the techniques of propaganda painting. Artists should promote the ideal socialist society: Heroic soldiers, happy farmers, healthy children and strong workers were the favorite subjects of these campaigns.

How to Govern the Countryside

China has come far, but it still has a long way to go.

When China took its first post-1949 census in 1953, its population was 582 million, of which more than 85 percent were peasant farmers. Almost sixty years later, its population has grown to over 1.3 billion, with approximately 50 percent residing in the countryside. 'Can China feed itself?' has become a hotly discussed question in Internet forums, and the answer is not unanimous. What is certain is that China's arable land is shrinking at an alarming rate. According to a prediction published by the magazine *Urban China*, by 2020 China's urban areas will be concentrated in one-third of its territory, with eleven 'mega-cities' occupying 96 percent of the total arable land. And what is more, China's rural residents will account for less than four percent of the total population, although they will be spread over almost two-thirds of the country. It is too early to know whether this prediction will prove true, but one thing is certain: With growing urbanization, the rural population will decline, and the affected traditional cultural spaces will gradually disappear.

It is paradoxical: Eighty years ago, the Communist Party built up its power in the countryside, from which it successfully isolated and eventually conquered the cities. In March 1949, Mao Zedong declared the official end of the Chinese Revolution's agrarian phase. The Party decided to shift its focus from rural to urban areas, which marked the beginning of one of its most ambitious projects: China's urbanization. The founding of the PRC also introduced a characteristic style of governing and controlling the country that persists even today: This style involves top-down decision making and the nationwide implementation of the norms and rules that Beijing wants to realize everywhere and consistently. Even though the official aim was and still is to improve citizens' welfare, the unspoken intention is to assert the Party's authority over its 'subjects.' Individual well-being has never been a priority for Chinese Communist leaders.

Massive efforts, supported by an enormous propaganda machine, have been made in recent decades to transform China from an agricultural country into an urbanized, modern one. Many government measures and policies have had very negative impacts on the countryside and its people. They caused inefficiencies in agricultural productivity and discontent among the peasants due to mismanagement by cadres and disregard for rural needs. The 1950 land reform, for instance, was followed by *agricultural collectivization* [nongye jitihua] between 1953 and 1956, in which peasants were deprived of land ownership and consequently lost much of their work

During the Cultural Revolution, Mao's portraits and sculptures became mass merchandise, manufactured in countless factories strewn across the country. For instance, in 1967 80 percent of this factory's total output (Photo left) was dedicated to printing Mao's image on silk. Everybody was expected to wear a Mao badge, and people carried the *Little Red Book* of Chairman Mao's quotations in their pocket and hung Mao's portrait on the wall in offices and at home. The photo on the right shows a two-level wall painting portraying Mao, once drawn during the Cultural Revolution and later, after the turn of the twenty-first century, again for a movie (Zhujiayu Village, Shandong).

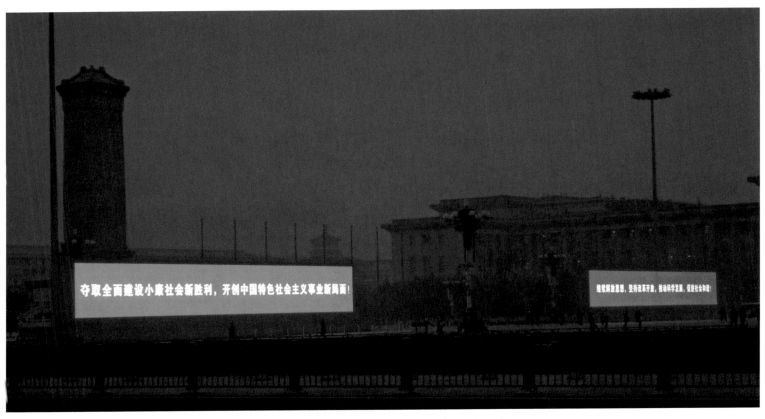

The slogan on the left reads: "To strive for the new victory with a comprehensive building-up of a moderately well-off society. To create a new phase for the socialist cause with Chinese characteristics."
T.an'anmen Square, Beijing Municipality

Sizhai Village, Zhejiang Province

In 1951, *The Life of Wu Xun* [Wu Xun Zhuan] became the first officially banned movie in the PRC. The central figure is a compassionate beggar who collects money to build free schools for poor children in Shandong Province. Before Mao criticized the film for "fanatically publicizing feudal culture," it had been highly acclaimed for its educational purpose. The ban was only lifted in 2012, and it soon became a hit on the Internet.

The 1997 film *Xiao Wu*, directed by Jia Zhangke, tells the story of a young pickpocket, Xiao Wu, in a small county seat in Shanxi Province. The main character, stemming from a rural peasant family, struggles to keep his balance in a frustrated romance and rapidly changing surroundings. The film shows, from the perspective of a passive, alienated individual, a chaotic world where shady wheeler-dealers are praised as upright entrepreneurs, and money really can buy you love and happiness.

incentive. Next came the establishment of People's Communes, the 're-invention' of the *household-registration system with its urban-rural dual structure* [cheng xiang eryuan jiegou], and the 1960s *Up to the Mountains, Down to the Countryside* campaign. The Party was convinced that the 1960s political movements known as *In Industry, Learn from Daqing* [gongye xue Daqing] and *In Agriculture, Learn from Dazhai* were suitable to link the cities with the countryside. Only in the late 1970s, after a long period of stagnation in agricultural productivity, did Deng Xiaoping finally introduce economic reforms.

The Opening-up policy contributed mainly to the nation's urbanization rather than to correcting the disastrous policies in rural areas. The dissolution of the People's Communes in the early 1980s showed that agricultural collectivization had failed. Family farms again became the basis of Chinese agriculture, this time under the *household-responsibility system*. This was first secretly introduced in 1978 in Xiaogang Village in Anhui Province, and two years later it was adopted nationwide. The Party returned responsibility for production to individual households.

At the same time, *township and village enterprises, TVEs* [xiangzhen qiye], a form of local initiative to overcome the legacy of central planning, were set up in many parts of the country. Originally responsible for the production of iron, steel, chemical fertilizers, etc., the TVEs later expanded into fields such as paper manufacturing or the textile industry, depend-

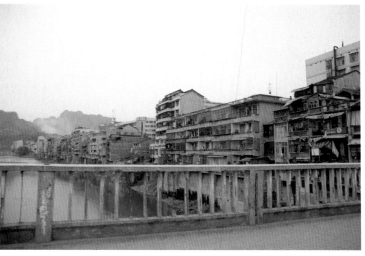

Contrary to what the cartoon portrays as a rich and natural countryside, in the real China small towns are often far less appealing (Photo: County Seat of Yongshun, Hunan Province).

ing on local conditions. The 'ownership' of TVEs varied: Some were managed by the local government, but others were more genuinely independent. In the provinces where TVEs were the most active, they employed up to 30 percent of the rural workforce during the peak period around 1996. Most of these TVEs, originally set up with the idea of *leaving the land without leaving the village* [li tu bu li xiang], saw their end approaching in the late 1990s due to a strong trend toward privatization.

Hand in hand with the establishment of the TVEs went the policy of so-called *small-town development* [xiao chengzhen jianshe]. It was introduced to help industrialize rural areas and reduce the pressure of mass migration to large cities. Besides, due to higher productivity, fewer rural workers were needed on farms. By developing small towns, rural areas could be urbanized, reducing the incentives for migration to big cities. As a result, the number of small towns increased from 2,173 in 1978 to 20,312 in 2000. However, as with other central-government policies in the past, the planning and expectations for the masses did not mirror individual aspirations. For many farmers, opportunities to earn more money in big cities seemed a better option than staying in a small town with limited prospects.

In 2005, the Communist Party proclaimed a new policy for rural China, *Building a New Socialist Countryside*. According to an OECD report, this policy "particularly targets agricultural productivity, land use, rural income, local governance reforms and public service delivery, aiming to

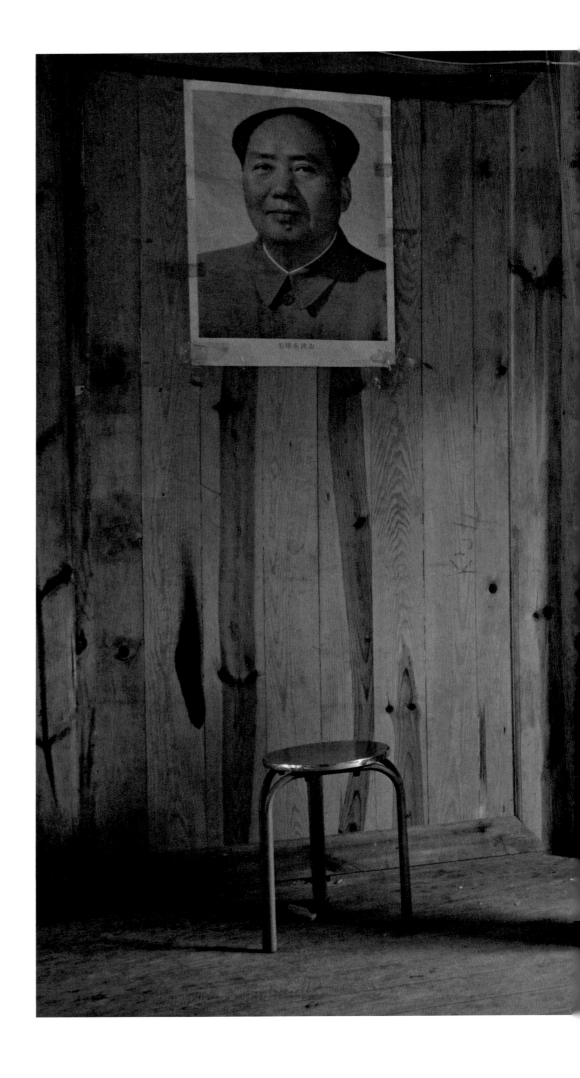

Sicheng Village, Hunan Province

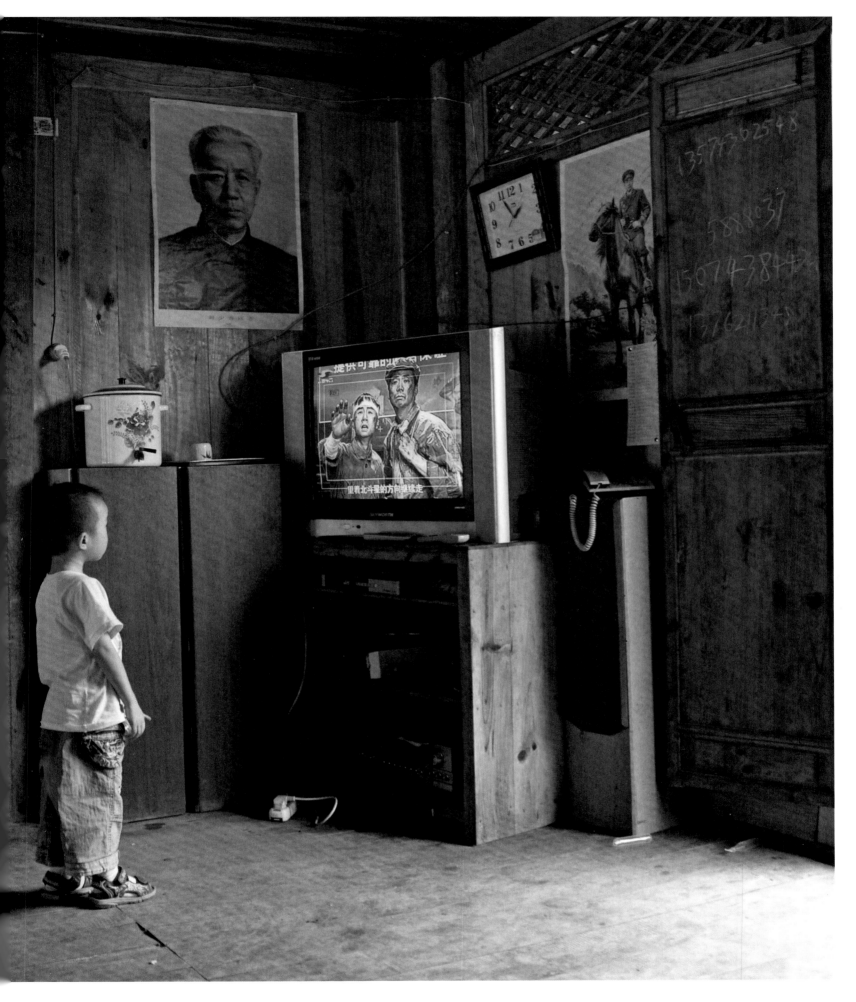

Soon after it was banned, *Will the Boat Sink the Water?* became an underground bestseller, with an estimated more than seven-million pirated copies sold as of 2005.

solve the *Three Rural Issues*." In spite of this policy, the gap between urban and rural areas continues to widen.

'Managing' China's vast territory and its people has never been an easy task for the ruling classes, be it in imperial times, in the Republican era (1911–1949) or in the PRC. Despite the Opening-up policy, the rural population's perception of its living conditions has actually become more negative. During the catastrophic Great Leap Forward, many farmers truly believed that local officials were hard working, honest and concerned about their welfare. Nowadays, the expression *monks with a wry mouth* [wai zui heshang] is a common pejorative designation for corrupt local officials who interpret the policies for their own benefit. People think of them as owning luxurious, Western-style houses, consuming lavishly or driving black limousines with tinted windows.

During Mao's era, equality between rulers and ruled was considered one of the reasons for the country's relative stability. Since the 1980s, an increasing wealth gap has become a potential source of social upheavals. Rural unrest has become a nationwide phenomenon that has caught the attention of both academics and journalists. In 2001, for instance, an influential Chinese academic published a book entitled *The Politics of Yue Village* [Yuecun zhengzhi], documenting contemporary rural protest in Hunan Province. The award-winning 2004 book *Will the Boat Sink the Water? The Life of China's Peasants* [Zhongguo nongmin diaocha] was banned shortly after its

Although some years ago the central government introduced regulations to discourage lavish public buildings, the phenomenon of building 'White Houses' is still widespread in rural areas. The fact that local governments in some poor counties spend almost half their yearly revenue to build extravagant public buildings has provoked much anger among farmers and netizens (Images from top to bottom: A district government compound in Manzhouli City, decades ago a small custom-station near the Russian border; a graphic master plan for a proposed new government office building in the same city).

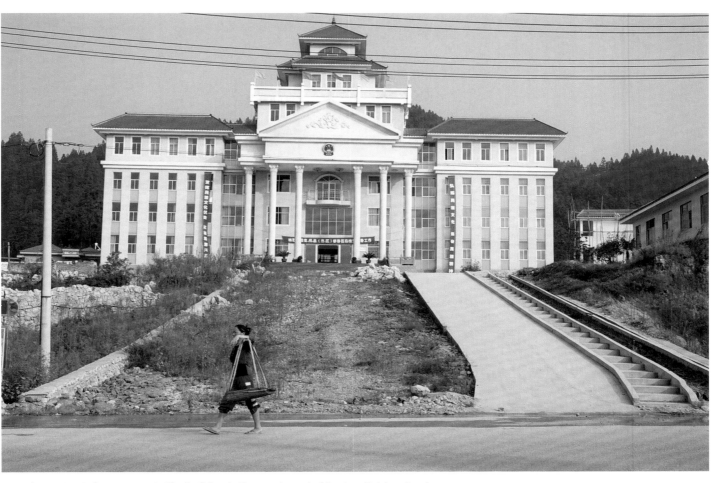

A newly constructed government office building in the county seat of Jinping, Guizhou Province

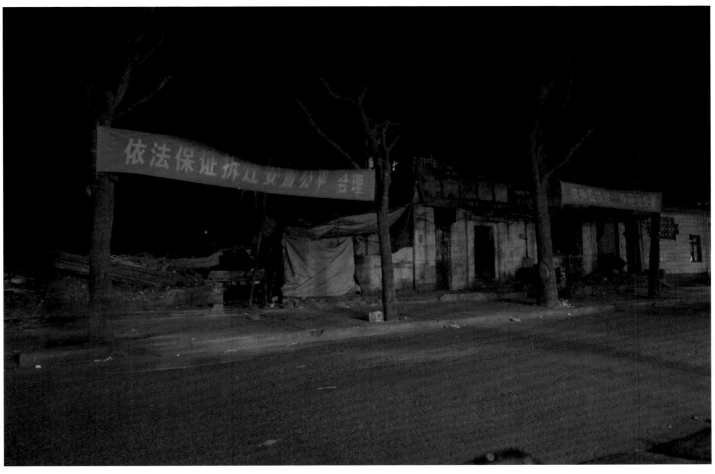

A slogan reads "Ensure a just and reasonable demolition of houses and relocation of residents according to the law" in the old town of Handan City, Hebei Province.

publication. It is full of stories about peasants' lives marred by poverty, injustice and violence, and exploited by greedy officials in Anhui Province.

Thousands of protest demonstrations, officially termed *collective public-security incidents* [quntixing zhi'an shijian], are held every year in rural China. The latest report released by the Ministry of Public Security in 2005 listed 87,000 protest demonstrations, riots and other 'mass incidents' related to land loss – to make way for roads, factories, high-rise buildings or villa compounds. The most important reasons why the rural population has participated in these incidents have been disputes over land subdivision and appropriation, followed by excessive taxation and fees for irrigation rights.

Since the beginning of the Opening-up, there has been a steady increase in inequality, corruption and criminality, ranging from petty theft to smuggling to murder. The acquisition of collectively owned or state-owned assets by shady individuals with good connections to government circles has gravely shaken many honest farmers' faith in social justice. While the central government abolished agricultural taxes in 2006, many township governments still exploit the one-child policy to extort money from farmers. When peasants ask for permission to have another child, officials demand bribes in exchange for birth permits – which of course sets in motion a vicious cycle of illegal activities that is hard to break. In such a social context, it comes as no surprise that many farmers idealize the 'good old days' of Mao Zedong, when Chinese society was relatively poor, but generally equal, with very little corruption, low crime rates, no drugs and no prostitution. The many portraits of Chairman Mao in peasant farmers' homes all over rural China (except in Xinjiang and Tibet) suggest how highly esteemed he is even today.

The government will continue to look for slogans and political movements to help solve the problems of managing the countryside and controlling its rural population. Propaganda has always been a key tool for the Party to 'educate and lead the masses' and is omnipresent in the countryside. An outsider can learn about an area's problems by reading the slogans daubed on

"Wen greets the tea pickers" was the headline that accompanied this photo in the *Shanghai Daily* on May 28, 2012. China's previous Premier, Wen Jiabao, is well-known for his dedication to the Three Rural Issues. He once openly commented that "China has failed to give farmers adequate protection from arbitrary land seizures." While Wen is praised by many as the people's premier, others have complained that during his tenure (2002-2012) the urban-rural gap increased.

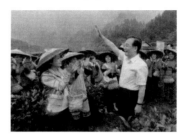

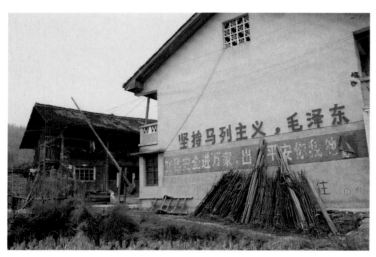

Ever since the founding of the PRC, Communist Party leaders have usually tried to leave their footprints on Chinese history, if only in the form of political slogans. Be it "Persevere in Marxist-Leninist-Mao-Zedong Thought," promulgated by Deng Xiaoping, the "Three Representatives" by Jiang Zemin or "A Harmonious Society" by Hu Jintao, political slogans are continually being introduced and replaced. Although such slogans are omnipresent, the farmers typically know little about their origins or meanings.

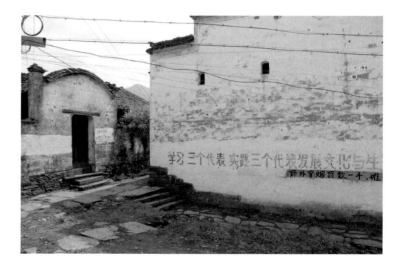

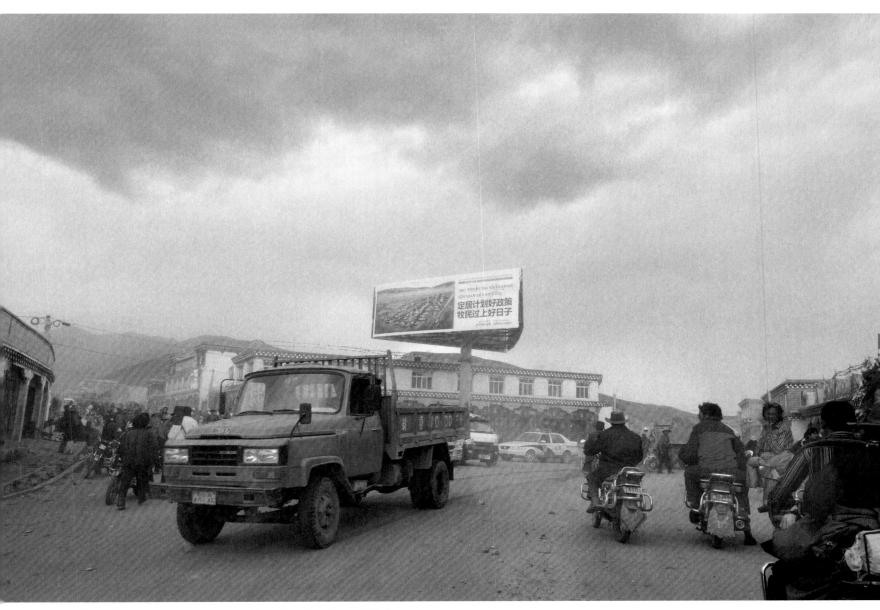

"The settlement plan is a good policy. Nomads will lead a good life."
Manigango (Manigange) Town, Sichuan Province

A slogan touting environmental protection is painted by hired farm laborers in Liulin County, Shanxi Province. Propagandistic slogans have been around for decades, but the focus has changed: A 1957 photo shows four well-known artists forcibly sent to the village painting socialist artworks during the *Anti-Rightist Movement* [fan youpai yundong]. A poster from the 1970s depicts a women's shock brigade pasting the slogan "Criticize the Doctrines of Confucius and Mencius."

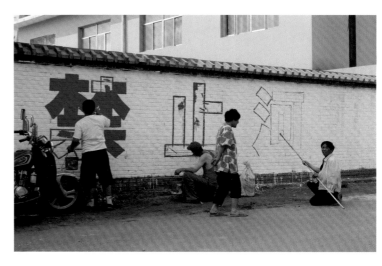

walls or posted on billboards. For instance, there are often references to 'drug trafficking' in Yunnan Province or *evil religions* in Shandong and Gansu Provinces.

The issue of justice in rural China has never been as important as it is today. Traditionally, Chinese political culture has emphasized maintaining social harmony and avoiding conflict. Law and litigation were for a long time considered unnecessary, 'un-Chinese' concepts, since the Chinese ruler had the Mandate of Heaven and was therefore untouchable by human laws. After the Cultural Revolution, the government formulated a vast body of laws with which to create a socialistic legal system. Further regulations have been designed to deal with the country's modernization process, but traditional thinking and philosophy prevail, especially in rural areas, where the principle of *being reasonable* [heli] has always been valued more highly than that of *being legal* [hefa].

Particularly in rural areas, respected elders have traditionally mediated disputes locally. Mediation has a long history in China, and the practice continued even after the founding of the PRC. It favors resolving disputes on a private basis with compromises and self-criticism, rather than through judicial rulings. Although in recent years the country has been deluged with new laws, unfamiliar regulations are yet to be accepted by villagers and farmers. As the metaphorical title of an academic paper asks, 'Who Will Find the Defendant if He Stays with His Sheep?'

It is ironic that the Party that originally seized power and built up its base in the countryside must now re-conquer these long-neglected areas from its bases in the cities. The Communist

Propaganda with Aesthetics

Visual propaganda has been used widely by the government, especially in rural areas where the illiteracy rate among middle-aged and elderly people is much higher than in urban areas. Be it for political purposes, the one-child policy, warnings about evil religions or swindlers, against the theft of railway equipment or to promote daily life practices such as personal hygiene and electrical safety, illustrated billboards have been a popular instrument for the education of the rural population. These images are sometimes simply hand-painted on the wall of a residential house, sometimes printed in cartoon style on metal or wooden signs along the main village roads or even beautifully painted on tiles in a traditional style. The Communist Party's enthusiasm for propaganda has meshed with the Chinese people's predilection to decorate their homes with wall and door paintings (Photos clockwise from left: Propaganda for electrical safety and women's rights, and condemning corruption, theft or tampering with public electrical power lines).

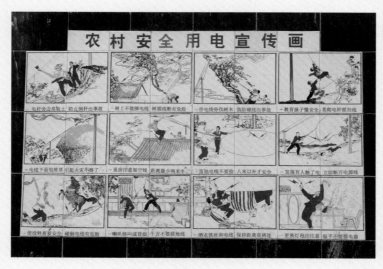

Village committee elections [cunmin weiyuanhui xuanju] were introduced to rural China in the late 1980s. Although some hoped these grassroots elections would usher in an era of widespread local democracy, many complain that the Communist Party still plays a far too manipulative and dominant role in election practices and in deciding outcomes. In addition, due to the power and privileges enjoyed by village heads, numerous stories about political corruption, electoral bribery, vote buying and other fraudulent practices have been circulating in recent years. Moreover, many elected village leaders often find themselves caught between strict orders from superior authorities and the problems of their implementation in an unsuitable rural situation. A news clipping from 2011 shows a village committee election in Ningxia Hui Autonomous Region.

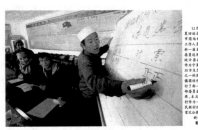

The 1992 film *The story of Qiuju*, directed by Zhang Yimou, tells how a peasant woman comes to sue a village head who injured her husband in a fight. Upset by the village head's haughty attitude, and unimpressed by the local police's mediation efforts, Qiuju, decides to seek justice from a higher-level authority. Despite her pregnancy, she seeks a remedy at the police department in the county seat and later at a municipal court. When she has complications while giving birth, however, the village head is the one who helps bring her to a hospital. After Qiuju and the village head finally settle their differences, however, the police show up to arrest him following a court decision.

leadership must assign judges to rural areas to stabilize its power, to counter local protectionism and decentralizing forces, and to nudge rural villages closer to the modern world. Bringing law and justice from the cities to the countryside is not an easy task, because Chinese farmers have always viewed outsiders as intruders not inclined to understand and respect local practices. The government's policy of *Bringing the Law to the Countryside* [songfa xiaxiang] will be much more difficult to implement than the materialistic policy to *Popularize Household Appliances in the Countryside*.

Chinese farmers' problems do not simply result from their meager incomes. China's economic boom has profited greatly from exploiting this vulnerable group. Long neglected by the government, farmers have had to bear the burdens of many failed policies. They deserve much more credit not only for their accomplishments and suffering, but also for their sincerity, a quality highly praised by many visitors to the countryside that may well outlive China's vanishing worlds.

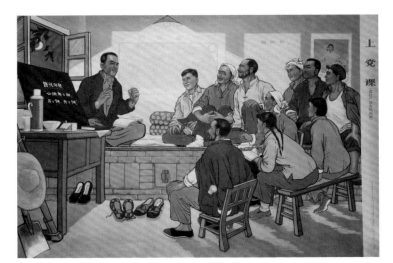

Over the years, the government has persevered in unstinting efforts to capture rural hearts and minds, but with continually changing accents – from political education to lectures (see the 1974 poster *Attending Party Lectures*), opera performances, books and films produced between the 1950s and 1970s, the promotion of legal education from the late 1970s on, to the distribution of household appliances, cell phones, personal computers and cars in the twenty-first century.

At the height of the Civil War in 1947, the Communists were forced to abandon their longtime 'Red Capital' of Yan'an, and Mao Zedong and other revolutionary leaders found refuge in *Yangjiagou Village* in northern Shaanxi Province. They stayed there for four months in the cave courtyard of Ma Xingmin, an eminent local landlord. The main room, officially designated as Mao's former residence, featured impressive Gothic windows. When Mao arrived, Yangjiagou had already gone through the first phase of land reform.

For the Communists, villages were tyrannized by evil landlords and rich peasants who lived in luxury, exploiting and oppressing other farmers. According to their doctrines, only if the *poor and lower-middle class peasants* [pin xia zhong nong] defeated their landlords could a new social order arise. Thus, Ma Xingmin, who had studied architecture in Shanghai and Japan, became the target of those *struggle sessions*. However, Communist ideology conflicted with the villagers' conventional morality, which was based on their daily life experience: In local history, the Ma family had always helped the peasants cope with natural

disasters and financial difficulties. Ma Xingmin was considered by many residents to be a generous person and philanthropist. In the view of Ma's former tenants, his decision to build a new cave courtyard was meant to provide work and food to starving villagers during the 1929 famine. Thus, the class struggle against Ma was psychologically traumatic for many villagers. It did not take long for people to switch their target to the corrupt local cadres. In the following months, most Ma family members fled from Yangjiagou.

Even though few members of the Ma family stayed in their home village, Yangjiagou was still regarded as a 'nest of landlords.' In the *Smash the Four Olds* campaign, young students from the county seat destroyed the temple, monumental gateway and dignified old buildings. When the *Cleansing the Class Ranks* [qingli jieji duiwu] movement was initiated in 1968, several Ma family members were sent from their work units in cities back to Yangjiagou for struggle sessions. Although most villagers were still reluctant to commit acts of violence against their former landlords' offspring, a brutal beating by some village

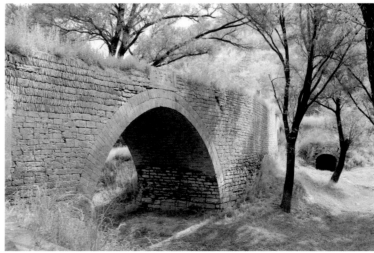

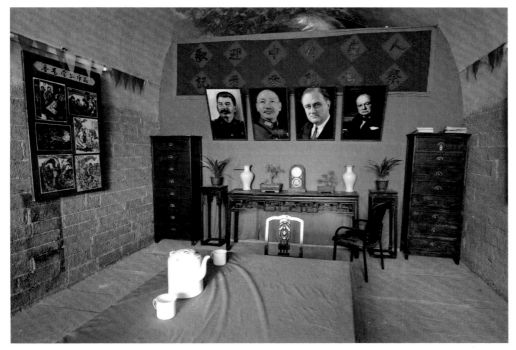

ruffians and Red Guards finally took the life of Ma Zhongtai, a nephew of Ma Xingmin. He had lived outside Yangjiagou for study and work and never managed the land owned by his family. Yet he was targeted as a representative of the 'evil' landlord family. He was brutally beaten to death near an old brick bridge that still stands amid lush grass. His wife committed suicide a few days after his death. This tragedy, though not recorded in any official document, still haunts many elderly villagers. Similar stories were all too common during the Cultural Revolution, and most of them will never become widely known.

Since 1978, Yangjiagou has been promoted as a revolutionary memorial site, and it was later named a *base for patriotic education*. A memorial hall dedicated to Mao's revolutionary campaign in northern Shaanxi Province opened in 2005. All the rooms in the former courtyard of Ma Xingmin are furnished with utensils allegedly used by the Communist leader. School and government groups pay their respects to the Chairman on regularly organized tours. Occasionally, a film or TV crew shows up to film patriotic stories of the Sino-Japanese War or the Long March. A visit to Yangjiagou on a dry, hot summer afternoon is unlikely, however, to evoke any association with the making of world history.

The 1959 propaganda painting *Fighting in Northern Shaanxi Province* illustrates a profoundly reflective Mao gazing across a gorge at the typical loess landscape.

The history of Yangjiagou goes far beyond the usual propaganda material: The forefathers of the Ma family were peasants who immigrated there from neighboring Shanxi Province in the early eighteenth century. Ma Yunfeng moved to Yangjiagou with his family to seek greater opportunities. Besides farming, he became rich by transporting merchandise for the then-famous Shanxi traders. Subsequently, he purchased a lot of farmland from local residents and also set up home schools. By the mid-nineteenth century, the Ma family had become the richest clan in this area. Many farmers in the surrounding villages moved to Yangjiagou to work for the Ma landlords.

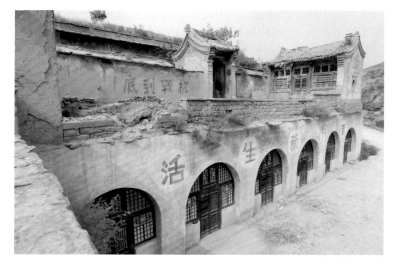

Financed by flourishing businesses, beautiful cave court-yards were built in and around Yangjiagou. The ever-expanding wealth of the Ma clan eventually created a village economy with an unusually high density of landlords. It was estimated that, until the 1940s, Ma landlords owned a total of about 7,000 acres of land, and there were more than 50 landlords among the 240 families.

Although there was a great gap in the wealth of landlords and tenant farmers, their relationships were relatively harmonious rather than antagonistic. The reasons were multifaceted. On the one hand, influenced by Confucianism, landlords organ-

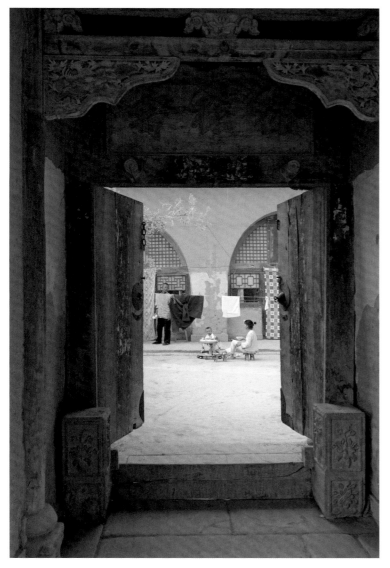

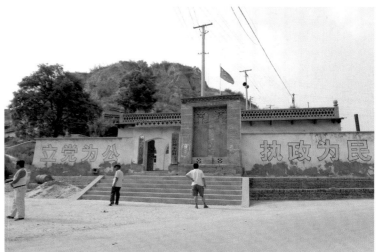

ized and financed local charitable activities and tried to use conciliatory strategies in their dealings with tenants. They also built fortresses to protect the whole village during much-feared nineteenth-century Muslim uprisings in northwestern China. On the other hand, due to limited land resources in this area, landlords and farmers were highly interdependent. Furthermore, the farmers' wives usually worked as maids or wet nurses for the landlords' families. Thus, the landlords were thought of not just as employers, but also as community leaders or even distant relatives.

Today, most of Yangjiagou's residents are older farmers leading simple lives. Many of the once-beautiful cave courtyards are deserted and run down. Political slogans from Mao's era can still be seen on walls. A rickety old theater stage from the Qing Dynasty (1644–1911) survives as a reminder of this area's rich past. In the afternoon, villagers like to gather around the old stage to chat and relax. The building opposite the stage houses the office of the *village committee*. Its wall is adorned with a slogan: 'Set up the Party for the public. Rule for the people.'

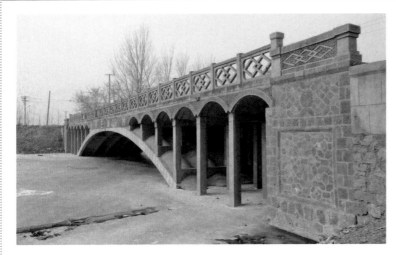

Xiaojinzhuang Village in Tianjin Municipality may be forgotten today, but most Chinese who lived through the 1970s have heard of it. Xiaojinzhuang was filled with impoverished peasants and, until the 1960s, used to suffer from frequent flooding. Complying with the movement *In Agriculture, Learn from Dazhai,* the villagers excavated the riverbed, covered the saline-alkaline soil with river mud and built a dike. Xiaojinzhuang was rewarded with increased agricultural production. But what ultimately transformed it overnight from a humble village to a shining national model was a fateful visit in the summer of 1974 by Jiang Qing, Mao's wife.

Before her arrival, Tianjin-based officials carefully instructed the farmers of Xiaojinzhuang in the etiquette of a Communist rural utopia. No wonder the village was exactly what Jiang had been searching for: Its villagers could perform *model operas*, recite socialist poems, fluently criticize Lin Biao and Confucius and even organize a *political night school* [zhengzhi yexiao]. It was, in short, a Chinese Potemkin village, and she swallowed it hook, line and sinker, because she wanted to. So bedazzled was she that Xiaojinzhuang became her favorite place and a weapon of the radical group against moderate leaders like Deng Xiaoping, who advocated economic pragmatism and more relaxed cultural policies.

Xiaojinzhuang's name soon appeared in the state media, which acclaimed it as an ideologically advanced cultural utopia (Illustration top right). Several books and even a collection of peasant poems were published on the Xiaojinzhuang experience (Picture right). Between 1974 and 1976, Jiang Qing visited the village three times and even invited Philippine First Lady Imelda Marcos to Xiaojinzhuang during the latter's goodwill visit to China (*Renmin Ribao* news clipping pictured bottom right).

When Jiang Qing first decided to visit Xiaojinzhuang, its villagers not only groomed themselves and tidied up the village, they also built a VIP toilet specially for her. All the local domesticated animals were locked away so they would make no disturbing noises while Jiang Qing took a nap in a guest room thoroughly cleaned and disinfected by nurses from Tianjin. On her several visits, Mao's wife enthusiastically changed some villagers' names on the grounds of their 'feudal' connotation.

After the devastating 1976 Tangshan Earthquake, Xiaojinzhuang quickly recovered and constructed a socialist-style village with identical red-brick houses lining broadened streets. However, as if the damage wreaked on her toilet by the quake were an omen, Jiang Qing and the *Gang of Four* [siren bang] were arrested a few months later. After her fall, Xiaojinzhuang stood for a long time at the center of a raging political storm, the target of an embarrassing critique. What remain of the dramatic 1970s upheavals for the villagers of Xiaojinzhuang are only a few disagreeable memories and the Xiangyang – literally 'Facing the Sun' – Bridge, which at that time made the village more accessible for admirers from all over the country.

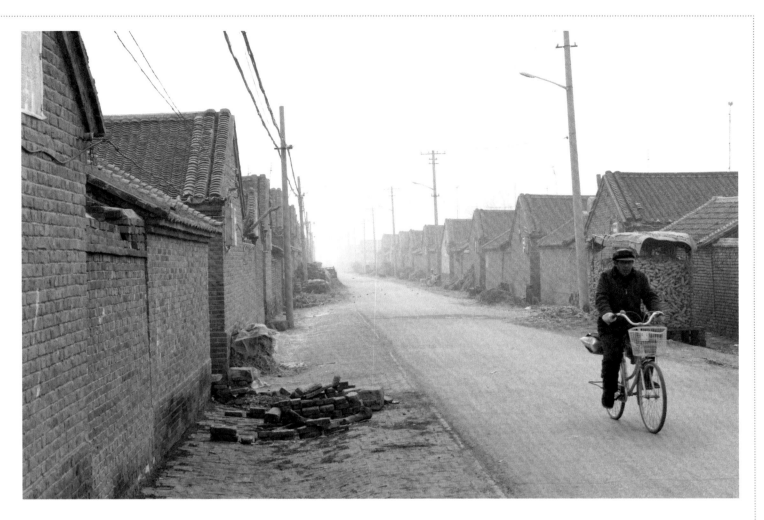

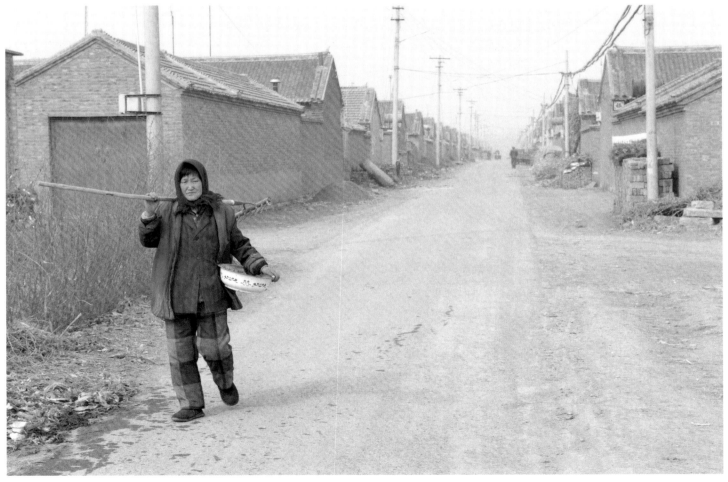

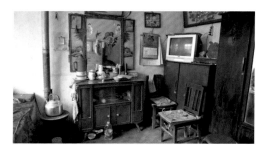

It is difficult to associate ordinary villagers with the 'progressive' peasants idealized in 1970s revolutionary publications. *Xiaojinzhuang's Ten New Things* (Picture bottom) was a classic at that time that included conducting a vigorous political night school; building a team of *poor and lower-middle class peasants* versed in Marxism and anti-Confucian history; performing *model operas*; establishing an amateur arts propaganda team; composing patriotic poems; founding a progressive library; telling revolutionary stories; promoting sports activities; and campaigning for feminism.

Xiaojinzhuang was in fact a sort of cultural theme park created by Jiang and her allied urban cadres. The most outstanding aspects of its model utopia were adapted to the popular issues of particular times: From agricultural progress in the early 1970s to culture, education and women's equality in 1974, and finally to anti-Deng Xiaoping political slander in 1976. Wang Xiaoqi (Pictured at his desk), a retired worker from the local agricultural office, still remembers how Jiang Qing changed his name to Wang Miekong, literally 'Extinguish Confucianism,' and two years later commented that it should be Wang Miedeng, 'Extinguish Deng Xiaoping.'

Aside from this extraordinary history, Xiaojinzhuang's villagers are indistinguishable from their neighbors: Their red brick houses line dusty streets. Good natured, plainly dressed farmers are busy with field work. Having enough food is not an issue anymore, but being affluent is still a dream. The desolate sports field stands as a silent irony to the past. The loudspeakers that used to blare out the leaders' messages are rusting away. Cold breezes laden with sand and a lethargic atmosphere bear down on the monotonous landscape. Refuse dumped carelessly in and around the village is the most visible environmental problem. However, most residents seem to be content with the district government's plan to build up this area as a production base for three important agricultural crops: Green onions, garlic and chili peppers, along with corn and cabbage. Every February, with the land still in the clutches of winter, local farmers optimistically begin to prepare for the garlic-planting season. Some of these agricultural products are exported to foreign markets. There is a small village factory, which stands on the site of the former political night school, but it has not brought any great profits.

The 'invention' of *model operas*, model workers and even *model villages* has long been a tradition in Communist China. But, as we can see from the model village of Xiaojinzhuang, trying to create a 'new socialist man' has not always benefited the rural population.

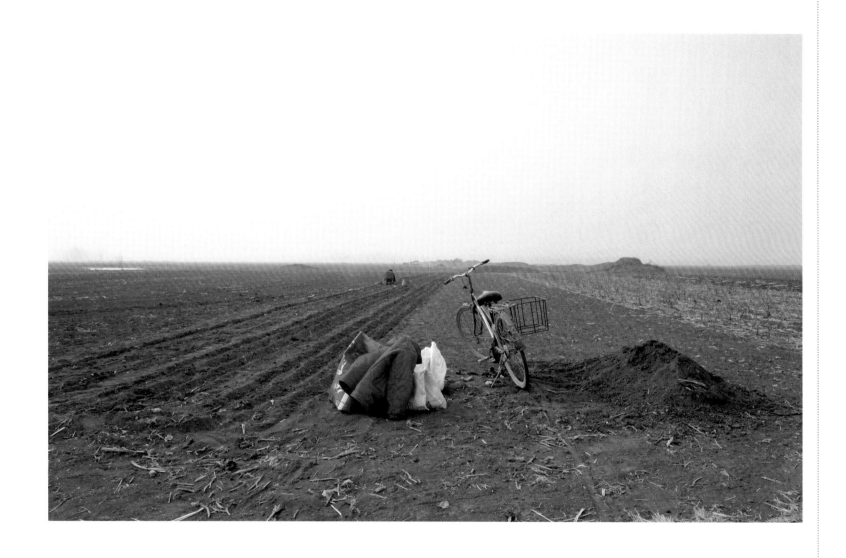

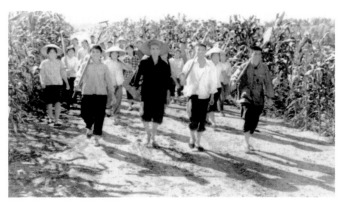

团结起来，争取更大的胜利

A 1970s photo with the title "Unite to win still greater victories"
shows cheerful and vigorous peasants from Xiaojinzhuang
as a main pillar of the nation's power at that time.

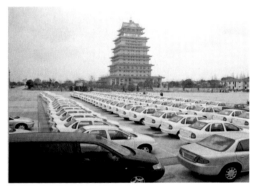

Model villages continue to prosper in the twenty-first century: *Huaxi Village* in Jiangsu Province exemplifies the newest formula for the future of China's countryside. It is a place where even the poorest families each possess one mansion, one car and savings of more than RMB 1 million (US $153,800). Located in a densely populated area, Huaxi used to be a miserable place where the residents could barely eke out a living. Then one man decisively changed the fate of the village and made it the richest in the country.

Wu Renbao grew up in an impoverished farmer's family and barely finished elementary school. After becoming the village's Party secretary in 1961, he tried every possible approach to pull Huaxi out of poverty. When the movement *In agriculture, Learn from Dazhai* was proclaimed, Wu led the villagers to expand and reform their farmland accordingly. However, the increased agricultural yield did not satisfy him. He therefore set up an underground hardware factory in 1969, which brought a comparatively modest level of prosperity to Huaxi. Since this factory was in obvious violation of the central government's policy, the villagers had to hide this industrial activity and pretend to just be working in the fields. Wu was obviously lucky compared to the similarly enterprising Party secretary of a village in Heilongjiang Province, who was accused of *taking a capitalist path* [zou zibenzhuyi daolu] and duly executed. Only after

Deng Xiaoping began to encourage economic development did Huaxi take a further step to openly expand its enterprises. In 1988, Huaxi became one of the first *villages with RMB 100 million in assets* [yiyuancun].

The Huaxi multi-sector industrial company began trading shares on the Shenzhen Stock Exchange in 1999. All Huaxi villagers became shareholders and were given a state-of-the-art European style mansion and a car (although they received only usage rights, not property rights). The marketing-savvy Huaxi officials are not modest about displaying their success to the outside world: Admiring one of the villagers' mansions is part of the pre-arranged itinerary for every visitor. In addition, Huaxi's tallest building, the Longxi International Hotel, was designed to be as tall as the tallest building in Beijing. This 74-story tower, opened in 2011, was dubbed the *new village in the sky* [kongzhong xin nongcun]. It is allegedly intended to relieve increasing pressure on the surrounding land.

Although Huaxi has benefited substantially from favorable government subsidies and relationships, its leaders prefer to avoid the topic. Huaxi's current Party secretary, a son of Wu Renbao, confessed in a recent interview that he spends his "days worrying about investment bubbles." Huaxi's multi-billion-dollar conglomerate makes great profits in the steel, shipping, tobacco and textile industries.

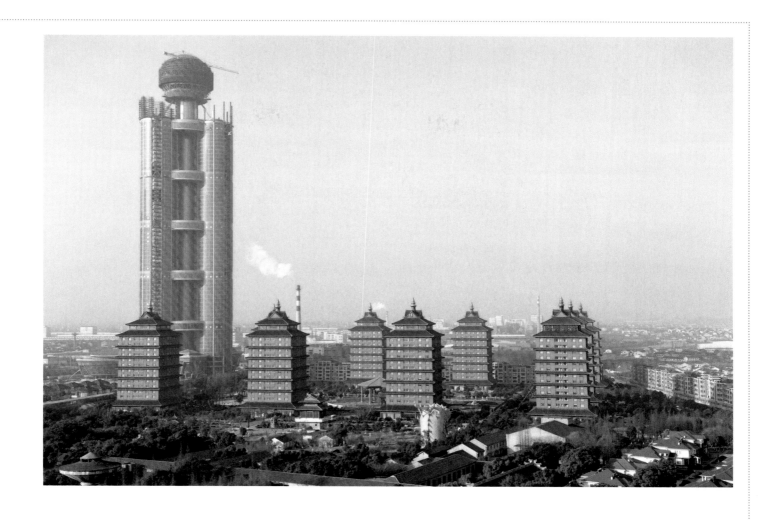

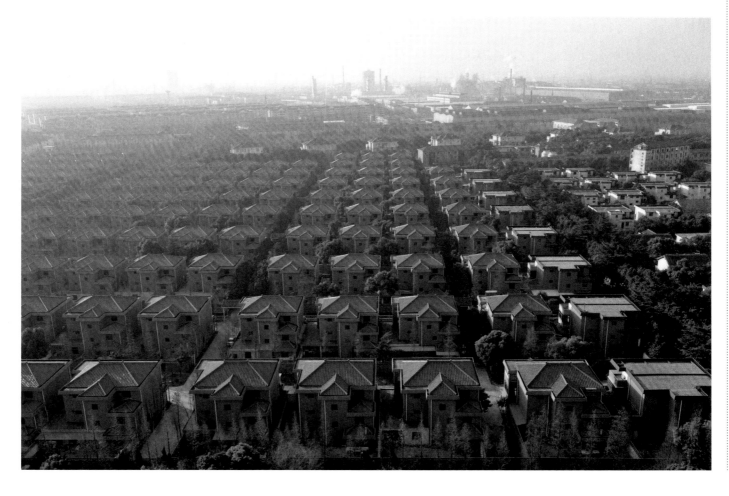

Cult propaganda plays a central role in the design of Huaxi Village and the villagers' daily life: Oversized billboards proclaiming Wu's sayings, heroic actions, admirable virtues and brilliant ideas have been erected everywhere on the streets, around the square and in the 'Museum of the Honest Government Culture of Comrade Wu Renbao.' Even a brand known as 'Renbao Western Clothes' is manufactured as a proud local product.

Next to wealth, health, culture and a spiritual life are highlighted in the village's publicity campaign. Enormous statues of Mao Zedong and other former Party leaders stand proudly, close to a statue of the seated Virgin Mary with the infant Jesus and a pavilion dedicated to the Confucian *Twenty-four Filial Exemplars*. Grandiose facilities such as a public sports center in the style of the Sydney Opera House and a World Theme Park featuring models of the Great Wall, the Paris Arc de Triomphe and the US Capitol in Washington were built to enrich villagers' physical and cultural lives. However, like the forlorn, seldom-visited statues, the sports center, with an untrimmed tennis court, is deserted, while the replicas of world-famous tourist attractions slowly disintegrate.

Despite its purported success, Huaxi is caught in several paradoxes and absurdities. First, its residents are unofficially categorized into three classes with different rights and privileges: The original 1,500 villagers, 30,000 new villagers from the surrounding areas, and 20,000 migrant workers. The latter, in particular, do not enjoy the same welfare benefits, and they work seven days a week for low pay. In order to enjoy the same benefits as the natives, they must be legally recognized as villagers through either marriage or outstanding professional competence. Second, the villagers' mansions, cars and savings are con-

fiscated if they decide to leave Huaxi. Likewise, villagers cannot spend 'their' savings without the village committee's permission. Third, because many high positions in the village committee and enterprises are occupied by the Wu clan, some describe the government as monarchical, or simply a family business. Finally, Huaxi proclaims itself to be a faithful model of socialism. But, obviously, it owes its accomplishment to the market economy. Leaving its collective ownership aside, many compare its rise to that of resource-rich communities in the Middle East.

Huaxi's leaders have always been very adroit at tailoring current political slogans to their aims. When the central government was proclaiming *One Country, Two Systems* [yi guo liang zhi], they immediately coined the slogan *One Village, Two Systems*, referring to the collective and private economies. Since the policy of *Building a New Socialist Countryside* was adopted, Huaxi has been extolling itself as a top model village. Actually, the only rural trace to be found in Huaxi is its agricultural experimental station, where giant pumpkins are preserved to impress visitors.

The glittering financial glories of Huaxi have made it a Mecca for officials and businessmen alike. More than two-million people visited Huaxi in 2009, either to learn from its economic success or to see the "World's First Village." An entrance ticket to the village costs RMB 120 (US $19), and the village has generated more than RMB 200 million (US $32 million) in income from the tourism industry alone. As Wu Renbao once said, "What is socialism? What is capitalism? We only want the things that are good for our people. We want people to get rich."

A photo of former President Hu Jintao and Wu Renbao

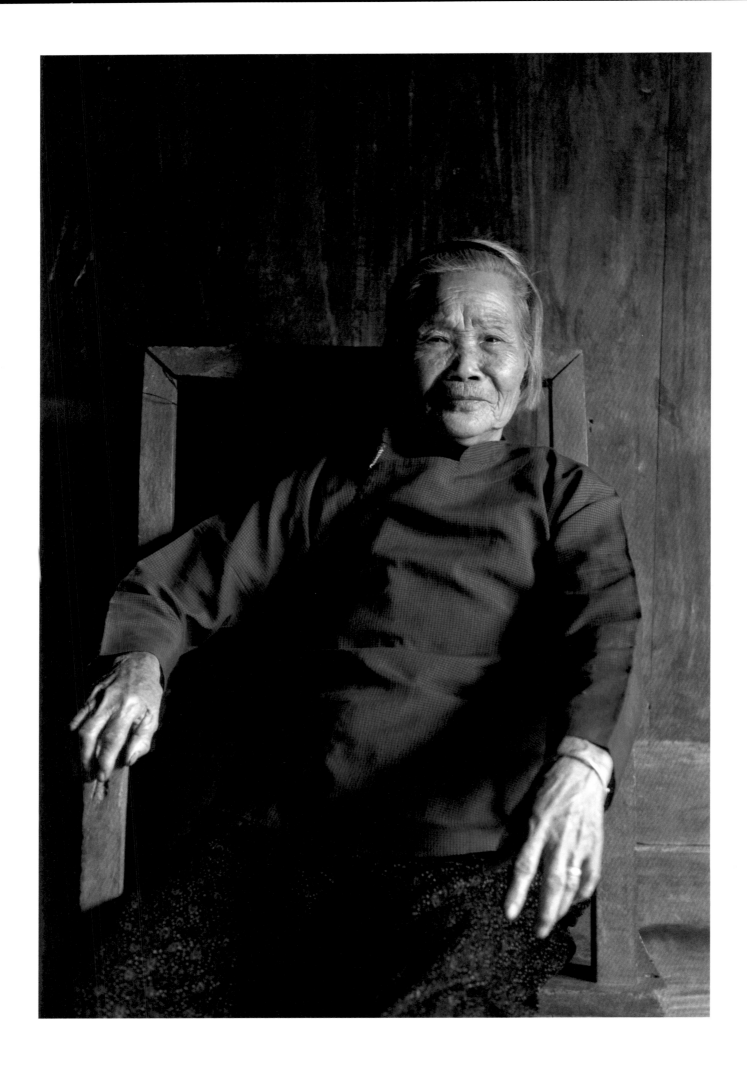

Personal Notes
and Acknowledgements

*China's Vanishing World*s represents the fulfillment of many years of intensive work: In carrying out this project, we planned numerous visits to the far-flung corners of this vast country and spent much time in the countryside studying the chosen areas, until at last we felt ready to present our material in the present book. The selection of regions to be covered was certainly important, but no less significant was the final mapping out of the most relevant topics for understanding rural China today.

What seems on maps to be only a very short distance between two points can in practice mean a strenuous and exhausting trip lasting many days. We would sit on a sofa in the comfort of a Shanghai apartment and plan our trips to distant rural areas in great detail. Unfortunately, we could never foresee all the difficulties we might encounter during our travels, such as finding a mountain road blocked by debris after a severe rainstorm. We have suffered more than our fair share of automobile breakdowns and gotten lost more than a few times. Sometimes even an all-terrain vehicle was not equal to hazardous boulder-strewn roads, and often the only way to reach a remote hamlet was on foot or horseback. Once (in western Hunan Province), a road was literally washed away. Luckily for us, sturdy workers were quickly able to erect a provisional log bridge – needless to say, in exchange for a generous reward.

Unfamiliar as we were with the local conditions of each place we visited, we often had to rely on experienced local drivers, who thereby earned our special gratitude. The majority were far more than just trustworthy drivers: They also helped us as interpreters in areas where the local residents did not understand or speak Mandarin, the Chinese *lingua franca*. They drove away stray dogs near farmers' homes and often served as bodyguards when we were anxiously seeking a meal upon arriving very late at night in a dark and gloomy county seat. Although our interests and inquiries must at times have seemed completely unreasonable, they still always did their best to help us achieve our goals.

Finding a meal was never our chief worry in the countryside. We subsisted chiefly on the local farmers' standard fare, supplemented by occasional luxuries such as the fresh chickens that local people often offer their guests. The hospitality of most of the farmers who offered to share their simple abodes with us is perhaps the most touching memory of our visits to the countryside. Their cordiality and honesty often made up for hygienic conditions that left much to be desired. Indeed, there were only three unpalatable occasions. Once we simply had to politely decline an offer to put us up for the night in a cramped, windowless thatched hut in the mountains of Hainan Island. On a second occasion, we balked at squeezing past an irritable Tibetan mastiff to reach a pit latrine, and a last time we returned to Shanghai after being plagued by fleas and suffering a broken ankle.

Our actual work in the field, e.g., talking to villagers, taking photos, looking for historical records, was definitely easier than it would have been a century ago. Although many rural people were extremely curious to see a European man traveling with an Asian woman, we never experienced the dangers that faced the pioneering Scottish photographer John Thompson: During one of his trips into the interior of nineteenth-century China, he was set upon by an angry mob. The Chinese, as Thompson later wrote, regarded photography "as some black art, which at the same time bereft the individual depicted of so much of the principle of life as to render his death a certainty within a short period of years." Instead, we often encountered warm-hearted villagers who were willing to share with us stories of their hard lives.

And yet, trying to collect surviving remnants of the past and delve into the history of an oppressed people was not an easy or lighthearted task. Usually, farmers who have lived through the upheavals of the twentieth century do not wish to talk about the past, which for them is like tearing open old wounds. However, and fortunately for us, some were even willing to share with us their personal tragedies during the Cultural Revolution and all the fanatical movements that still haunt them as nightmares. Even today, the living conditions of many peasants and their sense of powerlessness about their lives strike us as unbearably depressing. We have often felt saddened to hear of their fates, and it was a heavy burden to learn of the devastating effects of absurd governmental policies on these honest villagers' spirits. Yet we feel immensely grateful for their sharing so many life experiences with us so that we could document at least some of their stories here.

It seems to be an inevitable fate for cultural spaces all over the globe to vanish. In 1800, only three percent of the world's population lived in urban areas. Today, already more than half of the world's population lives in cities. The rapid urbanization process over the past few decades has had an especially devastating impact on developing countries like China. Having lived in Shanghai for almost a decade, we sometimes feel inwardly empty despite all the cultural opportunities and excitement a cosmopolitan metropolis has to offer. It may well have been our destiny to explore so many vanishing worlds in an effort to record them for posterity. When we were young, we especially loved to read *The Travels of Lao Can* by Liu E and the *Adventures of Tintin* by Hergé. These books filled our youthful minds with their enchanting 'ancient worlds.' A nostalgic sense of being at home in a totally strange place often gripped us on our travels through the countryside – whether briefly slumbering on the grass atop lush terraced hills, listening to crickets chirping at dusk while sharing a smoke with some rural farmer or imagining the hundred-thousand footsteps that have traversed a concave, mossy slate walk.

The bridge at Chaozhou in Guangdong Province where John Thomson was attacked by a mob

In the course of traveling and writing, we came to realize that China's vanishing worlds are disappearing at a rate with which we can hardly keep up. While the reader browses through this documentary volume, some of the places portrayed here will already be threatened by the construction of new highways or mass tourism, and others are literally disintegrating because nobody cares about their fate. Although in 2011 the National People's Congress passed a law to preserve China's intangible cultural heritage (the same law also stipulates that foreigners wishing to conduct field research must first obtain approval from the cultural authorities), this law will not prevent China from losing a great share of its cultural legacy in the course of its urban revolution. Fortunately, NGOs such as the Hong Kong-based China Exploration and Research Society or the Beijing Cultural Heritage Center are making great efforts to preserve whatever has not yet fallen victim to the merciless onslaughts of the omnipresent bulldozers.

We could never have published *China's Vanishing Worlds* without the great support of many generous friends and acquaintances. Besides drivers, farm hosts and all the 'kindly spirits' who assisted us in our labors, we received support from many other persons and institutions: We owe very special thanks to Daniel Schluep, CEO of the Swiss Titoni Ltd. watch company. He was the first person to generously and ardently support this project. The significant subsidies for the publication of this book that we received from him personally, Titoni Ltd. and its subsidiary, Golden Universal Watch Ltd. (Mr. Dennis Koh), encouraged us to continue our work with renewed enthusiasm. Time means everything to a watch company, and this book is in fact not only about forgotten places, but also about the search for lost time. In addition, three institutions have likewise greatly helped to make possible the publication of this ambitious documentation: Only thanks to generous grants from the Hans and Wilma Stutz Foundation, the Dr. Fred Styger Foundation and Kulturförderung Appenzell Ausserrhoden can the reader enjoy this uniquely specialized book. All three foundations are located in the canton of Appenzell Ausserrhoden, the *laojia* – as the Chinese call their ancestral homes – of one of the authors. Traveling through many areas of rural China has often reminded us of this beautiful, hilly homeland in eastern Switzerland. We are also very grateful to the Karl Mayer Foundation, which has been an enthusiastic and faithful supporter of our projects during the last ten years.

Our cooperation also won the support of SWISS International Air Lines, Switzerland's flagship carrier airline, and especially its Director Sales Asia Pacific, Markus Schmid, who encouraged us to persist in our arduous undertaking. James Stuart Brice, a loyal and earnest friend, and Daniel Moure have helped us in polishing our English text, while Professor Tom Grunfeld from Empire College of the State University of New York, a specialist in the history of modern East Asia, has offered valuable comments on the manuscript. Finally, we wish to thank Till Schaap, the Program Director of Benteli Publishing, for his great interest in and enthusiasm for this topic. Likewise, we want to express our sincere gratitude to Roger Conover, Executive Editor at the MIT Press, who believes in the importance of the topic and decided to bring our book to readers worldwide.

Cover of a 1976 edition of
The Travels of Lao Can by Liu E.

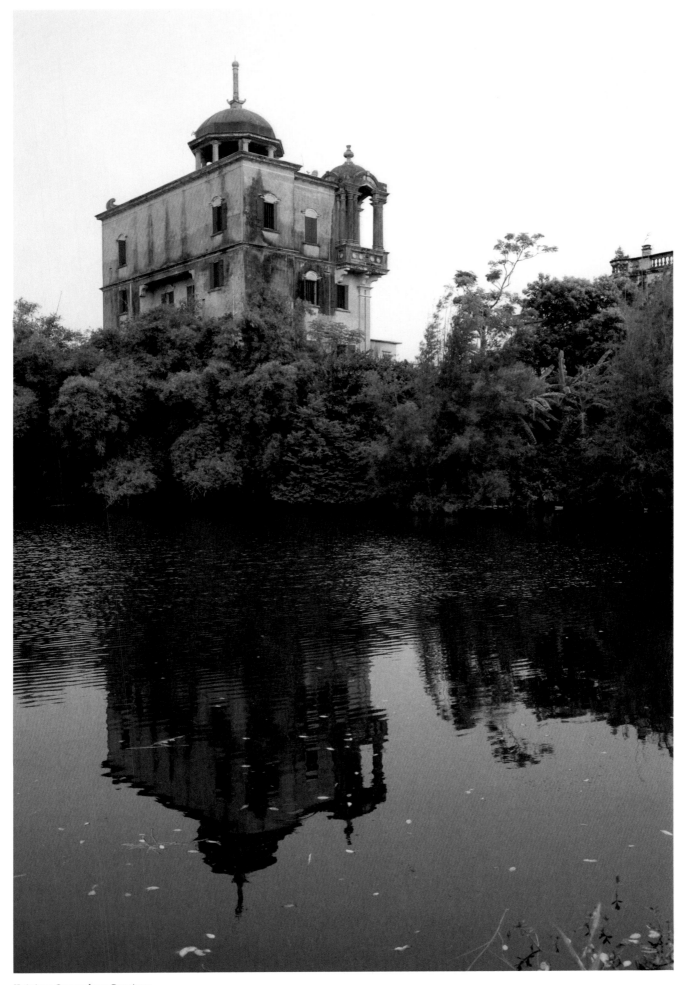

Kaiping, Guangdong Province

Appendix

Glossary

aiguo weisheng yundong 爱国卫生运动: Patriotic Sanitation Movement, an ongoing campaign originally established in the 1950s

aiguozhuyi jiaoyu jidi 爱国主义教育基地: base for patriotic education

ba 坝: dike, embankment

bagua 八卦: Eight Trigrams, i.e., eight diagrams used in Taoist cosmology

bai hua qi fang, tui chen chu xin 百花齐放推陈出新: *Let a hundred flowers blossom, pull up the weeds of the old to bring forth the new*, i.e., a slogan derived from the short-lived Hundred Flowers Campaign [百花运动] in 1957, which encouraged the expression of different opinions to promote progress in the arts and sciences.

bao 堡: place (in ancient times) to station soldiers, fortress

baogushi 抱鼓石: drum-shaped bearing stone of a house gate

baxian zhuo 八仙桌: lit. table of the eight immortals, i.e., a traditional square table for the seating of eight people

Beili Wang 被立王: Established King, a religious sect

Benzhu miao 本主庙: temple for the God of the village (in Bai Minority areas)

bianbianchang 边边场: dating place for unmarried Miao youngsters to get to know each other and select their partners

biandan jutuan 扁担剧团: itinerant theater troupe

bu gan bu jing, chi le mei bing 不干不净，吃了没病: lit. unclean food makes you more resistant to illness in the long run

Caishen 财神: God of Wealth

cha ma gudao 茶马古道: Tea Horse Caravan Trail

Changjiang sanjiaozhou 长江三角洲: Yangtze River Delta

changzhi jiu'an 长治久安: long peaceful reign

cheng xiang eryuan jiegou 城乡二元结构: urban-rural dual structure

chengshi 城市: city

chengshi laoye weishengbu 城市老爷卫生部: Ministry of Health for Urban Lords, a pejorative verdict by Mao Zedong on the Ministry of Health

chengzhenhua 城镇化: urbanization

chifan bu yao qian 吃饭不要钱: *Let everyone eat freely, enough and well*, a slogan used to promote communal canteens of the People's Communes

chijiao yisheng 赤脚医生: lit. barefoot doctor, i.e., rural doctors who received minimal basic medical training in the system of the People's Communes

chi zaocha 吃早茶: lit. drinking morning tea, i.e., a common daily practice in Guangdong Province for people who eat some snacks while drinking tea

chongshang kexue, pochu mixin 崇尚科学，破除迷信: *Uphold science in order to eradicate superstition*, a slogan since the 1990s

chongyang lou 重阳楼: building for honoring elderly persons in regions inhabited by the Dong Minority

chuan Guandong 闯关东: lit. crashing into the east of the pass, i.e., the migration of Han Chinese to northeastern China

chuang hua 窗花: lit. window flower, i.e., paper cutting for window decoration

citang 祠堂: ancestral temple

cun 村, alternatively nongcun 农村: village

cun weishengshi 村卫生室: village clinic

cun wenhua shi 村文化室: village cultural bureau

cunmin weiyuanhui 村民委员会: village committee

cunmin weiyuanhui xuanju 村民委员会选举: village-committee election

da ban gongye 大办工业: *Go in Big for Industry*, a slogan from 1958

dagong 打工: leave the countryside and work for others in towns or cities

dagongmei 打工妹: (slang) female migrant worker

dagong zidi 打工子弟: migrant worker's child

daguofan 大锅饭: food made in a large pot, describing the communal dining system in the 1950s. This term sometimes also refers to economic egalitarianism.

daike jiaoshi 代课教师: substitute teacher

dalian gangtie 大炼钢铁: *Make Steel in a Big Way,* a slogan from the 1950s

daojiao 道教: Taoism

dayuejin 大跃进: Great Leap Forward (1958–1961)

Dazangjing 大藏经: Great Treasury of Sutras, i.e., the Chinese Buddhist canon

diaojiaolou 吊脚楼: hanging house, a multi-storied building on a riverbank or slope

diaolou 碉楼: fortified watchtower

dikengyuan 地坑院, alternatively tianjing-yuan 天井院: underground courtyard house

dixia jiaohui 地下教会: underground church

dongfang shengqi hong taiyang 东方升起红太阳: *The Sun Rises in the East,* a slogan used during Mao's era

dou dizhu 斗地主: Fight the Landlord, a popular card game with a title that refers to the political campaigns of the PRC's early years

doufu 豆腐: tofu or bean curd

duo kuai hao sheng 多快好省: *More, quicker, better and more efficient,* a slogan that was used during the Great Leap Forward (1958–1961)

ernai 二奶: lit. second wife, i.e., mistress

Ershisi xiao 二十四孝: Twenty-four Filial Exemplars, Confucian stories of filial piety

Falun Gong 法轮功, alternatively Falun Dafa 法轮大法 Practice of the Wheel of Law

fan youpai yundong 反右派运动: Anti-Rightist Movement (1957–1959)

fangkai dupi chibao fan 放开肚皮吃饱饭: *Open your belly and eat as much as you can,* a slogan widely used in the system of the People's Communes

fazhan cai shi ying daoli 发展才是硬道理: Development is the Ultimate Principle, a government policy set up by Deng Xiaoping

fei jianzhi zhen 非建制镇: undesignated town

fei nongye hukou 非农业户口, alternatively chengshi hukou 城市户口: non-agricultural

registered residency status, alternatively urban registered residency status

fei wuzhi wenhua yichan 非物质文化遗产: non-material cultural heritage

feiqu 匪区: region of bandits

fengjin zhengce 封禁政策: quarantine decree

fengshui 风水: lit. wind and water, i.e., the ancient Chinese system of principles aimed to create a harmonious living environment

feng yu qiao 风雨桥: wind-and-rain bridge

fenpei gongzuo 分配工作: work allocation by the government during the era of the planned economy

Fuhuo Dao 复活道: Resurrection Way, a religious sect

Fu Lu Shou san xing 福禄寿三星: Three Gods of Good Fortune, i.e., of luck, prosperity and longevity

gaige kaifang 改革开放: Economic Reforms and Opening-up, a government policy established in 1978

ganji 赶集: lit. go to the market

gaokao 高考: National University Entrance Examination

ge 阁: attic or attic temple over a gateway

gedai jiaoyang 隔代教养: generation-skipping child-rearing, or being brought up by grand-parents

geng du chuan jia 耕读传家: cultivating both the land and the mind as the family dis-cipline, an ancestral motto influenced by Confucianism

gongban jiaoshi 公办教师: (officially) qualified teacher

gongfen 工分: lit. work points, i.e., used in the system of the People's Communes as the basis to divide income among members of a production team

gongxiaoshe 供销社: supply and marketing cooperative

gongye xue Daqing 工业学大庆: In Industry, Learn from Daqing, a political campaign from the early 1960s

gou 沟: ditch

gu 蛊: legendary venomous insect

guojiaji pinkunxian 国家级贫困县: national-level poor counties

Guan Yu 关羽, alternatively Guandi 关帝 or Guan Gong 关公: a famous general serving under the Emperor Liu Bei of Shu Han during the Three Kingdoms period (220 – 280 AD)

guanxi 关系: social networks

Guanyin 观音: Goddess of Mercy

Guanyin Famen 观音法门: Goddess of Mercy Dharma, a religious sect

gushu 蛊术: witchcraft using venomous insects

hai shui xi diao, yin bo ru xin 海水西调,引渤入新: Bohai-Xinjiang Water Project

hanhua 汉化: Sinicization, i.e., a term refer-ring to the process of 'becoming Chinese' or 'becomin Han' through political or cultural assimilation

Hanju 汉剧: Han Opera

heli 合理: be reasonable

hefa 合法: be legal

Heshen 河神: God of the River

hexie shehui 和谐社会: harmonious society, a political concept introduced by Hu Jintao

hongse lüyou 红色旅游: lit. red tourism, a state-run tourism project that attracts people to visit locations with historical significance to the Communist Party

Hongse Niangzijun 红色娘子军: *Red Women's Detachment,* a revolutionary ballet premiered in 1964; one of the eight model plays permit-ted in China during the Cultural Revolution

hongweibing 红卫兵: Red Guards

huangli 黄历, alternatively nongmin li 农民历: traditional almanac

huangtu 黄土: yellow earth or loess, a yellowish-brown silt or clay

Huangtu Gaoyuan 黄土高原: Loess Plateau

huaqiao 华侨: overseas Chinese

Huhan Pai 呼喊派: Shouters Faction, a religious sect

Huipai 徽派: Hui-style, i.e., coming from the ancient State of Hui

Huizhou 徽州: the ancient State of Hui

hukou 户口: household-registration record, can also refer to the household-registration system in general

humen 壶门: teapot-shaped door

huolu tou 活路头: labor leader of the Miao Minority, a hereditary position

Huoshen 火神: God of Fire

jiadian xiaxiang 家电下乡: Popularize Household Appliances in the Countryside, a political campaign and subsidy policy outlined in 2007

jiangshi 僵尸: lit. stiff jumping corpse, i.e., the Chinese version of a vampire, often used in legends from western Hunan

jianshe shehuizhuyi xin nongcun 建设社会主义新农村: Building a New Socialist Countryside, a government policy launched in 2005

jianzhi 剪纸: paper cutting

jianzhi zhen 建制镇: officially designated town

jiating jiaohui 家庭教会: house church

jiating lianchan chengbao zerenzhi 家庭联产承包责任制: household-responsibility system

Jiemeijie 姐妹节: Sisters Festival

jihua jingji 计划经济: planned economy

jihua shengyu zhengce 计划生育政策: lit. policy of birth planning, i.e., the one-child policy

jingshen wenming 精神文明: spiritual civilization, a political term used by the Communist Party to educate the masses

Jinju 晋剧: Shanxi Opera

jishi 集市, alternatively ji 集, chang 场, jie 街, xu 墟, dian 店: market

jiu shehui 旧社会: old society, i.e., the feudal society, as described by the Communist Party to distinguish itself from pre-1949 China

jizhen 集镇: market town

juntun 军屯: military station (in ancient times)

kaixin nongchang 开心农场: lit. Happy Farm, a popular online game

kang 炕: brick bed commonly used in the countryside of northern China

keju kaoshi 科举考试: imperial examination

kongzhong xin nongcun 空中新农村: lit. a new village in the sky, a term used by the officials of Huaxi Village to describe their 74-story skyscraper

kuaisu guihua 快速规划: rapid plan

Kuixing 魁星: God of Literature

Kunqu 昆曲: Kun Opera, one of the oldest extant forms of Chinese opera

langqiao 廊桥: covered bridge

laocheng gaizao 老城改造: redevelopment of old town areas

li tu bu li xiang 离土不离乡: leaving the land without leaving the village

liangshi shiyong zengliang fa 粮食食用增量法: method to increase edible grain and substitute food

Lingling Jiao 灵灵教: Spirit Church, a religious sect

Lingxian Zhen Fozong 灵仙真佛宗: Immortal True Buddha Sect, a religious sect

liuhecai 六合彩: Mark Six, a Hong Kong-based lottery betting game

liushou ertong 留守儿童: left-behind children, i.e., a phenomenon in the countryside due to work migration

Longwang 龙王: Dragon King, a Taoist deity

Lu Ban Jing 鲁班经: *Treatise of Lu Ban,* written between the thirteenth and fifteenth centuries

mabang 马帮: horse caravan

mahui 马会: equestrian festival

Mao zhuxi wansui 毛主席万岁: *Long Live Chairman Mao,* a popular slogan used in the Mao era. According to sources, it was first shouted by a crowd in 1939

Mao Zhuxi Yulu 毛主席语录: *Quotations of Chairman Mao,* a book of selected statements from speeches and writings by Mao Zedong, known in the West as the Little Red Book

Mazu 妈祖: Goddess of the Sea, popularly worshipped in Fujian, Guangdong, Zhejiang and Hainan Provinces

menlou 门楼: alley gate or gatehouse

menzhenshi 门枕石: bearing stone of a house gate

mianmomo 面馍馍: dough figure

mianzi gongcheng 面子工程: lit. face project, i.e., façade beautification project

miaohui 庙会: temple festival

minjian xinyang 民间信仰, alternatively shenjiao 神教: folk religion

mofan cun 模范村: model village

mu'ou ju 木偶剧: wood-puppet play

muban hua 木版画: woodblock printing

mumin dingju 牧民定居: nomadic settlement, a policy aimed at speeding up the sedentarization of nomads

nan shui bei diao gongcheng 南水北调工程: South-North Water Transfer Project

ni chengshihua 逆城市化: counter-urbanization

niu yangge 扭秧歌: lit. move with the rice-sprout song, i.e., a traditional folk dance popular in the northern provinces

nongcun fuye 农村副业: rural sideline production, i.e., economic activities aside from farming

nongcun jingjiren 农村经纪人: private agricultural middleman

nongcun shengyu laodongli 农村剩余劳动力: surplus rural labor force

nongjiale 农家乐: rural guesthouse

nongmang shitang 农忙食堂: temporary communal canteen during busy farming seasons

nongmin kexuejia 农民科学家: peasant scientist

nongmin 农民: farmer

nongmingong 农民工, alternatively mingong 民工: migrant worker

nongmingong weiquan 农民工维权: protection of rights of migrant workers

nongye chanyehua jingying 农业产业化经营: industrialized agricultural operation

nongye gongren 农业工人: (hired) farm worker

nongye hukou 农业户口, alternatively nongcun hukou 农村户口: agricultural or village registered residency status

nongye jitihua 农业集体化: agricultural collectivization

nongye xue Dazhai 农业学大寨: In Agriculture, Learn from Dazhai, a political campaign from the early 1960s

nongye 农业: agriculture

paifang 牌坊: monumental gateway

pidou hui 批斗会: struggle session, a method widely used during the Cultural Revolution by the Communist Party to publicly humiliate and persecute political rivals

pin xia zhong nong 贫下中农: poor and lower-middle-class peasant

ping 坪: open plain

Pingtan 评弹: oral performing art including singing and reciting, popular in the *Jiangnan* region

piying xi 皮影戏: leather-silhouette show or shadow-puppet play

po sijiu 破四旧: Smash the Four Olds, a political movement beginning in 1966 and aimed at destroying old customs, culture, habits and ideas

pu 铺: postal station (in ancient times)

qiaoqiao you miao, miaomiao you qiao 桥桥有庙，庙庙有桥: Every bridge has a temple. Every temple has a bridge

qiaoxiang 侨乡: hometown of overseas Chinese

qigong 气功: lit. life energy exercise, i.e., traditional and philosophical concept that combines breathing, movements and self-awareness

qilou 骑楼: arcade, an architecture style widely used in southern China

qingli jieji duiwu 清理阶级队伍: Cleansing the Class Ranks, a political campaign from 1968–1969

Qingmingjie 清明节: Tomb-Sweeping Day

quntixing zhi'an shijian 群体性治安事件: collective public-security incident, an euphemism for protest demonstrations

qunzhong jijixing 群众积极性: enthusiasm of the masses, a political term used during the era of the People's Communes

ren ding sheng tian 人定胜天: man will triumph over nature

ren you duo da dan, di you duo da chan 人有多大胆，地有多大产: The bolder man is, the bigger the harvests will be, i.e., a headline of an editorial in the People's Daily from 1958

renkou fanmai 人口贩卖: human trafficking

renmin gongshe 人民公社: People's Communes

remin gongshe da shitang 人民公社大食堂: communal canteens of the People's Communes

richu er zuo, riluo er xi 日出而作,日落而息: Go out to work by sunrise, and return to rest by sunset

san nian ziran zaihai 三年自然灾害: lit. Three Years of Natural Disasters, i.e., the Great Famine (1958–1961). The first term is usually used by the Chinese government, while the latter is used outside of China. Alternatively known as the Three Difficult Years [san nian kunnan shiqi]

san nong wenti 三农问题: Three Rural Issues, i.e., agriculture, rural residents and rural areas

shanshuihua 山水画: lit. mountain-water painting, i.e., landscape painting

shang luogu 上锣鼓: Topping the Gongs and Drums, a competitive performance in the Lantern Festival

shangpin jingji 商品经济: commodity economy

shangshan xiaxiang 上山下乡: Up to the Mountains, Down to the Countryside, a policy instituted by Mao Zedong in the late 1960s

shanqiang 山墙: gable wall

Shanshen 山神: God of the Mountains

shen 神: god, deity, spirit

shengchan dui 生产队: production team, a unit in the system of the People's Communes. After the dissolution of the latter in the mid-1980s, the production teams became villages again.

shehuizhuiyi jingshen wenming 社会主义精神文明: socialist spiritual civilization, a political term introduced in 2000 and used as a vague ideological justification for party and government propaganda campaigns

shehuo 社火: lit. social fire, i.e., performances dedicated to the God of Earth and the God of Fire during the Chinese New Year

sheji geming yundong 设计革命运动: architectural design revolution movement, a policy introduced by Mao Zedong in 1964 to call for China's own architectural design style

shenjiao 神教: Shenism, i.e., Chinese folk religion

shida yuanshuai 十大元帅: Ten Marshalls of the People's Liberation Army

shinian haojie 十年浩劫: lit. Ten-years Catastrophe, referring to the Cultural Revolution 1966–1976

shixiangsheng 石像生: stone made statues of officials and animals in imperial graveyards

sihai 四害: the four pests, i.e., rats, flies, mosquitoes and sparrows, a term used during the Four Pests Campaign from 1958 to 1962

sijiu 四旧: the Four Olds, i.e., customs, culture, habits and ideas

simiao 寺庙: temple

siren bang 四人帮: Gang of Four, a political faction composed of four party officials including Jiang Qing, Mao's wife

sishu 私塾: home school (in ancient times)

songfa xiaxiang 送法下乡: Bringing the Law to the Countryside

suoyi 蓑衣: straw rain cape

taiji 太极: a Taoist cosmological term, commonly translated as *supreme ultimate*

tang 塘: pond

tangbo/tangfan gudao 唐蕃古道: ancient China-Tibet Trail

Tao Hua Yuan Ji 桃花源记: The Tale of the Peach Blossom Spring, i.e., a synonym for a utopia-like place

tianjing 天井: lit. sky well, i.e., a small patio

tongqian 铜钱: ancient copper coin

Tubo/Tufan 吐蕃: Tibetan Empire

tudi gaige 土地改革: land reform

Tudigong 土地公: God of the Earth

tulou 土楼: earth building of the Hakka people

tun 屯: place to station soldiers (in ancient times)

wai zui heshang 歪嘴和尚: lit. monk with a wry mouth, i.e., a nickname for corrupt local officials

wan 湾: place on a bay or near a river bend (in ancient times)

wan'e de jiu shehui 万恶的旧社会: evil old society, a pejorative term used during the Cultural Revolution

weisheng cesuo 卫生厕所: sanitary latrine

weixing tian 卫星田: lit. satellite field, a field with skyrocketing agricultural production. This term was used in the 1950s to boost China's economic development in comparison with the Soviet Union, which launched Sputnik 1 in 1957

wenhua dageming 文化大革命: Cultural Revolution (1966–1976)

wenming hu 文明户: civilized household, a term used in a campaign of recent years in which individual households are accorded public recognition for fulfilling certain state and party norms

wenrenhua 文人画: literati painting

wenren yishu 文人艺术: literati art

xi 囍: a symbol made out of two characters meaning 'happiness' and commonly displayed at weddings

xiagongpeng 下工棚: (prostitute) selling sex to migrant workers

xiancheng 县城: county seat

xiang 乡: township

Xiangcun Da Shijie 乡村大世界: the Big World of the Countryside, a popular program of China Central Television

xiangzhen qiye 乡镇企业: township and village enterprise (TVE), a term officially introduced in 1984

xiao chengzhen hukou 小城镇户口: residency status of small cities and towns

xiao chengzhen jianshe 小城镇建设: small-town development

xiaomaibu 小卖部: mom-and-pop store

xiangtu wenxue 乡土文学: native-soil literature

Xibei San Ma 西北三马: the Three Mas of the Northwest, referring to Muslim generals of the Ma clique during the Republican era (1911–1949)

xibu dakaifa 西部大开发: Great Western Development Strategy, a government policy launched in 2000 to boost China's less-developed western regions

xiejiao 邪教: evil religion

xin zhiqing 新知青: new urban youth

Xinjiang Shengchan Jianshe Bingtuan 新疆生产建设兵团: Xinjiang Production and Construction Corps, established in 1954 with the aim "to develop frontier regions and ensure social stability and ethnic harmony"

xinshengdai nongmingong 新生代农民工: Generation Y migrant worker, i.e., people born in the 1980s and early 1990s

xique 喜鹊: magpie, homonym for 'bird of happiness'

xitai 戏台: theater stage

xizilu 惜字炉: stove for burning used writing paper

xuanzhi 宣纸: rice paper used in ancient China for writing and painting

xue shehuo 血社火: bloody performance dedicated to the God of Earth and the God of Fire during the Chinese New Year

xuedeng 雪灯: snow lamp, commonly used to commemorate ancestors in Manchuria

xuexi hui 学习会: study meeting, i.e., political meetings established by the Communist Party after 1949

yangban xi 样板戏: model opera during the Cultural Revolution, planned and set up by Mao's wife Jiang Qing

yaodong 窑洞: cave dwelling

Yaowang 药王: God of Medicine

yi guo liang zhi 一国两制: One Country, Two Systems, a policy that allows Hong Kong and Macao (and Taiwan) to have their own political systems while maintaining that there is only one China

yi nian yi ge yang, san nian da bian yang 一年一个样，三年大变样: *A new image every year and a complete change every three years*, a slogan first introduced by Deng Xiaoping to praise the development of Shanghai's Pudong Financial District

ying 营, alternatively yingpan 营盘: place (in ancient times) to station soldiers

yingbi 影壁: screen wall

yinzhai 阴宅: lit. dwelling for the deceased, i.e., a graveyard

yinzhai fengshui 阴宅风水: *fengshui* of a graveyard

yiyuancun 亿元村: village with RMB 100 million (US $ 15 million) in assets

yizhan 驿站: imperial postal station

yuan 院: courtyard

Yuanxiaojie 元宵节: Lantern Festival

yuanzang 援藏: Aid Tibet, a government policy aimed at raising the living standard in the Tibet Autonomous Region

Yugong Yishan 愚公移山: *The Foolish Old Man Who Moved the Mountains Away,* a Taoist fable with a main character who in the Mao era became a role model for peasants

zhai 寨: mountain settlement, usually fortified (mostly in ethnic-minority areas)

zangchuan fojiao 藏传佛教: Tibetan Buddhism, pejoratively called Lamaism

zhao 召: temple (in Mongolian), usually describing a settlement situated around a temple

zhengzhi yexiao 政治夜校: political night school

zhishi qingnian 知识青年, alternatively zhiqing 知青: urban youth

zhiye kusangren 职业哭丧人: professional funeral weeper

zhizhapu 纸扎铺: shop specializing in funeral paper goods

Zhong Gong 中功 (abbreviation for Zhonghua Yangsheng Yizhi Gong 中华养生益智功): Chinese Health Care and Wisdom Enhancement Practice, a religious sect

Zhonghua minzu 中华民族: Chinese nationality, referring to the modern notion of a Chinese nation including all ethnic groups in the territory of the PRC

Zhongguo lishi wenhua mingzhen, mingcun 中国历史文化名镇名村: Chinese historic towns and villages

zhongsheng pingjing 终生平静: lifelong tranquility

Zhongyuan 中原: Central Plain, referring to the middle and lower reaches of the Yellow River, which formed the cradle of Chinese civilization, i.e., today's Henan and Shaanxi Provinces

Zhushen Jiao 主神教: Religion of the Main God, a religious sect

zibenzhuyi weiba 资本主义尾巴: tail of capitalism, a pejorative term used during the Cultural Revolution

zongchuang 棕床: coir-woven bed

zongci 宗祠, alternatively citang 祠堂: ancestral temple

zou zibenzhuyi daolu 走资本主义道路: taking a capitalist path, a pejorative term used during the Cultural Revolution

zuzhi junshihua, xingdong zhandouhua, shenghuo jitihua 组织军事化, 行动战斗化, 生活集体化: militarized organization, combatant action and collectivized lifestyle, terms advocated by the Communist Party and used in the system of the People's Communes

Bibliography and further reading

An Official Guide to Eastern Asia (1915). Vol. IV: China. Prepared by the Imperial Japanese Government Railways. Tokyo.

Anderson, John (1876). Mandalay to Momien: A Narrative of the Two Expeditions to Western China of 1868 and 1875 under Colonel Edward B. Sladen and Colonel Horace Browne. MacMillan. London.

Archer, Charles S. (1941). Hankow Return. Houghton. Boston, MA.

Aubert, Claude/Li, Xiande (2002). 'Peasant Burden': Taxes and Levies Imposed on Chinese Farmers. Agricultural Policies in China after WTO Accession. OECD. Paris, p. 160–179.

Bianco, Lucien (2001). Peasants Without the Party: Grass-Roots Movements in Twentieth-Century China. M. E. Sharpe. Armonk, London.

Bramall, Chris (2007). The Industrialization of Rural China. Oxford University Press. Oxford, New York.

Brown, Jeremy (2006). Staging Xiaojinzhuang: The City in the Countryside, 1974–1976, in: Esherick et al. (Eds.): The Chinese Cultural Revolution as History, p. 153–184.

Buck, Pearl (1931). The Good Earth. John Day. New York.

Bulfoni, Clara/Pozzi, Anna, Eds. (2003). Lost China. The Photographs of Leone Nani. Skira. Milano.

Chan, Kam Wing/Zhang, Li (1999). The Hukou System and Rural-Urban Migration in China: Processes and Changes, in: The China Quarterly, No. 160 (December), p. 818–855.

Chang, Eileen (1955). The Rice-Sprout Song. A Novel of China Today. Scribner. New York.

Chau, Yuet Adam (2006). Miraculous Response. Doing Popular Religion in Contemporary China. Stanford University Press. Palo Alto, CA.

Chen, Guidi/Wu, Chuntao (2007). Will the Boat Sink the Water? The Life of China's Peasants. Public Affairs. New York.

Chen Han-seng (1936). Landlord and Peasant in China: A Study of the Agrarian Crisis in South China. International Publishers. New York.

China and the Gospel (1906). Annual Report of the China Inland Mission. London.

Chung, Jae-Ho/Lai, Hongyi/Xia, Ming (2006): Mounting Challenges to Governance in China:

Surveying Collective Protestors, Religious Sects and Criminal Organizations, in: The China Journal, No. 56 (July), p. 1–31.

Clark, Paul (2008). The Chinese Cultural Revolution: A History. Cambridge University Press. Cambridge, New York.

Clark, Robert S./Sowerby, Arthur de Carle. (1912). Through Shen-Kan: the Account of the Clark Expedition in North China, 1908-9. T. Fisher Unwin. London.

Cressey, George B. (1955). Land of the 500 Million. A Geography of China. McGraw-Hill. New York, Toronto, London.

Edgar, Huston J. (1927). The Land of Mystery, Tibet. China Inland Mission. Melbourne.

Edwards, Evangeline D. (1938). The Dragon Book. W. Hodge & Co. London.

Esherick, Joseph W./Pickowicz, Paul G./Walder, Andrew G., Eds. (2006). The Chinese Cultural Revolution as History. Stanford University Press. Palo Alto, CA.

Fei, Hsiao-Tung [Fei Xiaotong] (1939). Peasant Life in China. A Field Study of Country Life in the Yangtze Valley. Routledge. London.

Flath, James (2004). The Cult of Happiness: Nianhua, Art, and History in Rural North China. University of Washington Press. Seattle, WA.

Fortune, Robert (1852). A Journey to the Tea Countries of China including Sung-Lo and the Bohea Hills; with a short notice of the East India Company's Tea Plantations in the Himalaya Mountains. John Murray. London.

Fortune, Robert (1935). Three Years' Wanderings in China, including a visit to the tea, silk, and cotton countries. University Press Shanghai. Shanghai.

Friedman, Edward/Pickowicz Paul G./Selden, Mark (1991). Chinese Village, Socialist State. Yale University Press. New Haven & London.

Geary, D. Norman et al. (2003). The Kam People of China. Turning Nineteen. Routledge. London.

Golany, Gideon (1992). Chinese Earth-Sheltered Dwellings: Indigenous Lessons for Modern Urban Design. University of Hawaii Press. Honolulu.

Guldin, Gregory Eliyu, Ed. (1997). Farewell to Peasant China. Rural Urbanization and Social Change in the Late Twentieth Century. M. E. Sharpe. Armonk, London.

Hacker, Arthur (2004). China Illustrated. Western Views of the Middle Kingdom. Tuttle Publishing. North Clarendon, VT.

Han, Dongping (2008). The Unknown Cultural Revolution. Life and Change in a Chinese Village. Monthly Review Press. New York.

Hawkins, Horatio B. (1911). Geography of China. Commercial Press. Shanghai.

He, Jiangsui (2006). The Death of a Landlord: Moral Predicament in Rural China, 1968–1969, in: Esherick et al. (Eds.): The Chinese Cultural Revolution as History, p. 124–152.

Hedin, Sven (1925). My Life as an Explorer. Garden City Publishing. New York.

Hillman, Ben (2004). The Rise of the Community in Rural China: Village Politics, Cultural Identity and Religious Revival in a Hui Hamlet, in: The China Journal, No. 51, January, p. 53–73.

Hosie, Alexander, Sir (1914). On the Trail of the Opium Poppy. A Narrative of Travel in the Chief Opium-Producing Provinces of China. G. Philip & Son. London.

Hulshof, Michiel/Roggeveen, Daan (2011). How the City Moved to Mr. Sun. China's New Megacities. Martien de Vletter, SUN. Amsterdam.

Johnston, Reginald F. (1908). From Peking to Mandalay: A Journey from North China to Burma through Tibetan Such'uan and Yunnan. John Murray. London.

Knapp, Ronald G. (1992). China's Traditional Rural Architecture. A Cultural Geography of the Common House. University of Hawaii Press. Honolulu.

Knapp, Ronald G. (2005). Chinese Houses. The Architectural Heritage of a Nation. Tuttle Publishing. Clarendon, VT.

Knapp, Ronald G., Ed. (1992). Chinese Landscapes. The Village as Place. University of Hawaii Press. Honolulu.

Knight, John/Deng, Quheng/Li, Shi (2010). The Puzzle of Migrant Labour Shortage and Rural Labour Surplus in China. Discussion Paper Series of the Department of Economics Oxford University No. 494. Oxford.

Kung, James Kai-sing/Lee, Yiu-Fai/Bai, Nansheng (2011). *Human Capital, Migration, and Vent for Surplus Rural Labor in 1930s China: The Case of the Lower Yangzi*, in: The Economic History Review Vol. 64, Issue Supplement S1 (February), p. 117–141.

Lai, Hongyi Harry (2003). *The Religious Revival in China*, in: Copenhagen Journal of Asian Studies, No. 18, p. 40–64.

Lee Tsai, Lily (2002). *Cadres, Temple and Lineage Institutions, and Governance in Rural China*, in: The China Journal, No. 48 (July), p. 1-27.

Li, Bingqin/An, Xiangsheng (2009): *Migration and Small Towns in China. Power Hierarchy and Resource Allocation*. Working Paper Series on Rural-Urban Interactions and Livelihood Strategies No. 16 (July). London.

Li, Xiaocong, Ed. (2004). *Meiguo guohui tushuguan cang. Zhongwen gu ditu xulu* [A descriptive catalogue of traditional Chinese maps collected in the Library of Congress]. Wenwu chubanshe. Beijing.

Liu, Chang (2007). *Peasants and Revolution in Rural China. Rural Political Change in the North China Plain and the Yangzi Delta, 1850–1949*. Routledge. London.

Lum, Thomas (2006). S*ocial Unrest in China*. Federal Publications. Congressional Research Service (CRS). Reports and Issue Briefs. Cornell University. Ithaca, NY.

Luo, Pinghan (2001). *Daguofan: Gonggong shitang shimo* [Food for Everyone: The Story of the Communal Canteens]. Guangxi renmin chubanshe. Nanning.

Mackerras, Colin, Ed. (1983). *Chinese Theater. From Its Origins to the Present Day*. University of Hawaii Press. Honolulu.

Martin, Michael F. (1992). *Defining China's Rural Population*, in: The China Quarterly, No. 130 (June), p. 392–401.

Michie, Alexander (1864). *The Siberian Overland Route. From Peking to Petersburg, through the Deserts and Steppes of Mongolia, Tartary*. John Murray. London.

Mo, Yan (1993). *Red Sorghum. A Novel of China*. Viking Press. New York.

Min, Anchee/Landsberger, Stefan et al. (2003). *Chinese Propaganda Posters*. From the Collection of Michael Wolf. Taschen. Cologne, London, Los Angeles.

Ottley, William J. (1906). *With Mounted Infantry in Tibet*. Smith Elder & Co. London.

Pan, Lynn, Ed. (1998). *The Encyclopedia of the Chinese Overseas*. Harvard University Press. Cambridge, MA.

Paull, John (2007). *China's Organic Revolution*, in: Journal of Organic Systems Vol. 2, p. 1–11.

Piassetsky, Pavel J. (1884). *Russian Travellers in Mongolia and China*. Chapman and Hall. London.

Ren, Fang (2010). *The Rural Market in Late Imperial China*, in: Asian Social Science, Vol. 6 (June), p. 42–49.

Rudofsky, Bernard (1964). *Architecture Without Architects. A Short Introduction to Non-Pedigreed Architecture*. University of New Mexico Press. Albuquerque.

Scott, Charles E. (1917). *China from Within. Impressions and Experiences*. Fleming H. Revell Co. London, Edinburg.

Skinner, William G. (1964). *Marketing and Social Structure in Rural China: Part I*, in: The Journal of Asian Studies, Vol. 24, No. 1 (Nov), p. 3–43.

Skinner, William G. (1965). *Marketing and Social Structure in Rural China: Part II*, in: The Journal of Asian Studies, Vol. 24, No. 2 (Feb), p. 195–228.

Snow, Edgar (1937). *Red Star over China*. Victor Gollancz. London.

Spence, Jonathan/Chin, Annping (1996). *The Chinese Century. The Photographic History of the Last Hundred Years*. Random House. New York.

Stübel, Hans (1937). *Die Li-Stämme der Insel Hainan*. Klinkhardt & Biermann. Berlin.

Svensson, Marina (2006). *In the Ancestors' Shadow: Cultural Heritage Contestations in Chinese Villages*. Working Paper of the Centre for East and Southeast Asian Studies Lund University No. 17. Lund, Sweden.

Taylor, George E./Stewart, Maxwell S. (1942): *Changing China*. Institute of Pacific Relations and Webster Publishing Company. St. Louis, Dallas, Los Angeles.

Taylor, James H. (1892). *China's Millions*. China Inland Mission. London.

Taylor, James H. (1903). A *Retrospect*. Morgan & Scott. London.

Thøgersen, Stig (2000). *Cultural Life and Cultural Control in Rural China: Where is the Party?* in: The China Journal, No. 44 (July), p. 129–141.

Toops, Stanley (2004). *Demographics and Development in Xinjiang after 1949*. East-West Center Washington Working Papers No. 1 (May). Washington, D.C.

Tun, Li-ch'en (1936). *Annual Customs and Festivals in Peking as Recorded in the Yen-ching Sui-shih-chi*. Translated and annotated by Derk Bodde. Henri Vetch. Peiping [Peking].

Unger, Jonathan (2002). *The Transformation of Rural China*. M. E. Sharpe. Armonk, London.

Upham, Frank K (2005). *Who Will Find the Defendant if He Stays with His Sheep? Justice in Rural China*, in: The Yale Law Journal, Vol. 114, p. 1675–1718.

Waddell, Laurence A. (1905). *Lhasa and its Mysteries. With a Record of the Expedition of 1903–1904*. John Murray. London.

Waldron, Arthur (1998). *Religious Revivals in Communist China*, in: Orbis, Vol. 42, No. 2 (Spring), p. 325-334.

Wang, Can (2004), *Ethnic Groups in China*. China Intercontinental Press. Beijing.

Wu, Youru (1998). *Shijiu shiji Zhongguo fengqinghua* [Chinese Lifestyle paintings in the nineteenth century]. Hunan meishu chubanshe. Changsha.

Yan, Yunxiang (2002). *Courtship, Love and Premarital Sex in a North China Village*, in: The China Journal, No. 48 (July), p. 29–53.

Yang, Fenggang (2006). *The Red, Black, and Gray Markets of Religion in China*, in: The Sociological Quartely, No. 47, p. 93–122.

Yule, Henry (1875). *The Book of Ser Marco Polo, the Venetian, Concerning the Kingdoms and Marvels of the East*. In Two Volumes. Second Edition. John Murray. London.

Illustration Credits

Introduction
P12 Urbanization chart: *60 Years of China's Urbanization. Reviews and Prospects*, in: *Urban China*, vol. 40, 2010;
P13 Map top left: Archer, *Hankow Return*, 1941; Illustration: Michie, *The Siberian Overland Route*, 1864; Photo b/w: China Inland Mission, *China and the Gospel*, 1906; Map bottom right: Hawkins, *Geography of China*, 1911;
P16 Satellite photo: Google Map.

Settlements of *Fengshui*
P19 Illustrations from left to right: Yule, *The Book of Ser Marco Polo*, 1875; Piassetsky, *Russian Travellers*, 1884; Anderson, *Mandalay to Momien*, 1876;
P21 Colorful illustrations: Courtesy of Zhou Ji; Illustration bottom left: *Qinding Shujing tushuo*, 1905;
P26 Photo b/w: Luo, *Daguofan*, 2001;
P27 Map: Courtesy of Zhou Ji;
P29 Architectural Illustrations: Exhibited in the Himalayas Art Museum/Shanghai, *Updating China – Art and Architecture Exhibition on Sustainable Urban Development in China*, 2010;
P38 Map: Li Xiaocong, *Meiguo guohui tushuguan cang. Zhongwen gu ditu xulu*, 2004;
P39 Photo b/w and tattoo sketches: Stübel, *Die Li-Stämme der Insel Hainan*, 1937.

Arts of Architecture and Labyrinths of Space
P45 Photo b/w: Bulfoni/Pozzi, *Lost China*, 2003;
P47 Sketch: Courtesy of Zhou Ji;
P48 Photo b/w: Rudofsky, *Architecture Without Architects*, 1964; Illustrations: Golany, *Chinese Earth-Sheltered Dwellings*, 1992; Map: Cressey, *Land of the 500 Million*, 1955;
P49 Illustrations top: Knapp, *Chinese Houses*, 2005, adjusted by Cheng Yu-Ting; Map and illustrations bottom: Knapp, *Chinese Houses*, 2005;
P62 Map: Pan, *The Encyclopedia of the Chinese Overseas*, 1999. Courtesy of the Chinese Heritage Centre, Singapore;
P65 Print from the nineteenth century: Thomas Allon, in: Hacker, *China Illustrated*, 2004;
P67 Wood carving: We thank Professor Robert Gassmann (Zurich) for bringing this story to our attention.

Rural Aesthetics and Modern Kitsch
P71 Illustrations: Wu, *Shijiu shiji Zhongguo fengqinghua*, 1998;
P89 Photo b/w: Hua Ai, in: Spence/Chin, *The Chinese Century*, 1996.

Food, Water, Health and the Environment
P96 Photo b/w: Luo, *Daguofan*, 2001;
P99 Map: Cressey, *Land of the 500 Million*, 1955;
P100 Photo: Lu Guang, Courtesy of Beaugeste Gallery, Shanghai;
P101 Contemporary Chinese ink painting: Yang Yongliang, Courtesy of OFOTO Gallery, Shanghai;
P108 Illustration: Courtesy of Zhou Ji;
P114 *Zhujiajiao Newspaper* from 1932: We thank Deke Erh (Shanghai) for bringing the history of local newspapers in Zhujiajiao to our attention; Illustration: Courtesy of Cheng Yu-Ting;
P115 Illustrations from left to right: Fortune, *A Journey to the Tea Countries*, 1852; Yule, *The Book of Ser Marco Polo*, 1875;
P117 Map of the Shooting Districts Lying Between Hangchow, Nanking, Wuhu, and Shanghai (by Fred and Helen Mann), 1909.

Free Education for All?
P126 Photo b/w: by Helen Foster Snow, in: Snow, *Red Star over China*, 1937.

The Demise of the Farmer
P145 Photo b/w: Taylor, *Changing China*, 1942;
P148 Illustration top left: Courtesy of Han Ensheng; Illustration top right: Courtesy of Zhou Ji;
P150 Photo b/w: Bulfoni/Pozzi, *Lost China*, 2003;
P151 Photo b/w: Bulfoni/Pozzi, *Lost China*, 2003; Photo slave scandal 2007: Agence France-Presse.

Of Soul, Spirit and the Supernatural
P175 Illustration adapted by Cheng Yu-Ting from *Beijing Review*, May 15–21, 1989;
P177 Illustration: China Inland Mission, *China's Millions*, 1892; Map: Taylor, *A Retrospect*, 1903;
P179 Illustration top: Fortune, *A Journey to the Tea Countries of China*, 1852; Illustration bottom: Wu, *Shijiu shiji Zhongguo fengqinghua*, 1998;
P183 Map: Hedin, *My Life as an Explorer*, 1925;
P189 Illustrations right: Fortune, *Three Years' Wanderings in China*, 1935; Photo b/w: Scott, *China from Within*, 1917;
P200 Map: Hawkins, *Geography of China*, 1911.

Entertainment as a Refuge
P215 Photo b/w: Li Zhensheng, 1965. Courtesy of Beaugeste Gallery, Shanghai;
P222 Illustration bottom left: Edwards, *The Dragon Book*, 1938;
P223 Illustration: Yule, *The Book of Ser Marco Polo*, 1875;
P225 Illustration right: Courtesy of Han Ensheng;
P234 Photo b/w: Johnston, *From Peking to Mandalay*, 1908; Map: Clark/Sowerby, *Through Shen-Kan*, 1912.

Preserving the Cultural Heritage
P243 Photo of Dai minority girl: Wang, *Ethnic Groups in China*, 2004;
P 246/249 Sketches of Sideng East Gate and Sideng Square as well as theater model: Shaxi Rehabilitation Project, Institute for Spatial and Landscape Development, Swiss Federal Institute of Technology Zurich, 2010 (Courtesy of Diego Salmeron);
P247 Photo b/w: Ernest H. Wilson, 1908, Harvard University Library, Cambridge MA;
P253 Sketch of Wangyuelou: Architecture Department, Beijing Jiaotong University, 2006 (Courtesy of Shangzhuang Village Committee);
P256 Photo b/w: Ernst Schäfer, 1938/39, German Federal Archive (deutsches Bundesarchiv), Koblenz/Germany; Map: Hedin, *My Life as an Explorer*, 1925.

How to Govern the Countryside
P267 Photo b/w: Xinhua News Agency, in: Spence/Chin, *The Chinese Century*, 1996;
P269 Illustration: Courtesy of Li Xiaoyang;
P276 Photo b/w: Shi Panqi, in: Spence/Chin, *The Chinese Century*, 1996;
P277 Newspaper clipping: "Properly elect a village official for the benefit of the people," *Nongmin Ribao*, Dec. 3, 2011;
P282 Newspaper clipping: "First Lady Marcos accompanied by Jiang Qing and welcomed by villagers of Xiaojinzhuang in Tianjin," *Renmin Ribao*, Sep. 24, 1974.

Postscript
P292 Photo b/w: John Thomson, 1874, University of Otago Library Special Collections, Dunedin/New Zealand

The authors tried their best to find the copyrights of external illustrations used in this book.

About the Authors

Matthias Messmer, born in Switzerland in 1967, studied international relations and received his Ph.D. in the field of sociology at the University of Constance, Germany. The scope of his work includes cultural critique, writing and photography. His projects focus on Chinese cultural politics, pop culture and Western images of China. Messmer contributes regularly to international newspapers and magazines. He is also the author of *Jewish Wayfarers in Modern China* (2012).

Hsin-Mei Chuang, born in Taiwan in 1979, received her M.A. in journalism at the University of Wisconsin-Madison, USA. She is an independent cultural researcher and writer. Chuang has worked with numerous cultural institutions in Europe on exhibitions, publications and research projects about Chinese culture and art.

The two authors are collaborating on several other artistic and documentary projects. Messmer and Chuang have travelled extensively in China and its neighboring countries. They currently live in Shanghai and Switzerland.

The authors would like to thank the following individuals, companies and foundations for their generous support:

Daniel Schluep, Evilard
Shenzhen Golden Universal Watch Co., Shenzhen
The Hans and Wilma Stutz Foundation, Herisau
The Dr. Fred Styger Foundation, Herisau
The Karl Mayer Foundation, Triesen

TITONI
OF SWITZERLAND

Kulturförderung
Appenzell Ausserrhoden

SWISS

Mazar Village,
Xinjiang Uyghur Autonomous Region